# Effective Photography

# Effective Photography

John Frair
and
Birthney Ardoin

*University of Southern Mississippi*

PRENTICE-HALL, INC. *Englewood Cliffs, N.J. 07632*

*Library of Congress Cataloging in Publication Data*

Frair, John
    Effective photography.

    Bibliography: p.
    Includes index.
    1. Photography.  I. Ardoin, Birthney
II. Title.
TR145.F66      770      81-8616
ISBN  0-13-244459-3 (c)  AACR2
ISBN  0-13-244442-9 (p)

Editorial/production supervision: *Gretchen K. Chenenko*
Interior design: *Karen Wagstaff*
Cover design: *Diane Saxe*
Page layout: *Bruce Kenselaar*
Manufacturing buyer: *Ed O'Dougherty*

*Printed in the United States of America*

10  9  8  7  6  5  4  3  2  1

ISBN  0-13-244459-3
ISBN  0-13-244442-9  PBK

Prentice-Hall International, Inc., *London*
Prentice-Hall of Australia Pty. Limited, *Sydney*
Prentice-Hall of Canada, Ltd., *Toronto*
Prentice-Hall of India Private Limited, *New Delhi*
Prentice-Hall of Japan, Inc., *Tokyo*
Prentice-Hall of Southeast Asia Pte. Ltd., *Singapore*
Whitehall Books Limited, *Wellington, New Zealand*

To Otha C. Spencer, Ph.D.

# Contents

Preface   xi

## 1
## LIGHT
*1*

Properties of Light   2
Light Used as a Medium of Expression   14
Summary   18

## 2
## THE CAMERA
*20*

Camera Obscura   21
The Pinhole Camera   23
Viewing Systems   27
Special Camera Designs   40
Summary   42

## 3
## THE LENS
*44*

History of Lens Design   44
Optical Faults   46

*Contents*

Lens Properties  49
Lens Uses  57
Special Lens Designs  60
Summary  67

**4**

**CREATIVE CAMERA CONTROLS**
*68*

Shutters  68
Focus  82
Aperture  86
Summary  94

**5**

**FILM EMULSIONS**
*96*

History of Modern Film  96
Elements of Photographic Film  101
Emulsion Preparation  104
Characteristics of Black-and-White Film  107
Special-Purpose Emulsions  112
Summary  115

**6**

**EXPOSURE**
*117*

Factors Influencing Exposure  118
Film Speed Ratings and Their Meanings  119
Camera Controls  121
Equivalent Exposures  123
Determining Correct Exposure  124
Basic Reference Exposures  124
Light Meters  132
Summary  140

**7**

**COMPOSITION**
*141*

Common Compositional Mistakes  142
Subject-Background Relationships  143
Perceptual Grouping  148
Other Compositional Factors  154
Summary  161

**8**

FILM DEVELOPMENT
*163*

History of Film Development  163
Physical Aspects of Film Development  165
Types of Film Developers  168
Factors Affecting Film Development  169
Development Variations  175
Other Processing Chemicals  176
Summary  188

**9**

THE DARKROOM
*190*

History of the Darkroom  190
The Modern Darkroom  192
Safelights  192
Enlargers  194
Enlarging Lenses  198
Easels  200
Timers  201
Other Darkroom Equipment  201
Summary  204

**10**

PHOTOGRAMS
*205*

History  205
Demonstration of Photographic Principles  208
Materials for Making Photograms  214
Variations of Photograms  215
Summary  217

**11**

ENLARGING
*218*

Reasons for Enlargements  219
Enlarging Papers  222
Contrast and Tone Control  226
Print Manipulation  235
Summary  239

**12**

PRINT FINISHING
*240*

Print Mounting   240
Final Finishing   251
Summary   252

**13**

AVAILABLE LIGHT PHOTOGRAPHY
*254*

Development of Available Light Photography   254
Equipment Requirements   256
Available Light Conditions   259
Advantages and Disadvantages of Available Light   259
Summary   268

**14**

FLASH PHOTOGRAPHY
*269*

History of Flash Photography   269
Flash Exposure Calculations   272
Flash Synchronization   279
Flash Techniques   281
Summary   289

**15**

FILTERS
*290*

Filter Construction and Designations   290
Filter Usage   292
Filter Factors and Exposure Changes   298
Specialty Filters   299
Summary   303

**16**

PRINTING VARIATIONS
*305*

Using Texture Screens   305
Print Toning   309
Using High-Contrast Films   313
Summary   319

Glossary   321
Bibliography   340
Index   343

# PREFACE

This book is primarily written for the beginning photographer, but those with experience will find it useful, too. The approach is practical and emphasis is placed on perfecting the basic techniques of black-and-white photography, explaining the scientific principles of the photographic process, and enhancing effective visual communication. The book's mixture of the technical, artistic, historic, and communication aspects of photography is designed to support lectures, facilitate learning, stimulate creativity, and encourage experimentation. The organization is cumulative so that the reader can acquire certain tools, and then build upon them along the way.

Concepts, ideas, and practical matters are discussed in plain language. Technical terms are explained in the text, and the glossary should save both the novice and the veteran a few unrewarding dictionary searches.

The book is illustrated with many how-to-do photosections on such things as developing film; making enlargements, test strips, and proof sheets; and even making photograms and pinhole cameras. Step-by-step instructions are also given for dodging; burning-in; spotting, print positioning, and dry mounting prints; and cleaning lenses.

Other features of the book include coverage of visual composition and the psychology behind it, chapter summaries, and special information set in chart form. In addition, historical sections are incorporated into their respective chapters, to give insight into the development of the equipment and processes.

The authors are indebted to those persons who furnished illustrations for

this book. Special thanks go to Steve Artman, Betty Baker, Cheri Campbell, Alison Carlson, Russ Cloy, Steve Coleman, Lynn Creel, Anthony Creed Curtis, Ken Gaines, Marie Hakimzadeh, Ron Harlow, Beth Hatch, Tim Hope, Rebecca Johnson, Maurine Knighton, Jeff McAdory, Damian Morgan, Carter Owen, Mary Petterman, Jean Pustay, Danny Rawls, Cecil Rimes, Steve Saxton, Elizabeth Sneed, Kenny Stevens, David Taylor, Ann Turner, Lisa Vanzant, Brent Wallace, and Wanda K. Watson.

Deserving special acknowledgment are Susan Bryant, who typed the manuscript, and Barbara Stewart and James Bishop for furnishing equipment.

Deepest gratitude is extended to JoAnn Frair, who helped with the illustrations and served as a model on many occasions; and to family and friends, especially Tricia Jobe, Christopher, and Brandy, who gave encouragement and support.

John Frair

Birthney Ardoin

# LiqHT

Many things influence the photographic process, but none has a greater effect than light and its properties. Light is what makes sight possible, yet the characteristics and properties which make up light are often ignored or taken for granted. A basic understanding of the creative use of this natural energy is as important to the photographer as knowledge of paints is to the artist. Without it, the predictability and control over the final photographic product is left to chance.

Photography, in a literal sense, is the recording of images with light. Normally the recording is of images of sight, but the photographic image is never an exact duplicate of what is seen. Variations are caused by the differences in what the eye perceives and the reaction of the photographic process to light. In many instances a skilled photographer can manipulate the process through the selection of proper films and camera accessories to more closely approach visual reality or to transcend reality to produce images which are impossible to see through vision alone.

Whether the goal of the photographer is to faithfully reproduce nature or not, the primary controlling factor is light. It is not only necessary for sight, but because of its many characteristics and moods it becomes the palette which the photographer uses to gather color, tone, and brightness values to create the photographic image.

# PROPERTIES OF LIGHT

The eye and the photographic process do react the same as each other in many ways, but it is their differences which make the understanding of light important to the photographer.

**WAVELENGTH.** Light (infrared and visible) is similar to other radiant energy forms which make up the electromagnetic spectrum, such as radio waves, X-rays, gamma rays, and cosmic rays (Fig. 1.1). The similarity lies in their projection from an energy source, such as the sun, as particle waves with valleys and crests. The main difference is in the distance between the crests of the waves, which is referred to as the wavelength of the energy. Wavelengths of the visible light spectrum are usually measured in nanometers (nm) which are one-millionth of a millimeter. The distance between the wavecrests of radio waves, on the other hand, can be several miles in length.

As the wavelengths become shorter (closer together), the energy approaches visible light through the infrared portion of the spectrum. The area is visible because receptors in the eye, rods and cones, respond to those particular wavelengths of energy just as some materials in nature respond to other energy wavelengths. For example, certain crystalline formations are naturally sensitive to radio waves. These are used to regulate the exact frequency being transmitted or received. Also, some animals see partially in the infrared portion of the spectrum, giving them better night vision; and mela-

*FIGURE 1.1   Visible light is electromagnetic energy similar to other forms of energy such as radio waves and x-rays. The difference between types of energy is the distance between the crests of their vibrations.*

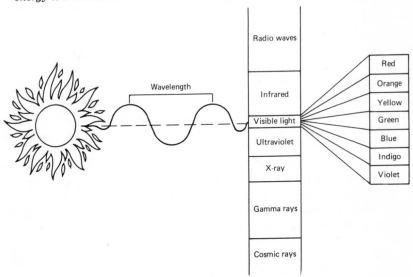

nin, a chemical in the body, responds to visible and ultraviolet light to produce tanning of the skin.

The rod-shaped receptors of the eye produce vision in black and white under low-light conditions. The primary receptors that give vision are the cones, which are used for normal sight under normal lighting conditions. Whereas both the rods and cones are sensitive to particular wavelengths of energy, the cones are responsive also to small differences in the wavelengths which strike them. The cones' response to changes in these wavelengths produces the sensation of color.

The visible portion of the spectrum is usually portrayed as a rainbow of different color sensations, beginning with red which has the longest wavelength, and then through the shorter wavelengths which produce the sensation of orange, yellow, green, blue, indigo, and violet. Sir Isaac Newton was one of the first scientists to discover that white sunlight was actually a combination of all colors. By using a prism to spread the light into its different wavelengths and then combining them again with the aid of another prism, he produced white light. Newton named seven colors of the spectrum, but the human eye is not sensitive to the wavelength he called indigo, and orange is rarely seen as a pure spectral color.

In the early 1800s the validity of Newton's theory that the eye was sensitive to this spectrum of colors was questioned by Thomas Young. He reasoned that too many different types of light-sensitive receptors would be required in the eye to respond to all of the different wavelengths. Through experimentation he arrived at the theory that the eye is sensitive to only three colors, which in combination with each other produce the sensation of the complete spectrum. Young believed originally that the eye's sensitivity was limited to the wavelengths which produce the sensations of red, yellow, and blue. Later he changed his colors to red, green, and violet. The three colors are now classified as red, green, and blue.

The final revision of the colors was, in part, due to experiments by James Clerk Maxwell, a Scottish scientist, who attempted to prove Young's theory. Maxwell photographed a tartan ribbon on black-and-white film using three separate exposures, one through a red filter, the second through a green filter, and the third through a blue filter. These three exposures were projected from separate projectors, each equipped with the same filter which the picture was photographed through and then superimposed one on top of the other to create a color image which corresponded to the original scene. Not only did Maxwell prove Young's theory, he also produced the first color photograph in the process.

The experiment carried out by James Clerk Maxwell in 1861 to produce a color image should not have worked since films of the times were only sensitive to the blue portion of the visible spectrum of colors and not to red and green light. The experiment worked, however, because of two phenomena: (1) The green filter he used was not spectrally pure, and it transmitted

some blue wavelengths, and (2) red appeared because the red ribbon he photographed not only reflected red wavelengths of light but also ultraviolet light, to which the film was sensitive. Today's emulsions are sensitive to all three wavelengths of light; therefore, the experiment will work quite well.

Later, more exacting experiments have further defined the eye's sensitivity to light wavelengths between 1/40,000 and 1/70,000 inch (in.) (400 to 700 nm). The cones in the eye are sensitive to all three colors, but they do not respond equally to all wavelengths. Although eye sensitivity varies, experiments have shown that the average eye reaches its maximum sensitivity under normal illumination at wavelengths of about 1/55,400 in. (554 nm) in distance. This wavelength corresponds to the color perceived as green-yellow, causing the eye to be more sensitive to green light than it is to red or blue (Fig. 1.2). These sensitivity responses of the eye produce colors which are considered normal.

Other materials also are sensitive to at least part of the visible spectrum. The ones with the greatest importance to the photographer are a group of chemicals called *halogens*. Halogens are nonmetallic elements, such as fluorine, chlorine, bromine, iodine, and astatine. Halogens by themselves are not sensitive to light, but when they are chemically combined with a metal they form a metallic salt called a *halide* that is sensitive to wavelengths of energy within the visible spectrum. Halides are used to record the photographic image on film and paper.

Halides used as part of the earlier black-and-white photographic processes were sensitive to blue and ultraviolet wavelengths of energy. Many of the films and most printing papers are still colorblind or nonsensitive to portions of the visible spectrum. In order to make film sensitive to all colors visible to

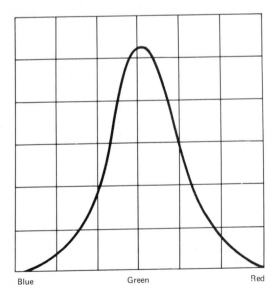

Blue          Green          Red

*FIGURE 1.2 The wavelengths of energy making up what is perceived as visible light reacts with the cones and rods of the eye to produce the sensation of color.*

the eye, special dyes, called *optical sensitizers*, are added to the halides. The films with these dyes are called *panchromatic film* and are for general use.

Panchromatic film is sensitive to the three primary colors which the eye sees, but it does not respond with the same sensitivity to the different wavelengths. Panchromatic film also retains its sensitivity to some of the wavelengths of the invisible ultraviolet radiation. These differences in response and sensitivity can cause a slight discrepancy between how a scene is recorded on black-and-white film and how the eye sees the scene. (See Fig. 1.3) Red and blue, for example, record on film with more intensity, and green will be darker than it appeared. Ultraviolet wavelengths, which are not seen by the eye, record as a haze, especially in landscape photography or when the photographer uses a telephoto lens.

The variation in the sensitivity of film affects the tonal values of the colors recorded on black-and-white film. Where the eye can detect subtle differences in colors, the film may record these different colors as one tone, which at times can be undesirable. Fluffy white clouds against a dark blue sky intended to be the focal point of landscape photography, for example, can reproduce as a light blank sky because the film is more sensitive to blue than the eye, and it records both colors at the same tonality. Foliage in the landscape will photograph darker than the eye sees it. These problems can be solved, however, with the use of filters on the camera's lens.

The colors of the spectrum are perceived because of their differing wavelengths, but the color of light sources are measured according to the average wavelengths they produce. A light source such as an incandescent bulb, for example, projects light that has an overall reddish cast because most of the wavelengths it produces are within the red part of the spectrum. Daylight, on

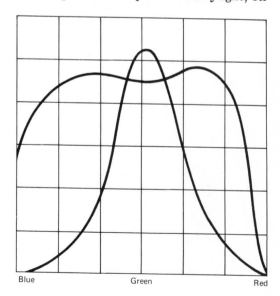

FIGURE 1.3 *The sensitivity of photographic film to the energy that produces the sensations of color can be altered when it is manufactured. The emulsion does not display the same degree of sensitivity to each wavelength as does the eye.*

Blue          Green          Red

**TABLE 1.1**
**PREDOMINANT COLOR OF LIGHT SOURCES**

| Clear Blue Sky | Color |
|---|---|
| Hazy or smoky day | Blue light |
| Overcast day | ↑ |
| Electronic flash | |
| Average daylight | |
| Noon sunlight | |
| Blue flash bulbs | |
| Clear flash bulbs | |
| Photoflood lights | |
| Professional tungsten bulbs | |
| Household light bulb | ↓ |
| Candle | Red light |

the other hand, consists of predominately blue wavelengths. Each light source produces a different average color, and this affects how the color is recorded on film. (See Table 1.1)

Each color film is manufactured to reproduce correct colors if the subject is illuminated by a particular color of light. When this occurs the film is said to be "balanced to the light source." Films with a "daylight" balance are designed to be used with sunlight (predominately blue), electronic flash, or blue flashbulbs. If the daylight balanced film is used under lights in a home (tungsten light) or under fluorescent lights, the overall picture will take on a reddish or greenish cast, depending on the light source. The eye and brain normally work together to compensate for the difference in light source colors, but a single photographic film does not compensate for the differences in light sources.

The sensitivity of films manufactured for specialized uses has been expanded into the ultraviolet, infrared, or even into the x-ray portion of the electromagnetic spectrum. These films allow the photographer to record objects in a manner that is not normally seen. (See Fig. 1.4)

The understanding of wavelength as a property of light and its effects allows the photographer to make corrections for the differences that occur between the observed and recorded image. It also makes it possible to move out of the realm of perceived reality.

INTENSITY.  Intensity or brightness, a second property of light, ultimately affects the quality of the photographic image more than any other light property. (See Fig. 1.5) It is influenced by several factors: (1) the power of the light source, (2) materials through which the light rays pass before striking the subject, and (3) the distance the light travels before striking the subject.

A visible difference in the brightness of light striking an object with varying intensities from several light sources is easily noticed. The illumination intensity of a 100-watt light bulb, for example, is greater than that of a 15-watt bulb, when both are placed the same distance from an object. This aspect of intensity is especially important when the photographer uses flash or

(a)

(b)

(c)

*FIGURE 1.4 The subject in these photo-graphs is dressed in a blue collared shirt with red, white, and yellow stripes. (a) A nonred sensitive film emulsion (orthochro-matic); (b) film that is sensitve to the three primary colors of vision: red, green, and blue wavelengths (panchromatic); (c) a record of the invisible infrared spectrum of energy.*

*FIGURE 1.5 The intensity or brightness of light is a sensa-tion which is produced by the height of the energy's wave crest. The higher the crest of energy, the more intense the light appears.*

Decreasing intensity

artificial light. Under daylight conditions, the brightness of the light source remains practically constant.

The second factor influencing light intensity, however, does affect daylight conditions. The material that sunlight has to pass through before striking the subject can be as simple as the atmosphere we breathe. As light travels through the air, it is scattered and absorbed by suspended particles, a process which reduces the intensity of the light. If the light passes through a layer of clouds, its intensity is reduced further by reflection and absorption, depending on the cloud's thickness. Other materials such as leaves and foliage influence the intensity of direct light striking the subject when it is underneath such coverings.

One of the most important influences on intensity is the *law of inverse squares*, which states that light intensity decreases inversely with the square of the distance it travels. This law normally does not present a problem for photographs taken in sunlight, but it becomes a major consideration in determining exposure for pictures taken with flash. Excessive lightness in the foreground of a flash picture is an illustration of this law in action when the subject is close to the light source. The farther an object is from the light source, the less intensely will the light strike it.

As with wavelengths, the eye and the photographic process have similar requirements and reactions to the intensity of light. Both require a specific level of brightness to produce optical images. Because of the elaborate automatic muscles of the eye's iris, and chemicals within the eye that control the rods' and cones' sensitivity to light, the quantity of light allowed into the eyes is automatically adjusted to prevent a vision overload. Even under normal conditions, however, sunglasses or other artificial materials may be needed to aid the eye in compensating for the varying intensities of light. The camera uses an adjustable aperture similar to the iris of the eye to control the amount of light striking the film.

The main physical difference between vision and photography is the manner in which the eye and camera see the brightness of a scene. The eye never views a scene as a whole but uses a scanning motion to receive overall perception. As the eye encounters areas of brightness, the iris contracts to admit less light, and the receptors become less sensitive to light. When the eye scans to a darker area, the iris dilates to admit a greater quantity of light, and the eye becomes more sensitive to light. Because of these automatic adjustments, one is seldom aware of changes in light intensity except when entering a bright area from an extremely dark area or vice versa.

The sensitivity of film, on the other hand, cannot adjust to changing light conditions as the eye does. While the eye automatically compensates for varying intensity levels, film can record only at one level at a time. The camera's controls have to be set to get an average exposure of the scene. The result does not correspond to vision. For example, when the eye views a scene, such as a person standing in front of a window with a bright outside light in the background, it can see details of both the outside and of the person inside.

But the film's capacity to record only a single light level limits details. Light intensity brighter than the optimum level results in overexposure. Less intensity than optimum creates a dark underexposed image. If the photographer bases the exposure on the bright outside, the face and body of the subject would record as a dark silhouette in the reproduced positive image. If the exposure is based on the facial and body areas of the subject, the background would reproduce as a blank expanse of white. Tonal reproduction can be controlled to a certain extent, however, with proper exposure, film development, and other darkroom manipulations, but awareness of the problem in advance is critical. Proper film selection can help.

Films for general usage are manufactured to accept a certain amount of overexposure and underexposure and still retain details in the lighter and darker areas. This latitude of acceptable exposure changes the contrast of the recorded subject. Some films reproduce only tones of pure black (no exposure) and white (correct exposure) and so increase the contrast of the scene. Others reproduce many different tones ranging from black through several intermediate shades of gray and pure white for the highlights. The photographer can select the film latitude characteristics best suited to reproduce the scene as it is visualized (Fig. 1.6).

The film's sensitivity to light is another factor to consider in film selection. A high light intensity allows the photographer to select a film with less

FIGURE 1.6 (a) Normal contrast. A film which gives a wide range of tones; (b) A high-contrast scene that recorded without the scene's normal middle tones of gray.

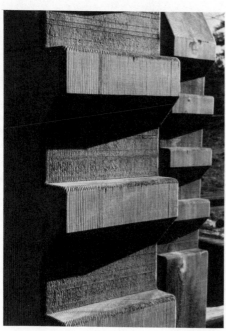

sensitivity to light; such films will retain greater detail in the subject than will the more light-sensitive films. Low light intensity makes it necessary to use a film with more sensitivity which will retain less subject detail.

Light intensity also has some artistic influence. For example, when a subject is placed in a brightly lit area and the surrounding areas are kept to a lower light intensity, the subject is isolated from the background and stands out with added emphasis.

**DIRECTION.**  A third property of light that is perceived by the eye and is of concern to the photographer is direction. Light waves travel in a straight line from the light source unless they strike something which changes their direction through diffraction or reflection (Fig. 1.7). Although vision is normally a product of reflected rather than direct light, the quality of the incident or direct light sets the mood for the photographic image.

The direction from which light strikes a subject plays an important role in revealing subject form. It creates highlights and shadows on the subject. The more oblique the angle from which the light strikes the subject, the more modeling and texture are visible. This is caused by the light rays skim-

*FIGURE 1.7  When light strikes an object, its rays change from direct to reflected light. (left)*

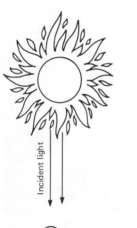

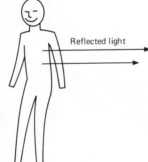

Incident light

Reflected light

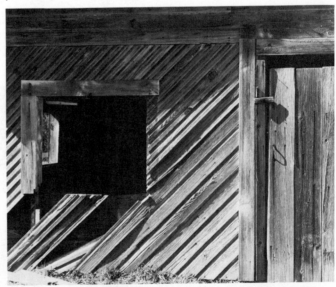

*FIGURE 1.8  The direction of light is a sensation used to delineate form and texture. The oblique angle of the light in this photograph caused it to skim across the surface of the boards, producing a tactile sense of roughness. (Courtesy Ron Harlow.)*

ming over the raised portions of the subject, highlighting them in contrast to the shadow areas which do not receive direct light rays. As the light source approaches the same angle as the camera's aim, the light appears less contrasty, and the subject has less apparent modeling. (See Fig. 1.8)

Photographed texture and contrast of a scene also are controlled, to a large extent, by the amount of light traveling in a single direction which strikes the subject. For example, on a bright sunlit day, a large percentage of the light rays striking a subject are traveling parallel to each other. This produces a scene with greater contrast between bright and shadow areas. If the light rays are dispersed by a layer of clouds, the change in direction will diffuse and soften the contrast of the light (Fig. 1.9). Not only does this diffusion demonstrate one of the principal characteristics of light, but for the photographer, it helps create many qualities and moods of the scene to be photographed.

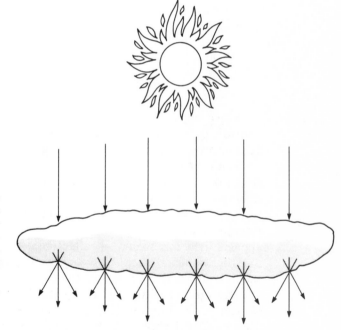

*FIGURE 1.9 Light passing through clouds or another diffusing medium is softened because the light rays are scattered. Bright sunlight is harsh because the rays travel almost parallel to each other. When scattered, they strike a subject from many directions at the same time.*

**REFLECTION AND ABSORPTION.** Diffusion is not the only characteristic of light that is important to the photographer. When light strikes an object, part of the rays are absorbed by that object and other rays are reflected (Fig. 1.10). The reflected rays make the object visible to the eye, but other wavelengths are reflected also. This occurrence is important to the photographer because an object's tones and colors are determined by the percentages of incident light and different wavelengths of light it reflects.

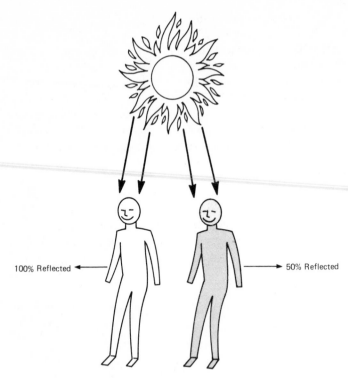

100% Reflected

50% Reflected

FIGURE 1.10 *The amount of light reflected from a subject determines the perceived tonality of the subject. The subject on the left is reflecting almost the same amount of light striking it, creating a sensation of white. The subject on the right is absorbing about 50 percent of the light and reflecting 50 percent producing the sensation of gray. Depending on the amount of light the subject is reflecting, the color could be perceived as white, black, or any of the many shades of gray.*

Since objects can reflect visible and invisible light, the photographer can control the recorded image by selecting film that is sensitive to visible light or infrared light waves. (See Fig. 1.4)

Both the tonality and color impression an object projects are based on its absorption and reflection characteristics. For example, two people standing side-by-side, one dressed in white and the other in black, are being struck by the same intensity of light. The tonality of the apparel, however, is seen differently because of the amount of light that each is reflecting. The one that appears light in tonality is reflecting a larger percentage of the rays than the one that appears black. Conversely, the black covering is absorbing more of the light and reflecting less of the rays.

Objects perceived as the neutral tones of white, gray, or black are reflecting the visible wavelengths of the spectrum in equal percentages. A white object reflects about 90 percent of red, green, and blue wavelengths. It absorbs only about 10 percent of each. A middle gray tone reflects and absorbs about 50 percent of each of the three visible wavelengths, and a black object could reflect as low as one percent of each.

In nature, however, seldom do objects reflect equal amounts of each wavelength. They are selective in their reflection. A leaf, for example, appears green to the eye because of the selective process. Although all three visible wavelengths may strike the leaf with the same intensity, the red and blue portions of the visible spectrum are absorbed more than the green wavelength. Therefore, more of the green is reflected, giving the visual impression

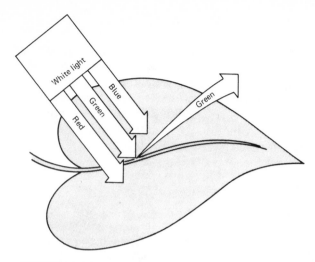

FIGURE 1.11 Seldom in nature does a subject reflect equally all three wavelengths of light to which the eye is sensitive.

that the leaf is green in color (Fig. 1.11). Any object which is perceived as having color is selectively reflecting and absorbing portions of the visible spectrum. This means that the object is reflecting its visually perceived color and absorbing all others.

**POLARIZATION.** Polarization of the light rays is another property of light which concerns the photographer. Technically, polarization is the angular orientation of the wave crests, but in simple terms, it is what the eye sees as reflection or glare.

When light is transmitted from a source, the rays travel in a straight line with the waves vibrating in all possible directions perpendicular to the direction of travel. When the unpolarized light rays strike a nonmetallic surface, the wave vibrations can become polarized, so some of the reflecting rays vibrate in the single direction parallel to the surface. This polarized plane of light is what the eye sees as reflections or glare. (See Fig. 1.12)

Both the eye and photographic film react to polarized light, but the eye and brain work together so that one is not consciously aware of the glare

FIGURE 1.12 The light we see as reflections is only polarized light.

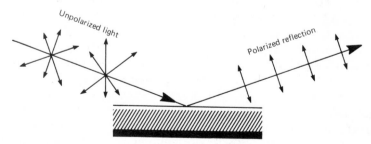

most of the time. When reflections become disturbing to vision, they can be controlled with polarized sunglasses. In a photograph, however, the polarized light can produce distracting reflections and also destroy color purity.

Typically polarized reflections create problems when the photographer makes pictures of objects located behind glass, such as a store front, or shoots highly polished items, such as tables. At times, however, polarized light is intentionally used for limited purposes, such as to make crystalline structures visible or to show stress distribution on models of buildings, airplanes, and other materials.

In normal situations, these reflections in glass and other nonmetallic surfaces can be reduced or eliminated with proper polarizing filters. These filters can also darken sky tones and improve color purity. The sky is perceived as being blue because of the reflections and dispersion of light rays by water droplets and other matter suspended in the air. The polarizing filter reduces some of the reflections, causing the sky to appear darker depending on the angle between the sun and filter. Most of the world of color also is influenced by reflections of the sky color. For example, the green of foliage is affected because some of its surface actually reflects the blue of the sky along with the selective reflection of the three wavelengths of light. The result is that much of the color purity of the object is diluted, making for radical color changes when color film is used.

## LIGHT USED AS A MEDIUM OF EXPRESSION

Since light is essential to both photography and vision, it is inevitable that many of the psychological qualities of light are needed to complete the communication of the photographic image. Many of the nuances of light are taken for granted and perceived only on a subliminal level. The quality of the light adds feeling and mood to the scene we see. But these qualities take on added clarity and emphasis when used deliberately by the still photographer. It is the different features of light which create a special mood or feeling for the subject of the picture.

**CREATES A MOOD.** Light primarily creates moods psychologically by allowing viewers to place themselves in the situation and allowing them to add information mentally to complete the image in a personal way. A photograph of a foggy morning, for example, creates a setting with which most viewers can associate. Even though the pictorial beauty can be enough of an attraction, viewers will project into the image the quietness and serenity they, themselves, have experienced in a similar situation.

Different types of light project psychological moods by themselves and are not always dependent on subject matter. For example, contrasty lighting creates mental images of drama, mystery, and even romance. Lack of contrast in lighting can create feelings of serenity, coolness, and quietness. Although

the contrast of the light is not dependent on the subject matter, appropriate subject matter heightens the feelings of the viewer on an unconscious level.

The tonality of the photograph also plays an important role in creating a mood. Photographs which are predominately light in tone produce feelings of lightness, freedom, and gaiety. Predominately dark pictures give a sense of heaviness, somberness, and tend to enclose the subject. By using the natural psychological feelings created by contrast and tonality, better communication results between the photographer and the viewer (Fig. 1.13).

Although this book is mostly concerned with black-and-white photography, we should note that the colors in color films, either in negative or transparency (slide) form, also affect mood, composition, and the perception of objects within the photograph. Bright colors, such as red, yellow, and orange, attract the eye just as readily in color photography as light tonality does in the black-and-white process. Psychologically, lighter hues produce feelings of femininity, lightness, and grace, while darker hues of the same colors create impressions of masculinity, romance, and somberness. Contrasting colors are more dynamic and moving; subtle differences in hue are much quieter. The selection of color is especially important in making pictures of people. A subject's brightly colored clothes, for example, can draw attention to themselves and away from the subject's face. At the same time, the colors of facial complexion are diluted.

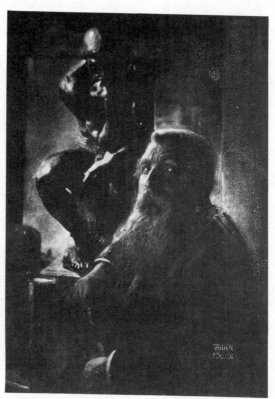

FIGURE 1.13 A very pensive mood is created through the tonality and lighting in this photograph by Steichen. Light is used to emphasize both subject matter and mood. [Edward Steichen, Rodin and "The Thinker." (1902), Platinum and pigment print, 17 × 12 5/16". Collection, The Museum of Modern Art, New York. Reprinted with the permission of Joanna T. Steichen.]

The psychological implications of color are a most interesting subject that is being investigated through continuing research, and of course, it is not limited to photography.

**REVEALS TEXTURE.**  The different qualities of light also physically affect the way a subject is recorded. Natural textural qualities of a subject can be emphasized or softened depending on the type of light used.

Textural qualities are apparent because of highlights and shadows created by raised surfaces which project shadows into the lower areas of the subject. When the contrast of the light source is strong, the light will create more brilliant highlights and darker shadows, thus emphasizing the texture of the subject. If the same subject should be photographed with a light source which has less contrast, such as on a cloudy day, there would be little difference between the brilliance of the raised areas and the adjoining depressions. This type of light produces little textural emphasis.

For some subjects an emphasis on the natural texture is not always desirable. Portrait photographers, for example, will occasionally use contrasty light sources for males to emphasize facial lines and texture. This produces a picture most people have come to associate with masculinity. But it is normally thought to be more flattering to a woman to deemphasize skin texture and lines. For them, the character lines emphasized by contrasty lighting become an indication of age.

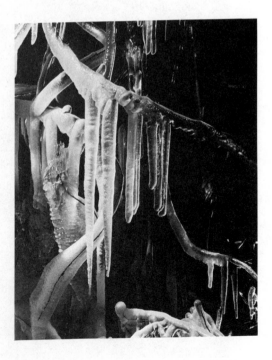

*FIGURE 1.14  Light skimming over the surface of the icicle helps emphasize the texture and gives the subject a translucent quality. (Courtesy of Russ Cloy.)*

Many objects in nature derive their beauty from their natural texture and their identity depends on their texture being recorded correctly. Weathered wood appears more beautiful with the light skimming across its surface, highlighting the raised wood and throwing the cracks into black shadows. The textural emphasis also serves to point out the erosion of the wood by the elements of the weather. (See Fig. 1.14)

**ISOLATES THE SUBJECT.** Subject isolation is another role light can play in the communication of the photographic image. Both subject tonality and subject lighting are important in this respect. The eye is naturally attracted to lighter tones. By selecting darker backgrounds to contrast a lighter subject, the dominance of the subject is enhanced in the photographic composition. This subject tonality can be achieved by either placing the subject in the scene's brightest light or by selecting the object with the lightest tonality as the subject.

An example of the effectiveness of lighter tones drawing attention would be a picture of a person with sunlight spilling over the top of the head, throwing the face into a shadow except for the tip of the subject's nose. All attention of the viewer is directed to this point, and it becomes the focal point for the picture.

The photographer, however, can use lightness of the subject in a positive way to emphasize and isolate it from the surroundings. (See Fig. 1.15)

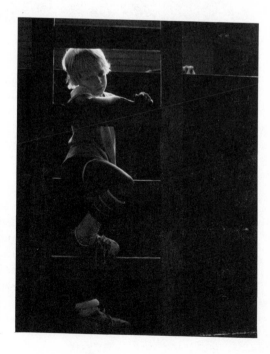

*FIGURE 1.15 Backlighting the subject helps to isolate and separate it from the darker foreground and background. Because the light beam striking the subject in the illustration is small, the subject is isolated more than it would be if the whole figure had been backlighted. (Courtesy of Jean Pustay.)*

**UNIFIES VISUAL ELEMENTS.** Besides isolating the subject, light can unify different visual elements into a perceptual group. This allows the photographer to present diversified objects in the picture area and still produce a visual perception of oneness because of their tonal similarity (Fig. 1.16).

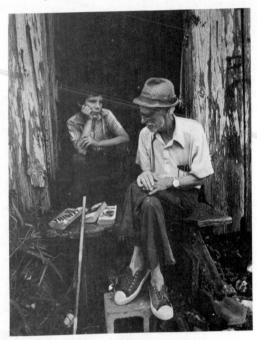

*FIGURE 1.16 Tonal similarity of the old man and the young boy helps the viewer to see the two objects as a unified whole. The darker surroundings and background also help the viewer to concentrate upon the subject. Often, objects even more widely separated, can be unified with the use of light and tonality. (Courtesy of Carter Owen.)*

## SUMMARY

The different qualities of light have a great influence on the photographic process. Many of the effects of light on photographic emulsions are similar to those on vision, but it is the difference that makes it necessary for the photographer to understand the way in which light and film react.

Wavelength produces the sensation of color in film and vision, but relationships of tones are different on film. The reason is that the spectral sensitivity of the eye and film differ. Although both are sensitive to all three primary colors, film has greater sensitivity to red and blue, while the eye is more sensitive to the yellow-green hues of light. The photographer can choose from many types of emulsions to record the image. The decision on which to use influences how the image is seen and how the different hues on the scene are translated in tones of black and white. For example, some film emulsions are sensitive only to portions of the visible spectrum and not to red light. Other emulsions will record portions of the invisible electromagnetic spectrum, such as x-ray radiation, infrared, or ultraviolet light.

The intensity of the light is perhaps one of the greatest influences on the

quality of the recorded image. It determines both the quality of light and the exposure settings which the photographer uses.

Other influences on the photographic image, in addition to wavelength and intensity, are reflection and absorption, direction, and polarization. Reflection and absorption affect the tonality of the recorded image and the color. Direction of light primarily influences contrast of the scene, while polarization produces reflections.

With a thorough understanding of the many properties of light and their influences on the photographic image, the photographer can use light to create moods and feelings, to further reveal textures of the subject, to isolate the subject from the background, and to unify many different visual elements into a complete composition.

# 2

# THe Camera

The most visible piece of equipment used in photography is the camera. Because it is essential in the photographic process, manufacturers have designed cameras to meet all levels of skills and needs. The cameras range from the totally factory-set, nonadjustable, Instamatic type to cameras that have manual adjustments to focus and expose the film. The opposite extreme of the Instamatic camera is one that automatically adjusts the exposure to the light condition and the film which the photographer is using.

Accessories for a camera vary from meters to read the light's intensity to motors which automatically advance the film and prepare the shutter for the next exposure. These features, by and large, distinguish one camera model from another. And the price the photographer pays for a camera depends more on the type and number of built-in convenience features than on the quality of workmanship.

The simplest camera models costing only a few dollars or the most expensive, however, serve the same basic functions in the photographic process. These functions are (1) to hold and protect the light-sensitive film from exposure to light until the photographer is ready to record the scene on the film; (2) to project and focus the light rays onto the film at the right time of exposure; and (3) to regulate the amount of light which is allowed to enter the camera and strike the film at the right time of exposure. Each of these three essential functions have remained unchanged since the beginning of photography in the early 1800s. Although cameras come in different sizes, shapes, formats, and price ranges, the basic camera still performs these functions.

## CAMERA OBSCURA

Much of the automation of the modern camera is the result of computer technology, but the basic design stems from an evolutionary process which is believed to have begun in the third century BC. Uncertainty exists among historians as to when the concept of image formation was actually developed. Indications are, however, that it occurred between 384 BC and 322 BC when Aristotle observed the image of an eclipsing sun being projected onto the ground through gaps in the leaves of the surrounding trees. This formation of the sun's image was studied by others in following centuries, eventually leading to the development of the *camera obscura* (literally meaning "dark chamber").

There was no single inventor of the camera obscura, but records indicate that the principles were used as early as the eleventh century to observe solar eclipses. During this period scientists drilled holes in the ceilings and walls of a room so that the image of the sun could be projected onto a wall or floor for viewing (Fig. 2.1). In the 1500s Girolamo Cardano, a physician and professor of mathematics at Milan, replaced the hole with a simple lens to increase the clarity and brilliance of the projected image. He also suggested using the camera obscura to observe street scenes by projecting the image on a piece of white marble.

Although the principles of the camera obscura were known over the centuries and even described by Leonardo da Vinci around 1490, it was not until 1558 that Giovanni Battista della Porta published the first complete description of the camera obscura in his book *Natural Magic* and suggested uses for it as a tool for the artist as well as for the scientist. On the strength of this publication, della Porta is usually regarded as the inventor of the camera obscura.

*FIGURE 2.1  The first known published illustration of a camera obscura observing a solar eclipse. Published in 1544. (Gernsheim Collection, Humanities Research Center, The University of Texas at Austin.)*

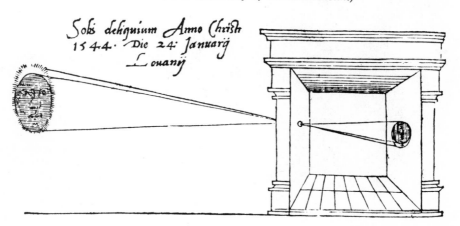

In his description of the camera obscura, della Porta suggested that the person who could not draw could project the image onto a drawing board and trace the scene. Not content with simply observing things in the street, he also staged theatrical productions on a sunlit stage just outside the darkened room, using scenery, actors in costume, and music.

Until the seventeenth century the camera obscura was still a room in a house, but the function expanded from a scientific instrument to a tool for producing magical effects. Magicians, fortune tellers, and charlatans mystified their customers with images of moving people, strange animals, and street scenes that were projected into the darkened room or sometimes into glasses of water or wine. The action was staged outside and then projected into the house.

The camera obscura gradually emerged as a tool for the artist. As the change occurred, the need for mobility resulted in the camera obscura taking the form of a portable tent or sedan chair and gradually of a small box which could be carried into the field by the artist.

This small box was equipped with a lens, and then a mirror, to project the image onto a sheet of tracing paper. By the early 1700s the camera obscura finally reached a point where it was ready to be used as a photographic camera by simply substituting light-sensitive material for the artist's drawing paper and installing a timing device, called a shutter, to regulate the amount of time light was permitted to strike the film. Almost one hundred years would pass, however, before the invention of photography in 1824 (Fig. 2.2).

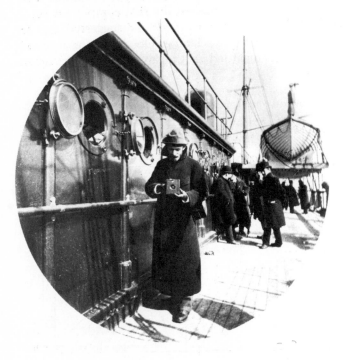

FIGURE 2.2 George Eastman is shown using the Kodak camera which helped popularize photography. He is aboard the steamship *Gallia* around 1890. The simplicity of the camera operation was attested to by the slogan, "You push the button, we do the rest." For the first time the photographer was able to make exposures on a flexible film and then send it off for processing and printing. (Courtesy of Eastman Kodak Company.)

# THE PINHOLE CAMERA

A modern equivalent of the early camera obscura is the pinhole camera, a photographic instrument that does not use a lens to form an image. It instead uses a small sharp-edged hole to form the image on light-sensitive materials within the camera. It is the simplest of all cameras but at the same time contains all of the basic components of its expensive counterparts without their refinements. Basically all cameras, including the pinhole, contain these parts: (1) a light-tight container for light-sensitive material; (2) a device to admit light; and (3) a time control for exposing the film.

The pinhole camera is a light-tight container that holds light-sensitive material in one end and has a small pinhole in the opposite end to admit light. A flap over the pinhole normally controls the time that light is allowed to enter and expose the light-sensitive material in the camera. All other cameras have refinements of this basic design to increase efficiency and ease of operation.

The normal refinements are a lens, instead of the pinhole, to collect and more sharply focus the light rays reflected from the subject; a shutter, in place of the manual flap; and some form of film transport, so that more than one photograph can be taken without reloading the camera with light-sensitive film. Other refinements include viewfinders to help in composing the photograph, adjustable focusing, adjustable apertures and shutters to help control the amount of light entering the camera, meters to read light intensity, automatic film transports, etc.

The pinhole camera will not produce high quality photographs. If it is built carefully, however, its quality can compare to the less expensive cameras of today. It also has the capability of keeping every object in front of the camera in equal sharpness. The quality of the image produced depends on the size and sharpness of the pinhole used for the aperture, but it can never be in critical sharpness since it is not a focused image. (Critical sharpness is obtained when light is focused through a lens in a way that it forms a point rather than a circle.) The fact that light travels in a straight line is what makes it possible for the pinhole to form an image. Every visible object reflects light rays from each point on the object in many directions at the same time. These individual light rays travel in a straight line away from the object. (See Fig. 2.3) If a box with a single small hole in the end is pointed at the object, some light rays will be reflected directly towards the hole and will pass through to the opposite side. As each of these rays passes through the opening and strikes the interior surface opposite the pinhole, a tiny spot of light is formed at that point which corresponds exactly to the subject point it was reflected from in both position and brightness. It is the blending of these different points which produce an image that can be recorded on light-sensitive material.

In theory, only one light ray is admitted through the pinhole from each point on the subject. The rays cross as they enter the camera to form an

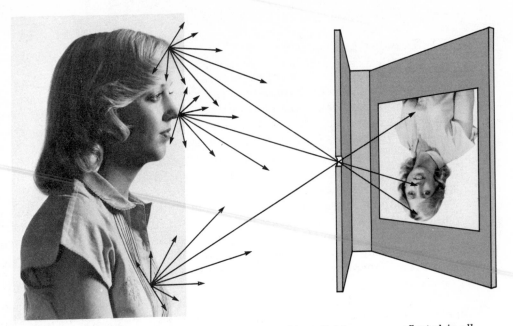

FIGURE 2.3 *When light strikes an object, light rays are reflected in all directions. The pinhole camera forms an image without a lens because the hole limits the angles of light entering the camera.*

image that is reversed from top to bottom and from left to right. In practice, the pinhole allows more than one light ray to enter from each point on the subject, and these rays do not strike the same point on the film. The larger the pinhole, the more light rays from a single point enter the camera, and the more diffused is the image. Therefore, the pinhole needs to be made as small as possible to increase image sharpness. But there is a limit as to how small the pinhole can be made because of the effect of *diffraction* (or bending of light rays as they pass sharp objects), which also decreases image sharpness. For normal photography a pinhole size of about 1/64-in. diameter is satisfactory.

The basic appeal of the pinhole camera is that it can be made of materials that are found around the average home, and the construction is limited only by the imagination of the builder. For example, no two cameras need be the same. Materials used in construction and the size of the camera can be varied to fit the needs of the photographer. The size can be adjusted to give a normal angle, a wide-angle, or a telephoto view depending on the distance from the pinhole to the light-sensitive materials. For a wider than normal perspective a shallow light-tight box is used. A telephoto effect can be achieved by using a long box, or the camera can be constructed with a tube that telescopes back and forth to vary the distance.

The camera itself can be made from such things as oatmeal boxes, shoe boxes, 35mm film canisters, or other such materials; or it can be made from cardboard panels cut to a specific size as illustrated in Fig. 2.4.

You do not require any special materials to construct a pinhole camera. It can be made from things found around the house, and its size and shape is limited only by the imagination of the builder.

Although the camera in the illustrations was made from mat boards, a shoe box, or an oatmeal box, or, even a 35mm film container could be used just as easily for its construction.

The size and shape of the camera does have an effect on the picture. A shallow container, for example, produces a wide-angle view while a longer distance from the pinhole to the film gives a telephoto effect. Distance also affects exposure time. The longer the distance from the pinhole to the film, the more time is required for proper exposure.

In its simplest form the pinhole camera uses a single sheet of light-sensitive material which has to be replaced in a darkroom after each exposure. So the camera should be constructed with an easy access to the film area. The design of the camera also can be improved to allow the photographer to take many pictures without reloading the camera in a darkroom. Film cartridges, such as those that fit into the Kodak Instamatic camera, for example, can be used instead of single sheets of film. (Courtesy of Danny Rawls.)

*FIGURE 2.4(a)   For convenience in loading the camera, its construction will be large enough to use 4 × 5 inch film sheets. Other film sizes can be used even though the camera is designed to fit that size, but that will necessitate cutting the film in a darkroom. The materials needed for the construction of the camera are six pieces of mat board that is black on one side, five of which should be 5 in. square and the sixth, 7 in. square. A roll of duct (silver or gray cloth) tape, a small piece of heavy aluminum foil, and a sharp knife are needed also. (Bottom left.)*

*FIGURE 2.4(b)   After gathering the materials, cut a 1/2-in. circular opening in one of the 5 in. square mat boards. Darken the edges of the opening with a pencil or felt tip pen. This piece will be the front of the camera. Assemble the board with the remaining four 5-in. square sides, black side inward, and tape into place. Make sure that they fit as tight as possible so light will not enter at the edges. The 7-in. square board will be the back of the camera and must be removable so that the film can be loaded into the camera before each exposure. (Bottom right.)*

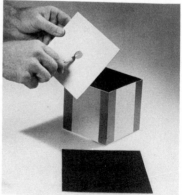

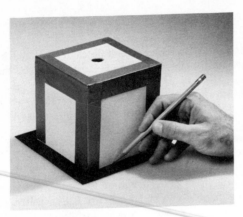
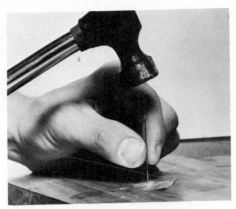

FIGURE 2.4(c)  To construct the back of the camera, place the partially assembled material on the remaining board and center it. Trace the dimensions of the camera with a pencil on the black side. Then score along the lines with a sharp knife and then cut through the boards from the corners of the scored section to the outer edges. Fold forward and tape into place so that it is like the top of a shoe box. (Top left.)

FIGURE 2.4(d)  The most critical part of the camera's construction is the pinhole that forms the image. Careful workmanship at this point will result in better pictures later. Select a piece of heavy duty foil about 1/2 in. square that is free of wrinkles. Place it on a hard surface such as a formica counter top or a piece of glass. Pierce the foil at its approximate center with a sewing needle by lightly tapping it with a hammer. Be careful not to get any burrs or indentations in the foil as they will affect the picture quality. The sharper the edges of the hole, the sharper the picture will be. Darken the side of the foil that will face the film with soot from a candle or match. (Top right.)

FIGURE 2.4(e)  After the pinhole is made, attach it with tape over the circular opening in the front of the camera, positioning it in the center of the opening. Cover the pinhole with a small flap of tape to protect the film from light until it is time for the exposure. At this point the camera is complete and is ready to be loaded with film. (Below.)

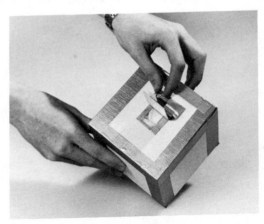

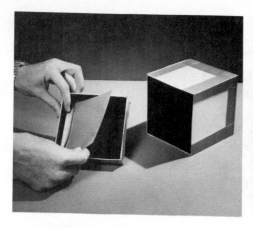 

*FIGURE 2.4(f)  To load the camera, take it and some tape into a dark room. A bathroom without windows works well. Remove the back and turn out the lights. Place the film, emulsion side out, on the inside of the back and tape it into place. If you are using 4 × 5 film, note the code notches on one corner. These notches should go in the right-hand corner of the top edge. After taping the film into position, replace the back on the camera, and you are ready to take a picture. An alternate material that can be used in place of film is photographic enlarging paper. Either will produce an image, but you will not be able to enlarge the image when you use the paper, and the necessary exposure time will be considerably longer.*

*FIGURE 2.4(g)  Exposure times will vary depending on the construction of the camera, the size of the pinhole, the light conditions, and the type of film used. A good starting point, however, is about 15 sec in bright sunlight using Kodak Plus-X film. To make the exposure, raise the flap covering the pinhole for the time needed. After the exposure is completed, return the flap so that it covers the pinhole. Take the camera to the darkroom to unload the exposed film and replace it with an unexposed sheet.*

*While the quality of the pinhole image is not as sharp as an image made with a lens, if care was taken in the construction of the camera you should get pleasing results. (Top right.)*

## VIEWING SYSTEMS

The basic construction of the pinhole camera or any other camera, for that matter, is essentially the same. Cameras are manufactured in a variety of sizes and shapes and accept different film sizes, but the viewing systems they employ provide a common reference point and an easy way to classify types of cameras. These viewing systems are: (1) viewfinder viewing, (2) reflex viewing, and (3) direct viewing.

**VIEWFINDER VIEWING.**  The viewfinder camera in its simplest form uses the least complicated viewing system available. Its function is to indicate approximately how much of the subject will be included in the picture. (See Fig. 2.5)

*FIGURE 2.5 Viewfinder viewing system.*

Within this viewing system, three different finder forms are available: independent, optical, and accessory. The independent finder is similar to the sight on a gun. Some are nothing more than a hole that runs through the camera with a peep sight on one side and an opening that is proportional to the size of the film on the other side of the camera. Another type of independent viewfinder is a wire finder, shaped to correspond to the film size with a peep sight for the photographer to look through. This type of viewfinder also is used with other viewing systems because of the speed with which it allows the photographer to frame the subject.

The system used on most of the viewfinder cameras today is the optical viewfinder. This system employs lenses to control the image size much the same as a telescope. One lens is attached to the back of the camera and another to the front, allowing the photographer to see the image right side up and with correct lateral (left to right) orientation. As the price of the camera increases, the optics used in the viewfinder will frame the subjects more accurately. One of the main advantages of the optical viewfinder is that it produces a brilliant image that allows the camera to become an extension of the photographer's eye.

The convenience of the viewing system, the ease of operation, and its construction with few breakable moving parts have made the inexpensive optical viewfinder one of the more popular cameras. Although this type of camera design generally uses a film size of 35mm or smaller, some models are designed for the larger film formats.

The viewfinder system has its disadvantages, however. While the brilliant viewfinder allows interaction with the subject and makes the camera convenient to use in low light situations, it does not show the photographer what areas of the photograph will be in focus. All appear in focus. In many cases the photographer has to estimate the distance from the camera to the subject in order to focus the camera lens.

To overcome this disadvantage, manufacturers have incorporated a focusing system, called a *split-image rangefinder*, into the viewfinder. The focusing system most widely used is a rangefinder system directly coupled to

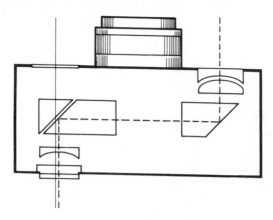

FIGURE 2.6 A viewfinder viewing system
which incorporates a built-in rangefinder focus-
ing system.

the focusing of the camera's lens (Fig. 2.6). With mirrors and prisms, a sepa-
rate image of a subject is overlaid on the viewfinder image. The image is
moved by focusing the lens. For the subject to be in focus, the two images
have to line up to form a single image.

The viewfinder camera in many of its inexpensive forms lacks one or
more of the refinements considered to be essential for the professional pho-
tographer, such as adjustable aperture settings on the lens, adjustable focus,
and variable shutter speeds that allow the photographer more control over
how a subject is recorded on film. Many inexpensive models have a set focus
range, aperture, and shutter speed that are designed to give good results only
under normal lighting conditions and at distances which the amateur chooses
to take the picture.

Some viewfinder cameras, however, are well suited for the professional
photographer. The cameras come equipped with both aperture and shutter
controls and with a coupled rangefinder that gives an indication of the area
which will be in critical focus. In addition, some of the cameras also have
meters which measure the intensity of the light and then display in the view-
finder the correct exposure settings for the camera's lens and shutter.

Even with the automatic devices, which are a convenience for the pho-
tographer, the viewfinder camera system still has one serious flaw. What the
eye sees through the viewfinder and what the lens records on film are slightly
different because the lens and the viewfinder are not located in the same
place. This difference is referred to as the *parallax error.* Parallax prevents
the viewfinder from becoming an effective tool to photograph subjects that
are closer than four or five feet. (See Fig. 2.7) Although the problem still
exists at distances further than five feet, the difference in viewpoint is not as
noticeable.

Some of the more expensive rangefinder-coupled viewfinder cameras at-
tempt to correct the problem of parallax. This correction is usually accom-
plished with a moving opaque screen that changes position on the viewing

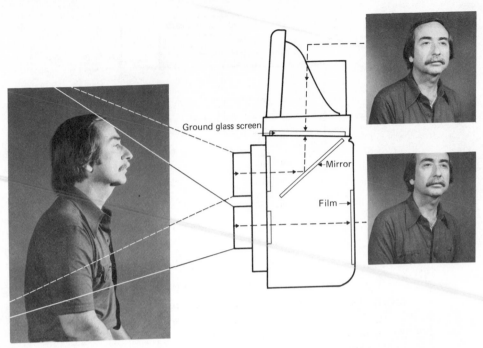

FIGURE 2.7  *One of the disadvantages of both the viewfinder viewing and twin-lens reflex systems is parallax error.*

area as the camera lens is focused at different distances. The movement of the screen corrects the area observed through the camera to correspond more nearly to the areas of the scene which will be recorded on the film.

Another advantage of the viewfinder camera is that many of the more expensive models have a range of interchangeable lenses that can give the photographer a wide-angle or telephoto view of the subject. The use of these interchangeable lenses, however, makes it necessary on some models to use an accessory finder. The accessory finder fits separately onto the camera and is matched to a particular lens' image size.

No camera can be constructed to meet all photographic needs. Each system will have its share of strengths and weaknesses resulting from a design.

**REFLEX VIEWING.** The reflex system is a compromise design that takes advantage of some of the features of both the viewfinder and direct viewing systems. The image of the reflex viewer is projected through a lens to a mirror set at a 45° angle behind the lens and then reflected onto a ground glass focusing screen. The system has been popular since the early 1900s, and the modern camera that incorporates this design follows the design of the camera obscura in its final form.

Modifications of the design have been made so that the photographer has a choice of two distinctive types of reflex viewing: the single-lens reflex (SLR), which is close to the original design of the camera obscura, and the twin-lens reflex (TLR). Each system has developed along its own lines and has special advantages which are not shared. A common advantage, however,

is that they allow the photographer to compose and focus the picture on a ground glass until the moment of exposure.

The physical construction of the *twin-lens reflex* creates some of the disadvantages of this system, including bulkiness. The camera itself is essentially two cameras, complete with lenses that are combined into two sections, one stacked onto the other. The viewing section containing one lens is located at the top, and the bottom section has the exposure controls to take the picture. The lenses produce identical image sizes, but the top viewing lens produces a brighter image for easier focusing. (See Fig. 2.8)

In the process of composing a photo, the viewing lens projects the subject image onto a mirror that is set at a 45° angle behind the lens. Then the image is directed to a ground glass viewing screen in the same size as the image to be recorded on film. Although the reflected image appears right-side up, it is laterally reversed (left to right reversal), making it visually awkward for many photographers, especially for those who are not familiar with the twin-lens reflex system.

The image is normally viewed from the top of the camera where the ground glass viewing screen is located. This screen is referred to as a waist level viewfinder because the camera is usually held about waist high. Although convenient, the camera's low position can create problems for taking portraits of people and landscapes. In taking landscape pictures, for example, the low camera position produces excessive foreground areas. In taking portraits, the camera lens looks up the subject's nose.

FIGURE 2.8 (a and b)   Twin-lens   reflex   camera   viewing system.

(a)

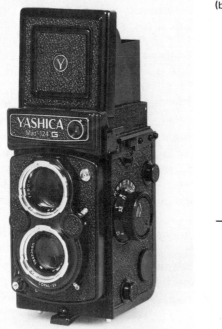

(b)

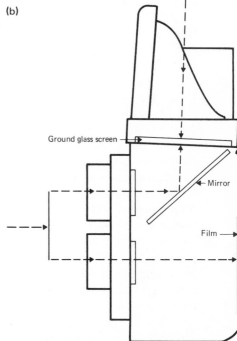

Ground glass screen

Mirror

Film

A disadvantage of the camera's design shared with the viewfinder but not with other types of camera designs is that the two lenses are located close to each other but are still separated, causing parallax error. The parallax, or differences between the two images, is not severe unless the subject being photographed is near the camera. As with the viewfinder, objects farther than four or five feet from the camera are not affected by parallax. Some twin-lens cameras have devices built in that correct this difference in viewpoint through the use of a sliding mask, but others have to be corrected manually by shifting the camera's position.

An advantage of having two lenses is that the photographer is able to view, focus, compose the photograph, and retain the viewed image throughout the exposure. This system also allows the photographer to see the image move in and out of critical focus through a focusing viewing lens, an advantage not shared with the viewfinder where the image appears in focus at all times.

When the photographer focuses the viewing lens, the picture-taking lens is automatically focused by the movement of the panel on which the lenses are mounted. The design of this panel, except on Mamiya cameras, does not permit the interchange of lenses. Nor does it allow enough movement to focus telephoto and wide-angle lenses. This limitation forces the photographer to shoot with a normal perspective lens. Manufacturers make accessory lenses, however, that attach to both the viewing and taking lenses and give slight wide-angle and telephoto effects.

The viewing lens also is not equipped with an aperture. Therefore, the photographer can see only the area in front of the camera that is in critical focus. Other areas not seen in critical focus may be recorded in acceptable focus. This acceptable focus area is referred to as *depth of field* (the areas in front of and behind the point of critical focus that are in acceptable focus). The inability to preview depth of field is a disadvantage of the system, but manufacturers make an effort to eliminate the problem by engraving a scale on the side of the camera to indicate the approximate area that will be in acceptable focus.

The twin-lens camera, in spite of its disadvantages, is versatile and is used by many professional photographers because of its large film size and ease of handling. The system is suitable for depicting outside life and street scenes because the photographer can focus on moving subjects and compose the photograph at the time of exposure. The camera is also used in landscape photography, pictorial still life, and news photography. The skilled photographer can make the camera overcome many of the disadvantages built into the camera design.

Many disadvantages of the twin-lens reflex and the viewfinder camera systems are eliminated in the design of the *single-lens reflex* viewing system, including parallax error. The main advantage of this system is that viewing, focusing, and picture taking are done through a single lens rather than two separate optics, permitting the photographer to see the subject exactly as it

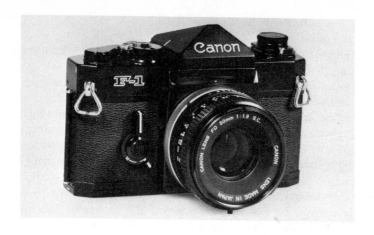

(a)

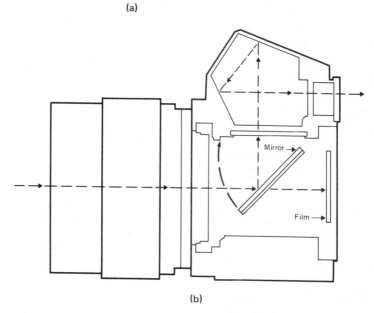

(b)

*FIGURE 2.9 (a and b)   Single-lens reflex camera viewing system.*

will be recorded. The advantage is maintained even when telephoto or wide-angle lenses are used. (See Fig. 2.9)

The single-lens reflex design is similar to the twin-lens reflex in that the mirror is set behind the lens at a 45° angle to project the image to a viewing screen. But the mirror in the single-lens reflex is movable and swings out of the way at the time of exposure, allowing the photographer to use the same lens for both viewing and picture taking.

Although the movable mirror eliminates parallax error, it does create other problems. Most cameras, especially the 35mm film formats, provide for the mirror to return to the viewing position immediately following the exposure. Even with this instant return, sight of the subject is lost during the exposure. Normally, this is not a problem for the photographer; but in cases

where the subject's movements are rapid or erratic or the exposure time is long, the photographer may lose framing of the subject.

Noise and vibration are other problems caused by the movement of the mirror. Noise created by the mirror swinging out of the way and returning can be a distraction to the subject, especially in wildlife photography, or in situations where the photographer is trying to take candid pictures. The vibrations of the mirror's movement also make it difficult to hold the camera steady for sharp pictures at long exposure times. Both of these disadvantages can be overcome, however, with a mirror lock-up, available on some cameras, and an accessory finder to eliminate the noise, and a tripod (a three-legged camera support device) to prevent movement. But either correction of the problem reduces the mobility and versatility of the camera.

The image produced by the single-lens reflex, like the twin-lens reflex, is rightside-up; but it is laterally reversed when it is produced on a ground glass viewing screen. Most 35mm camera manufacturers project the image through a pentaprism (five-sided prism) so that lateral reversal is also corrected. However, a pentaprism adds weight to the camera and also makes the viewed image darker than the brilliant viewscreen of the viewfinder and twin-lens reflex. Because of this darker viewing, the single-lens reflex is difficult to focus accurately under low light conditions.

The mirror does not always return automatically with the larger film format sizes. It has to be returned to the viewing position manually by cocking the shutter. A pentaprism finder is optional equipment on the larger film format cameras, so the viewing screen is brighter.

A feature of some single-lens reflex cameras allows the photographer to preview depth of field. This permits the photographer to view more accurately the scene as it will be recorded on film.

The single-lens reflex is one of the more popular cameras among photographers because of its compactness, light weight, and ease of operation. Many of these cameras also have built-in exposure meters which will set automatically either the aperture or shutter speed to meet the light conditions. Large numbers of easily interchanged telephoto and wide-angle lenses are available for them. A frequent optional feature is an automatic film advance, which also cocks the shutter with each exposure.

The disadvantage of the single-lens reflex not shared with the twin-lens reflex and the viewfinder is that the high degree of automation requires many delicate parts and circuits that can be harmed with rough handling or by lack of proper care.

The camera is suitable for photographic work requiring rapid shooting, such as sports and news. It is used by many fashion photographers; and in the 35mm format, it has some use for commercial photographers. It is close to an ideal camera for the amateur because of the available lenses and accessories. In the larger format, 120 size film, it is well suited for portrait and commercial photography.

**DIRECT VIEWING.** The direct viewing system was the logical step from the camera obscura as developed for the artist. The camera obscura needed only minor modifications to become a tool for the photographer. By the early 1800s and the invention of photography, artists were already utilizing different lenses on the camera obscura to give them wide-angle and telephoto views as well as normal views. The projected image from the lens was either seen directly from the back of the camera obscura or was viewed on top through the use of reflex viewing (Fig. 2.10).

*FIGURE 2.10 (a and b) View camera.*

(a)

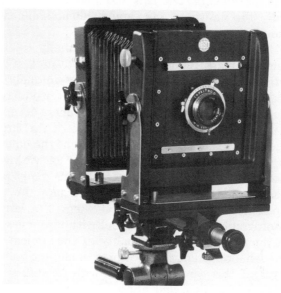

(b)

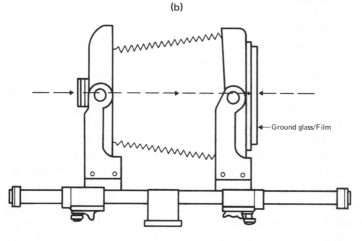

←— Ground glass/Film

The early camera models with direct viewing originally projected the image to the back of the camera and through a sheet of tracing material. When the tracing material was replaced by a ground glass viewing screen, and an aperture was fitted in the lens, the camera obscura was ready for photography. The photograph was made by substituting a piece of light-sensitive material at the back of the camera for the ground glass viewing screen. The exposure was controlled by a cap which was placed on the lens although later a shutter was used.

The direct viewing camera has evolved slightly from the camera obscura to meet the need for more versatility. A *bellows* (an accordion type of light-proof material) has been added to allow for a larger range of cameras and lens movements. The lens and shutter have become more refined. But essentially the design of the camera remains unchanged from the earlier camera obscura.

The direct viewing system, normally referred to as a view camera or a studio camera, retains some of the advantages of the single-lens and twin-lens reflex systems, and some advantages uniquely its own. The film size it uses and the quality of the image which it produces are two of those advantages. Normally a large format size, the camera accepts film which is 4 × 5 in., 5 × 7 in., 8 × 10 in., or larger. Because of the large film size, the negatives can be retouched easily, and the quality of the enlargements is better.

Of all the viewing systems, direct viewing possesses the least moving parts; but at the same time it retains many of the advantages of the more fragile single-lens reflex. These include the capability of interchangeable lenses and through-the-lens viewing. The large viewing screen enables the photographer to see the subject with both eyes, giving a better understanding of the two-dimensional quality of the subject. The camera will accept, with adapters, different film formats, including roll and instant films. The advantages of this camera continue with its ability to independently control distortion in vertical and horizontal subjects with a series of swings and tilts of both the lens and the film.

The use of the view camera still evokes a mood of the past with its unhurried tempo. Work has to be deliberately unhurried. Therefore, the direct viewing system is good only in situations where speed is not essential. The photographer must focus the subject on the ground glass view screen and afterwards move the screen out of the way and put film in its place to record the subject. The camera is awkward and bulky and needs a tripod support, greatly reducing its portability. Many photographers also find viewing the image projected by the lens a disadvantage because it is upside-down and laterally reversed. The image needs to be viewed in a darkened area. For this reason the user of the view camera gets underneath an opaque cloth to focus and compose the photographs.

The view camera is well suited for subjects that are stationary, and thus it finds its primary use in architectural photography and in advertising, illustrations, and landscapes. The camera system also is suited for close-up photog-

raphy because the distance between the lens and the film can be extended, enabling the photographer to make close-up photographs without special lenses or adapters. The direct viewing camera is not suited for moving subjects or for pressure situations where the photographer has to hurry to take the photograph.

A combination of the direct viewing camera and viewfinder camera was popular for many years and still finds some use. The field or press camera combined the direct viewing so that the photographer could focus through the ground glass or use the viewfinder/rangefinder combination in pressure situations. This compromise camera was adopted by many newspaper and magazine photographers because it gave them many of the advantages of both cameras. The smaller single-lens reflex, however, has replaced, for the most part, the bulkier press camera for this type of work. (See Fig. 2.11)

──────────────────── How To Hold A Camera Properly ────────────────────

Regardless of the camera viewing system the photographer uses, all cameras normally need to be held motionless during the exposure. A tripod is the solution in some cases, but because of the loss of mobility most photographs are made with the camera in the hands.

When the tripod is not used, the image sharpness and quality can deteriorate with even a slight motion caused by simply pressing the shutter release or by prolonged exposure. Most photographs, therefore, contain some motion. Correct camera holding techniques can help reduce the problem.

Techniques vary with the different types and sizes of cameras and are influenced by the situation under which the photographer is shooting. This insert illustrates several ways to reduce motion when using a 35mm viewfinder, a single-lens reflex, or a larger twin-lens reflex camera. A view camera cannot be successfully held by hand.

*FIGURE 2.11(a)   This is the normal holding position for making pictures with a twin-lens reflex camera. The left hand is used as a platform to rest and hold the camera. The right hand steadies the camera and trips the shutter release. In this position keep the arms close to the body and squeeze the shutter release slowly while making an effort not to move the camera.*

FIGURE 2.11(b)   For a lower than normal angle of view, rest the camera and hands on the knee. The hand position is the same for this camera placement as it is for the normal position. Make sure that the arms and elbows stay close to the body for an even steadier photograph.

FIGURE 2.11(c)   The lowest camera angle is obtained by placing the camera on the floor. Steady the camera with both hands, and if possible rest the back of the camera on the knees.

FIGURE 2.11(d)   Occasions arise when the photographer needs a high angle of view and does not have access to a stepladder or other object to raise the camera's height. The solution is to invert the camera and extend it above the head. Keep the arms as straight as possible while holding the camera securely. Press the shutter release very gently.

*FIGURE 2.11(e)   For action photography, the use of the ground glass view screen can be awkward. Most twin-lens reflex cameras have a viewfinder system called a sports finder that gives the photographer an eye level, nonfocused view of the subject. The hand and arm positions for using the sports finder are similar to those of the normal camera position. The camera, however, does need to be prefocused on the subject.*

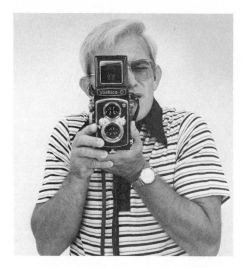

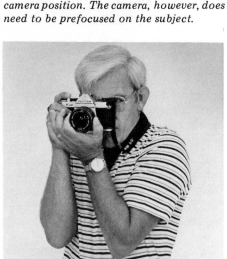

*FIGURE   2.11(f)   When a viewfinder or 35mm single-lens reflex is used to make a horizontal picture, the camera body and lens are cradled in the left hand. This not only helps to support the camera but allows the photographer to adjust the focus ring on the camera without changing the hand position. The camera should be held more firmly with the left hand than the right to prevent camera motion at the time the shutter release is pressed.*

*It also helps if the photographer, while keeping the elbows close to the body, turns slightly away from the subject and extends the left foot towards the subject. Although it is better to keep both eyes open for focusing and shooting, many photographers prefer to close their left eye.*

*FIGURE  2.11(g)   When the camera is in the vertical position, support it and the lens with the left hand while firmly holding the camera to the forehead. Some photographers prefer the shutter release at the bottom of the camera, but for fast focusing and shooting, it is better at the top. This position necessitates raising the right arm while drawing the left arm to the body for further camera support.*

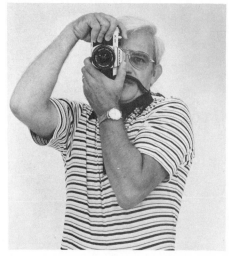

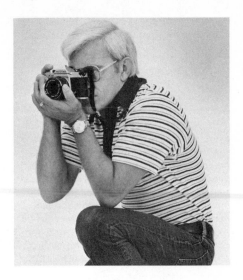

FIGURE 2.11(h) For a low angle view-
point, place the elbow of the left arm on a
knee and maintain the same camera hold-
ing position for either the horizontal or
vertical picture.

## SPECIAL CAMERA DESIGNS

In a miscellaneous category, several other cameras deserve special mention.
Among the most popular are the "instant" film camera manufactured by
Polaroid and Kodak. They utilize one of the standard viewing systems, but
provide a finished picture in seconds without the need of a darkroom. One
Polaroid model, using a viewfinder system for framing and composing, auto-
matically focuses the subject with a built-in sonar device. The camera pro-
duces a signal pulse at the time of exposure which bounces off the subject
and returns to the camera, focusing it at the appropriate distance. Other
instant film cameras also eject the picture automatically at the end of each
exposure. (See Fig. 2.12)

FIGURE 2.12 Polaroid became the first
company to produce an instant picture.
This camera not only ejects the exposed
image automatically, but through a sonar-
type device, it automatically focuses the
camera's lens to the distance of the subject
in front of the camera. (Courtesy of Polar-
oid Corp.)

A camera which can have general usage although it is designed for underwater photography is the Nikonos. Other manufacturers make similar cameras. Of course, most cameras can be adapted for underwater use by enclosing them in a water-proof housing. Such cameras, as well as those especially designed for this type of photography, can be used also for making pictures in the rain or around elements which could harm an unprotected camera, such as sand and salt.

Other designs have been developed for the completion of specific jobs by the professional photographer. These cameras have restricted uses and are of little importance to the beginning photographer, except as a point of reference. Some of these cameras give panoramic views on 120 film through the use of a moving lens; others are used strictly for identification. Some are designed for surveillance and automatically take pictures by remote control or at preset times during the day and night. Other cameras are designed for high speed sequence photography, with capabilities ranging from four to eight pictures per second to thousands of pictures per second.

Some cameras use large film sizes, and others are ultraminiatures which can be hidden in the palm of the hand. Others come equipped with lenses which can photograph in total darkness through the use of electronically enhanced infrared light, while some are designed to be used in the surgical wards of hospitals.

All camera designs involve compromises which keep any one camera from being best suited for all situations. The skilled photographer can stretch the usage of a camera system to meet many requirements for which the camera was not designed, but knowing the limitations of the camera and selecting one which is better suited is the sign of a true professional. (See Table 2.1)

TABLE 2.1
ADVANTAGES AND DISADVANTAGES OF VIEWING SYSTEMS

| Viewing System | Advantages | Disadvantages |
|---|---|---|
| Viewfinder | 1. Brilliant viewfinder<br>2. Easy to focus under low light levels when equipped with rangefinder<br>3. Quiet operation<br>4. Few moving parts<br>5. Relatively inexpensive | 1. Lack of focus perception<br>2. Separate viewing and focusing<br>3. Parallax error in viewing<br>4. Limited interchangeable lenses<br>5. Unable to preview depth of field |
| Twin-lens reflex | 1. Through-the-lens focusing<br>2. Large image size viewing<br>3. Area of critical focus can be viewed<br>4. Continual view of subject through exposure<br>5. Bright image focusing | 1. Parallax error in viewing<br>2. Laterally reversed viewed image<br>3. Unable to preview depth of field<br>4. Lack of interchangeable lenses<br>5. Slow operation |

**TABLE 2.1 (continued)**
**ADVANTAGES AND DISADVANTAGES OF VIEWING SYSTEMS**

| Viewing System | Advantages | Disadvantages |
|---|---|---|
| Single-lens reflex | 1. Through-the-lens focusing and viewing<br>2. Parallax error eliminated<br>3. Interchangeable lenses<br>4. Ease of operation<br>5. Accurate framing of subject<br>6. Large number of accessories | 1. Dim image under low light situations<br>2. Loss of image viewing during exposure<br>3. Many movable, breakable parts<br>4. Difficult to hold still during long exposures<br>5. Small image viewing<br>6. Can be expensive with accessories and convenience features |
| Direct viewing | 1. Through-the-lens viewing<br>2. Interchangeable lenses<br>3. Large negative size<br>4. Distortion corrections<br>5. Depth-of-field preview<br>6. Few moving parts<br>7. Accurate framing of subject<br>8. Close-up photography without accessories | 1. Dim image for focusing<br>2. Slowness of operation<br>3. Has to be used on a tripod<br>4. Film has to be removed after each exposure<br>5. Needs to be used under bright light conditions<br>6. No automatic features<br>7. Bulky and awkward<br>8. Loss of image after film is inserted into camera |

## SUMMARY

Major modifications to the original design of the camera obscura have been made to meet the needs of modern photography, but the basic functions of the camera remain unchanged. The camera must protect and hold the light-sensitive film, collect and focus the light rays for the wanted exposure, and control the intensity and time of the light striking the film. These three functions are essential to the camera's operation regardless of the many convenient features in present designs.

While all cameras serve the same function, the differences among them are in their design. The principal variation is in the types of viewing systems the cameras employ to compose and focus the subject. The simplest is the viewfinder viewing system, which may be as basic as a gunsight type finder or one that requires optical devices to limit the subject area seen through the brilliant finder to approximately what will be recorded on film. Its lack of moving parts and its brilliant image for low light level viewing are the main advantages of this system, but it does not permit the photographer to see which areas of the subject are in focus and what exactly will be recorded on the film. Some of the more expensive models incorporate a rangefinder to help in focusing, but parallax error is inherent in the design.

The reflex viewing system with single or twin lenses is one of the more popular camera designs. A mirror behind the lens projects the viewed image.

A twin-lens reflex utilizes one lens to view the subject and a separate matched lens to make the photograph that is almost identical to the viewed image. While this system has many advantages, among them the ability to focus the viewed image, it still shares with the viewfinder the problem of parallax error.

The single-lens reflex design with only one lens to both view and make the photograph removes the problem of parallax. It has grown in popularity because of its wide range of convenient accessories, such as interchangeable lenses, motorized film advances, and built-in exposure systems. This camera viewing system is normally expensive and relatively fragile, however, when compared to the viewfinder or twin-lens reflex. Also, the single-lens reflex is difficult to focus when used with wide-angle lenses and under low light levels.

The direct viewing system comes closest to the original camera obscura in design. Its ability to view and photograph the subject through the same lens is an advantage, but the camera is suitable only for slow deliberate work of stationary subjects because of its size and bulkiness. It does allow for distortion-free images, however; and because of the large film size used, it produces the highest technical quality in recording the image.

Other cameras using one or more of the viewing systems are designed for special purposes. Motorized high speed cameras for sequence photography and cameras designed for only wide-angle photography, for example, are available. Other camera designs make multiple images on the film, and some use one of the instant films on the market. The range of cameras and accessories available to the photographer for particular jobs or situations is almost unlimited.

# The Lens

The lens is one of four elements common to all cameras. The other three, a light-proof container, exposure controls, and light-sensitive film, are indispensible to the photographic process, and they vary little in function. The lens is the most versatile. Its primary function is to project an image; but as the pinhole camera demonstrated, a lens is not essential for the simple recording of an image.

The camera lens, constructed of one or more pieces of shaped glass or plastic, becomes an extension of the eye and allows the photographer to see in ways not possible without optical aides. It can magnify vision to allow microscopic views or expand it into a panorama. It allows the photographer to record details on the Moon or of the smallest insects with equal ease. Some lenses create apparent distortions of perspective while others correct normal perspective distortions.

## HISTORY OF LENS DESIGN

Lenses being used today have been developed through an evolutionary process that can be traced to the eleventh century. Like the camera, the history of the photographic lens is connected directly to the development of the camera obscura.

The inherent problem with the early camera obscura was the lack of brilliance of the projected image. The hole projecting the image was the problem.

FIGURE 3.1  Wollaston  meniscus
lens.

To obtain a sharp image, the hole had to be small, but the small size restricted the light rays, causing the image to be dim. Enlarging the hole to give more image brilliance produced a less sharp image. The use of the camera obscura for viewing of eclipses and other bright objects created few problems; but as its uses expanded, the need for a bright image grew.

This problem was partially solved in the mid-1500s when the lenses "used by farsighted old men" were placed into enlarged holes in the camera obscura. This substitution of a simple *convex lens* gave a more brilliant and sharper image but produced image distortions.

Improvements were made on the lens used on the camera obscura in 1812 when an English physician, William Hyde Wollaston, added an aperture in front of a concavo-convex shaped lens. (See Fig. 3.1) This reduced some of the optical distortions called aberrations. The concavo-convex shaped lens, called a *meniscus* lens, is used even now on some of the inexpensive cameras and has been used more than any other lens designed for photographic purposes.

Although it was a great improvement over existing lenses of the day, the Wollaston meniscus lens left much to be desired. To reduce the aberrations or distortions, the aperture opening of the lens had to be small in diameter. But this restricted the amount of light entering the camera. This light reduction, coupled with the use of film requiring a large amount of light, necessitated exposure time to be several minutes and sometimes hours long.

A change in design occurred in 1840, when the Hungarian mathematician J. Petzval produced a lens that allowed about 16 times more light to enter the camera than the Wollaston meniscus lens. The Petzval lens produced the brightest image of any design for a period of 80 years and was considered to be the best portrait lens in the world (Fig. 3.2).

FIGURE 3.2  Petzval compound portrait
lens.

FIGURE 3.3 Converging lens shapes: (a) plano-convex, (b) biconvex, (c) concavo-convex, Diverging lens shapes: (d) plano-concave (e) biconcave, and (f) concavo-convex.

All lenses work on the principle that light rays are bent or refracted as they pass through a transparent material, such as glass or plastic. The degree to which the rays are bent depends on the thickness and density of the material through which the rays pass. Modern lenses are made not only in different shapes, but the glass elements that make up the lens differ in densities, causing the light rays to bend in different degrees. In practice the different lens elements either cause the light rays to converge on a single point or to diverge. The converging lens shapes are plano-convex, biconvex, and concavo-convex. The negative shape or diverging lenses are plano-concave, biconcave, and concavo-convex (being thicker at the edges than at the middle). (See Fig. 3.3)

The earlier, simple lenses contained only one shape or element. This lens design produced image distortions because of the difference in thickness between the center and the edges of the lens. To correct these optical distortions manufacturers had to fabricate more complex lenses with several simple lens elements. These lenses are referred to as *compound lenses.*

## OPTICAL FAULTS

A perfect lens design would project a point as a point or a straight line as a straight line, but in practice, lenses are never perfect. Each lens element creates its own image distortions. Designers combine different shapes and types of glass so that the optical distortions created by one lens element are cancelled by the distortions produced by others. The process is called *correcting the lens.* In general, the better the distortions or aberrations are removed, the more the lens costs. In practice, lenses are never fully corrected because the cost would be prohibitive. Their ultimate use determines the degree to which the manufacturer corrects the lens' faults. For example, a lens designed to be used on a 35mm camera would need more correction than the same lens designed for a 4 X 5 camera. The extent of enlargement of the small 35mm negative would emphasize faults more than a comparable enlargement of the large negative.

The main faults with which the lens is plagued are: (1) *chromatic aberration,* (2) *spherical aberration,* and (3) *image distortion,* a fault that affects image shape but not sharpness.

**CHROMATIC ABERRATION.** Chromatic aberration is visible when a prism is used to convert light into a rainbow of different colors. Light rays passing through the transparent prism are bent or refracted. All the wavelengths, however, are refracted at a different angle, causing the red wavelengths to be focused at one point, blue at another, and green at a third point. (See Fig. 3.4) To correct chromatic aberrations, designers use elements of different shapes, and glass of different densities. If the distortions are not corrected, so that all colors focus at the same point, the image has an overall soft quality. Such an effect, for some purposes, is sometimes desirable. Many of the older lenses used for portrait photography, for example, were deliberately designed with chromatic aberration to give a soft focus effect.

Chromatic aberration was not as much of a problem with the older films as it is with the modern panchromatic films. Until the 1940s most films were not sensitive to red light and less sensitive to green than they are today. Films are now sensitive to all colors of the spectrum, causing chromatic aberrations to be more noticeable in the recorded image. But even with the modern lens design, all of these distortions are not removed because of the costs involved.

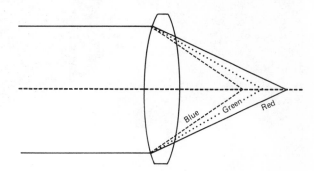

*FIGURE 3.4 Chromatic aberration causes the different wavelengths of light to be focused at separate distances from the lens.*

**SPHERICAL ABERRATION.** Spherical aberration, another optical fault, is caused by the uneven thickness of the lens elements. Light rays passing through the thinner portions of the lens are refracted at a greater angle than those which pass through the thicker parts, thus preventing the rays from focusing at the same point and creating an unsharp image (Fig. 3.5). Spherical aberration is corrected by the design of different curves in the lens elements and by the inclusion of an aperture in the lens to block light from passing through the thinner areas. Some portrait lenses make use of deliberate spherical aberration to achieve a soft focus effect. The degree of softness can be controlled by changing the aperture's diameter. The lack of sharpness produced by chromatic aberration, on the other hand, cannot be controlled. (See Fig. 3.6)

Even with lenses which are supposedly fully corrected, not all of the spherical aberrations are removed. A lens does not project a sharp image at its widest aperture settings because light enters through the outer, thinner por-

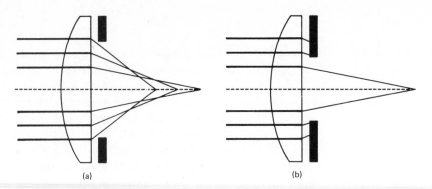

(a)                                              (b)

*FIGURE 3.5 Spherical aberration produced by light travelling through different thicknesses of glass is corrected in a lens design with an aperture. The aperture blocks out the rays passing through the thinner, outer edges of the lens in (b).*

*FIGURE 3.6 A lens which has not been corrected for chromatic and spherical aberration creates a soft focus image. This photograph was made through a magnifying lens mounted in a tube and taped to the front of the camera. The different colors of the spectrum focusing at different points and the failure to correct the spherical aberration with an aperture created the soft image.*

tions. As the diameter of the lens' aperture is decreased, a sharper image of the subject is produced.

**IMAGE DISTORTIONS.** While the sharpness of the subject is affected by chromatic and spherical aberrations, a third problem called image distortion affects the subject's shape. Image distortions take two forms: barrel or pin-cushion distortions. (See Fig. 3.7) Both types can be demonstrated with a grid of horizontal and vertical lines. Barrel distortion causes the center of the grid to be rendered correctly; but as the edge of the grid is approached, the straight lines curve inward. Pin-cushion distortion also renders the middle of the grid correctly; but as the outer edges are approached, the lines curve outward instead.

(a)                     (b)                     (c)

FIGURE 3.7  Image distortion does not affect the sharpness of the image, but it does alter the shape of the subject. If the subject is graphed into horizontal and vertical lines (a) and photographed with a lens that suffers from barrel distortion (b), the magnification of the image decreases as the distance from the lens axis increases. (c) demonstrates the opposite effect, pin-cushion distortion. The magnification of the image increases as the distance from the axis increases.

## LENS PROPERTIES

All lenses have other properties which are of concern to the photographer. They not only influence the quality of the image by determining sharpness and contrast but also influence the conditions under which the lens is used.

**FOCAL LENGTH.**  One property common to all lenses despite the camera used is *focal length*. Simply defined, it is the magnification of the lens, and it determines the image size on the film. It causes the image to record as a telephoto view, a normal view, or a wide-angle view. Focal length is commonly referred to in millimeters (mm), centimeters, and inches. Millimeters is the most common way of designating focal lengths, and the focal length in millimeters is usually engraved on the lens.

The focal length of a lens is found by measuring from the optical center of the lens (called the *nodal point*) to the point where the lens sharply focuses the light rays from a subject located at infinity. For example, with a subject at infinity, the distance between the optical center of the lens and the point of focus is 25 millimeters (mm). Thus, the lens would have a focal length of 25 mm (Fig. 3.8). If the distance between the nodal point and the point of focused light is 300 mm, then the lens has a focal length of 300 mm.

The dimension of the image produced by a particular focal length lens is

FIGURE 3.8  The focal length of a lens is measured from the nodal point to the focal point on the lens when the subject is in focus at infinity.

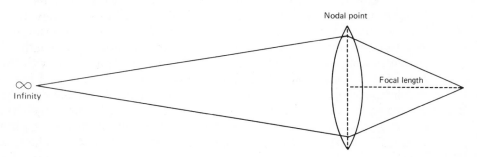

Nodal point

∞
Infinity

Focal length

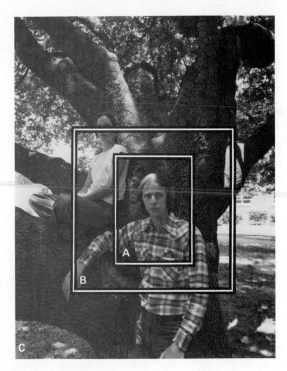

*FIGURE 3.9  The use of any specific focal length lens with a variety of film sizes will produce the same image size, but the surrounding area will be expanded. A 90 mm focal length lens was used for this illustration. A telephoto effect (a) is produced on 35mm film; (b) a normal angle of view with 120 film; and (c) a wide-angle effect with 4 × 5 film.*

the same whether it is used with a 35mm camera or with the larger film sizes. An apparent size difference appears, however, because of the area around the subject which is included on the film. For example, if a lens with a focal length of 90 mm produces an image size of ½ in. on 35mm film, the dimension of the image produced on the larger 4 × 5 in. film would still be ½ in., but the surrounding area would be much greater. This would cause the image to have an apparent telephoto view on 35mm film and a wide-angle view on the 4 × 5 film. (See Fig. 3.9)

A direct relationship exists with the focal length of the lens and the image size. The longer the focal length is, the larger the image size will be when all pictures are made from the same distance between the camera and subject. The reverse also holds true.

Another factor involving focal length is apparent perspective distortion. Perspective is not a product of the lens, but it is distorted by the distance from which the subject is photographed. Lenses with short and long focal lengths do not produce the same image size on film when they are used at the same distance from the subject. To get the same dimensions, the photographer must work closer to the subject with the short focal length lens than with the long. The foreground objects in the picture made with the short focal length lens, however, will appear larger in comparison. If the photographer made both pictures from the same distance, the image size would not be the same; but through the enlargement process, if the images were projected so that the subjects were the same size, the perspective of the scene made with both focal length lenses would appear the same. The quality of the photograph would suffer, however, because of the degrees of enlargement of the smaller image size. (See Fig. 3.10)

(a)

(b)

(c)

(d)

*FIGURE 3.10  The same perspective on a subject is produced by both a wide-angle and a telephoto lens if the subject is enlarged to comparable size. Both (a) and (b) are shot from the same distance. The only difference is that (a) is made with a 28 mm wide-angle lens and (b) is made with a 200 mm telephoto lens. When the outlined center section of (a) is enlarged in (c) to produce the same image size as (b) the perspective of both photographs are the same. The degree of enlargement required for the wide-angle view, however, degrades the image quality. (d) is also made with the use of a 28 mm wide-angle lens to produce the same image size as the telephoto view. Because the photographer is much closer to the subject a perspective distortion is apparent.*

In practice, the longer the focal length, the more compressed the subjects at varying distances will appear, or stated differently, objects far from the camera will appear greater in size in relationship to the foreground size. This is called *compressed perspective*. The shorter the focal length, the more distorted the perspective will appear. The focal length of the lens also affects other photographic variables which will be covered in later chapters.

**LENS SPEED.**  Another property is lens speed, which refers to the light admitting powers of the lens. It is a mathematical calculation based on the focal length of the lens and the diameter of the lens opening. The formula for finding the relative speed of a lens is

$$\text{Relative aperture }(f/) = \frac{\text{Focal length }(F)}{\text{Aperture diameter }(D)}$$

For example, if a lens has a focal length of 5 in. and the diameter of the lens opening is 2½ in.

$$f/ = \frac{5}{2\frac{1}{2}}$$

$$= f/2.0$$

If the aperture of the same lens is reduced to 1¼ in., then the relative aperture would be

$$f/ = \frac{5}{1\frac{1}{4}}$$

$$= f/4.0$$

Many times the maximum speed settings on a lens is expressed in unusual numbers, such as $f/3.5$, $f/1.8$, or $f/0.95$. These are the relative aperture settings of the lens at its widest aperture, or $f/$stop.

Referring to aperture settings as $f/$stops is a carryover from the early days of photography when lenses did not have adjustable iris diaphragms. The early lenses used metal plates with holes of different sizes drilled in their center to regulate or "stop" the amount of light entering the lens. Photographers still refer to the change in aperture sizes as "stop changes" even though the term is no longer correct. Any exposure change either in aperture, shutter speed, or light intensity is expressed in *stops of light*.

The material used in lens construction may appear transparent, but it actually absorbs and reflects many of the light rays which strike it. The efficiency of the lens to transmit as many of the light rays as possible, along with other factors, helps determine the speed of the lens. Regular optical glass

will transmit about 95 percent of the light which strikes the lens element; the other 5 percent is either absorbed or reflected. In the design of a compound lens, if it has eight surfaces, the lens itself would reflect and absorb about 40 percent of the total light striking the front element of the lens. The light reflected on the inside of the lens causes *lens flare* and reduces the contrast and sharpness of the projected image. A lens only passing 60 percent of the light striking it also would be inefficient.

Optical designers have found that if the glass surfaces of the lenses are coated with metallic vapors, the light reflections can be reduced to about one percent per element. Coating the eight element lens would reduce the light loss from 40 percent to only 8 percent and the efficiency and speed of the lens would be increased. Most modern lenses are *coated lenses* and are easily recognized by a slight color tint to their elements.

In addition to determining the lighting conditions for which a lens is designed, i.e., a slow speed for bright light and a fast lens for dim, lens speed also influences the sharpness of the recorded image.

The placement of an aperture to control light intensity in the lens is an important design consideration. For the simple meniscus lens, the aperture is best placed behind the lens element; but for the compound lens, the aperture is located between the elements at approximately the center point of the lens. While it plays a critical role in the photographic process by helping to control exposure, the aperture is important also in controlling spherical aberrations. The aberrations can be reduced further through correct placement and size reductions of the lens aperture. As the aperture's diameter is constricted (stopped down), the light entering the lens through the thinner, outer areas is restricted. The result is a reduction in the effect of spherical aberration. Light rays diverge, however, when they pass a sharp opaque barrier, such as the opening of the aperture, and diffraction of the rays can occur if the lens aperture is reduced too much. The result degrades the image. Normally the optimum setting for a lens to produce the sharpest image is about two stops smaller than its maximum opening. This not only applies to camera lenses but to enlarging lenses as well. But with the lens reaching its point of optimum sharpness below maximum aperture, one designed for photography under low light conditions will not be as sharp when used under bright sunlight as a slower lens designed for normal outdoor photography.

**RESOLUTION.** Two other properties of the lens of less concern to the photographer than focal length and speed are resolution and covering power. Resolution is the ability of the lens to form a clearly defined image. Many factors enter into the resolving power of the lens, such as aberration corrections, type of camera on which the lens will be used, etc. Most of the modern lenses, however, are designed to produce more detail than the film can record. The resolution of the lens is usually directly proportional to the price of the lenses: the more resolution, the higher the price.

In tests of resolving power, a lens capable of resolving or separating 80 to 85 lines per millimeter is considered to have excellent resolving power. The size of the aperture opening affects the lens sharpness with the least sharpness at the widest aperture because of spherical aberration. Some lenses will have acceptable resolution at the smaller openings but will not be acceptable for critical work at a wide-open aperture diameter.

Another influence on resolving power is the film size. A lens designed for the small format 35mm needs more resolving power than one to be used with 4 × 5 film because of the degree that the negative must be enlarged for the final print.

**COVERING POWER.**   The covering power of a lens is its ability to project an image which covers the film's dimensions. The coverage is determined by

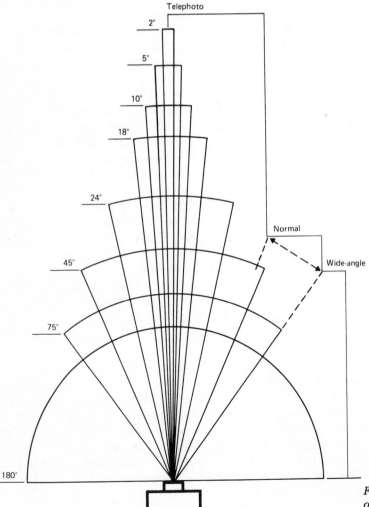

*FIGURE 3.11  Lens angle of view*

the lens' construction and by the angle in which light is projected from the back of the lens to the film area. All medium and small film sizes will be covered adequately by all lenses designed for that film size. It does not represent a problem for a lens designed for the 35mm, which normally uses the center, sharpest part of the projected image. But for the photographer who uses the view camera, with its ability to change the relationship between the lens and film plane, covering power becomes important.

ANGLE OF VIEW.   Yet another property which all lenses have in common is angle of view. This is the spread of light which the lens sees. It can be compared with the beam of light projected by a flashlight. The light beam is conical in shape, and the degree of the beam's spread is similar to that of a lens. To expand the comparison further, the angle of view of a flashlight would be similar to a wide-angle lens, but the more constricted spread of a spotlight would make that view more similar to a telephoto lens. Specifically, a normal lens will show an angle of about 40 to 50° in front of the camera; a wide-angle lens has a view of 60 to 180°, and a telephoto can have a spread of light as small as 1°. (See Figs. 3.11 and 3.12)

The angle of view plays an important role in photography because it has to match the camera and film size. It is not only concerned with the angle the lens sees but also with the angle it projects. A focal length which is normal for one camera format can be wide-angle for another or a telephoto for a third. In this respect the projected angle of view becomes an important consideration to the photographer. A lens which is a telephoto for the 35mm camera may project an image which is sufficient to cover the film size. But if the same lens is placed on a 4 × 5 camera, while it still projects the same image size, it would create a circular pattern on the film and not expose the edges because of the lens' design. A lens designed for a particular film format is not necessarily interchangeable on another format or film size. Lenses designed for large format cameras can generally be used with smaller

FIGURE 3.12 *This series of photographs was taken from the same position with lenses of various focal lengths. The wide variety of interchangeable focal length lenses expands the effect obtained by the photographer. (a) 18 mm; (b) 28 mm; (c) 50 mm; (d) 90 mm; (e) 135 mm; (f) 180 mm; (g) 200 mm.*

(b)

(c)

(d)

(e)

(f)

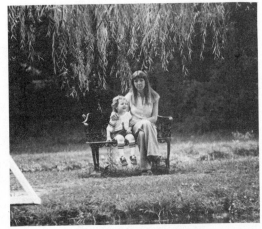

(g)

formats. However, a lens designed for a smaller format camera normally cannot be used with a larger size camera.

## LENS USES

**NORMAL LENS.** For different photographic uses and film sizes, lenses have a variety of focal lengths. The normal lens is the photographer's working optic and usually is a compromise between speed and sharpness, long and short focal lengths. It also gives a perspective and angle of view of the subject which is close to what is seen with the eyes. The focal length of a normal lens is calculated by measuring the diagonal of the film with which it is to be used. The result is translated into what is roughly near the focal length.

The diagonal of 35mm film, for example, is roughly 2 in. or 50 mm, which is also the focal length for the normal lens of a 35mm camera. The 120's 2¼ × 2¼ in. negative has a diagonal of roughly 80 mm, and the 4 × 5's diagonal is about 6 in. or approximately 150 mm. The sizes of their focal lengths for normal optics are respectively the same.

The normal lens of 80 mm for 2¼ × 2¼ film size would become a short telephoto for 35mm film size, and a wide-angle for 4 × 5 because of the angle of view. The image size produced by the lens, however, would be the same with each of the three film sizes.

**WIDE-ANGLE LENS.** The wide-angle lens has a shorter than normal focal length and a wider than normal angle of view for a particular film size. Unlike the normal focal length lens which can be standardized for a particular film size, the wide-angle can be any lens that produces an angle of view from 180° to 50°. But the standard for wide-angle is calculated by measuring the short size of the film format rather than the diagonal.

The standard wide-angle focal length lens, however, is just a starting place, and other lenses are available which will produce greater angles of view. For example, wide-angle lenses for a 35mm camera may range from 10 mm to 35 mm; for 2¼ × 2¼ cameras, from 40 mm to 60 mm; and for 4 × 5 cameras, from 60 mm to 100 mm.

Two problems common to all wide-angle lenses because of design are lack of edge sharpness and illumination. The conical view produced by the lens is both sharper and brighter in the center than at the edges of the projected field.

For any standard lens design the distance from the optical nodal point to the film is equal to the focal length of the lens when the subject is at infinity. If the photographer is using a 21 mm wide-angle lens on a 35mm single-lens reflex camera, however, the distance from the center of the lens, approximately where the aperture blades are located, to the film plane is 21 mm when the lens is focused on infinity. The camera mirror, used to view the subject, needs about an inch or 25 mm of clearance to move so that the image can be recorded on film. But the distance from the back of the lens to the film is only about half this distance, causing the lens to interfere with

the motion of the mirror. With earlier models of the wide-angle lens, the camera mirror had to be raised out of the way and the subject viewed through an auxillary viewfinder.

Now most of the wide-angle lenses are constructed as a retrofocus or inverted telephoto design so that the distance to focus the subject at infinity is greater than the focal length of the lens. The inverted telephoto lens uses a diverging front element and then converges the image with the other lens elements. This lens design is used most commonly with the single-lens reflex or smaller format cameras and can be recognized by its large front element. It allows the photographer to use the extreme wide-angle lens with the convenience of single-lens reflex viewing.

The wide-angle lens can be used by the photographer to produce size distortions and angles of view that cannot be seen by the unaided eye. Through deliberate distortions of size relationships of subjects, it is able to add visual dominance to the subject and isolate it from the background. In crowded conditions the wide-angle lens can make the scene appear less crowded. It is useful in photographing overall views without having to move to another camera position farther away.

Distortion is not a product of the lens but is created by the photographer. It is produced by the distance the photographer has to be from the subject to fill the frame with the smaller image. This causes an object close to the camera lens to assume a larger size and proportion than one that is farther away. These distortions, when deliberately planned, can work for the photographer. On the other hand, if obvious size distortion is not wanted in the picture, the camera has to be positioned carefully to eliminate them. (See Fig. 3.13)

FIGURE 3.13  *The wide-angle lens can be used by the photographer to create deliberate distortions or perspectives to emphasize subject matter.*

**TELEPHOTO LENS.** The telephoto lens, like the wide-angle, has a variety of focal lengths. They are longer than normal and give the impression of being closer to the subject than one actually is. The telephoto allows the photographer to get closer without moving, i.e., gets a larger image. (See Fig. 3.14)

Each lens has its own special use, and selection is based on the need of the photographer. Telephotos are relatively slow speed lenses that admit less light than normal. Therefore, they are better suited for outdoor situations with high light intensity.

When used with 35mm cameras telephoto lenses are usually classified as *short, normal, medium, or long* telephotos. The short lens, which has a focal length range of 85 to 90 mm, is good for many situations, including outdoor portraiture, fashion photography, and some sporting events. Normal telephotos can be used for studio portraits, fashion, still life, and in many cases, sports and news. Its focal length ranges from 100 to 135 mm. With the medium telephoto, the photographer starts to get compression of the different focal planes within the picture, and objects in the foreground. Its range from 250 to 300 mm is good for outdoor portraits and candid pictures of people, especially children. The lens can be used also in a limited way for wildlife photography and is extremely good for such sports as football and baseball. The long telephoto lens with its focal length ranging from 400 to 500 mm has limited uses because of its minimum focusing capability and its lack of mobility. These lenses have to be placed on a tripod to get sharp photographs because most of them have slow lens speed. There is limited use of this lens in news photography, but it is good for sports, wildlife, and taking candid shots of people.

*FIGURE 3.14  The telephoto lens allows the photographer to get closer to the subject without moving and to make larger sizes of distant subjects.*

Extremely long lenses, beyond 800 mm, have fewer capabilities, but they are valuable for getting large suns for montages and silhouettes. The background of photographs taken with this lens appears as a solid mass of overlapping colors and tones. It is good for wildlife shots and for photographing the moon and eclipses of the sun.

Telephoto lenses have two physical designs: true telephoto and catadioptric. The true telephoto lens can have either a focal distance that is equal to the focal length of the lens or one that is less. To illustrate the difference, a lens with a focal length of 300 mm would require a physical distance of 300 mm from the center of the lens to the focal point, in one design. The other design would require less distance and, therefore, would be shorter and more compact. Size is not an important consideration for the shorter telephoto lengths; but in the case of the 300 mm lens, one design would have a physical length of about one ft, and the other would be 6 to 8 in.

## SPECIAL LENS DESIGNS

A design which is rapidly increasing in popularity is the catadioptric or mirror lens. It utilizes curved mirrors instead of transparent glass to form the image. The front element of the lens, which produces a slight correction in the image, projects the light to a curved mirror surface located in the back of the lens. This mirror projects the image back to the front of the lens so that it converges to be reflected by a second mirror located in the center of the front element. The image is then projected through another lens element to the camera and film (Fig. 3.15).

While common usage of catadioptric lenses is a fairly recent development in photography, the basic idea has been used for other purposes since the early 1700s, and the first successful mirror lens design for photographic purposes occurred around 1931. Its main use until recently, however, was in astronomy. This is the lens design of the 200-in. reflector used as the telescope at Mt. Palomar in California. Many smaller catadioptric telescopes were altered so that they could be used photographically.

This type of lens has an advantage in that it produces an image free of chromatic aberration. Another advantage is its length and weight.

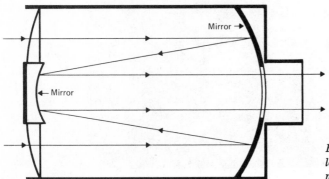

*FIGURE 3.15    The catadioptric lens design is a radical change from most optical designs.*

The main problem with this design is that it cannot be used with an aperture. This forces the photographer to use the lens at its maximum light admitting power. Neutral density filters between the lens and the film are used to adjust the intensity of light. While these filters are often incorporated into the lens, some lenses force the photographer to view a darkened image while focusing and composing since the light absorbing filter has to be manually added to the back of the lens before the lens is attached to the camera.

Photographs made with the catadioptric lens can usually be distinguished from pictures made with other types of telephoto lenses by the shape of the out-of-focus circles of light in the background of the picture. Because the light is transmitted through a lens with an opaque center spot in the front element, the out-of-focus spots of light have the appearance of a doughnut shape rather than a point of light.

An accessory available to the photographer that increases the lens' focal length is a *tele-extender*. It is a device made up of additional lens elements and is attached to the camera's lens. The magnification of the extender doubles or quadruples the focal length of the existing lens. A 50 mm lens with a 2X tele-extender, for example, would have an effective focal length of 100 mm. A 3X tele-extender would increase it to 150 mm. The tele-extenders are relatively inexpensive, but the quality they produce is less than that of the true telephoto lens. (See Fig. 3.16)

Other lenses and accessories are available for special purposes. One design is being incorporated into more lenses to extend the focus range. The normal focus range of a lens is from infinity to about three feet, depending on the

*FIGURE 3.16 The photographs shown have the same magnification although the one on the left (a) was made with a 300 mm lens, and the other, (b) with a 150 mm lens. A 2X tele-extender used with the shorter focal length lens equalized the magnification.*

lens' focal length. But the macro or extended-focusing lens can focus as close as two to three inches without special attachments.

The *macro-focusing* lens is a normally designed lens except it has an extended focusing range that allows extreme close-ups. A special design called a *macro lens* not only focuses to an extreme close-up but also has a flat field of view.

The normal lens has a field of critical focus that is slightly curved in comparison to the flatness of the film. This is called field curvature, and it does not normally create a problem because the depth of acceptable focus causes the subject to appear in focus along a flat plane. As the photographer focuses on closer subjects, the area of acceptable focus decreases, and the curvature of the focus becomes more apparent. With the macro lens, a flat field of focus parallel with the film is projected, causing the subject to be in focus all along this flat plane in front of the camera lens. Other lenses, such as those for enlargers, while not macro, make use of the flat-field principle since the image is projected onto a flat plane. Without the flat field of focus, the print would be sharp at the center and gradually become out of focus at the edges.

The macro-focusing and macro lens allow the photographer to record images which cannot be seen without optical aids to the eye. Because the eye does not focus closer than 6 in., photographs taken close up often have a special appeal to the viewer. A macro photograph is useful also in showing details in smaller objects and other subjects which would be otherwise difficult to see. (See Fig. 3.17)

*FIGURE 3.17 The main difference between macro and close focusing lenses is that the former has a flat field of focus and the latter, a curved field. A macro focusing lens was used for (a), (left), and a close focusing lens for (b), (right).*

There are several attachments for normal lenses which the photographer can use to get a macro photograph. The most common are accessory lenses that change the focal length. The supplementary close-up lenses, or *diopters*, usually distort the image at the edges; and because of the curvature of the focus field, the image is not usually sharp from edge to edge on the negative unless an extremely small diameter aperture setting is used. The supplementary lenses attach directly to the existing lens and come in differing degrees of closeness.

Another accessory to make macro photographs is a supplementary bellows which goes between the camera and the lens. A disadvantage of this system is that the lens loses its capability to automatically adjust the aperture to a preset setting. A second problem with this accessory is a loss of light in the camera that stems from the distance the light has to travel from the lens to the film. It is called *bellows factor* and is not usually a problem unless the exposure is based on a reading from a light meter that is not in the camera. The main advantage of the bellows over the supplementary close-up lenses is that the latter accessory needs to be used at a set distance from the subject. The bellows permits the photographer to select the degree of magnification on the subject.

Similar to the bellows are *extension tubes*, which also increase the distance from the lens to the film and allow the photographer to focus closer to the subject. The range of magnification the photographer gets with the extension tubes is controlled, however, by the length of the tube and is not adjustable like the bellows. However, extension tubes of different sizes can be combined to control the degree of magnification. Extension tubes are used also with macro-focusing lenses to extend their focusing range even farther or with normal use lenses to make them capable of macro-focusing.

Another special purpose optic is the *zoom lens*. It is a variable focal length lens which can change the image size continually. The lens was originally developed for the motion picture industry so that the image size could remain the same on moving objects without moving the camera, but it is used now by the still photographer for special purposes. An inherent advantage is that it gives the photographer wide-angle, normal, and telephoto capabilities in a single optic. At the same time all combinations of focal lengths within a given range are made available. For the 35mm cameras, they are medium wide-angle to normal, medium wide-angle to short telephoto, normal to medium telephoto, and short telephoto to long telephoto zoom lenses.

The zoom lens is used in sports and news photography and to create special effects. Many on the market also have macro-focusing capabilities to extend their versatility. (See Fig. 3.18)

The zoom lens, like any compromise, creates advantages by sacrificing other features. The biggest disadvantage is its bulkiness, especially in the longer focal lengths, and also it is not as sharp as a fixed focal length lens.

Sharpness, contrast, and other qualities of the recorded image depend not only on the type of lens used but on the care given them. A lens which

FIGURE 3.18 *The zoom lens can be used at a fixed focal length during an exposure or zoomed to create a motion effect, as this photograph illustrates.*

is not clean, for example, will not perform at the level for which it was designed or for what is needed for modern films and enlargements.

Optical glass used for making lenses is much softer than normal glass and is easy to scratch and harder to clean once it is allowed to become dirty. The best protection starting from the moment of purchase is a protective ultraviolet or haze filter which screws onto the lens, and a lens cap for when the camera is not being used. These filters do not affect the lens quality, and they do not change the colors recorded on the film. In addition to protecting the lens, they reduce haze in landscapes. (See Fig. 3.19)

──────────────────────Lens Cleaning──────────────────────

The lens has the responsibility of projecting the image that is to be recorded. Special care, therefore, should be taken in handling and cleaning both camera and enlarging lenses. A dirty lens will degrade the photographic image in both sharpness and contrast. Scratching the lens element by improper cleaning can physically damage it and eventually cause a separation of the glued elements within the lens.

If the lens is new, cleaning is normally limited to simply blowing off the dust from the front and back elements. Afterwards, the front of the lens should be protected by a filter. When the lens is not on the camera, a lens cap should be placed on the back.

If the lens is older and has collected both dust and fingerprints, a more thorough cleaning is required.

FIGURE 3.19(a) *Proper materials are needed to clean a lens. The use of handkerchiefs, shirt tails, and other articles of clothing causes more harm than good by scratching the delicate coating on the lens element.*

*Lens tissue, designed for photographic purposes, a lens cleaning fluid, a soft brush, and canned pressurized air are suitable. Proper care in the use of these materials is necessary.*

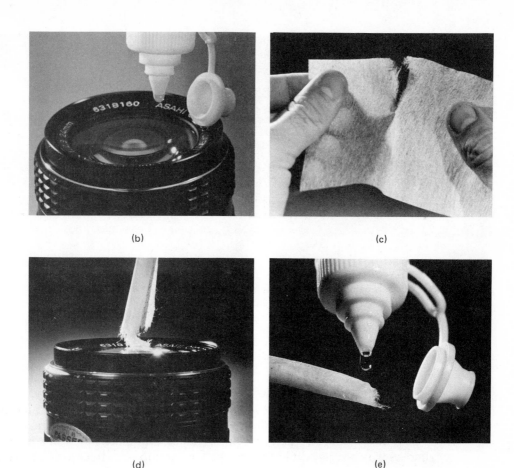

(b)

(c)

(d)

(e)

*FIGURE 3.19(b)  Don't apply lens cleaning fluid directly. It can collect in the junction of the lens element and barrel and eventually in the lens itself. The cleaning fluid is a solvent which will dissolve the adhesive that holds the lens elements together.*

*A safer method of cleaning is illustrated in the following photographs.*

*FIGURE 3.19(c)  Just as incorrect application of cleaning fluid can damage a lens, improper use of the tissue, such as crumpling it and creating sharp edges, can scratch the coating and lens element. A better method is to tear the tissue in half and roll each part into a tube with the torn fibrous side at one end. These tubes can be used to apply lens cleaner and to brush and buff the lens.*

*FIGURE 3.19(d)  Loose dirt is blown free from the lens by using either canned pressurized air or a blower-type brush. Any remaining dust particles can be brushed off with a tissue tube. Use of the pressurized air again is a good double precaution.*

*The lens tissue needs to be disposed of after each use. The dirt embedded in the tissue brush can scratch the lens coating if it is reused.*

*FIGURE 3.19(e)  For stubborn fingerprints or other smudges on the lens, cleaning fluid should be used. Remember that it can harm the lens if applied directly. A better method is to apply the cleaning fluid to the tissue and then clean the lens with the applicator.*

(f)                                        (g)

FIGURE 3.19(f)  After the fingerprints and grease are removed from the surface, buff the lens with a clean tissue tube. Do not use the tissue which was originally used because of the dirt embedded in it. Repeat the cleaning procedure on the back surface of the lens.

FIGURE 3.19(g)  After the lens has been cleaned, place a skylight or haze filter over it to protect the lens element from fingerprints. From then on the filter is cleaned instead of the lens. If the filter becomes scratched, it can be replaced cheaply.

In addition to the ultraviolet filter the lens should have a hood. Its primary purpose is to shield the lens from light sources outside the picture. It reduces lens flare and a degrading of the image sharpness and contrast.

*Lens hoods* come in different sizes, shapes, and materials. Some are metal cylinders which screw directly into the lens or clip onto it. Others are made of collapsible materials or box-shaped accordion materials which can be adjusted for individual lenses. Regardless of the construction, the hood is an essential part of the lens and should be used every time a picture is taken.

The angle of view of the lens, whether wide-angle or telephoto, will determine which lens hood needs to be used. The telephoto lens uses a hood which is long and narrow, while the hood for a wide-angle lens has to be shorter in length than a telephoto or normal lens hood because of its wider angle of view.

A problem created by the use of a lens shade which does not match the lens is a vignetting effect on the picture. The edges of the photograph darken because the lens takes an out-of-focus picture of the inside lens hood. This is particularly prevalent with the use of wide-angle lenses. The picture frame should be checked carefully for this vignetting effect if the lens hood being used did not come from the manufacturer of the lens.

The hood also protects the front element of the lens from damage if it is a metal hood (Fig. 3.20).

The photographer should check also the inside of the lens hood periodically to make sure that there are no bright metal areas. If the inside should get scratched, it can be repaired with a flat black paint and a small brush.

The hood pays off in sharpness, more contrast, and better protection for the lens.

FIGURE 3.20 *The lens hood needs to be matched to the angle of view of the lens. In this illustration, a hood designed for a normal lens is used on a wide-angle lens, creating a vignette effect.*

## SUMMARY

The lens is one of four elements common to all cameras. Its normal function is to project a near distortion-free image to the film, but each lens element produces distortions or aberrations of the image because of its physical shape and other characteristics. The main faults of lenses are spherical and chromatic aberrations, and barrel and pin-cushion distortions. Designers attempt to remove as many of these faults as possible without making the costs of the lens prohibitive, but no design is free of all faults. In addition to cost, the amount of correction is determined by how the lens is to be used, and the type of camera and the film size of the camera on which the lens will be used.

Other lens properties of concern to the photographer are: focal length, which determines image size; lens speed, which controls the maximum amount of light passed through the lens; resolution or sharpness of the lens; covering power; and angle of view. The latter property is one of the factors that determine whether the lens is normal, wide-angle, or telephoto.

Each lens is designed for a particular camera type, and what is a normal lens for one camera format may be a wide-angle or telephoto lens for another. Many of the amateur and professional cameras are designed to accept lenses with many different focal lengths to increase their use and versatility.

Besides the usual range of focal lengths, specially designed lenses are available which allow the photographer to focus closer than normal and produce images which cannot be seen by the unaided eye. Other lenses zoom from one image size to another without need of attaching several lenses to the camera. Accessories, such as bellows attachments and extension tubes, help increase the versatility of the lens and change its characteristics.

# CREATIVE CAMERA CONTROLS

The photographer can determine the emphasis and mood of the photograph by creatively manipulating the aperture, shutter, and focus controls of the camera. The camera's design, however, determines the degree of control. Some are made with all three controls permanently set by the manufacturer to match the lighting conditions and distances to subject normally used by the beginning photographer. Other camera designs allow minor adjustments in one or more of the controls, but those with the complete range of settings for the aperture, shutter, and focus allow the photographer to record the subject most imaginatively.

Although the interaction between all three controls produces the desired creative results, each has specific responsibilities for the image change. The shutter and aperture have the added responsibility of helping to determine exposure.

## SHUTTERS

The shutter protects the film from light until the selected instant when the photograph is made. It also regulates the exact amount of time that light is allowed to strike the film, thus controlling the exposure. Early cameras did not have a shutter and didn't require one. Film was much less sensitive then, and the exposures were long enough to make a mechanical timing device unnecessary. Early camera lenses were covered with an opaque cap to protect

the film from light. Exposure time was measured in minutes, and when the photographer was ready to shoot the picture, the lens cap was simply removed to start the exposure. The cap was replaced after enough time had elapsed. Because of the long exposures, small variations in time were not critical. Today's films, however, are much more sensitive to light, and exposure has to be recorded accurately in fractions of seconds rather than in minutes.

This need for split-second accuracy has resulted in the development of a complicated and delicate timing device capable of regulating exposures that range from several seconds to small fractions of seconds, such as 1/500 or 1/2000 sec. The range of shutter speeds available on the camera depends on the camera's design and on the construction of the shutter.

**TYPES OF SHUTTERS.** Camera shutters can vary radically in both construction and operation. They can be located in various positions within the camera, depending on the camera's design. The two most common positions are within the lens or at the back of the camera, at the focal plane, where the image is formed. Because of these locations, shutters are commonly referred to as *between-the-lens shutters* or as *focal plane shutters*.

The between-the-lens shutter can be located in front of the lens, between the lens elements, or behind the lens. Some older camera models and a few modern inexpensive designs place the shutter either in front of or behind the lens, but the most common location is between the lens elements, next to the aperture. (See Figs. 4.1 and 4.2) Because of its location and since the shutter normally remains in the closed position to protect the film from exposure to light, a separate viewing and focusing system from the picture-taking lens needs to be employed. The twin-lens reflex camera, with its separate viewing and picture-taking lenses, is suited well for the between-the-

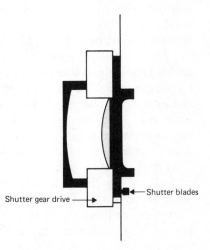

Shutter gear drive → ← Shutter blades

*FIGURE 4.1 The between-the-lens shutter is located with the camera's aperture between the different lens elements.*

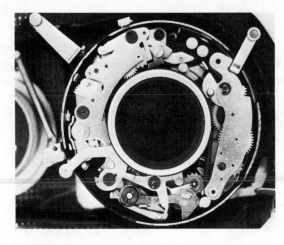

FIGURE 4.2  *The between-the-lens shutter is a series of overlapping metal blades which are opened and closed by a timing device pictured here.*

lens shutter design. The viewfinder and direct view cameras can also utilize this shutter location without creating any design problems.

The latter design can use this shutter because film is not placed into the camera until after the process of viewing and focusing is completed. This allows the image to be viewed through an open shutter, which is closed before the film is put into place for the exposure.

The between-the-lens shutter is not used normally with the single-lens reflex camera, except for a few large format designs. A light-proof barrier, however, is needed behind the viewing mirror to protect the film from exposure during the viewing and focusing procedures. When the exposure is made, the shutter closes, the viewing mirror and light-proof barrier move out of the way, and then the shutter opens and closes to make the exposure.

Between-the-lens shutters are either *presetting* or *self-setting*. The self-setting shutters, used in the less expensive, nonadjustable cameras, are normally limited to one or two different shutter speeds. They are of the simplest design and utilize a revolving opening or a simple blade device to regulate exposure. When the photographer depresses the shutter release to expose the film, the motion also places tension on a spring which opens and closes the shutter during a fixed interval.

The presetting shutter is more complicated in construction and uses spring tension and timing gears to regulate the exposure. It utilizes a separate cocking mechanism to apply spring tension before the shutter is released for the exposure. The spring tension can be applied with a lever that is separate from the other controls or in conjunction with another camera action. A common method is to apply the tension with the same lever and motion which advances the film to the next frame.

Preset shutters are a series of overlapping metal blades which are opened and closed by the gears of the timing mechanism. Since the blades are located near the center of the lens, the opening of the shutter exposes the film more or less equally from the beginning of the exposure to the end. The blades of the shutter expand outward to form an opening slightly larger than the size of the maximum aperture opening of the lens. They remain in

this open position for the preselected time and then close to block out all light that passes through the lens. The need for the shutter blades to expand almost instantaneously to their fullest opening limits the shortest shutter speed times. The minimum time in which most between-the-lens bladed shutters remain open is 1/500 sec, which can be considered a disadvantage when compared to the 1/2000 sec available on some focal plane shutters. The fact that all of the film frame is exposed from the beginning is an advantage that will be discussed more fully in the chapter on flash photography.

As stated earlier, some large format SLRs use between-the-lens shutters, but a more convenient solution for this camera is to use a shutter placed behind the lens and the viewing mirror at the film plane so that the image can be viewed while the shutter is in the closed position to protect the film from exposure to light. (See Figs. 4.3 and 4.4)

Focal plane
Shutter location

*FIGURE 4.3  The focal plane shutter is located in the rear of the camera, just in front of the film's surface and the lens' focal plane.*

*FIGURE 4.4  Conventional focal plane shutter, constructed of flexible curtains which cover the film until the time of exposure.*

The focal plane shutter, aptly named because of its location in front of the film near the focal plane of the camera, can take the form of either cloth curtains or metal blades. The cloth curtain focal plane shutter is the older design and consists of two rubberized light-proof curtains that contain an opening in each, slightly larger than the film size. One curtain is the opening curtain and the other the closing curtain. When the shutter release is depressed, the opening curtain travels across the film exposing it to light through a corresponding hole in the closing curtain. As it completes its travel across the film, it stops and leaves the film exposed to light entering the lens. At a predetermined time the opaque portion of the closing curtain starts its trip across the film to complete the exposure. Normally the travel time of each curtain is constant, and at speeds slower than 1/60 sec all portions of the film receive some exposure at the same time. At faster shutter speeds, the size of the openings is decreased so that the closing curtain starts across the film before the opening curtain has completed its trip. This, in effect, forms a slit which travels across the film's surface exposing only a portion of the film to light at a time (Fig. 4.5). As the shutter speed is increased, the openings become further offset to each other so that the total size of the opening becomes progressively smaller. The shutter, while traveling at the same speed across the film's surface, does not give as much exposure to the film because of the smaller opening.

The metal bladed focal plane shutter is a newer design and combines features of both the cloth curtain and the metal bladed between-the-lens shutter.

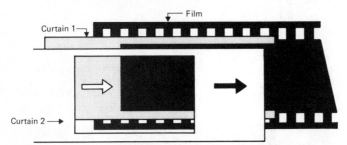

FIGURE 4.5  *Shutter curtains 1 and 2 travel across the film surface at the same speed. By adjusting the width of the slit produced by the overlap of the curtains, the photographer is able to regulate the film's exposure to light.*

FIGURE 4.6  *The metal focal plane shutter, unlike its cloth counterpart, usually opens from the center, similar to the between-the-lens shutter. In addition, the shutter opening is regulated with a timing mechanism, rather than having a constant speed.*

Although it is located at the focal plane, it opens from the center similar to the between-the-lens shutter. (See Fig. 4.6) This does not have any real bearing on the creativity of the photograph, but it does affect the use of flash, which will be discussed in a later chapter. The metal bladed focal plane shutter is also more compact than the older shutter design, making it more convenient to use in the smaller camera bodies now in production.

**MOTION CONTROL.**  Subjects for most photographers are alive and move through time and space, but for many years the photographed image was accepted only if it was sharply defined in the smallest detail. To capture such a well-defined image during that stage of the development of the photographic process, the object had to be totally motionless.

In the beginning, the procedure for making a photograph was time consuming. Hours were needed to correctly expose the picture, necessitating stationary subjects. Moving objects could be recorded only as ghostly blurs. (See Fig. 4.7)

One of the primary goals in the development of the photographic process, therefore, was to decrease the time needed to expose a picture. Camera lenses designed to admit more light and films made more sensitive to light combined to gradually shorten the required exposure time. Because of the difficulty in recording a motionless image, photographers went to great lengths to remove all motion from the picture. Early subjects used for portraiture, for example, were powdered with white flour to reflect more light, and they were braced into place to prevent body motion.

*FIGURE 4.7 Because lengthy exposures were needed, landscapes were the primary objects for the photographer's lenses in the early years. Daguerre accidentally recorded the first image of a man when he made this exposure. The person had stopped to get his boots shined and stayed motionless long enough for his image to be recorded. (Daguerre: A Parisian Boulevard, Daguerreotype, c. 1838. Bayerisches Nationalmuseum, Munich.)*

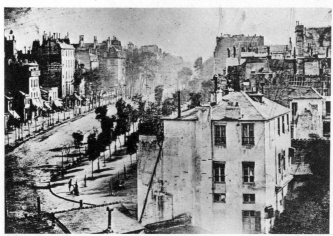

Although lack of motion is still needed for certain subjects and situations, capturing the expression of the subject's motion becomes more important at times than getting sharply defined details. During the past 20 years, blurs in the photographic image as a means of expressing and communicating subject motion have been increasingly accepted. Whether the photographer uses the camera to freeze the action that surrounds us each day or allows it to flow in a blur, the resulting photographic image still remains an abstraction of the event or the subject. The difference between the stopped action and the blur is in the amount of exposure time which the photographer selects to represent the whole of the action.

In still photography, motion is a sensation which has to be detected by the viewer through visual clues. The photographer can suggest motion in two ways: (1) stopping the action, and (2) allowing the action to blur. In stop action, the position and expression of the subject and compositional factors can suggest motion. Although the subject is frozen in movement, the viewer's mind adds information that motion preceded the time of exposure and continued afterwards. Thus, the illusion of motion is retained in a still photograph. What the photographer is communicating is, "This is what happened during 1/1000 sec of action." The use of stop action also gives the viewer time to isolate and study details which may not be visible during the normal flow of motion around us. There is a fascination in being able to see something different from what we normally are able to perceive. This holds true whether it is the instant slow motion replay of a football game, or stopping the action of a bullet or the shatter of a light globe in mid-air (Fig. 4.8).

Besides stopping the action, motion can be expressed with a blurred subject against a sharp background, or with a sharply defined subject against a blurred background, or with a combination. In any of the three techniques, the movement becomes more pronounced when the blur of the motion is used in contrast with the sharpness of other portions of the photograph.

*FIGURE 4.8  The shattering of the light globe by a small caliber bullet is frozen in time at 1/1000 sec.*

Although stop-action and blur-motion photography are opposite extremes of motion expression, factors which affect one will affect the other. How the motion is recorded on film lies in the ability of the photographer to relate shutter speed and camera motion to the speed of the subject. Obviously, if the camera movement and shutter speed setting do not freeze the action, the subject will be blurred.

When the photographer desires to stop or freeze all movement, the shortest available exposure time should be selected. Some factors, however, will limit the shutter speeds which can be used. These are the intensity of the light, the aperture setting of the lens, and the sensitivity of the film to light. The correct exposure of film to light is still critically important to the photographer and should be considered first, although the shutter has a dual role of controlling both exposure and motion.

Other factors which influence the selection of a shutter speed to stop or blur the action are: (1) speed of the subject, (2) the angle of the approaching motion, (3) distance of the action from the camera, and (4) the relationship of the action to the camera. (See Table 4.1 page 76) A subject is either at rest (nonmoving) or changing position in space. A change in position takes time, so the photographer can stop motion by selecting an exposure duration that is shorter than the time needed for the subject to change position. As the speed of the subject increases, the position changes take less time; therefore, the exposure duration has to be shortened to stop the motion. (See Fig. 4.9)

Another factor involved in the control of motion is the angle of the action relative to the film plane. Motion that directly approaches the camera

*FIGURE 4.9 Subjects traveling at different speeds produce different amounts of blur, as shown in this illustration.*

**TABLE 4.1**
**SHUTTER SPEEDS FOR MOVING SUBJECTS**

| Subject | Approximate Speed (mph) | Distance Between Subject and Camera (ft) | When Motion Relative to Camera Is | | |
| --- | --- | --- | --- | --- | --- |
| | | | Head on | At 45° (in seconds) | At right angles |
| *Slow motion* | | | | | |
| Pedestrians, street scenes and construction. Slow moving water and boats, parades, etc. | 5-15 | 10-15 | 1/200-1/250 | 1/300-1/500 | 1/400-1/500 |
| | | 25 | 1/100-1/125 | 1/200-1/250 | 1/300-1/400 |
| | | 50 | 1/50 -1/60 | 1/100-1/125 | 1/200-1/250 |
| | | 100 | 1/25 -1/30 | 1/50 -1/60 | 1/100-1/125 |
| *Medium fast action* | | | | | |
| Active sports, horse racing, scenes from trains, etc. | 15-30 | 10-15 | 1/500 | 1/500 | 1/1000 |
| | | 25 | 1/200-1/300 | 1/250-1/500 | 1/500-1/1000 |
| | | 50 | 1/100-1/200 | 1/200-1/300 | 1/400 |
| | | 100 | 1/50 -1/100 | 1/100-1/200 | 1/200-1/300 |
| *Swift action* | | | | | |
| Speeding cars and trains, motorcycles, aircraft, etc. | 50 | 12 | 1/1000 | 1/1000 | 1/1000 |
| | | 25 | 1/400-1/500 | 1/1000 | 1/1000 |
| | | 50 | 1/200-1/250 | 1/400-1/500 | 1/1000 |
| | | 100 | 1/100-1/125 | 1/200-1/250 | 1/400 |

(a)                                                    (b)

FIGURE 4.10 Motion approaching the camera from a near head-on posi-
tion is much easier to freeze but harder to blur than movement nearly
parallel to the camera plane. Both (a) and (b) were shot at the same shutter
speed, but subject (a) is frozen while (b) is considerably blurred.

or proceeds directly away from it in a straight line exhibits very little action,
making it easy to freeze with relatively long exposure durations. But on the
other hand, an expressive blur is difficult to achieve at such an angle. As the
angle of approach of the action becomes more nearly parallel to the camera
and film plane, the speed of the action increases. Therefore, shutter speeds
of a shorter duration must be used to stop the action. Blur motion is easier
to achieve, even using a relatively fast shutter speed. (See Fig. 4.10)

The distance of the action from the camera also affects its apparent
speed. The amount of movement across the film plane is less when the sub-
ject is far away, but the closer the action is to the camera, the more the sub-
ject appears to move and the faster the shutter speed must be to stop the
action. At the same time, close action allows a blur to be obtained using a
relatively short exposure time. Action which takes place farther away from
the camera can be stopped with a much longer shutter speed and is harder to
blur than close action. The exception is when a telephoto lens is used, which,
in effect, moves the photographer closer to the action. The subject may be at
a great physical distance, but the optical distance can be quite close after it
is magnified by the optics of the lens. (See Fig. 4.11)

The relationship of motion to the film is also involved in stopping or
blurring the action. In addition to using a telephoto lens, other methods can
be employed to change the relationship. One way to decrease the apparent
motion is to move the camera in the same direction and at the same speed as
the action. The photographer can photograph the moving object from a
vehicle traveling at the same speed, or the camera can be panned in the same
direction and speed of the subject.

Pan motion is a technique that creates an expressive blur to indicate

(a)

(b)

*FIGURE 4.11 (a) Motion located at a great distance from the camera is more difficult to blur than motion close to the camera. (b) The relationship between the subject and the camera can be altered to produce greater blurring of the image with a telephoto lens.*

action, while retaining the subject's identification. To accomplish this, the camera is moved or *panned* in the same direction and at the same speed as the subject's movement for the duration of the exposure. The camera's motion causes the subject to remain stationary in relation to the film but presents a symbolic indication of the subject's speed because the background is blurred. (See Fig. 4.12)

For panning to be effective as a motion technique, certain requirements are necessary. These are: (1) the action should be close to the camera, (2)

*FIGURE 4.12 An example of panning. Notice in this example that the background is blurred because the camera was moved to maintain a stationary position on the motorcycle rider.*

there should be enough action in the subject to justify the use of a blur technique, (3) the background should be of uneven tones, and (4) the path of the motion should be as nearly parallel as possible to the path of the camera's movement.

The closer the subject's action is to the camera, the faster the subject will move in relationship to the area covered on film. To keep the subject within the camera frame during the exposure, the camera has to be moved at a synchronized speed. This action creates a blurred effect on the background. If the subject is far away from the camera, less movement of the camera is involved, resulting in little apparent blurring unless the photographer uses a telephoto lens, which optically brings the subject closer to the camera.

If the subject is slow moving, there is little justification for using a blur technique. An exception would be if the photographer wanted to exaggerate the subject's speed or isolate it from a distracting background. Other techniques, however, would be more effective.

The tones of the background play a role in determining the effectiveness of pan motion. Uneven or mottled tones work much better for this technique than even tones, which provide little apparent blurring to contrast the sharpness of the subject (Fig. 4.13). The blurred streaks caused by the camera panning across highlights and shadows are similar to the symbolic streaks used by cartoonists to indicate speed. The streaks become the visual reference to the speed of the subject.

The camera can be panned only in a single direction at a time. Action that is parallel to the camera's movement will record as stationary, but any other motion, either in a different direction or at a different speed, will record as a blur. For example, if the pan motion technique is used to photograph a runner, the motion of the camera would be parallel with the flow of the body, but not with the legs, arms, and hands of the runner. Their up-and-down movements would be recorded as blurs, while the body would be stationary. (See Fig. 4.14) The rotation of wheels on a bicycle, like the arms and legs of a runner, is another example of how differences in speed by dif-

*FIGURE 4.13 The blur streaks of uneven tones in the background produce the illusion of speed similar to the streaks which the cartoonist places in a drawing to indicate movement.*

FIGURE 4.14 Although panning with the subject's movement will freeze the action, portions of the subject not moving in the same direction as the panning camera will not be frozen.

ferent parts of an object can present a symbolic expression of motion. The amount of blur recorded in other portions of the photograph is determined by the speed of the shutter. Under bright sunlight conditions, however, a slow shutter speed cannot be used when the light intensity dictates that the photographer use a film that has low sensitivity to light. This will be covered in later chapters.

The major characteristic of pan motion is the expression of motion that retains the identity and many details of the subject. A second technique, called *blur motion*, causes the subject to be blurred as it travels across a sharply defined background. With this method the identity of the subject is lost, but the background is used to communicate the story and to give meaning to the blur. Because of its important role, the background should be well lit and composed as the focal point to the photograph, with the subject flowing across the background in a blur. (See Fig. 4.15)

The amount of blur the photographer gets with the blur motion technique depends on the same conditions required for panning. It is affected by the speed of the subject, direction of motion, and distance of the subject from the camera.

The faster the subject travels, the more it blurs, and motion that travels parallel to the film and camera is easier to blur. Similarly, the subject should be as close as possible to the camera. The camera is left in a stationary posi-

FIGURE 4.15 The use of blur motion dictates that either the foreground or background areas of the picture carry information which gives identity and reason for the blurred subject. In this picture, the individual identity of the subject is not important, but the situation is clearly defined. (Courtesy of Ann Turner.)

tion for blur motion, however, rather than being panned along the path of the subject's travel. If the subject is distant from the camera, the action does not move across the film as rapidly as it would up close, limiting the blur.

The final consideration for blur motion is the shutter speed. By selecting the proper shutter duration, the action can be blurred to the extent that identification is totally obscured, or it can be minimally blurred to retain partial identification of the subject (Fig. 4.16).

Table 4.1 is a guide to shutter speeds which will stop action. Slower shutter speeds will blur the action.

(a)

(b)

(c)

FIGURE 4.16 The selection of the shutter duration allows the photographer to control the amount of subject identity to be retained. In this example, (a) was made with a shutter speed of 1/60 sec, and much of the identity of the subject is lost. (b) was made with a shutter duration of 1/125 sec, and allows more subject identification while retaining the blurred appearance. (c) was taken with a shutter speed of 1/250 sec, has portions of the subject in frozen detail while other more rapidly moving parts retain their blurred appearance.

FOCUS

The second major camera control which affects the image is focus. With this control the photographer can create an image with sharp details (in focus), or with degrees of blurriness (out of focus), depending on the setting of the lens, and the point of focus. The lens has the function of gathering light rays and converging them to a point. This function can be easily illustrated with a simple lens, such as a magnifying glass. The magnifying lens can be held so that the rays from the sun are projected onto a piece of paper. Depending on the distance of the paper from the lens, the rays of the sun are seen as a circle of light or a point of light. The lens projects the sun's rays in a conical shape that gradually converges to a point and then diverges. When the lens is positioned above the paper so that the light is neither converging nor diverging but creating its smallest point on the paper, then the sun's rays are in focus. (See Fig. 4.17) This process of moving the lens to form a point of light is called focusing.

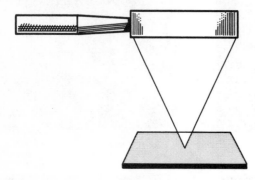

*FIGURE 4.17 When light is projected through a lens so that it forms the smallest point, the light source is in focus.*

CRITICAL FOCUS. Light reflected from a scene is projected by a camera lens in the same manner as the sun's rays. However, the law of optics states that light rays traveling from various distances from the lens cannot be converged to a point at the same distance behind the lens (Fig. 4.18). Since the distances normally involved in photography are from a few feet in front of the camera to photographic infinity, the photographer has to decide on the point of focus for the scene. Only objects located along a single distance plane can be recorded in critical sharpness. All other distances in front of or behind this plane of critical sharpness will be recorded out of focus to varying degrees. The greater the distance between the object and the plane of focus, the more blurred the image will be. In order for the selected image to be sharp, the lens and the film must have a certain relationship. The correct relationship depends on two factors: (1) the focal length of the lens, and (2) the distance of the subject from the lens.

The focal length of the lens is the distance required to focus a subject

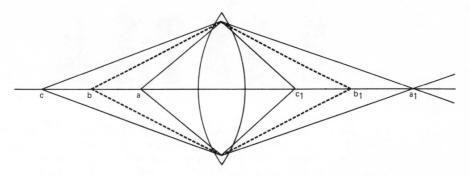

FIGURE 4.18 *The closer an object is to the lens, the farther the film must be for the image to be recorded in focus. In this figure, the source of the light rays are on the left, in front of the lens, while the focusing points are on the right, behind the lens. Point a, closest to the lens, focuses at a1, the farthest point behind the lens. Conversely, point c, farthest from the lens, focuses at c1, the closest point behind the lens.*

located at infinity. (This is a simple definition of a complex formula and is correct only for simple lens designs. The focal length of more complicated designs are worked out by special formulas.) If the focal length of a simple lens is 80 mm, for example, the required distance from the center of the lens to the point of focus when the subject is located at infinity is 80 mm. A lens which has a focal length of 200 mm requires a distance of 200 mm. In each case the distance relationship between the lens and the film would be different because of the focal length. If the subject is at infinity and the film is located at the proper distance that corresponds with the focal length of the lens, the subject will be in sharp focus. Infinity, described in photographic terms, refers to the horizon or objects 1,000 yards or so from the camera.

When the subject moves towards the camera from infinity, the relationship between the lens and film has to be changed to keep the image sharp. As the subject gets closer and closer to the camera, the lens-to-film distance has to change. This changing relationship is focusing.

**TYPES OF FOCUSING MECHANISMS.** All but the most inexpensive cameras have some means of changing the lens and film relationship so that the photographer can focus the image. The inexpensive models have a preset distance where the subject is recorded sharply. The focus setting on these cameras is based on the average subject distance that the amateur uses. Some other inexpensive designs give the photographer different ranges of focus that are suitable for close-up, intermediate, and distant scenes. (See Fig. 4.19)

Other cameras used by both the amateur and professional photographers allow an adjustable focusing range from about three feet to infinity. Specially designed lenses expand this focusing range from a few inches to infinity. The adjustable focus camera changes the focus in one of two ways: (1) changes the distance between the lens and the film, or (2) changes the focal length of the lens. The most common means of focusing is to adjust the dis-

3.5'  5'  10'  ∞

FIGURE 4.19  *These diagrams are similar to those which appear on simple cameras which do not have a total continuous focus range. They indicate the approximate distances the subject will be recorded most sharply. The single feature indicates a sharp focus at about 3½ feet from the camera; the double figure, about 5 feet; three figures, about 10 feet; and the mountain silhouette for more than 10 feet and for landscape pictures.*

tance between the lens and the film. As the subject approaches the camera from infinity, the distance between the lens and the film must be increased to keep the subject in sharp focus. On most small format cameras (35mm cameras) the change in distance is accomplished by using a helical focusing mount. (See Fig. 4.20) With this type of focusing, turning the focusing ring on the lens will screw the lens element away from the film, thereby increasing the distance between the lens and the film. The whole board supporting the lens of a twin-lens reflex camera is moved in and out with a rack and pinion device (Fig. 4.21). This accomplishes the same results as increasing or decreasing the distance between the lens and the film.

The second way to focus the image is by changing the focal length of the lens. The required separation between the lens and the film is different for each focal length lens when the subject is at infinity. As the subject approaches the camera, the focal length of the lens can be changed to accommodate this approach while the separation between the lens and the film remains constant. By decreasing the focal distance required for the lens the subject remains in focus at distances closer than infinity. The focal length of a lens may be altered by increasing or decreasing the separation between the different lens elements. This is referred to as *cell focusing* or *internal focusing*. In earlier designs, the front elements of the lens were moved in and out from the rest of the lens elements with a screw mount. This lens focusing

FIGURE 4.20      Helical focusing lens.

FIGURE 4.21 *Focusing mechanism for a typical twin-lens reflex camera.*

design is still used on some modern inexpensive cameras. Some modern lenses for professional equipment, however, are now being manufactured that change the separation of groups of elements within the lens itself to alter the focal length of the lens. This design is called an internal focusing lens. It has the advantages over conventional helical focusing lenses in being lighter in weight, more compact, and faster to focus.

**FOCUS AS A CREATIVE CONTROL.** As stated earlier, the object of focusing the camera lens is to have the light rays from the subject form a pinpoint of light on the film so that the image is recorded in its sharpest definition. The camera lens, however, can only focus light rays from a subject at one distance at a time, causing objects at varying distances in front of the camera to be recorded as either sharply focused or out of focus. Although this can be a troublesome point, it also can be an advantage to the photographer. The human eye is basically lazy and prefers not to look at unsharp areas. The eye, therefore, is attracted automatically to the sharpest area of the print, where it exerts less effort in distinguishing details. By making the subject the sharpest point and leaving the surrounding areas out of focus, the attention of the viewer is automatically drawn to the area of the scene which the photographer wants emphasized. (See Fig. 4.22)

FIGURE 4.22 *By deliberately manipulating the different planes of focus, the photographer forces the attention of the viewer to the subject of the picture. (Courtesy of Brent Wallace).*

The aperture is the third creative control on the camera. It influences exposure similar to the shutter and is used to help correct lens' faults. The aperture also plays a creative role in image formation. The size of the aperture opening, along with other factors, determines how much of the photographic image is seen in acceptable sharpness.

This acceptable sharpness differs from critical sharpness, since in theory only a single distance in front of the camera can be recorded in its sharpest detail at any one time. But the eye will accept as being in sharp focus an image that is slightly less than sharp. It is this acceptable blur that the aperture helps control.

In the example of the sun's rays being projected by a magnifying lens, it was stated that the rays were projected by the lens in a conical shape which gradually converged to a point and then diverged. If the paper is placed at the point of critical focus, the image of the rays created is the smallest possible point. Positioning the paper closer or farther from the lens than the critical focus distance will produce a circle of light (Fig. 4.23). The circle of light, called a *circle of confusion*, is made up of out-of-focus light rays. The image projected to the film reacts in a similar way. If the film is located at the point of critical focus, the image is at its sharpest point. But if the circles of confusion produced by an out-of-focus image are small enough, the eye cannot distinguish the difference between the small circle and the pinpoint of light. (See Fig. 4.24) The size of the circles of confusion seen as acceptably sharp is not definite but dependent on the size of the final enlargement of the image and on the distance from which it is viewed. Normally the image is considered sharp if the circles of confusion are less than 1/100 in. when the viewing distance is more than 10 in. At this point the eye cannot distinguish

*FIGURE 4.23 The farther the film is moved from the point the light rays are critically focused, the larger the circles of confusion become.*

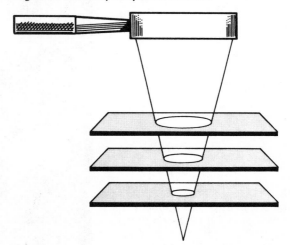

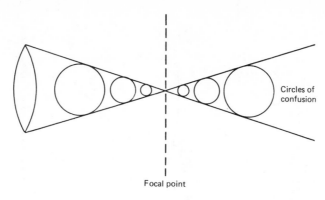

Circles of confusion

Focal point

FIGURE 4.24    The circles of confusion diminish as they
approach the focal point of the lens and expand as they
proceed past the point.

between the points of light and the small circles of confusion. The image
gradually becomes more blurred, however, as the size of the circles of con-
fusion increases.

**DEPTH OF FIELD.**    The acceptably sharp image caused by the circles of
confusion gives the photographer more than one distance in front of the
camera in apparent sharpness at a time. This range of distances which appear
sharp is called the depth of field of the lens, or more commonly, *depth of
field*.

While the points of light reflected from the subjects will still converge
to a point behind the lens at different distances, the size of the circles of
confusion created on the film can be controlled by the size of the aperture
opening. This allows the photographer to control the amount of apparent
sharpness over different distances of the scene.

Light passing through the lens is projected to a point at an angle which
begins at the outer edges of the lens, causing the light rays to converge at a
large angle. This results in fairly large circles of confusion until the light rays
converge to a point. (See Fig. 4.25) When the aperture's diameter is reduced,
however, the light rays which normally form the greater angle are blocked
from passing through the lens by the aperture blades. Only light rays which
conform to the size of the opening of the aperture are allowed to pass, and
these converge to a point at a smaller angle, causing the circles of confusion
to gradually approach the point of focus at less angle than they would with
the larger aperture opening. The point of focus of the light rays does not
change, but the constriction of the aperture causes the circles of confusion
to be reduced in size and appear in focus.

With the aperture the photographer is able to adjust the amount of scene
that is viewed in acceptable focus. The larger the aperture opening, the less
area in front and behind the point of critical focus is in acceptable sharpness.
The smaller the aperture opening, the greater the distance that is in accept-
able sharpness.

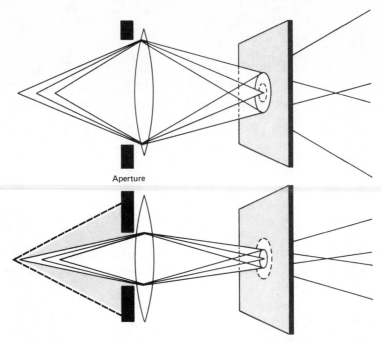

Aperture

FIGURE 4.25 *The broken circle in the top illustration indicates the size of the circle of confusion the eye will see as acceptably sharp. The diameter of the light projected from two points, however, exceeds this acceptable circle and would appear as out-of-focus on the film. With the inclusion of an aperture in the lens, as in the lower illustration, the angle of the light passing through the lens is reduced. The light rays still focus at the same points, but the circles of confusion they produce will be smaller and appear acceptably sharp.*

From a creative viewpoint, the photographer has control of focusing an exact area of the scene. For landscape photography, where both a near and a distant area is needed in acceptable focus, an aperture opening with a smaller diameter is used to increase the depth of field. On the other hand, if elements in the picture are distracting, they can be recorded as out-of-focus blurs by selectively focusing on the subject and then using a large aperture diameter to limit the acceptable sharpness to a shallow distance spread. (See Fig. 4.26)

Although the aperture is the main control in determining the range of acceptable focus, other factors will influence the depth of field of the photograph. These are: (1) the focal length of the lens, and (2) the distance of the subject from the camera.

The closer the subject is to the camera, the greater the angle of the image projected by the lens. The effect on the focus of the image is the same as that of a large aperture opening; the depth of field is decreased. But the farther the subject is from the camera, the greater the depth of field. The use of focal length to control depth of field is similar to the use of distance since focal length, in effect, creates optical distance. A wide-angle lens makes the subject appear farther from the camera, but a telephoto lens decreases the visual distance by optically moving the subject towards the camera. When

(a)

(b)

FIGURE 4.26  *A large aperture opening of f/5.6 was used in (a) to produce a shallow area of sharpness. The subject is recorded sharply against an out-of-focus background and foreground. As the size of the aperture opening was decreased to a setting of f/11 for (b), more of both the foreground and background becomes acceptably sharp. At a small diameter aperture setting of f/16, as in (c), most of the foreground and background become acceptably sharp.*

(c)

(d)

FIGURE 4.26 (d)  *By limiting the areas of acceptable focus the photographer is able to emphasize the subject by isolating it against what would otherwise be a distracting background. (Courtesy of Steve Artman.)*

89

the photographer is using different focal length lenses the following hold true: The shorter the focal length of the lens, the greater is the depth of field. The longer the focal length of the lens, the less the depth of field is at a given aperture setting.

The aperture, distance, and focal length work together to control the amount of acceptable sharpness within the photograph. Control of acceptable sharpness is one of the more important creative considerations. Depth of field provides control over areas in and out of focus. The photographer can control the situation where extreme depth of field is needed to communicate visual impressions or where a shallower depth of field is needed to isolate or emphasize the subject. How much area of acceptable sharpness is necessary for a particular scene is determined by technical and aesthetic considerations.

The amount of acceptable sharpness to be recorded in a scene is indicated in a variety of ways depending on the type of camera being used. The simpler modern cameras have a fixed depth of field which allows the scene to be in acceptable focus from about six feet to infinity. Other camera models are designed with a scale which indicates the amount of acceptable sharpness at different aperture and distance combinations. The depth-of-field scale is located on the lens of some cameras (Fig. 4.27) and on the side of others, such as the twin-lens reflex (Fig. 4.28).

Some single-lens reflex cameras allow the photographer to visually preview the area of focus by depressing a control on the camera which reduces the aperture of the lens to its picture-making size. The control, called a *depth-of-field preview button*, shows the photographer the exact area which will be in focus before the photograph is made. A disadvantage of this system is that the image brightness decreases as the aperture of the lens is *stopped down*. And the smaller the diameter of the aperture becomes, the more difficult it is for the photographer to see the exact amount of acceptable sharp-

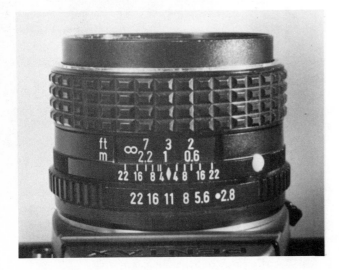

*FIGURE 4.27  Depth-of-field scale located on the lens of the camera.*

FIGURE 4.28  *Depth-of-field scale located on the side of the camera.*

ness the lens is providing. The depth-of-field scales on the lens and sides of the camera are more awkward to use, but for many occasions they will provide an easier indication of the near and far distances which are acceptably sharp.

Making use of the range of acceptable sharpness (depth of field) can also be used to the advantage of the photographer when pictures are being made of fast, erratically moving subjects, such as children, animals, and sporting events. In such situations, not enough time is available to set the aperture and focus the camera between exposures without risk of missing part of the action. The camera can be prefocused, however, to set acceptable sharpness in a predetermined area where the action will take place. This is called *zone focusing*, and it involves the manipulation of the aperture and other influencing factors.

To use zone focusing, the photographer decides on the boundaries which need to be included in the area of acceptable focus. The distances to the nearest and farthest points are calculated next. The easiest way to compute these distances, besides making a guess, is to focus the camera on the nearest point and check the distance on the lens focus scale. The procedure is repeated for the farthest point of focus, and the lens focus is set about a third of the distance into the area that needs to be in focus. Once the point of critical focus is established, the depth-of-field scale, either on the side of the camera or on the lens, gives the aperture setting needed for acceptable focus over the complete range of distances wanted in the focus zone. (See Fig. 4.29)

The point of critical focus is a third into the scene because the ratio of front to back sharpness is 1/3 : 2/3. The depth of field expands more rapidly behind the point of critical focus than it does in front of it. (See Fig. 4.30)

The depth-of-field requirements dictate the needed aperture setting, and then the shutter speed that will give the photographer the correct exposure

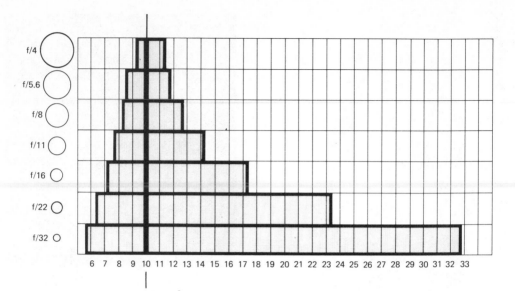

FIGURE 4.29  *The chart shows the effect of different aperture settings on the area of focus with the point of critical focus remaining constant. The size and setting of the aperture is on the left side of the chart; the near and far distances which would appear in focus at each aperture setting is indicated in the shaded portion. This chart is based on the use of an 80 mm focal length lens.*

FIGURE 4.30 (a and b)  *Zone focusing requires that the photographer premeasure or calculate the distances from the camera to the nearest and farthest points where the action will take place.*

(a)                                                    (b)

is selected. The acceptable focus will cover the predetermined area; and when the action is within the boundaries of the lens' depth of field, the photographer only has to trip the shutter to make the picture. The subject and the action may not appear to be in sharp focus through the viewfinder, but the depth of focus will render everything within the zone in acceptable sharpness.

HYPERFOCAL FOCUSING. Hyperfocal focusing produces the maximum depth of field for a given aperture setting. It is used in outdoor scenes where an extreme distance range needs to be kept in acceptable sharpness. The photographer can use it to increase the amount of foreground distance in acceptable focus while still allowing the background to stay in acceptable focus to infinity.

The normal procedure for focusing landscapes is to have the point of critical focus at infinity. A normal lens, however, will record objects closer than about 25 feet out of focus. The hyperfocal technique increases the distance in acceptable focus to about 12 feet. Instead of being critically focused on infinity, the infinity setting is placed opposite the smallest lens aperture depth-of-field marking. Actually the lens is now critically focused closer than infinity, but the depth of field keeps the objects at infinity in acceptable focus. Other areas close to the camera also are now in acceptable focus. The exact distance can be read from the opposite, smallest lens aperture depth-of-field marking.

In recent years, an increasing trend in camera design is to automate the camera functions which control focus and exposure. This automation is a convenience, but thus far it primarily affects only 35mm cameras.

Camera manufacturers began the process by fitting a light meter as an accessory on top of the camera. This meter, which was connected to the camera, measured the amount of light being reflected from the scene and produced exposure readings for setting the aperture and shutter speed. A photoelectric meter was later incorporated into the camera system itself. It measured the light that the scene reflected through the lens and onto the film or the viewing screen. Since the advent of more subminiaturization it is now possible to connect the photoelectric meter with a small computer inside the camera which translates the intensity of light into signals which automatically set the aperture and shutter speed. This setting will produce the correct exposure for the average lighting conditions.

Besides automation of exposure settings, some camera models use infrared, radio waves, or other means to measure the distance of the subject from the camera and set the focus of the lens to that setting. These two functions combined produce a camera which automatically focuses and sets the exposure settings, freeing the photographer to simply compose the scene in the viewfinder and trip the shutter release.

The photographer still has a choice, however, as to which camera design to use, with selections available from manually set cameras, semiautomatic, or fully automatic designs.

The semiautomatic camera allows the photographer several choices as to how the image is recorded. Generally it can be set manually, using a manual over-ride feature, or in a semiautomatic configuration. When the camera is used in its automatic mode, the photographer selects the setting for one of the exposure controls, and the camera automatically produces the correct exposure by adjusting the other control. Semiautomatic cameras usually come in one of two forms: aperture priority or shutter priority.

The aperture priority camera allows the photographer to select and control the aperture setting. The camera will automatically set the shutter speed. The shutter priority system works in an opposite manner with the photographer selecting the shutter speed and the camera automatically adjusting the aperture setting. Each camera system has its advantages and disadvantages. When the photographer is able to control the aperture setting, depth of field recorded on the film is more easily controlled. The shutter priority system allows more critical control over the motion recorded on the film. With both systems, however, the photographer is able to preview the settings the camera will use before the shutter is tripped.

While both the manual and semiautomatic cameras still allow the photographer to retain some technical control over how the image is recorded, the total automatic system does everything from focusing to exposing. This does not mean, however, that the pictures made with this system are less creative.

There are, and probably always will be, arguments between the proponents of each system as to which is best. Those preferring the completely manual system argue that it allows them total control in creating the image. Those who prefer the semiautomatic system contend that partial automation makes the technical aspects of photography much less important and more concentration can, therefore, be placed on artistic expression and visual communication. Photographers who prefer total automation of focus and exposure express a belief that a technical knowledge of camera operations should not be a limiting factor in the expression of visual ideas. Camera automation allows them to interact with the subject more freely, resulting in better composition and a photograph which is more representative of their artistic needs.

## SUMMARY

The camera has three controls which creatively influence how the image is recorded on film. They are shutter, focus, and aperture. Each control interacts with the others to give the desired results, but each has its own primary influence. The shutter controls motion, the focus controls critical sharpness, and the aperture controls depth of field.

The control of motion with the shutter allows the photographer to stop action within the photograph or to let it flow in an expressive blur. The iden-

tity of the subject can be retained by moving the camera in the same direction and with the same speed as the subject. This technique, *pan motion*, produces a sharp subject against a blurred background. *Blur motion*, another motion technique, causes the subject to be blurred and the background to be sharp. The distance of the subject from the camera and its speed influence how the motion will record. Other influencing factors are the angle from which the subject approaches the camera, the focal length of the lens, the shutter speed, and the relationship of the motion to the film plane.

The focus on the camera or lens determines which distance in front of the camera will be recorded in critical sharpness. Since only a single distance in front of the lens is critically sharp at one time, the point of focus determines this area.

The aperture expands the area of focus, however, by causing other distances in front and behind the point of critical focus to be in acceptable focus. This range of distances in acceptable focus is called depth of field. The smaller the diameter of the lens aperture, the greater is the distance in acceptable focus; or stated another way, the depth of field is increased. The larger the aperture, the less is the depth of field. The focal length of the lens and the distance of the subject from the camera also influence the area of acceptable focus.

# 5

# Film Emulsions

The photographic process today is made possible by some materials that are naturally sensitive to light. When they are exposed, a change occurs in their composition, and an image is recorded.

## HISTORY OF MODERN FILM

Knowledge about the materials used in today's film emulsion has been fairly widespread since about 1200 when it was noticed that silver nitrate could be used to darken wood, leather, and feathers. The relationship between the darkening of the silver nitrate and its cause, however, was not discovered until around 1727. Before then, the belief was held that silver nitrate darkened because of a reaction to air or heat. Johann Heinrich Schultze, a German anatomy professor, noticed during an experiment that a solution of chalk, nitric acid, and a small amount of silver became darker on the side facing sunlight. Through experimentation, he found that light, rather than other factors, caused the darkening. It was this discovery which later led to the development of the photographic process.

Not only was Schultze the first person to discover this relationship, but because of his experiments, he became the first to produce an image by photomechanical means.

To prove his theory, he cut stenciled figures and words out of paper and wrapped the paper around a flask containing a silver nitrate solution. After

exposure to light, the open spaces in the stencil were recorded in the mixture as darkened areas.

The experiments performed by Schultze were expanded by Thomas Wedgewood in the late 1700s. In collaboration with Humphry Davy, he explored the idea of recording scenes directly from nature with a camera obscura and sensitized plates. Although these were the same experiments that later would lay the groundwork for the first permanent photographic image, this time they were unsuccessful because they did not expose the sensitized plate long enough to form an image.

One of the main differences between earlier experiments and the present photographic process is in how the image is formed. The earlier process relied on sunlight to completely form the visible image through a physical reduction of the silver nitrate to metallic silver. The modern process uses a chemical reduction which requires much less initial exposure of the film to light. (See Chap. 6)

Disappointed in their attempts to create a camera image, Wedgewood and Davy continued to experiment with the process and succeeded in producing the equivalent of the modern photogram. (See Chap. 11) The images, called silhouettes, were made by laying opaque objects on sensitized paper and exposing the paper and objects to sunlight until an image was formed through physical reduction. Although the process was photomechanical in nature, the image was not permanent. The silver nitrate which had not been reduced to metallic silver by the sunlight continued to react to light each time the image was viewed. The silhouettes could only be seen for a short time by candle light.

The experimenters never found a chemical which would permanently "fix" the image, but they were the first to arrive at the idea of photography and to demonstrate one of its possibilities.

Ironically, the first permanent photographic image was produced by a totally different principle from today's procedure which uses silver salts. The earlier process did not require a fixing agent to make the image permanent.

About 1816, Joseph Nicephore Niepce of Chalon-sur-Saone, France, made an image with a camera obscura and plates sensitized with silver chloride and succeeded in partially fixing it with a weak solution of nitric acid. The chemical eventually bleached out the image, but the photographs could be viewed for a short time in bright sunlight.

The direction of his experiments changed in 1822 when he turned away from the silver process and began using an asphaltic varnish, bitumen of Judea, which he thinly spread on metal plates. Bitumen of Judea struck by enough light became hard, but the unexposed portions remained soft. The soft areas could then be washed away, leaving a very faint positive image. In 1826, Niepce exposed a pewter plate coated with bitumen of Judea in a camera obscura aimed at the rooftops outside his attic window and produced the first permanent photographic camera image (Fig. 5.1). The exposure

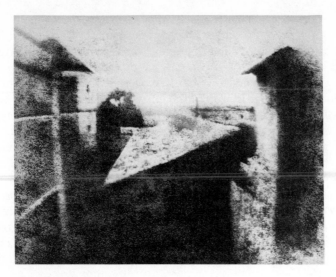

FIGURE 5.1 The View From The Window at Gras by Nicephore Niepce was the first permanent photograph made with a camera. The picture on an 8 × 6-1/2 pewter plate sensitized with bitumen of Judea required an exposure of about 8 hours on a summer day. (Nicephore Niepce: View From The Window at Gras, 1824. Gernsheim Collection, Humanities Research Center, University of Texas at Austin.)

lasted for about eight hours, and the sun seems to be shining on both sides of the courtyard in the photograph. The image was both positive in tone and permanent. Most of the images produced by Niepce were silhouettes, similar to those made by Wedgewood and Davy, except they were permanent.

While Niepce became the *father of photography*, Louis Jacques Mandé Daguerre eventually made photography popular for the masses. The two men were introduced by a lensmaker, Charles Louis Chevalier, because of a mutual need. Niepce believed that the only way to speed up his photographic process was with lenses which allowed more light into the camera. Daguerre had made improvements in the camera obscura which produced a more brilliant image. The two experimenters formed a partnership to develop Niepce's process, but after two years of guarded correspondence and exchange of information, Niepce died before any real progress was made.

Working with the information gained from Niepce, Daguerre discovered the sensitivity of silver iodine to light. With silver-coated copper plates, he attempted to produce camera images by exposing them to iodine fumes. The plates were not sensitive enough to light, however, to produce images with short exposure times. But an accident in 1835 led to a practical solution. The incident, considered one of the classic legends in photography, occurred when Daguerre placed a partially exposed plate into a closet with the intention of refinishing it for later use. When he returned several days later, he found the image fully formed. After a series of exposures and through the process of elimination, he found that fumes from a broken mercury thermometer had reacted with the silver iodide to intensify the exposed image.

This discovery, that an image can be invisibly formed within silver iodide and made visible through chemical development, reduced exposure time to about 20 minutes. The exposure was made for the *latent image* (from the Latin *letere*, be hidden), and then the invisible image was developed chemically during an after-process.

Daguerre prematurely announced that he had successfully fixed the im-

ages of light, but like those of his predecessors, the images would fade with exposure to light. Two years later in 1837, he found that common table salt dissolved in hot water would desensitize the plate and create a permanent image. The *Daguerreotype*, as the process was named by the inventor, was made available to the world on August 9, 1839. Each image was produced in positive form on a silvered plate.

At the same time that Daguerre was working on the direct-positive approach, William Henry Fox Talbot, an English scientist and scholar, was developing a negative-positive method of photography which had a more profound, long-term effect than the Daguerreotype. (See Fig. 5.2)

This process, originally called a *Calotype* and later changed to the *Talbotype*, is the forerunner of the present negative-positive method. But it had an isolated impact on photography in the beginning because of patent restrictions. The Talbotype utilized a paper base coated with silver iodine to record a negative image. After it was developed, the image was soaked in a solution of sodium hyposulfite, a chemical still used and popularly called *hypo*. This chemical caused the image to become permanent. The finished negative image was waxed to make it translucent. The nearly transparent negative image was placed in contact with another sheet of light sensitive paper in bright sunlight to produce the positive image.

With this process, any number of positive reproductions could be made from a single negative image. On the other hand, reproduction and duplication were extremely difficult to achieve with the Daguerreotype, and the highly reflective nature of its polished silver plates made even simple viewing difficult. The Talbot approach removed some of the disadvantages of the

FIGURE 5.2  *The positive-negative era of photography had its beginning with this negative image made on a paper base in 1835. After making the paper base translucent by waxing it, Fox Talbot could make as many reproductions as needed from the same negative. (William Henry Fox Talbot: First Paper Negative, Lacock Abbey, 1835. Courtesy Science Museum, London.)*

Daguerreotype while allowing the photographer to use the same short exposure times. But its silver process and latent image development did not produce the sharp detail evident in the Daguerreotype. The diffusing qualities of the translucent paper produced a slightly unsharp image. (See Fig. 5.3)

The search for the perfect support and for the perfect emulsion continued, and different materials were tried and rejected. The supporting base was changed to glass because of its transparency and then later to celluloid nitrate which provided a dimensionally stable base. However, celluloid nitrate is extremely flammable. This emulsion support was replaced by celluloid acetate, or safety film, in the 1930s. Modern films utilize either a triacetate or a polymer support.

An effective emulsion medium to suspend the light-sensitive silver salts also was difficult to find. Many different materials were tried and abandoned. Albumen (eggs whites) and collodion were two of the most successful emulsion mediums until the invention of the gelatin process by Dr. Richard Maddox in 1871. Maddox, an English physician and amateur photographer, found that the then popular collodion could be replaced by gelatin sensitized with silver bromide. Because of bad health, he published his discovery for others to improve upon. Richard Kennett, an English amateur photographer, began distributing a sensitized gelatin in pellet form in 1873. The pellets were dissolved in hot water and the melted emulsion was spread on a glass plate. This procedure caused an interesting side effect. The heating process, now called *Ostwald ripening*, made the emulsion so sensitive to light that the inspection lights used to monitor the process exposed the emulsion. Kennett decreased its sensitivity, but even then it was still about four times as sensitive to light as the earlier emulsion. An advantage was that it could be stored for long periods of time before and after the exposure without losing sensitivity.

With the invention of the gelatin emulsion *dry plate*, which reduced ex-

FIGURE 5.3  The Calotype or Talbotype was a negative-positive process which produced the print from a paper negative. The texture of the paper on which the negative was made produced a softer image than the Daguerreotype. (William Henry Fox Talbot, Sailing Crafts, 1845. Courtesy Science Museum, London.)

posure times to less than a second, photography truly became instantaneous. Film preparation was taken out of the hands of the individual photographer. Film was mass produced, and the finished product was sold to the photographer. The emulsion preparation started by Maddox is still similar in many respects to the principles used today. The main difference between films of the late 1800s and the present comes from a better understanding of the photographic process and the photochemical reactions involved in image formation.

## ELEMENTS OF PHOTOGRAPHIC FILM

Photographic film is made up of three basic elements: (1) the supporting base, (2) the emulsion medium, and (3) the light-sensitive materials that actually record the photographic image. As we have seen, the support used to carry the emulsion medium and the light-sensitive materials have undergone many changes since the beginning of photography. The early support materials were opaque in nature and the image was difficult to reproduce. China, pewter, and silver-plated copper for the Daguerreotype process were popular, but their shine made viewing difficult.

The Talbotype process used paper to support the photographic emulsion, but it diffused the image during the reproduction stage, resulting in loss of sharpness and details. Paper is still used today as an emulsion support for photographic prints.

The glass that replaced the metal of the Daguerreotype and paper of the Talbotype processes had many of the characteristics considered desirable even by today's standards. The main advantages of glass are in its dimensional stability and chemical inertness. It does not stretch or curl during processing, nor does it react with any of the chemicals used in processing the emulsion. Glass also does not deteriorate with age or in storage, and it has the transparency needed to produce sharp reproductions of the negative image.

Glass does have certain characteristics which make it undesirable as a general support material. Its weight, fragility, and thickness make it troublesome to store and transport. Its inflexibility prevents it from being used in the manufacture of roll films, which are popular today. Because of its advantages, however, glass is still used in specialized areas of photography.

The search for a flexible film support revived the paper negative. But this time the paper support was stripped from the emulsion before the emulsion was printed. The *stripping film* process was patented by Frederick Scott Archer in 1855 but did not become popular until George Eastman introduced its use with the *Kodak* camera in 1888. Film, with an emulsion on a rolled paper base, was placed into the camera. The customer exposed the film and returned the camera, film intact, to Eastman for developing and printing. (See Figs. 5.4 and 5.5)

Celluloid was introduced in 1888 by John Hyatt of the Celluloid Manufacturing Co. of Newark, NJ as a substitute for the glass plate. It was made in

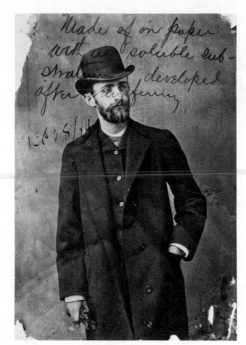

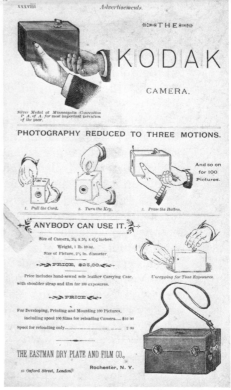

FIGURE 5.4  *This picture by George East-
man with his handwritten note was made
on a light-sensitive emulsion attached to a
paper base. After the image was developed,
the emulsion was stripped from the paper
support and transferred to a glass plate or
gelatin support for printing. (Courtesy of
Eastman Kodak Company.)*

FIGURE 5.5  *The introduction of the
Kodak camera made photography available
to the novice. Loaded with film for 100 ex-
posures, it required only three simple steps
to make the picture. The camera was re-
turned to the manufacturer after all expo-
sures were made. The pictures produced
by this camera were 2-5/8 in. in dia-
meter. (Advertisement courtesy of East-
man Kodak, 1889.)*

sheets 1/100-in. thick and answered the needs of the photographic indus-
try. The celluloid was light and flexible and did not react with the chemicals.
Several months before the company introduced its product, The Rev. Han-
nibal Goodwin of Newark applied for a patent for a transparent roll-film
made of nitro-cellulose and camphor (celluloid). His claim, however, was not
specific enough to satisfy the examiners, and the patent was not granted un-
til September 1898.

During the time that Goodwin's patent was under consideration, the
Eastman Company began marketing a similar nitro-cellulose roll film. It was
patented for Eastman by Henry M. Reichenback in 1889. Goodwin was un-
able to raise sufficient money to begin production of his film until 1900.
Unfortunately, before production began he met with an accident and died.

Anthony of New York, a firm that later became ANSCO and then GAF, acquired the controlling interest in The Goodwin Film and Camera Company which had begun to produce the film in 1902. Anthony sued Eastman Kodak for patent infringement on the grounds that Kodak's manufacture of celluloid film had departed from Reichenback's formula and was being made according to Goodwin's.

After prolonged litigation Kodak settled with the owners of the Goodwin patent for five million dollars. By this time, however, Eastman Kodak had a virtual monopoly on the world's manufacture of roll film.

The modern era of photography began with the transparent roll film. The only changes made in the film support have been the replacement of the highly flammable celluloid nitrate with the safer celluloid acetate in 1930 and the introduction of celluloid triacetate and polymer plastic supports.

Another important physical characteristic of the film is the emulsion medium, the material which keeps the individual light-sensitive crystals separated from each other and in a stationary position.

The perfect emulsion medium is still being sought, but the gelatin selected by Maddox in the 1870s serves better than any other material at present. Scientists are still investigating the use of synthetic polymers as a gelatin replacement, but gelatin still offers the most advantages.

The emulsion medium must meet certain requirements to be effective. It should be able to accept and disperse chemicals rapidly, so that even development and fixation can take place. Gelatin meets this requirement because of its ability to absorb about 100 times its weight in moisture. At the same time, it is not readily soluble at the normal times and temperatures used in processing films and photographic prints. Although gelatin is not influenced by the image-forming chemicals, it does react with the light-sensitive crystals in a beneficial way.

An added advantage for the manufacturer is that gelatin turns into a liquid when heated with hot water. In this form, it is compatible with the manufacturing process. The gelatin can be cooled to a gel, and at normal temperatures it sets to a hard pliable film which is durable under handling. It is also readily available at a reasonable cost and does not decompose with age.

Scientists continue to look for a substitute, however, because gelatin is an animal product and cannot be manufactured synthetically. Since it is a natural product, certain properties of the gelatin will vary from source to source, making it necessary for the manufacturer to practice strict controls over its preparation and use.

On the other hand, some gelatins have the extraordinary ability to increase the light sensitivity of the film. This was first noticed when large scale manufacturing of the emulsion was started in the late 1800s. Manufacturers discovered that they were getting variable results from apparently identical operations. In 1923 Samuel Sheppard discovered that the difference in results was produced by allyl isothicyanate (mustard oil). This chemical causes some batches of gelatin to increase the sensitivity of the image-forming crystals

suspended within the emulsion. This will be discussed later in this chapter.

The final physical characteristic of film is the light-sensitive material used to record the image. The chemical compounds used in the photographic emulsion are *silver halides*, a combination of silver and a member of the *halogen* family. It results in a light-sensitive silver salt which has the capability of recording a latent image with a relatively short exposure to light. The image can be converted to a visible metallic silver with a suitable chemical reducer called a developer.

If the silver halides are given prolonged exposure to light, physical reduction of the silver salt occurs, and the halides become discolored. This visible discoloration was the process used in image formation before the discovery of the latent image development by Daguerre.

The chemical combinations *silver chloride, silver bromide,* and *silver iodide* are the halides commonly used in the manufacture of photographic emulsions. Each of the common halides has a specialized purpose. Silver chloride (AgCl), the least sensitive to light, is used as the sensitizing agent in the preparation of low-light-sensitive photographic printing papers. It also is combined with a second halide, silver bromide, to produce emulsions used for some photographic enlarging papers which produce a brownish-black tone in the reproduction.

Silver bromide (AgBr) is the most common silver halide used in the production of emulsions for both films and papers. It is the main sensitizing compound in all film emulsions and in enlarging papers, many of which bear its name.

Silver iodide (AgI) produces the highest sensitivity to light of the three common halides. But it is used only in small amounts and always in combination with another halide to produce film emulsions with high sensitivity.

## EMULSION PREPARATION

The three physical properties of film are combined by the manufacturer in five stages: (1) precipitation, (2) ripening, (3) washing, (4) digestion, and (5) coating. The procedures of each stage differ depending on the final use of the emulsion and on the formula of an individual manufacturer. In many cases several stages are processed simultaneously.

Precipitation influences the degree of light sensitivity which can be obtained in later stages of the emulsion. Although manufacturers keep their formulas as trade secrets, generally potassium bromide is mixed with a weak solution of gelatin during that first stage. The gelatin holds the potassium bromide in suspension. Silver nitrate is added to this mixture and chemically reacts with the potassium bromide to form the silver bromide halide and potassium nitrate. The latter is a chemical waste, which is removed later.

The sensitivity of the emulsion produced during this stage depends on the speed with which the silver nitrate is added, the amount of gelatin in the potassium bromide and the type of gelatin solution, and other factors and chemicals which affect the solubility of the silver bromide.

If the silver nitrate is added quickly to the potassium bromide and gelatin solution, many small crystals of silver bromide are formed. A slower process results in fewer original crystals, but these act as collection points for the formation of larger crystals within the emulsion. An emulsion with many small silver bromide crystals will have a lower sensitivity and higher contrast than the emulsion which has the larger crystal formations.

A greater gelatin concentration in the original solution also causes larger numbers of smaller silver halide crystals to be formed. The effects of the variations, however, are limited.

The other factors and chemicals which affect the solubility of the silver bromide are the length and speed of the mixing, the temperature of the gelatin solution, and the addition of other chemicals, such as ammonia. Each of these will cause the smaller silver bromide crystals to dissolve and then reform as larger crystals, a process that increases the inherent light sensitivity of the emulsion.

Ostwald ripening, or simply ripening, is the second stage of production; and to a large extent, it determines the degree of sensitivity of the final emulsion. Ripening is heating the solution to a high temperature for a specific length of time. It can be done at the same time as precipitation or separately. The increase in heat causes many of the small crystals to dissolve and attach themselves to larger crystals. The times and temperatures of the ripening stage determine how many of the crystals are dissolved and how large the other crystals are allowed to grow. Thus, the sensitivity of the emulsion is regulated in this manner. This control, as well as others, that the manufacturer has during the precipitation and ripening stages allow the production of emulsions with many different features.

Toward the end of the ripening stage more gelatin is added to the solution. This gelatin differs from the original gelatin in that it contains a predetermined amount of thiocyanates. Their purpose is to increase the sensitivity of the emulsion even further. The complete reaction within the emulsion by this chemical is still not fully understood, but one of the common beliefs is that thiocyanate forms minute sensitivity specks of silver sulfide within the lattice of the silver bromide crystal. These sensitivity specks later aid in the formation of the latent image.

When the ripening stage is completed the emulsion is cooled so that it forms a gel. The gel is shredded into noodles and washed to eliminate the potassium nitrate and other chemical impurities which may have formed. If the emulsion is to be used on an enlarging paper, the washing stage is omitted because the unwanted compounds will be absorbed into the paper support and will not interfere with the image formation or development of the image.

After washing is completed, the emulsion is remelted for the digestion or after-ripening stage. During this time, the crystals do not grow any more, but the silver halides become more sensitive to light because of the chemicals included in the additional gelatin. Besides increasing sensitivity, after-ripening stabilizes the sensitivity of the emulsion. Without this step, sensitivity could vary with time of storage. (See Fig. 5.6)

During the digestion stage, other chemicals are added to harden the emulsion and to change its sensitivity to different wavelengths of light. Dyes, called *optical sensitizers,* are added now to determine exactly to what wavelengths of light the emulsion is sensitive. The first photographic emulsion and the silver bromide crystal are naturally responsive to only the ultraviolet, violet, and blue portions of the spectrum. During the late 1800s, a discovery was made that this sensitivity could be changed with the addition of dyes to the emulsion. The first dyes used in film production extended the sensitivity of the emulsion to include yellow, but practically none in the intervening green portion of the spectrum. Later dye combinations gave the film sensitivity to ultraviolet, violet, blue, green, and yellow. In 1904, pinacyanol, a dye which produced sensitivity in the red portion of the spectrum, was discovered and so film became responsive to the same wavelengths as the human eye.

FIGURE 5.6 *Silver halide grains magnified 10,000X. The larger grains (left) produce greater sensitivity to light, but the smaller, more numerous grains produce greater detail and less granularity in the image. (Courtesy of Eastman Kodak Company.)*

The final stage of the emulsion production is to coat it onto a suitable support or base. Supports used today can be paper, cellulose triacetate, a polymer plastic, or in special cases, glass. The emulsion is coated in layers about 1/1000-in. thick; and in the case of some films, a second coating is applied, one on top of the other. After the initial coatings, a separate layer of pure gelatin is added as a supercoating or dressing to protect the emulsion from abrasion. The gelatin layer causes the emulsion and support to curl towards the gelatin side. To cancel this curling tendency, a separate coating is applied to the back of the film. The layer of gelatin applied to the base side of the support also contains dyes which absorb any light passing through the emulsion during the exposure. Without this absorbing *antihalation backing*, light rays could reflect back through the film to produce a secondary image. The backing is not normally noticed because it becomes decolorized during the processing of the emulsion. After all coatings of the support are completed, the film is chilled, cut into appropriate sizes, boxed, and shipped. (See Fig. 5.7)

*FIGURE 5.7 A typical film emulsion would contain the following layers: (a) a supercoating which serves as an antiabrasion layer to protect the emulsion from scratches, (b) silver halides suspended in a gelatin emulsion, (c) adhesive coating, (d) film base, (e) adhesive layer and, (f) a final coating of gelatin to reduce excessive curling of the film.*

## CHARACTERISTICS OF BLACK-AND-WHITE FILM

Negative materials differ widely in their physical and photographic properties because each is designed for specific purposes. One of the main photographic properties which changes according to film type is the sensitivity of film to light. Emulsion's sensitivity to light also influences physical properties, such as grain size.

Film sensitivity, or speed, is expressed usually in arithmetic or logarithmic form. The arithmetic form expresses the sensitivity in numerical values which are directly proportional to the sensitivity of the film and inversely proportional to the amount of exposure needed for the subject. The most widely used is the *ASA* speed rating. ASA stands for the *American Standards Association*, which is now called the *American National Standards Institute*.

In this system of ratings, a film with an ASA rating of 100 is twice as sensitive to light as a similar film which has an ASA rating of 50. At the same time, it takes half as much light to correctly expose the film with an ASA rating of 100 as it does with the ASA 50 film.

The logarithmic scale most commonly used is the *DIN* (*Deutsche Industrie Norm*). This system is the standard sensitivity guide in Europe. It expresses the sensitivity of the film as logarithmic functions of the actual sensitivity. A film with a DIN rating of 18 would be twice as sensitive to light as one with a DIN rating of 15. For each increase of 3 in DIN number, the sensitivity of the film is doubled (Fig. 5.8).

*ISO* (*International Standards Organization*) speed ratings are a combina-

*FIGURE 5.8   ISO speed scales.*

| Arithmetic | Logarithmic |
|:---|:---|
| 3,200 | $36^\circ$ |
| 2,500 | $35^\circ$ |
| 2,000 | $34^\circ$ |
| 1,600 | $33^\circ$ |
| 1,250 | $32^\circ$ |
| 1,000 | $31^\circ$ |
| 800 | $30^\circ$ |
| 640 | $29^\circ$ |
| 500 | $28^\circ$ |
| 400 | $27^\circ$ |
| 320 | $26^\circ$ |
| 250 | $25^\circ$ |
| 200 | $24^\circ$ |
| 160 | $23^\circ$ |
| 125 | $22^\circ$ |
| 100 | $21^\circ$ |
| 80 | $20^\circ$ |
| 64 | $19^\circ$ |
| 50 | $18^\circ$ |
| 40 | $17^\circ$ |
| 32 | $16^\circ$ |
| 25 | $15^\circ$ |
| 20 | $14^\circ$ |
| 16 | $13^\circ$ |
| 12 | $12^\circ$ |
| 10 | $11^\circ$ |
| 8 | $10^\circ$ |
| 6 | $9^\circ$ |
| 5 | $8^\circ$ |
| 4 | $7^\circ$ |

tion of both the ASA arithmetic designations and the DIN logarithmic designations in a single designation. While most films give both ratings, an effort is being made to standardize the rating system.

The ratings when given on a film package appear like this

|  |
| :---: |
| ISO 125/22° |
| ASA 125/22 DIN |

A direct relationship exists between the sensitivity of the film and the apparent size of the silver grains which make up the final image. As we saw during the discussion on emulsion preparation, the smaller crystals of silver halides are dissolved and then reformed into larger crystals. These larger crystals also clump together. They are able to form more metallic silver during the developmental stage of image formation even when they are exposed to the same amount of light as smaller crystals. Although the individual grains of metallic silver cannot be seen, except under greater magnification than normally achieved in making an enlargement, there is an appearance of grain because the clumps of many smaller grain crystals become visible. (See Fig. 5.9)

Film emulsions with high sensitivity to light are characterized by larger grain particles. The lower the sensitivity, the smaller are the clumps of silver halide crystals in the unexposed emulsion, and the smaller are the clumps of metallic silver during development. As the sensitivity of the film increases, the clumps of silver become more pronounced.

This crystal clumping affects image definition as well. Definition is the impression of clear detail experienced by the viewer. Since all emulsions commonly manufactured promote the clumping of silver halides, those with smaller crystals also have less space between the image-forming silver halides. The closer the crystals are together, the finer the detail can be recorded. Therefore, a fine-grained film (one with small silver halide formations) produces greater detail than a similar emulsion with larger crystal formations.

The sensitivity of the film also affects the contrast of the emulsion. The lower the sensitivity, the higher the contrast is recorded by the emulsion. A film which is highly sensitive to light also produces less contrast within the scene.

The contrast of the film may not be apparent in the finished product because films are developed generally to a uniform contrast range. Since the higher speed film has less contrast, however, it is capable of accepting a larger latitude of over- and under-exposure and still record a useful image.

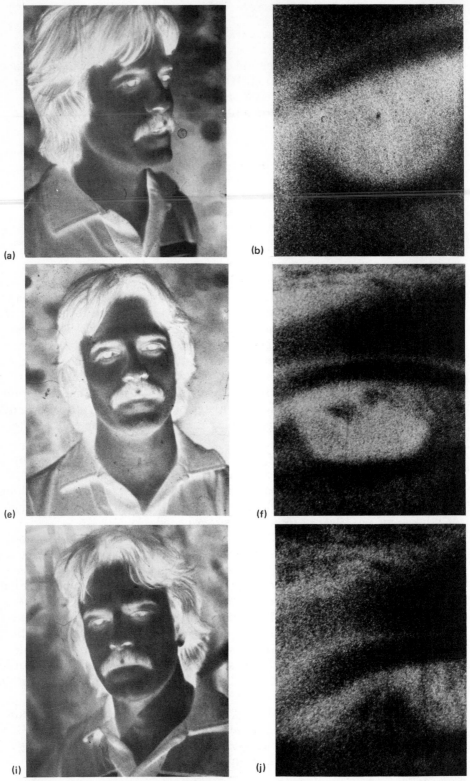

FIGURE 5.9 (a) Panatomic X — 1X enlarge.; (b) Pan X — 26X enlarge.; (c) Pan X — 66X enlarge.; (d) Pan X — 246X enlarge.; (e) Plus X — 1X enlarge.; (f) Plus X — 26X enlarge.;

*(g) Plus X—66X enlarge.; (h) Plus X—246X enlarge.; (i) Tri X—1X enlarge.; (j) Tri X—26X enlarge.; (k) Tri X—66X enlarge.; (l) Tri X—246X enlarge. (Courtesy of JoAnn Frair.)*

The photographic and physical characteristics can be broadly summarized as follows:

Slow-speed films:  sensitivity to about ISO 50/18° ·
                   Low sensitivity to light
                   Extremely fine grain structure
                   Very high definition
                   Little latitude for over- and under-exposures
                   High contrast
                   Accept extremely great degree of enlarging

Medium-speed films:  ISO 125/22°
                     Medium sensitivity to light
                     Fine grain size
                     High definition
                     Moderate latitude for over- and under-exposures
                     Medium contrast
                     Accept great degree of enlarging

High-speed films:  ISO 250/25° to ISO 400/27°
                   High sensitivity to light
                   Moderate grain size
                   Medium definition
                   High latitude for over- and under-exposures
                   Accept moderate degree of enlarging

## SPECIAL-PURPOSE EMULSIONS

Photographic emulsions commonly used are divided into four basic types according to their sensitivities to different portions of the spectrum: (1) orthonon, (2) orthochromatic, (3) panchromatic, and (4) infrared. Their color sensitivity is produced by the addition of different optical sensitizers during the manufacturing stage.

*Orthonon* emulsion is a blue-sensitive emulsion and is seldom used for any type of pictorial work. Since its color sensitivity is in the ultraviolet, violet, and blue portion of the spectrum, it is not suitable for objects where colors need to be reproduced in subjective tones of gray. Greens, yellows, and reds would record much dimmer than they appear to the eye. The orthonon emulsion is available, however, in some films used for copying black-and-white drawings and other black-and-white materials. Although photographic printing paper is not considered film, it is coated with an orthonon emulsion, which allows it and any other orthonon emulsion to be processed under an

amber or a yellow-green safe light. The light is safe for use when processing because the emulsion has little or no sensitivity to the color produced by the light source. (Safe lights are discussed in Chap. 9.)

*Orthochromatic* emulsions have been almost completely replaced in general use by the newer panchromatic film. Orthochromatic emulsion is sensitive to ultraviolet, violet, blue, green, and yellow portions of the spectrum. It is a nonred sensitive emulsion and processing is done under this color safe light. The orthochromatic emulsion is still used in the printing industry for making copies of black-and-white subjects that are to be reproduced by a printing process. (See Fig. 5.10)

*Panchromatic* emulsions are sensitive to the same spectrum of colors

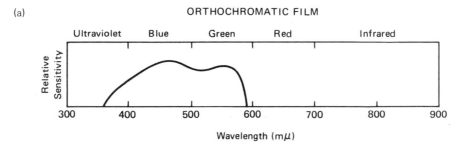

(a)

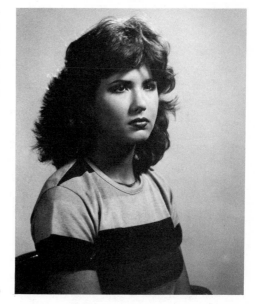

*FIGURE 5.10 (a) The colors recorded by orthochromatic film are in the blue and green wavelengths. Since the emulsion is not sensitive to red, scenes record differently than they are seen with the eye. The red in (b) appears as dark grey tones.*

(b)

which the eye sees but to different degrees. Because it reproduces colors in similar tones as viewed, it is used as a general-purpose emulsion. Panchromatic emulsions normally are processed in total darkness (Fig. 5.11).

*Infrared* emulsions have an extended red sensitivity into the invisible infrared portion of the spectrum. It retains its sensitivity to the ultraviolet, violet, and blue portions of the spectrum, but it lacks sensitivity to yellow and green. Normally, a black-and-white infrared sensitive film is used outside with a red filter which will absorb the blue portions of the visible wavelengths. This causes only the infrared wavelengths to be recorded on film. (See Fig. 5.12)

Other film emulsions provide special features, such as a retouching surface on one or both sides, extreme high sensitivity for low light level photography, high contrast to produce pure black and white without intermediate tones of gray, emulsions which can be reversed to produce a positive black-and-white transparency instead of a negative image, emulsions which are sensitive to x-radiation, and still others that will record the scene in either negative or positive color.

(a)

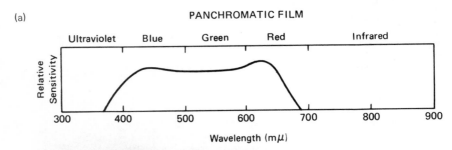

(b)

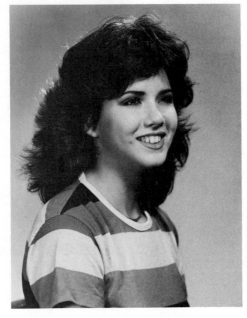

*FIGURE 5.11 (a) Panchromatic film emulsions are sensitive to all three primary wavelengths. (b) A discrepancy in tonality can occur because panchromatic film is more sensitive to the red and blue portions of the visible spectrum and less sensitive to the green portion than the eye.*

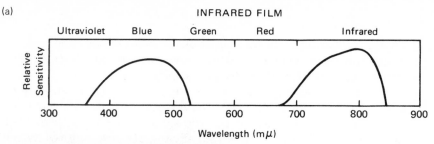

(a)

INFRARED FILM

Ultraviolet    Blue    Green    Red    Infrared

Relative Sensitivity

300    400    500    600    700    800    900

Wavelength (mμ)

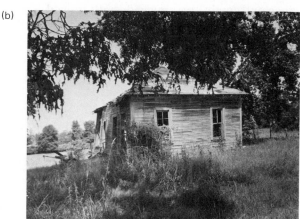

(b)

FIGURE 5.12 (a) Relative sensitivity of infrared film. The way a scene appears to the eye can be altered radically on a photograph with infrared sensitive film. As shown, objects do not always reflect the same proportion of infrared radiation as they do visible light. (b) was made with panchromatic film. (c) was made with black and white infrared sensitive film, and the camera's lens was equipped with a dark red filter.

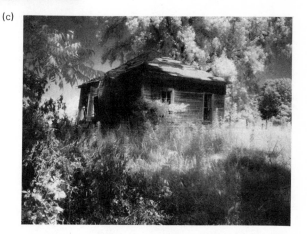

(c)

## SUMMARY

The photographic process is made possible because some silver compounds, called halides, are naturally sensitive to light and have the capability of producing an invisible latent image after exposure to light. Some of the first photographic processes used other materials and compounds, but the most common halides in use today are silver bromide, silver chloride, and silver iodide. Each of these compounds produces different results in the final

115

emulsion. Through the combination of these halides and other factors, the manufacturer is able to produce a wide range of photographic emulsions which exhibit different photographic characteristics.

Some of these characteristics are different light sensitivities, different contrasts, and sensitivities to different portions of the electromagnetic spectrum. Films can be selected to produce a high sensitivity to light at the expense of larger, more pronounced silver grain size and less definition in the final image. Other films produce extremely fine image definitions but have a much lower sensitivity to light. Emulsions, such as the infrared sensitivity films, expand the vision of the photographer to record images outside the normal spectrum of sight.

# 6

# EXPOSURE

Light intensity is one of the essential ingredients in photography. It, above all else, influences the final quality of the photograph. The balance, however, between too much light intensity and the amount required to properly expose the light-sensitive materials, the other ingredients, is delicate.

In the photographic process, light particles strike the silver halides within the emulsion causing a change in its basic structure and forming a latent image. This invisible image is later converted through a chemical procedure into metallic silver which is visible to the eye. The density or opaqueness of the negative image depends in part on the intensity and duration of the light which strikes the silver halides.

The reaction between light and silver halides is still not thoroughly understood. The general belief is that when light particles strike the silver halide crystal, the energy of the light is absorbed by free silver ions within the silver halide crystal lattice causing some silver ions to migrate from their normal position to collection sites. This small exposure produces an invisible image within the silver halide crystals. If the exposure is carried on for a longer period of time under intense light, a physical reduction produces a visible image. In this case chemical reduction is not needed, but much longer exposure is required for physical reduction to occur.

Many earlier photo images were made by the physical reduction of silver halides into metallic silver until Daguerre discovered the formation of the

latent image. (See Chap. 5) The number of silver ions freed in the formation of the latent image determine the amount of metallic silver which is eventually formed during the chemical reduction (development) of the halide crystals. The more light particles that strike the silver halide crystal, the more silver ions are energized out of their normal position. During the development of the image, the ion collection points act like magnets to draw other silver ions freed by the chemical reduction, and this produces small grains of silver. These silver grains, which are clumped together, become the visible image.

Areas on the film emulsion with the most metallic silver take on an opaque appearance. Other areas receiving less exposure to light particles do not form as much metallic silver, and therefore, are more translucent appearing. Each film has an optimum exposure to light to produce the needed translucency or density. More exposure will create a negative which has too much opacity or density; less than optimum exposure produces an excessively transparent image. Need for an optimum exposure makes the control of light a critical step for the photographer.

## FACTORS INFLUENCING EXPOSURE

Four things control or influence optimum exposure. They are: (1) *film sensitivity*, (2) *lens aperture diameter*, (3) *shutter speed*, and (4) *light intensity*. A term used to express a change in any of the four influences is *stop*. It originally referred to an aperture control, a metal plate with a hole in its center. It was inserted into the lens to control or "stop" a portion of the light from passing through the lens. Although this term is no longer used in its original meaning, it has become part of the photographic language to indicate a change, by a factor of two, in any of the exposure controls.

For example, if the light's intensity is doubled, light intensity is increased by one stop. If a film is twice as sensitive as another film, the difference in their light sensitivity is one stop. A shutter speed which has an exposure duration twice as long as another is one stop slower. Increasing the size of the lens' aperture which doubles the amount of light entering the camera is also a one-stop change. A decrease by half also constitutes a one-stop change for any of the exposure factors, since a stop is a change in exposure by a factor of two in either direction.

Each exposure factor also has its own measurement reference numbers. Light sensitivity is measured in lumens or foot candles. Film sensitivity is expressed in ISO, ASA, or DIN ratings. Aperture settings are measured in *f*/stops or *f*/numbers, and shutter speeds are measured in time duration. The individual measurements indicate to the photographer a change in exposure values.

## FILM SPEED RATINGS AND THEIR MEANINGS

As we saw in Chap. 5, the sensitivity of film to light is expressed as the speed of the film. It is indicated by an arithmetic or logarithmic value, usually in the ISO, ASA, or DIN systems. Each system has a different set of numbers that indicate the sensitivity of the film to light, and the relative sensitivity of one film emulsion to another.

The ASA system is a proportional scale. An ASA rating of a film that is twice the number of another film means that the first film is twice as sensitive or one stop more sensitive to light. For example, a film with an ASA rating of 400 is one stop or twice as sensitive to light as an ASA 200 film. Stated differently, the ASA 400 film needs only half as much light to correctly expose it as the ASA 200 film.

An information sheet which indicates the ISO/ASA rating of the film is packaged with the film. (See Fig. 6.1) This information is located also on the film box. A recent trend, at least for color films manufactured by Kodak, is to include the ASA rating as part of the film name: Kodachrome 25 has an ASA rating of 25, Kodacolor 400 is 400, etc.

(a)

*FIGURE 6.1(a)   The information presented on the film box indicates to the photographer: (1) the type of film and its use, (2) how many exposures on the roll of film, (3) color sensitivity of the film, (4) the speed of the film, and (5) the emulsion number and date by which the film should be used.*

(b)

# KODAK TRI-X PAN FILM
## IN ROLLS AND 135 MAGAZINES

**FILM SPEED**
**ASA 400**

This high-speed, fine-grain film with very high sharpness is especially useful for dimly lighted subjects and fast action, for extending the distance range for flash pictures, and for photographing subjects requiring good depth of field and high shutter speeds. Use this film in cameras with adjustable shutter speeds and lens openings.

**Handling:** Load and unload your camera in subdued light. After the last exposure and before opening the camera, rewind 135 film into its magazine.

**DAYLIGHT PICTURES** ● Set your exposure meter or automatic camera at **ASA 400.** If negatives are consistently too light, increase exposure by using a lower film-speed number; if too dark, reduce exposure by using a higher number.

If you don't have a meter or an automatic camera, use the exposures for the appropriate lighting conditions in the table below.

### DAYLIGHT EXPOSURE TABLE FOR KODAK TRI-X PAN FILM

| Shutter Speed 1/500 Second | Shutter Speed 1/250 Second | | | |
|---|---|---|---|---|
| Bright or Hazy Sun on Light Sand or Snow | Bright or Hazy Sun (Distinct Shadows) | Cloudy Bright (No Shadows) | Heavy Overcast | Open Shade† |
| f/22 | f/22* | f/11 | f/8 | f/8 |

*f/11 at 1/250 second for backlighted close-up subjects.
†Subject shaded from the sun but lighted by a large area of sky.

**FLASH PICTURES** ● Blue flash: Determine the f-number for average subjects by dividing the guide number for your reflector and flashbulb by the distance in feet from the flash to your subject. If negatives are consistently too light, increase exposure by using a lower guide number; if too dark, reduce exposure by using a higher guide number.

### GUIDE NUMBERS FOR BLUE FLASH

| Reflector | Flashbulb | X Sync 1/30 | M Synchronization 1/30 | M Synchronization 1/60 | M Synchronization 1/125 | M Synchronization 1/250 |
|---|---|---|---|---|---|---|
| | Flashcube | 180 | 120 | 120 | 100 | 75 |
| | HI-POWER FlashCube | 260 | 170 | 170 | 140 | 110 |
| | AG-1B | 130 | 90 | 90 | 75 | 65 |
| | AG-1B | 180 | 130 | 130 | 110 | 90 |
| | M2B | 170 | NR | NR | NR | NR |
| * | AG-1B | 260 | 180 | 180 | 150 | 130 |
| | M2B | 240 | NR | NR | NR | NR |
| | M3B, 5B, 25B | 260 | 240 | 220 | 180 | 150 |
| | 6B†, 26B† | NR | 260 | 180 | 120 | 85 |
| * | M3B, 5B, 25B | 360 | 340 | 320 | 260 | 220 |
| | 6B†, 26B† | NR | 360 | 260 | 170 | 120 |

*Polished bowl. †Bulbs for focal-plane shutter. NR—Not Recommended.

**WARNING:** Bulbs may shatter when flashed; use flashguard over reflector. Do not use flash in explosive atmosphere. See flashbulb manufacturer's instructions.

**ELECTRONIC FLASH** ● Use this table with electronic flash units rated in beam candlepower seconds (BCPS). To determine the f-number, divide the guide number for your flash unit by the distance in feet from the flash to your subject.

| Output of Unit BCPS | 350 | 500 | 700 | 1000 | 1400 | 2000 | 2800 | 4000 | 5600 | 8000 |
|---|---|---|---|---|---|---|---|---|---|---|
| Guide Number | 85 | 100 | 120 | 140 | 170 | 200 | 240 | 280 | 340 | 400 |

**FILTERS** ● When you use a filter, increase the normal exposure by the factor indicated in the table. However, if your camera has a built-in exposure meter that makes the reading through a filter used over the lens, see your camera manual for instructions on exposure with filters.

| Filter | No. 6 | No. 8 | No. 11 | No. 15 | No. 25 | Polarizing Screen |
|---|---|---|---|---|---|---|
| Daylight | 1.5 | 2* | 4 | 2.5 | 8 | 2.5 |
| Tungsten | 1.5 | 1.5 | 3* | 1.5 | 5 | 2.5 |

*For correct gray-tone rendering of colored objects.

**EXISTING-LIGHT PICTURES** ● If you don't have an exposure meter or automatic camera, try the settings in the table.

| Picture Subject and Lighting | Shutter Speed | Lens Opening |
|---|---|---|
| Home Interiors at Night— | | |
| Areas with Bright Light | 1/30 | f/2.8 |
| Areas with Average Light | 1/30 | f/2 |
| Interiors with Bright Fluorescent Light | 1/60 | f/4 |
| Indoor, Outdoor Christmas Lighting at Night | 1/15* | f/2 |
| Brightly Lighted Street Scenes at Night | 1/60 | f/2.8 |
| Neon Signs, Other Lighted Signs at Night | 1/125 | f/4 |
| Store Windows at Night | 1/60 | f/4 |
| Floodlighted Buildings, Fountains, Monuments | 1/15* | f/2 |
| Fairs, Amusement Parks at Night | 1/30 | f/2.8 |
| Night Football, Baseball, Racetracks | 1/125 | f/2.8 |
| Basketball, Hockey, Bowling | 1/125 | f/2 |
| Stage Shows—Average Lighting (bright lighting 2 stops less) | 1/60 | f/2.8 |
| Circuses—Floodlighted Acts | 1/60 | f/2.8 |
| Ice Shows—Floodlighted Acts | 1/125 | f/2.8 |
| Ice Shows, Circuses—Spotlighted Acts | 1/125 | f/2.8 |
| School—Stage and Auditorium | 1/30 | f/2 |

*Use a camera support for exposure times longer than 1/30 second.

**PROCESSING** ● Take exposed film to photo dealer for developing and printing. To process film yourself, follow these instructions:

**Handle in Total Darkness.** However, when development is half-completed, you can use a safelight at 4 feet from the film for a few seconds. Equip the safelight with a KODAK Safelight Filter No. 3 (dark green) or equivalent, and a 15-watt bulb.

**To open a 135 magazine,** hold it with the long spool end down; use a lid lifter or hook bottle opener to remove the upper end cap.

**Develop** for the times suggested below. If your negatives are consistently too low in contrast, increase development time; if too high in contrast, decrease development time. The most widely used times and temperatures are in heavy type.

### DEVELOPING TIMES IN MINUTES*

| KODAK Packaged Developers | SMALL TANK†—Agitation at 30-Second Intervals 65°F 18°C | 68°F 20°C | 70°F 21°C | 72°F 22°C | 75°F 24°C | LARGE TANK—Agitation at 1-Minute Intervals 65°F 18°C | 68°F 20°C | 70°F 21°C | 72°F 22°C | 75°F 24°C |
|---|---|---|---|---|---|---|---|---|---|---|
| HC-110 (Dilution B) | 8½ | 7½ | 6½ | 6 | 5 | 9½ | 8½ | 8 | 7½ | 6½ |
| D-76 | 9 | 8 | 7½ | 6½ | 6 | 10 | 9 | 8 | 7 | 6 |
| D-76 (1:1) | 11 | 10 | 9½ | 9 | 8 | 13 | 12 | 11 | 10 | 9 |
| MICRODOL-X | 11 | 10 | 9½ | 9 | 8 | 13 | 12 | 11 | 10 | 9 |
| MICRODOL-X (1:3) | – | – | 15 | 14 | 13 | – | – | 17 | 16 | 15 |
| POLYDOL | 8 | 7 | 6½ | 6 | 5 | 9 | 8 | 7½ | 7 | 6 |
| DK-50 (1:1) | 7 | 6 | 5½ | 5 | 4½ | 7½ | 6½ | 6 | 5½ | 5 |
| HC-110 (Dilution A) | 4½ | 3½ | 3¼ | 3 | 2½ | 4½ | 4½ | 4 | 3½ | 3¼ |

**NOTE:** Do not use developers containing silver halide solvents.
*Unsatisfactory uniformity may result with development times shorter than 5 minutes.
†Usually one-quart size or smaller.

**Rinse** in KODAK Indicator Stop Bath or KODAK Stop Bath SB-5, or equivalent at 65 to 75°F (18 to 24°C), for 30 seconds with agitation. You can use a running-water rinse if an acid stop bath is not available.

**Fix** in KODAK Fixer, KODAK Fixing Bath F-5, or equivalent or KODAFIX Solution for 5 to 10 minutes, or KODAK Rapid Fixer for 2 to 4 minutes, at 65 to 75°F (18 to 24°C) with agitation.

**Wash** the film for 20 to 30 minutes in running water at 65 to 75°F (18 to 24°C). To minimize drying marks, treat in KODAK PHOTO-FLO Solution or equivalent after washing, or wipe surfaces carefully with a KODAK Photo Chamois or a soft viscose sponge.

You can use KODAK Hypo Clearing Agent after fixing to reduce washing time and conserve water. First, remove excess hypo by rinsing the film in water for 30 seconds. Then, bathe the film in the KODAK Hypo Clearing Agent solution for 1 to 2 minutes with moderate agitation, and wash it for 5 minutes, using a water flow sufficient to give at least one complete change of water in 5 minutes.

**Note:** Keep temperatures of rinse, fix, and wash close to developer temperature. Dry in a dust-free place.

**MORE INFORMATION.** If you have questions about this film, write to Kodak, Dept. 841B, at the address below. See the many Kodak books for sale by your photo dealer.

**READ THIS NOTICE:** This film will be replaced if defective in manufacture, labeling, or packaging. Except for such replacement, the sale or any subsequent handling of the film is without warranty or liability even though defect, damage, or loss is caused by negligence or other fault.

**Consumer Markets Division** — **Kodak** Rochester, New York 14650

KP¢ 55858k 1-78 — Printed in U.S.A.

KODAK, TRI-X, HC-110, POLYDOL, MICRODOL-X, DK-50, KODAFIX, PHOTO-FLO, and D-76 are trademarks.

---

*FIGURE 6.1(b) Enclosed in most film boxes is an information sheet similar to this which gives the photographer the speed rating of the film, basic exposure settings, and processing information. (Courtesy of Eastman Kodak Company.)*

# CAMERA CONTROLS

Each film needs an optimum amount of light for correct exposure. The intensity of the light reflected from a subject, however, is not constant. Obviously, intensity between a bright sunlight day and the light available in a darkened room are different. Nevertheless, satisfactory exposure of the film can be accomplished in either situation by the manipulation of the camera's controls, the aperture and shutter.

Many inexpensive cameras have preset apertures and shutters which give acceptable exposures only under average lighting and with a limited number of film speeds. The fully adjustable camera, however, provides a wide range of aperture settings and shutter speed durations to regulate the total amount of light striking the film.

The adjustments to the aperture opening are given values, called $f$/stops or $f$/numbers. These $f$/stops are calculated by dividing the focal length of the lens by the diameter of the aperture opening

$$f/ = \frac{\text{Focal length of the lens}}{\text{Aperture diameter}}$$

For example, if the lens' focal length is 3 in. and the diameter of the aperture is 1½ in.

$$f/ = \frac{3}{1.5} = 2 \quad \text{or} \quad f/2$$

Normal $f$/stops follow a logical sequence. It can be easily calculated by remembering the first two $f$/stops, $f$/1 and $f$/1.4. The third number is twice the first, or $f$/2; the fourth is twice $f$/1.4, or $f$/2.8. The same procedure is continued for the remainder of the sequence, with one exception. When $f$/5.6 is doubled it is rounded off to $f$/11. The total sequence looks like this

$$f/1, \ 1.4, \ 2, \ 2.8, \ 4, \ 5.6, \ 8, \ 11, \ 16, \ 22, \ 32$$

The smaller $f$/stops represent larger aperture openings. Therefore, as the number increases, less light is allowed to enter (Fig. 6.2).

Many times the lens will have different $f$/stops than the normal sequence, such as $f$/1.7, $f$/2.5, or $f$/3.5. These figures usually indicate the maximum light admitting ability of the lens. In other words, this is the maximum opening of the lens.

There are still some lenses which do not use the International Series of $f$/stops. Most of these are of an older design and may have aperture openings designated as $f$/11.3, $f$/6.3, $f$/18 or some other unusual numeration. Most of these designations are now obsolete and seldom will the photographer en-

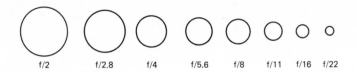

f/2    f/2.8    f/4    f/5.6    f/8    f/11    f/16    f/22

*FIGURE 6.2  Each aperture f/stop represents the size of the aperture opening in comparison to the focal length of the lens. Each full f/stop on the aperture also admits either twice or half the amount of light through the lens as the aperture settings on either side. For example, f/5.6 allows twice as much light as f/8 and half as much light as f/4.*

counter them. If the out-of-sequence number is the first of the series, then it represents the maximum aperture opening of the lens.

The steps between each $f$/stop represents a one-stop increase or decrease in exposure, which is the same as doubling or halving the amount of light passing through the lens. Changing the aperture from $f$/8 to $f$/5.6 increases the exposure by one stop, while a change from $f$/8 to $f$/4 represents a two-stop increase in exposure.

Other terms are used to express exposure settings. The aperture has been *opened up* to a *larger diameter*, for example, when the $f$/stop is changed, such as from $f$/8 to $f$/5.6. Changing the lens aperture opening in the opposite direction *stops down* the lens to a *smaller diameter*.

The shutter also regulates exposure. Whereas the aperture controls light intensity, the shutter regulates exposure duration. The time in which the shutter is open is measured, and like the aperture settings the settings run in a sequence. Although the speeds vary with different cameras, the sequence usually includes the following range: 1 sec, 1/2 sec, 1/4 sec, 1/8 sec, 1/15 sec, 1/30 sec, 1/60 sec, 1/125 sec, 1/250 sec, and 1/500 sec. Some cameras may extend this range to 1/1000 sec and even 1/2000 sec. Most cameras also have a B setting. The B stands for "bulb" and is a carry over from the past when camera shutters were operated by air pressure. The shutter would remain open as long as the bulb was squeezed. The bulb setting on the modern camera operates similarly. The shutter remains open as long as the shutter release is depressed, otherwise it closes. B is used for long exposures, like those needed for night photography.

Another designation on some shutters is a T setting, which stands for time exposure. The T is similar to the B setting, except the shutter stays open until the shutter release is depressed a second time. The main advantage of the T setting is that the shutter will remain open without the photographer having to touch the camera during the exposure, lessening the possibility of camera movement.

Each of the numeric shutter settings represents a doubling or halving of the time in which light is allowed to pass through the shutter. A speed of 1/60 sec is twice as slow as a shutter speed of 1/125 sec. This also represents a one-stop change in light. (See Fig. 6.3)

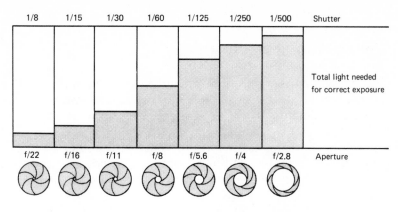

FIGURE 6.3  *These different exposure combinations repre-*
*sent equal total light striking the film.*

## EQUIVALENT EXPOSURES

Adjustments to the aperture and shutter can compensate for changes in either the light's intensity or the film's sensitivity. Depending upon the photographer's creative objective, many aperture and shutter speed combinations can be used to give correct exposure.

If a correct exposure for a scene is $f/8$ at 1/125 sec, the photographer can have equivalent exposure results with any of the following combinations of aperture and shutter speeds

$f/2.8$ at 1/1000 sec
$f/4$ at 1/500 sec
$f/5.6$ at 1/250 sec
$f/8$ at 1/125 sec
$f/11$ at 1/60 sec
$f/16$ at 1/30 sec
$f/22$ at 1/15 sec

All of these exposure combinations are equivalent to one another and will produce the same density on the negative.

When the photographer changes the aperture from $f/8$ to $f/5.6$, the enlarged aperture increases the amount of light striking the film by a factor of two, or by one stop. To compensate for this increase in light, the shutter speed is reduced by one stop by changing the time light is allowed to enter the camera from 1/125 sec to 1/250 sec. The one-stop increase in exposure caused by the aperture setting is canceled by an equivalent decrease in exposure by the shutter.

Equivalent exposures are important because they provide the photographer with a creative license. A faster shutter speed freezes the action. A slower speed allows motion to be recorded as blurs. The change in aperture settings influences depth of field or areas of acceptable focus within a scene. (See Chap. 5)

## DETERMINING CORRECT EXPOSURE

Determining correct exposure presents a problem since no single exposure is correct for all parts of a scene. Film, unlike the eye, cannot make compensating adjustments to different light intensities. It has to record varying amounts of light as a whole.

Setting the camera's exposure controls becomes a critical factor in the photographic process. Although several methods are used to determine the correct settings, only one does not depend upon a mechanical light-measuring device.

## BASIC REFERENCE EXPOSURES

Basic reference exposures utilize visual clues to aid the photographer in determining the aperture and shutter speed settings. Although this system, sometimes called a paper exposure meter, is not as accurate as a photoelectric light meter for calculating exposure settings, it does offer some advantages. (See Fig. 6.4)

For example, if the subject is rapidly moving from one daylight condition to another, or if the lighting conditions are changing, reference exposures are both convenient and speedy to use. The photographer can also use basic reference exposures as a check on the mechanical light meter's performance and accuracy.

The main advantage of this system, however, is that it allows the photographer to comfortably make the pictures with any type of film, under most daylight conditions, and with reasonable accuracy. The reference exposure system works because any change in light intensity, film speed, aperture, or shutter speed can be measured in *stops* of exposure. Each stop is an equal measure of change.

When the basic reference exposures are used, the four exposure variables are paired. Light intensity change is paired and controlled by the aperture; film speed change is paired and controlled by the shutter speeds. Pairing is

| DAYLIGHT EXPOSURE TABLE FOR *PLUS-X PAN FILM* | | | | |
|---|---|---|---|---|
| For average subjects, use f-number below appropriate lighting condition. | | | | |
| Shutter Speed 1/250 Second | Shutter Speed 1/125 Second | | | |
| Bright or Hazy Sun on Light Sand or Snow | Bright or Hazy Sun (Distinct Shadows) | Cloudy Bright (No Shadows) | Heavy Overcast | Open Shade† |
| | | | | |
| f/16 | f/11* | f/8 | f/5.6 | f/5.6 |

*f/8 at 1/125 second for backlighted close-up subjects.
†Subject shaded from the sun but lighted by a large area of sky.

FIGURE 6.4 *Exposure tables included with most films indicate the correct exposure settings under most daylight conditions. (Courtesy of Eastman Kodak Co.)*

done this way because of the similarities between the numeral sequence of the shutter speeds and the film speed ratings. For example, Kodak's Plus X film has an ISO/ASA rating of 125/22°; camera shutters also have a speed of 1/125 sec. Similarly, Kodak's Panatomic X film has an ISO/ASA speed of 32/16°, which is near the shutter speed of 1/30 sec. Because of these numeral similarities, the photographer can easily make a mental substitution of the film's ISO/ASA rating for a shutter speed reference.

When the basic reference exposures are used, different daylight conditions are given aperture settings and the ISO/ASA speed is used as a numeric reference for setting the shutter speed.

### Bright sunlight

### Reference Exposure — *f*/16 at 1/(ISO/ASA rating)

The intensity of bright sunlight is relatively consistent during all seasons and during all times of the day, except in the early morning and late afternoon. Because of this consistency and the ease of recognizing bright sunlight, this lighting condition is used as the standard for the reference exposures.

On a bright sunlight day, nothing obscures or diffuses the sun's light rays, and this produces a contrasty lighting situation with distinct sharp-edged, dark shadows, bright highlights, and a few middle tones (Fig. 6.5).

The range of reflected light intensities are normally too great for the latitude of the film to record with detail. This can cause either the shadow or highlight areas of the scene to record without details. Photographs of people

*FIGURE 6.5 (a) Reference exposure for bright sunlight conditions. (b) The sunlight skimming across the roughness of the wrench further accents its texture. (Courtesy of Brent Wallace.)*

(a)

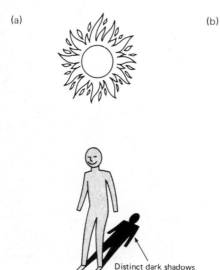

Distinct dark shadows

Bright sun
f/16 @ ASA

(b)

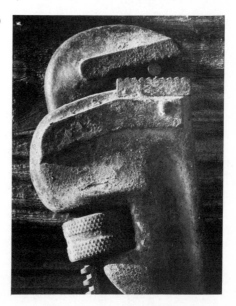

taken close to the camera in this lighting condition are prone to be unflattering because of the deep dark shadows that appear in the eye sockets and under the chin. Also people have a tendancy to squint because of the light's brightness. Although this very bright light intensity is not suited for general portraiture, some subjects are enhanced. Those whose main characteristic is texture are flattered by the contrast of the bright sunlight, especially if the light skims across the surface of the subject. Bright sunlight is suitable also for some landscapes and for pictures of people when the subjects are located at a distance from the camera, or when the photographer uses the light creatively to give a dramatic quality to the photograph.

To make a photograph under this lighting condition, the aperture should be set at $f/16$ and the shutter speed at what is most similar to the numeric value of the ISO/ASA rating of the film. For example, the following exposure settings would be correct for each of the different film speeds

$f/16$ at 1/30 sec (for use with an ISO/ASA 32/16° film)
$f/16$ at 1/125 sec (for use with an ISO/ASA 125/22° film)
$f/16$ at 1/500 sec (for use with an ISO/ASA 400/27° film)

These exposure settings will give approximately the correct negative density under most bright sunlight conditions. The exceptions would be photographs taken on snow, sand, or concrete where more than the normal amount of light would be reflected into the subject. In these situations the exposure should be $f/22$ at 1/(ISO-ASA).

### Hazy sunlight

### Reference exposure $f/11$ at 1/(ISO-ASA rating)

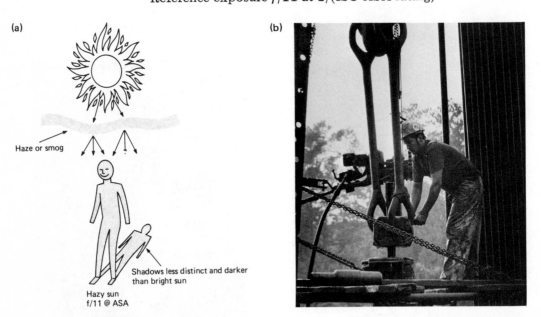

*FIGURE 6.6 (a) Reference exposure for hazy sunlight conditions. (b) Hazy sunlight. (Courtesy of Carter Owen.)*

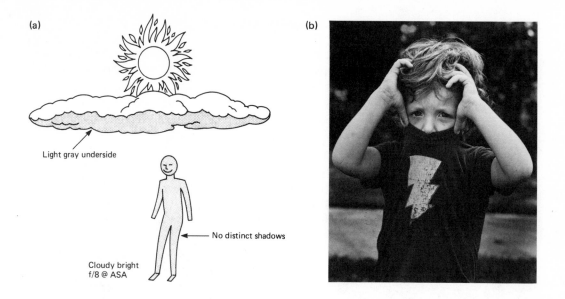

*FIGURE 6.7  (a) Reference exposure for cloudy bright lighting conditions.
(b) Cloudy bright lighting.*

Early morning and late afternoon sunlight conditions are considered hazy. A light overcast of clouds, smoke, or smog also will produce the same light intensity. (See Fig. 6.6) The sun is still visible through intervening material, and shadows are still cast by the subject. The shadows, however, are neither as dark nor as sharp-edged as they are in bright sunlight.

This type of lighting condition is good for general landscapes, textural subjects, and for some dramatic portraitures.

Since the intensity of the light is reduced by the clouds, smoke, or smog, the aperture diameter needs to be enlarged to $f/11$. This admits one stop more light than that required for bright sunlight. The shutter speed remains at 1/(ISO-ASA).

<div align="center">

Cloudy bright sunlight

Reference exposure $f/8$ at 1/(ISO-ASA rating)

</div>

Cloudy bright light, a condition produced by a layer of clouds between the sun and the subject, creates no shadows. But the photographer needs to be aware of the tonality of the cloud layer. Under cloudy bright lighting conditions the bottom of the clouds will be white or light gray. (See Fig. 6.7)

This lighting is almost ideal for outside portrait photography because the contrast range of the light can be recorded on film. It does not cause the subject to squint like bright sunlight. This type of light is good for general photography, landscapes, and for nearly all subjects.

The intensity of light transmitted through the clouds can vary consider-

ably, depending on the thickness of the clouds. The photographer is advised to deliberately over- and underexpose some to ensure a negative which will produce the best quality.

<center>Open shade</center>

<center>Reference exposure $f/8$ at $1/$(ISO-ASA rating)</center>

Open shade produces the same quality of light as cloudy bright sunlight. Photographs of this type are made on a bright sunlight day with the subject standing in the shade of an object without an overhang. This allows light to strike the subject from the top and from two or more sides. (See Fig. 6.8)

(a)

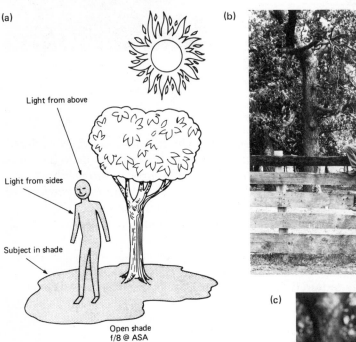

Light from above

Light from sides

Subject in shade

Open shade
f/8 @ ASA

(b)

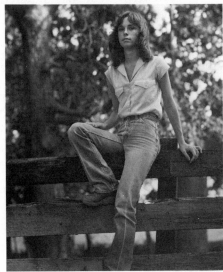

(c)

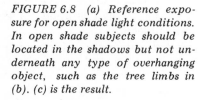

*FIGURE 6.8  (a) Reference exposure for open shade light conditions. In open shade subjects should be located in the shadows but not underneath any type of overhanging object, such as the tree limbs in (b). (c) is the result.*

The quality of light produced by open shade is useful for taking squint-free portraits. It has a nice soft quality and gives full details in the shadows and highlights to produce pleasing portraits.

## Backlight

### Reference exposure f/8 at 1/(ISO-ASA rating)

Backlighting is produced on a bright sunlight day by facing the subject away from the sun. This throws a shadow over the front portions of the subject facing the camera, similar in contrast to open shade and cloudy bright conditions. (See Fig. 6.9)

FIGURE 6.9 (a) Reference exposure for backlight conditions. (b,c) Backlight. (b) The front of the subject is in its own shadow and creates a halo effect around the subject. This type of lighting is used quite often for outdoor portraiture (c) since it produces good separation between the subject and the background.

Backlighting is one of the favorite lighting conditions of the professional photographer for outdoor portraiture. One of the reasons is that it produces a halo effect around the subject. It is also one of the more difficult lighting conditions under which to photograph because of the problems created by the light intensity in the background. If the sky is the background of the picture, light flare will diffuse and degrade the contrast and details of the subject. Backlighted subjects photograph best against a darker background. When that is not possible the photographer can aim the camera down at the subject and use grass or other dark material as the background. (See Fig. 6.10)

The reference exposure is easier to use than a mechanical meter with this type of lighting. The meter can give a false impression of the tonality of the scene much of the time because of the intensity of the background. This will be discussed in more detail later in the chapter.

### Cloudy dark

### Reference Exposure *f*/5.6 at 1/(ISO-ASA rating)

Cloudy dark is a difficult lighting condition to determine visually because of the similarity of its intensity to cloudy bright light. The visual clue is the color of the clouds' underside. Under cloudy dark conditions the bottom side of the obscuring clouds are a dark gray. (See Fig. 6.11)

Photographs made under this lighting condition tend to lack contrast. Subjects with little inherent contrast may take on an overall gray appearance.

### Deep shade

### Reference Exposure *f*/5.6 at 1/(ISO-ASA rating)

Just as open shade produces the same quality and intensity of light as cloudy bright, deep shade produces the same quality and intensity as cloudy

*FIGURE 6.10 One of the problems that can plague the photographer when making pictures of backlit subjects is the flare from bright areas in the background.*

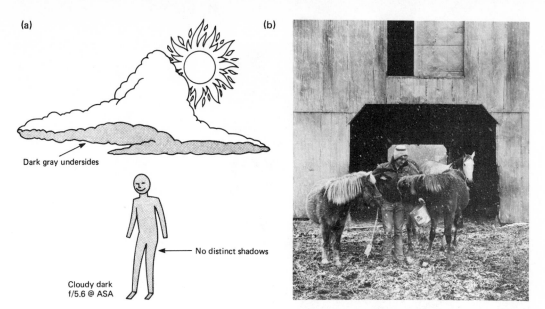

(a)

Dark gray undersides

No distinct shadows

Cloudy dark
f/5.6 @ ASA

(b)

FIGURE 6.11 (a) Reference exposure for cloudy dark light conditions. (b) Cloudy dark lighting. (Courtesy of Ron Harlow.)

dark. The visual clue that distinguishes deep shade is an overhang that keeps light from striking the subject from above. (See Fig. 6.12)

This type of lighting occurs underneath a tree, on a porch, or under an umbrella during a bright sunlight day. As with cloudy dark, the contrast of the scene tends to be flattened out, giving an overall gray appearance to the subject.

FIGURE 6.12 (a) Reference exposure for deep shade lighting conditions. (b) Deep shade.

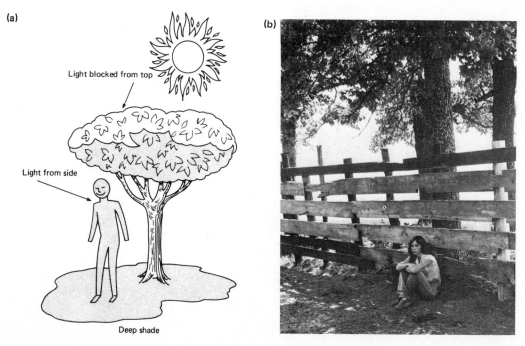

(a)

Light blocked from top

Light from side

Deep shade

(b)

FIGURE 6.12 (c) The lighting con-
trast produced is very low but can
be used to make pleasing soft
portraits.

## LIGHT METERS

Basic reference exposures are both convenient and speedy to use, but a more
accurate means of determining exposure settings is with a *light meter*. A
light meter is a mechanical device that measures light intensity and then
translates the measurement into exposure information.

Light meters come in two basic designs: (1) *incident light meters* (Fig.
6.13), which measure the intensity of the light striking the subject, and (2)
*reflected light meters* (Fig. 6.14), which measure the light being reflected

(a)

(b)

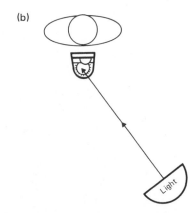

FIGURE 6.13 (a) Incident light
meter. (b) The incident light meter
measures the intensity of the light
striking the subject.

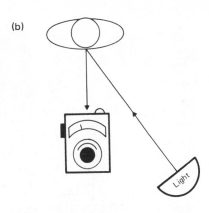

FIGURE 6.14 (a) Reflected light meter. (b) The reflected light meter measures the intensity of the light reflected from the subject.

from the subject. Many meters make provisions for both types of light intensity readings.

The oldest and most common design is the reflected light meter. It can be constructed as part of the camera or separate from it. The independent hand-held meter measures the reflected light from an area about equal to the view seen through a camera with a normal lens, or about a 50° angle of acceptance. A few of them read only a small spot of the scene. This area can be as small as a 1° angle in front of the meter. Although these meters are reflective in nature, they are called spot meters. (See Figs. 6.15 and 6.16)

To use a reflective meter effectively, the photographer must understand what the reading represents and some of the problems which can cause an

(a)

(b)

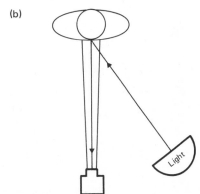

FIGURE 6.15 (a) A Pentax Digital Spotmeter. (b) The spotmeter measures the amount of light being reflected from the subject. Unlike conventional reflected light meters, however, it measures the light from a very small area of the subject, in this case about 1°

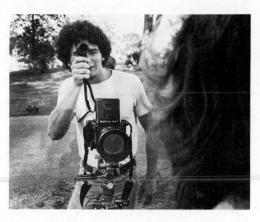

FIGURE 6.16(a) The reading from the spotmeter can be made from any of the conventional positions for a reflected meter. Here the reading is taken from the camera position.

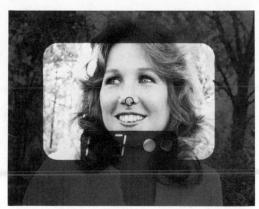

FIGURE 6.16(b) The view the photographer would have of the model from the camera position. The circle in the center of the illustration shows the area of the scene being measured by the meter for its light intensity.

inaccurate reading. The exposure settings given by the light meter represent a translation of the tonal values of the scene into a reproduced tone of medium gray. This gray tone with an 18 percent reflectance value is the standard exposure value.

When the intensity of light being reflected from a white subject is measured, the light meter produces exposure settings which will reproduce a tonality of 18 percent, or medium gray, on the negative. A black subject being struck by the same intensity of light will reflect less, so the light meter will give a different reading. This reading, however, will reproduce the subject on the negative at the same 18 percent gray tonality.

If a reading is taken of light reflected from a medium gray subject, a third exposure setting will be displayed. Like the other two, this reading reproduces the same density and tonality of gray on the negative. All three exposure readings are correct, but only for producing a negative density and tonality of 18 percent gray. (See Fig. 6.17)

(a)

FIGURE 6.17 The tonality reproduced on the negative depends on the area of the scene from which the light is measured. Here the light is measured from the black area of (a), the middle gray area of (b), and the white area of (c). In each case the camera records on film a middle gray tonality of the area from which the meter reading was taken.

**TAKING METER READINGS.** When the reflected light meter in the camera is used or the hand-held meter is used from the camera position, a reading of both the bright and dark areas of the scene are averaged to produce a mid-point exposure between the tones that are brighter and darker than 18 percent gray. If the scene contains an equal amount of light and dark tones, the averaged meter reading will produce exposure settings that match the tonality of the original scene. If areas within the scene are not representative of the overall tones, such as a large area of bright sky, the sun, etc., then the averaged reading will produce exposure settings that, while technically correct, do not reproduce the scene in its correct tonality and density on the negative.

With the averaging exposure system, any scene or subject with predominately light or dark tones will reproduce incorrectly on the negative. (See Fig. 6.18)

*FIGURE 6.18(a) The reflected light meter automatically averages the intensities of light being reflected from the scene. To get an accurate meter reading from the camera position, be careful not to include extremely bright or dark areas within the view of the meter.*

*FIGURE 6.18(b) When the location of the subject and the surrounding lighting conditions do not permit you to eliminate areas which would produce false meter readings, you can make a substitute reading using the back of your hand.*

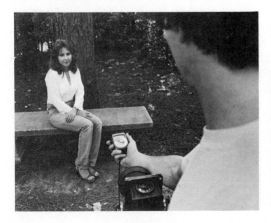

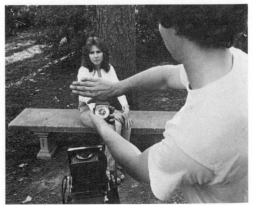

FIGURE 6.18(c) *When possible you should move close to the subject you are photographing and take an isolated measure of the light intensity being reflected from the subject.*

Similar to the average reading is a brightness range reading. To determine exposure settings with this system, individual reflective readings are taken from different parts of the scene, some from the dark areas and others from the bright areas. Once the range of exposure is found, exposure is set midway between the bright and dark readings. This method eliminates some of the problems of the averaging method of exposure. The final averaging is not influenced by the size of the light or dark areas, only by its brightness. This is useful for photographing subjects with an uneven distribution of light and dark areas.

The brightness range reading is used primarily when the exposure and development of the film are adjusted so that the range of tonal values will be recorded on film correctly. Many times the difference between the light and dark areas is too great for the film to record details in both. This contrast can be adjusted during the exposure and development of the film so that the tones are correctly reproduced.

The main disadvantage of this system is that the readings must be taken close to the subject rather than from the camera position. Sometimes the readings cannot be conveniently made.

The third method of taking reflected meter readings is to make a gray card reading. Since the 18 percent gray card is the exposure standard, any reading taken of the card will reproduce correct tonality at the exposure given by the meter. The gray card is placed close to the subject or in the same lighting condition as the subject, and a meter reading is taken of the light it reflects. The camera aperture and shutter speed settings are indicated on the meter. When the photograph is taken at the gray card exposure, all other light intensities are reproduced in their relative tonalities. The gray card reading does not consider the brightness range of the scene nor is it influenced by unequal light distribution. (See Fig. 6.19)

When the photographer does not have a gray card to read, the back of the hand can be used as a substitute. The hand's skin tone, while not medium gray, can be used to calculate exposure. Caucasian skin is one stop brighter on an average than 18 percent gray. Average Black skin reproduces as 18 percent gray. The reading given from white skin needs to be reduced by one stop; the reading from average Black skin is correct for the scene. When the

*FIGURE 6.19 Since a light meter translates the different levels of reflected light into exposure settings that will produce a tonality of middle gray, you can use a medium gray (18 percent reflectance) as the reflecting source instead of the subject. This allows you to make a reflected meter reading from subjects with an uneven distribution of light and dark tones.*

back of the hand is read, it does need to be in the same light condition as the subject.

The incident light meter measures the intensity of the light striking the subject rather than reflected light. Therefore, the readings are not influenced by the different reflectance values of the scene or by the inclusion of light sources in the picture frame.

Light readings with the incident meter can be taken from the camera position if it is in the same light as the subject, or from the subject position with the meter's light gathering sphere aimed at the camera lens. The readings for exposure will be similar to those taken with a reflected meter using the averaging reading technique. (See Fig. 6.20)

Whether the light is read with an incident meter or a reflected meter the photographer should keep in mind that the exposure settings the meter produces are subject to interpretation. The meter is a mechanical device which only does what it is programmed to do. The final decision on exposure of the scene still must be made by the photographer. (See Fig. 6.21)

*FIGURE 6.20 An incident light meter measures the intensity of the light striking the subject from the light source rather than the amount of light reflected from the subject. The reading can be taken from the camera position, as in (a), or from the subject position, as in (b).*

(a)                                                              (b)

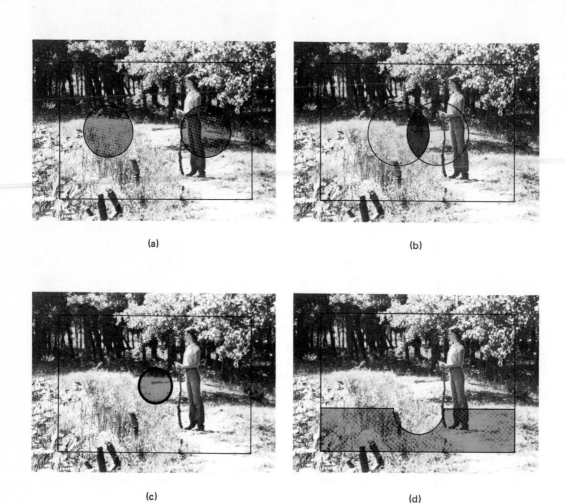

(a)

(b)

(c)

(d)

FIGURE 6.21 (a) One of the most common types of built-in light meters is the averaging meter, which reads the light intensity of the left center and the right center of the scene in equal proportion and then averages the two readings to produce the exposure setting. This meter will give accurate exposure settings if the areas of the reading have equal amounts of light and dark. (b) Unlike the area read by the averaging meter, portions of the picture scene measured by the center-weighted meter overlap. Because of this, the overlapping area of the scene has the greatest influence on the exposure setting since it is, in effect, read twice. (c) The spot meter takes light measurements only from the center of the picture frame, a much smaller area of influence. Although this reading area is a larger area than that measured by a handheld spot meter, it does allow the photographer to isolate the amount of light reflected from the subject. (d) The bottom-weighted meter is designed to measure the light reflected from the lower portions of the scene and to make the exposure calculations from that reading.

**BRACKETED EXPOSURES.** The possibility exists that if the photographer uses basic reference exposures or a light meter to get the camera's exposure settings, the negative will still not be ideally exposed. The reasons vary. It may be that the photographer has aimed the meter at an area of the scene which has an illumination that is not representative of the whole scene, or it may be due to mechanical malfunction.

Even if the correct area of the scene is measured with an accurate reading meter, each camera will produce different exposures because of the lenses and shutters. For example, most between-the-lens shutters open and close more slowly than indicated at their fast shutter speeds. Focal plane shutters have a tendency to be inaccurate at slow shutter speeds. In spite of these discrepancies, exposures are still within correctable ranges for darkroom manipulation.

When several exposure factors are combined, however, the result can be less than ideal. To ensure taking a usuable negative, standard practice is to take the indicated normal exposure and two other exposures. One exposure of the scene is deliberately overexposed, another is set at the indicated exposure, and a third is deliberately underexposed. This is referred to as *bracketed exposures.*

The professional photographer will often use a slight $1/2$-$f$/stop variation to insure perfect exposure. But it is more common to use a larger one-$f$/stop bracket. If the exposure indicated by the meter was $f$/16 at 1/125 sec, for example, this setting would be the basis for the normal exposure. The one-$f$/stop bracket would then appear like this

One-stop overexposure    - $f$/16 at 1/60 sec or $f$/11 at 1/125 sec
Normal exposure           - $f$/16 at 1/125 sec
One-stop underexposure - $f$/16 at 1/250 sec or $f$/22 at 1/125 sec

Unlike the equivalent exposure settings discussed at the beginning of this chapter, the bracketed exposure settings change the total amount of light entering the camera. In the example of one-stop over exposure settings, one of the choices, $f$/16 at 1/60 sec, is the same aperture setting indicated in the normal exposure, but the amount of time the light is allowed to strike the film increases from 1/125 sec to 1/60 sec. The other choice in the overexposure keeps the shutter speed at the same setting as it is for the normal exposure, 1/125 sec, but allows more light into the camera with a larger aperture opening ($f$/16 to $f$/11; one-stop more light).

The same choice of exposure settings would be available in making the underexposure portion of the bracketed exposure. It should be noted that if the photographer is making $1/2$-$f$/stop bracket, the lens aperture is the only control which can be adjusted since shutter speeds cannot be placed between settings. Most camera lenses, however, are designed with 1/2-stop settings.

Bracketing exposures with automatic or semiautomatic cameras may have to be done by changing the film sensitivity setting on the camera's

light meter dial. The ISO/ASA rating of the film on the dial programs the exposure for that sensitivity. To program the meter to give an inaccurate reading, a different sensitivity setting can be used. For example, if the photographer is using a film with a ISO/ASA rating of 125/22° under the same conditions as previously used, the different meter settings would then be in this sequence

| | |
|---|---|
| One-stop overexposure | ISO/ASA 60 |
| Normal exposure | ISO/ASA 125 |
| One-stop underexposure | ISO/ASA 250 |

Many cameras, however, have a setting which makes bracketing exposures more convenient. Most semiautomatic and automatic cameras have dials which allow the photographer to have a +4X (two-stop overexposure), +2X (one-stop overexposure), 1X (normal exposure), and a 1/2X (one-stop underexposure) simply by rotating a dial to the appropriate setting.

While this procedure may seem to be both wasteful and time consuming to the novice, it is a smart way to insure that the scene the photographer wants to preserve is recorded on the film in a usuable manner.

## SUMMARY

Correct exposure is determined by light intensity, film sensitivity, aperture size, and shutter speed. Light intensity is measured in lumens or footcandles; film's sensitivity by ISO, ASA, or other standard designation; aperture settings in $f$/stops or numbers; and shutter speeds in units of time. Each measurement is numerically proportional and changes are commonly expressed in exposure stops, allowing the photographer to pair light intensity to aperture settings and film speed to shutter speeds so that basic reference exposures based on visual clues can be calculated. These basic reference exposures are convenient to use but are not as accurate as a mechanical light meter.

Meters which either measure reflected light intensity or the amount of light striking the subject translate these measurements into exposures which reproduce tones of medium gray. The photographer can use several techniques to measure the intensity of light. The different intensities of the scene can be averaged by measuring different parts of the scene and then averaging the readings from the dark and light areas, or by using a meter that automatically produces an average of the different light intensities, or the photographer can make the measurement from a neutral gray card which matches the tonality the reading represents in the image reproduction.

Each technique has its advantages and disadvantages, and each works best under some conditions. The photographer should be aware, however, that a mechanical light meter gives a reading that does not represent the actual tonality of the subject, but the exposure settings will record the area as a neutral shade of gray.

# COMPOSITION

In its simplest form, composition is an arrangement or grouping of different parts into a unified whole. It is an ordering process which attempts to eliminate confusion by producing clarity. Music, poetry, and written and oral communication are composed. Similarly, the communication value of the visual art forms is enhanced by composition as well.

The musical composer arranges the elements of tone, harmony, and rhythm to achieve a desired response from the listener. Likewise, the photographer uses the elements of sight, such as tone, line, and mass, to produce a desired response from the viewer.

When the photographer aims the camera and trips the shutter, composition has taken place. The process occurs whether the decision was made consciously or unconsciously. The end results, however, can be predicted only when composition is made a conscious part of the photographic process. A photographer who leaves the arrangement of visual elements to chance will occasionally have good composition because of luck, but to repeat good composition successfully becomes difficult.

Photographic composition can be simplified occasionally by some rules of thumb. But the subject cannot be approached with hard and fast rules each time a photograph is made. Depending on individual preferences and objectives, excellent results can be achieved by following guidelines or by deviating from them. Quite often, the beginning photographer falls prey to making any one of several common mistakes in composition.

## COMMON COMPOSITIONAL MISTAKES

One of the more prevalent compositional problems involves treatment of the subject within the composition. Some photographs, such as those which emphasize texture or pattern, do not need an individual subject mass. In these cases, the subject matter is the total pattern and design. Most photographs, however, benefit from having a subject perceived separately from the background. The subject then becomes the focal point of interest in the composition.

Sharing information is the single most important role of the photograph. It is made to satisfy a desire to share with the viewer what has been seen or felt. It communicates some special characteristic of the subject or scene. Unfortunately, many times the intended communication becomes clouded because subject emphasis is lacking. The subject which prompted the photographer to make the picture is either too far from the camera or is lost in the clutter of the background.

This problem can be illustrated with the following example. A photographer starts out to record a simple family portrait. The family (subject) is sitting on the porch. The photographer backs up so that the whole house is visible. In doing so, neighbors' houses on both sides are included in the frame. Although the intention was to make a family portrait, the picture turns out to be a general view of the family's house and neighborhood, which by chance happens to include a family sitting on the porch. This may be an extreme example, but similar communication errors occur because the subject is not emphasized in the photograph.

The subject, in this example, could be made the focal point by simply moving closer to the family or by using a lens focal length that reduces the visual distance between the camera and the subject. The size of the subject increases as a result, giving it emphasis and isolating it from distracting backgrounds (Fig. 7.1). At times, however, isolation from the environment is not

(a)

FIGURE 7.1 (a) Photographs that contain several visual elements will not have a focal point if the photographer is too far from the subject of the picture and shows a general view of the scene. (b) The picture can be improved in interest and composition by moving closer to the subject and isolating a single unit.

(b)

FIGURE 7.2 One way the photographer can make a subject dominant by its size while retaining contributing background information is to move the subject away from the background. This causes the background to become smaller in relationship to the subject.

desired. In those cases, the subject is placed close to the camera, and the neighborhood is used as an unobtrusive, information producing background. While the subject is still the focal point, the background contributes information without competing for attention. (See Fig. 7.2)

Enlarging the size of the subject to make it dominant within the composition is only one of several techniques used. Sharpness, tonality, position, and interest value are other approaches. Regardless of technique used, however, generally only one mass should be considered for the subject of the photograph. A picture with more than one is almost as confusing to the viewer as a photograph without a definite subject. It creates an ambiguity which allows the viewer to choose a subject over the one preferred by the photographer.

## SUBJECT–BACKGROUND RELATIONSHIPS

Vision involves a scanning procedure during which the eye and mind select portions of what is seen to be either the subject or background, depending

on the interest of the viewer. The subject areas are sharply defined. The backgrounds are unfocused. During the process, the relationship of sharp and unsharp areas are in constant change.

Several persons will perceive different areas of a scene in sharp focus, depending on individual interests. When a room is entered, for example, attention of the person is attracted to some objects or persons. When this attraction occurs, the eye and mind focus on the subject and isolate it from the background. This isolation sets up a subject–background relationship. To enhance the relationship, the viewer approaches the subject to isolate it further from the background.

Separation of the subject from the background is necessary also in photography. Without an easily perceptible subject, the viewer is allowed to search for meaning within the total visual frame, which when found, may not correspond to that intended by the photographer. Enhancement of the subject–background relationship creates clearer communication between the photographer and the viewer.

The subject can be enhanced during several stages of the photographic process. Before the image is recorded on film, the photographer can decide on several methods to affect it, involving: (1) film sensitivity, (2) camera position, (3) light conditions, (4) aperture and shutter settings, and (5) moment of exposure. After the image has been recorded on film, it can be controlled during film development and by print manipulations.

Whereas film sensitivity seems on the surface to be only exposure related, it can also serve as subject enhancer. The image on film consists of small clumps of metallic silver. The size of these clumps, while influenced by many factors during the photographic process, determines the film's sensitivity to light. Films with high sensitivity have larger grain structures. The lower the sensitivity, the smaller and more numerous are the individual grains. The smaller and more numerous silver grains are capable of recording finer detail in the subject. A photograph made with low sensitivity film retains more information and, thus, can communicate more. The film's granularity can be compared to a television picture with or without interference. Snowy interference is similar to film with large grain. Information is present, but interference makes it difficult to see. Information contained in the interference-free picture flows more easily to the viewer.

Camera position plays an important role in photographic composition. It determines how the subject is recorded, which portions of the background are recorded, and the relationship of the background to the subject. Through camera placement, background objects can be retained or eliminated. When they are distracting, they can be eliminated by simply moving the camera to the left or right, up or down. (See Fig. 7.3)

Lighting conditions also affect the subject–background relationship. The eye of the viewer is drawn naturally to the lightest area of the photographic image. By placing the subject in the brightest light, the enhanced image be-

FIGURE 7.3 *Background distractions (a) can be removed by a simple change in camera position. In (b) the camera was moved further to the right and to a lower position to isolate the subject and his work. (Courtesy of Betty Baker.)*

comes easier to see, and the background becomes more subdued in comparison to the lighter subject (Fig. 7.4).

The eye has a tendency to rest on the sharpest area of the photograph when other parts are unsharp. By manipulating the aperture and shutter speeds, the photographer can regulate the areas of sharpness within the picture frame. The aperture, which controls depth of field, can limit or extend the sharpness of the scene to a selected distance plane. This allows the photographer to record the background without identifiable features or sharp focus. The shutter speed, which controls motion, can be used to blur the

FIGURE 7.4 *The eye is naturally drawn to the lightest area of the print. The subdued tonality of the background helps to emphasize the focal point of the composition. (Courtesy of Alison Carlson.)*

subject or the background, depending on the camera and subject motion. In either case, the controls allow the subject to be isolated from the background. (See Chap. 4) (See Fig. 7.5)

The final compositional control before the image is recorded on film is in the selection of the exact instant of exposure. The technique is more often apparent in action photography. The sports photographer, for example, must anticipate the exact moment of peak action. Exposures made before or after this peak miss the most intense action of the scene. (See Fig. 7.6)

The moment of exposure reflects the culmination of all the decisions the photographer has made to this point in film selection, camera placement, lighting conditions, aperture, and shutter settings. It determines the body language, position, and expression in portraits, plus the background, light, and sharpness of the subject.

After the exposure has been made, the photographer still has limited control over the final composition of the picture. The developer and developing time can be varied to change, to a limited extent, the contrast of the tones already recorded on film. During the printing of the negative, the photographer can enlarge the image so that some of the outer portions of the

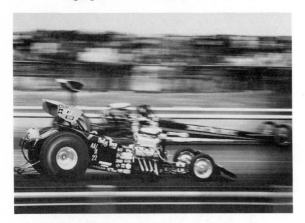

*FIGURE 7.5(left)  Isolating from the background by making it sharp and the surroundings unsharp. Here the camera was panned with the moving subject so that it stayed in the same position in relationship to the film while the background blurred across the film frame. (Courtesy of Wanda K. Watson.)*

*FIGURE 7.6(right)  The moment selected to represent the action of the subject is critical for creating an exciting and informative composition. Capturing the peak of the action results in more interaction between the viewer and the photographer because the viewer is mentally affected by what preceded the action as well as what will naturally follow.*

scene are eliminated from the print. This *cropping* technique can remove distracting elements near the subject. (See Fig. 7.7)

During the printing process, tonal values and contrast can be altered to lighten and darken shadow and highlight areas. (See Fig. 7.8) Photographic images can be created in the darkroom which do not and could not exist in nature in their pictured relationships. These photographic procedures will be discussed in Chap. 16.

(a)

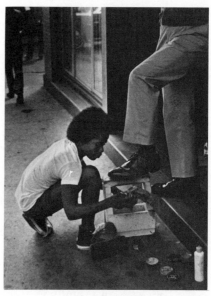

FIGURE 7.7 *Cropping the image in (a) removes distractions from the subject and allows the photographer to place greater emphasis on the focal point of the picture, as in (b). (Courtesy of JoAnn Frair.)*

(b)

FIGURE 7.8 *Selectively darkening and lightening areas of the print can remove visual distractions from the photographic image. Darkening the tree, foreground, and top of the house in (b) places greater emphasis on the porch area. (Courtesy of Steve Saxton.)*

(a)

(b)

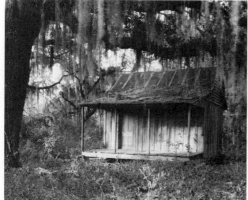

# PERCEPTUAL GROUPING

The subject can be enhanced by the perceptual grouping of different objects in a single visual unit. Perceptual grouping is a psychological phenomenon which involves the mind and the eye. It tends to combine separate objects and occurrences because of their closeness or similar nature.

**PROXIMITY.** Perceptual grouping of visual elements is aided when objects are placed close to each other, either side-by-side or in a front to back relationship. Perceptual grouping can occur also by placing events that take place at different times within the same photograph (temporal proximity).

The physical nature of the photographic print changes the visual relationship of photographed objects. Nature is observed as a three-dimensional form, containing height, width, and depth. The photographic image is two-dimensional, containing only height and width. The depth of the scene in nature is collapsed into a single plane when reproduced photographically.

This results in objects being visually combined with the subject. Combining similar objects can be done intentionally by the photographer. Unfortunately, the beginner may accidentally combine objects with no logical relationship. This produces photographs of people with "tree limb antlers" growing from their heads, or with power lines running in one ear and out the other, two examples of many unlikely combinations which can be caused by the collapse of depth and by perceptual grouping. (See Fig. 7.9)

Visual grouping also occurs for objects located side-by-side. Their lateral spacing creates impressions of either multiple or consolidated subjects. Closer objects are visually connected and attract each other. Farther away, they repel each other and take on the appearance of being separated. As spacing

*FIGURE 7.9(a) A photograph compresses depth into a two-dimensional image which only contains width and height. This compression can cause objects in the background to be photographed as a visual part of the subject in the foreground. In this illustration, the palm trees become extensions of the subjects' heads.*

FIGURE 7.9(b) When a scene is transferred to a photographic reproduction, the third dimension of depth is eliminated. The objects which would normally be perceived by the eye as being in the background are brought to the same plane as those in the foreground.

increases, their separateness increases. In this case, the eye and mind have to decide upon the subject of the photograph. If all other factors are equal, the eye will revolve from object to object because of the ambiguity in the subject–background relationship. To overcome this confusion, the photographer can move the objects closer to each other so that they become united, and perceptual grouping of the objects is enhanced. (See Fig. 7.10)

FIGURE 7.10(a,b) Separation between objects within the picture frame, as in (a), produces the impression of dual subjects, allowing the viewer to make the subject selection rather than the photographer. By removing the space between them, as in (b), the two objects are perceived as a single subject.

(a)

(b)

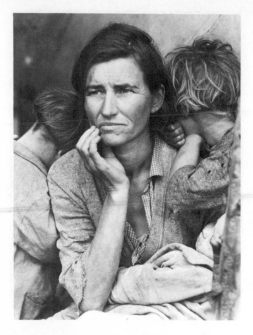

FIGURE 7.10(c) The close proximity of the mother and two children aid in perceptual grouping so that all of the elements are seen as a single unit. Other compositional factors adding to the effectiveness of the illustration are the lines on the mother's hand and arm and the similarity of the children's heads. The mother's face is also the only element shown in its entirety which places further emphasis on it as subject of the picture. (Dorothea Lange: California 1936. Reproduction courtesy Library of Congress.)

FIGURE 7.10(d) Grouping is enhanced in this illustration by the closeness of the father and son, but the son lingering behind is an example of how separated objects can sometimes add to the picture's composition. The lack of proximity of the son gives the viewer the impression that the son is becoming separated from his family, which increases the mood of isolation. (Arthur Rothstein: Farmer and Sons Walking in Dust Storm, Cimarron, Okla., 1936. Reproduction courtesy Library of Congress.)

Temporal grouping of objects and events occur in photographic montages, collages, and multiple exposures. This type of photographic print combines visual images which have been recorded at different places or during different time periods into a single visual image. As a result, the eye and mind group these events into a single unit (Fig. 7.11). It allows the photographer to combine images, which because of size, time, or distance cannot be physically combined but have a natural relationship in the mind of the viewer.

Grouping is a natural occurrence in life as well as in photography. Events in life that occur close together are grouped naturally in the mind to form a pattern. It has been thought that bad luck happens in groups of threes, and that the quality of life is improving when good events occur close together.

(a)

(b)

(c)

(d)

*FIGURE 7.11 Temporal proximity grouping allows the viewer to com-
bine images made at different times into a single unit. In this illustration,
the sequence of events of the plane arriving with a missing wheel (a), pre-
paring for a touchdown (b), balancing on a single landing gear (c), and
finally tipping over into a controlled crash (d) gives the viewer a visual im-
pression of the complete event.*

The psychological nature of these occurrences have been examined by the
Gestalt school of psychology. This has photographic applications, as do other
Gestalt theories.

Visual information is both physiological and psychological in nature. It is
a product of the photographic image and is given added meaning by the
viewer, often larger in scope than what the photographer intended. No two
viewers will add the exact same information to the visual image or respond in
the same way.

SIMILARITY.   Perhaps an even stronger influence on perceptual grouping is
similarity. Objects and events similar in size, shape, position, color, meaning,
and tonality form a repetitive pattern. This pattern occurs in the mind be-

151

cause of a natural tendency to group similar things. Even objects located within the picture frame at dispersed points can form patterns in the mind because of their similarity.

The natural tendency to group similar things can be used by the photographer to create both subject and background. Usually, a break in the rhythmic pattern of similar objects and events can be used to emphasize a dissimilar thing. This isolates the singular subject with greater clarity than it would on a background which does not have a similar pattern. A round object on a background of square shapes, for example, will draw the attention of the viewer. The squares, because of their repetitive nature, become "common." It is the difference or contrast which gains the viewer's interest (Fig. 7.12).

Another example of this type of subject enhancement is illustrated by the way we observe the world around us. A person who travels the same route each day soon fails to notice the surroundings because the pattern is the same. Other persons, too, are not noticed unless they are strangely dressed, or have some other unusual characteristic. When a break in the pattern occurs, interest is stimulated, and differences are noticed.

The same type of visual perception plagues the viewer of the photographic image. Grouping of similar objects occupying a large area tends to

(a)

(b)

FIGURE 7.12 (a) Similarity between the shape of the gear and its shadow allows easy perceptual grouping of the two visual elements. (b) Similarity grouping can be used to create emphasis on the subject by making the subject different from the grouping. In this illustration, the eye is naturally attracted to the single, open mail box because it breaks the repetitive pattern of the closed boxes. (Courtesy of Lisa Vanzant.)

lull the eye and mind. When a break in the pattern is introduced, however, regardless how small and insignificant, the oddity tends to become the subject of the photograph.

This observation holds true as long as the majority of the picture frame can be organized and grouped into a pattern. But when large spaces are dissimilar, and a smaller area has similar traits, then the similarities are grouped into a pattern which is seen as subject. (See Fig. 7.13)

Another form of similarity grouping is created when the photographer uses symbolic associations to produce images in the viewer's mind. The mental pictures are then combined with the visual image to produce a photograph with greater meaning. Not only does the viewer become involved in the creative aspects of image formation, but the meaning supplied by the mental association is directly related to the viewer's past. In this process, the photographer is asking the viewer to make an association based on past experiences and memories and then to combine it with the present image in such a way that it still retains the intended communication. The photographer's symbols must be carefully selected so that they will evoke the wanted response. Otherwise, a discrepancy occurs between what the viewer sees and what the photographer wanted to say. (See Fig. 7.14)

*FIGURE 7.13 The similarity between the large tractor and the smaller toy tractor enhances the perceptual grouping of the different elements within the composition. (Courtesy of JoAnn Frair.)*

*FIGURE 7.14 The combination of the tombstones and the dark smokestacks produces a symbolic association in the mind of the viewer that gives meaning which neither of the two elements would be capable of creating individually. The use of objects which can have similar meaning enhances the communication of the photograph. (Walker Evans, Graveyard at Easton Penn., 1936; Reproduction courtesy Library of Congress.)*

Symbolic associations encourage subject dominance and add meaning to the photographic image. Other factors, such as *line*, *balance*, and *tone*, also influence how a picture is perceived.

Lines serve the purpose of guiding the eye from point to point within the picture frame. They add visible information to the scene, create mood, and sensations of motion and rest. A line does not always have to be visible to be an effective part of the composition. It can be implied by the extension of an arm or the direction of a gaze.

In basic form, lines can be horizontal, vertical, diagonal, zig-zag, or curved. Each produces a different psychological sensation. Within the composition, they are most effective when they are used to support the subject matter within the photograph. Lines suggesting peace and tranquility, for example, would not be effective with subjects involved in a violent and active sport unless the photographer was trying to create mood juxtaposition. Each form of line will support a particular mood.

A composition with horizontal lines has a peaceful, inactive nature. The horizontal line suggests restfulness, inaction, and slow motion. Inactive subject matter, such as landscapes, produce nice compositions when the emphasis is placed on horizontal lines (Fig. 7.15).

Vertical lines suggest stability, permanence, dignity, and movement of the subject. They are used by architects to produce buildings with a permanent look. Figures and other objects can benefit from an emphasis of vertical lines. A judge photographed from a low angle, for example, takes on a more dignified, stable appearance than when the vertical form is reduced by a higher camera angle. (See Fig. 7.16)

Subjects which make use of diagonal lines generate a sense of movement and action. The more diagonal lines are extended to the corners of the picture space, either real or implied, the faster the sense of motion. Motion of

*FIGURE 7.15 The near horizontal lines of this composition emphasizes the peaceful and restful nature of the scene. The darkness of the tonality enhances this mood of stillness. (Courtesy of Beth Hatch.)*

FIGURE 7.16 Vertical lines create a sense of strength and dignity whether the subject is a modern building, as in this high-contrast illustration, or the columns of an antebellum home. The feeling can be further emphasized by using a lower than normal camera position. (Courtesy of Rebecca Johnson.)

moving cars, motorcycles, and other speeding objects increase when diagonal lines become part of the composition. (See Fig. 7.17)

Zig-zag lines are used to express violent action and motion. The mental picture produced by lightning, for example, is forked and erratic movement of energy. In drawings, it is represented by a zig-zag line. Violent actions, such as in football and other sporting events, also produce zig-zag lines as part of the composition. (See Fig. 7.18)

FIGURE 7.17 The diagonal lines in a composition create a feeling of motion. The more nearly the diagonal extends from corner to corner of the print, the faster the motion seems to be.

FIGURE 7.18 Zig-zag lines produce a feeling of rapid, violent motion. The fire escape running down the side of the building gives the impression of a fast route from danger. (Courtesy of Steve Coleman.)

The curved line is the opposite of the zig-zag in that it suggests gentle motion. The photographic composition using the curved line is graceful and peaceful. The soft S curve of a winding road or the gentle curves of a ballerina enhance the feeling of grace and gentle motion. (See Fig. 7.19)

Besides supporting mood, lines can function as a guide within the visual image. Sidewalks, fences, and other objects with real lines catch the eye and guide them, especially if the tone of the line is light. A good example is a sidewalk leading to the front door of a house. Generally, the flow of lines in a composition should enter from the left side of the image to allow the eye to follow it into the subject. If the line exits and enters from the right, the eye may be drawn off the picture area because of the attraction and movement the line causes. The direction the line gives the eye can be controlled to some extent by darkening the tonality of the lines toward the edge of the print. This darkroom printing procedure will be discussed in a later chapter.

Intersecting lines also become a target for action. The eyes are normally drawn to the intersecting points as they are to the circles surrounding a bullseye. Where the lines intersect, the eye expects the focal point of the action to take place (Fig. 7.20).

*FIGURE 7.19  The curved lines of the oak trees are associated with restfulness. To relax the motion of the image even further, the lightness of the fog's tonality creates an airy softness.*

*FIGURE 7.20  When lines of a composition intersect physically, or their continuation would cause an intersection, the viewer expects something of interest to be at the meeting point. By placing the subject of the photograph at this point, there is greater emphasis on the subject. (Courtesy of Marie Hakimzadeh.)*

**BALANCE.**   People have the ability to intuitively perceive the balance points of objects automatically. When an object is seen, the viewing process automatically tries to place the object in balance with its environment regardless of its shape or position. If an object appears to be falling, the mind and eye still attempt to balance it in relationship to its surroundings. The point of balance can be measured accurately with instruments and calculations, but the eye can produce the same degree of accuracy almost instantaneously.

Symmetrical objects are the easiest to balance. They have equal mass and duplicate details on each side of the center point. The face is an example of the few natural objects with near symmetrical characteristics. The nose line is the dividing point between left and right. If the face is aimed directly forward, and the photographer includes equal space on each side of the center line, then the photograph would be symmetrical and also would have *axial* balance. (See Fig. 7.21)

When the eye perceives symmetry, it automatically divides the space into two equal sections, left and right, by invisibly tracing a vertical axis through the center of the image. The axis is called a *felt axis.* For more stability, a secondary invisible line is added to the figure by the eye and mind to form a horizontal base.

A symmetrical figure or composition, therefore, achieves balance and stability with little effort. But little interest is generated by this type of composition. Symmetry offers few visual surprises. It can be compared to a life style with no deviations from day to day or even minute to minute. Such stability may be satisfactory for a few personalities, but for many would produce a boring existence.

Symmetrical compositions lack the dynamic qualities which produce a visual image that has movement within the still visual frame. Symmetry produces rest; dynamic composition provides more viewer interest and movement.

*FIGURE 7.21 Symmetrical compositions tend to have static interest. The picture area can be divided into equal spaces, either vertically or horizontally.*

The dynamics of a composition are influenced by several factors, only one of which is balance. The others (line, mass, and tone) interact to produce a dynamic quality within the total composition.

While symmetry reduces interests in the composition, asymmetry, with an unequal distribution of elements within the visual frame, is one way to increase interest.

A process of counterbalancing, however, is necessary to achieve balance. This process can be illustrated by the way we walk or stand. As long as we stand upright with equal weight on each foot, we are, in effect, symmetrically balanced. As we place more weight on one foot than the other, counterbalancing takes place. The body shifts position of the upper weight in the opposite direction. In the process, symmetrical balance no longer exists, but a form of counter or asymmetrical balance is achieved.

The visual image experiences this type of asymmetrical balancing. Different masses, tones, and other compositional elements produce visual weights which need to be balanced by the photographer. This is done by distributing weight equally within the composition. Dark tones, for example, have more visual weight than light tones; large masses have more weight than small masses. Therefore, a large mass can be counterbalanced by a smaller darker mass.

The different compositional elements which produce visual weight cannot be conveniently separated because they constantly interact with each other to produce the total compositional balance. When the viewer sees the composition, personal involvement and greater interest occur because of this balancing process.

During the viewing process, the eye and mind readily accept axial balance or asymmetrical balance as being a natural state. A third arrangement of visual elements within the composition, however, produces neither type of balance. This arrangement is ambigious in nature. An example of an ambiguous state can be demonstrated with a dot located in a rectangular field. When the dot is in dead center, a state of axial balance exists. If the dot is moved into the upper right-hand quadrant of the field, a state of imbalance is created. But this imbalance can be reconciled in the mind of the viewer. If the dot is moved only slightly from its centered position, however, neither balance nor reconcilable imbalance is apparent. The eye and mind then expend extra energy trying to bring the dot into balance with its environment. (See Fig. 7.22)

Vision is the most direct and efficient of all the senses, and compositions which demonstrate ambiguity are counterproductive. They produce an uncomfortable feeling because the viewer cannot reconcile the compositional balance.

Visual interest creates compositional weight and importance. The amount of visual weight a subject possesses depends on many factors, including the position the subject occupies in relation to the edge of the picture. The eye

(a)                                        (b)

FIGURE 7.22 A balanced composition (a) has equal weights on each side of the point of axial balance and is easy to view. When the weight is distributed unequally, however, so that neither balance nor marked unbalance occurs, as in (b), the composition becomes ambiguous and is undesirable.

is inclined to view a photograph in a natural scanning pattern and spends more time in the lower left portions of the picture frame. The reason for this is debatable. Some people believe that it is caused by learning to read from left to right. Others believe that this preference may be caused by the uneven distribution of blood to the left and right brain lobes. But regardless of the cause, people of Western cultures prefer the subject in the lower left section of the visual frame.

A photographic composition whose subject position conforms to this natural preference and expectation creates minimum stress during the visual process. It creates minimum visual weight and interest because of its conformity. But if the subject is placed directly opposite from the expected position, a situation is created which produces maximum visual stress, interest, and weight in the composition.

The production of stress in a photograph can be compared to tuning a violin string. If the string does not have enough stress (a symmetrical composition), it will not produce the required tones. If it is tightened too much (ambiguity in composition), it will snap and not produce any notes. But when just enough stress is placed on the string (asymmetrical composition), it produces the notes and tonalities that make music possible. The production of compositional stress is similar. The photographer attempts to produce just enough stress so that the composition creates maximum interest without making the viewing of the picture too easy or too difficult.

There is a tendency to simplify concepts as much as possible. The subject of compositional weight and balance is no exception. The *rule of thirds*, for example, is a simplified guide to increasing subject interest by positioning. It is applied by mentally dividing the picture frame into thirds: horizontally, vertically, and in depth. Placing the subject along any of the lines, or at intersecting points increases stress and interest. Maximum interest is achieved by positioning the subject in the upper right quadrant (Fig. 7.23).

FIGURE 7.23 *By positioning the subject of the photograph into the upper right quadrant, maximum stress and interest are created. (Courtesy of Maurine D. Knighton.)*

The rule of thirds produces a photographic composition without symmetrical balance. The position of the lines guide the photographer in placing horizontal ground lines to remove the possibility of symmetrical composition in landscape and seascape photographs.

TONE.  Tone (the light and dark values of the different visual elements) can be used to create mood and interest in the photographic image and can add emphasis to the subject.

A subject whose tones contrast with the surrounding area will stand out from the background. If a light subject is placed against a white background, little tonal contrast is evident. Against a darker background, contrast is increased. The separation which occurs enhances the subject by giving it emphasis.

The eye is attracted to areas of contrast and, in particular, to areas with light tones. If a light area contrasts with a large darker area, the attraction is enhanced. Dark objects can appeal to the eye if they are placed on a light background.

When the photographer is working with a single object against a plain background, subject enhancement can be achieved easily. Often, however, the subject must compete with other objects which have the same tone qualities. This can be corrected in the darkroom, and the printing techniques required will be discussed in Chap. 12.

The tonality of the photograph strongly influences the mood projected by the subject matter. An overall dark tone produces a somber feeling and, in spite of its weight mass, gives the subject a serious quality. (See Fig. 7.24) Photographs which utilize all lightly toned subjects radiate lightness, airiness, and happiness. Subjects with dark tones project masculinity and the light tones are more feminine in appearance.

A light subject in a dark field can take on a dramatic look, as characterized by a spotlight piercing the darkness and striking a subject on a darkened stage. The contrast between light and dark tones also dramatizes texture on wood or other objects. (See Fig. 7.25)

FIGURE 7.24 *The silhouetted mass in the foreground takes on a sinister look because of its contrast to the surrounding light areas. (Courtesy of Anthony Creed Curtis.)*

FIGURE 7.25 *Placing a light subject against a dark background emphasizes the subject-background relationship and gives the subject a more dramatic appearance than it would have against a background of a similar tonality. (Courtesy of Cecil Rimes.)*

Rules that reduce concepts into simple guidelines can be useful to the photographer. But they should be used only as guides. The interaction of all the different compositional elements make hard and fast rules inapplicable in many cases. The beginning photographer must be aware of their limitations and of their influence on the communication of the photographic image. Then, change in compositional form can be accomplished through creative experimentation.

## SUMMARY

Photographic composition is the grouping and arranging of different visual elements into a unified whole. Guidelines for producing "good" composition can be useful to the beginning photographer if they are not followed too rigidly. They can be especially helpful in avoiding common compositional pitfalls.

One of these mistakes is failure to provide a dominant subject within the composition. This can be caused by being too far away from the subject or because the subject and background merge in confusion.

For the photographic image to be effective, a strong subject and background relationship is needed. The photographer can enhance the relationship with the camera and in the darkroom. Before the photograph is made, camera positioning, aperture, and shutter settings can be used to increase the visibility of the subject to the viewer. In the darkroom, the photographer can change the tones of different areas and, by cropping, eliminate outer edges of the image which detract from the subject.

Most compositional guidelines have their base in psychology since sight is both a physiological and mental process. Because of the meld, many theories explored by the Gestalt school of psychology can be applied to photographic composition. Gestalt psychologists have explored concepts of grouping in life events. Perceptual grouping follows the same theories.

Photographic application of these theories allow the photographer to enhance the subject–background relationships within the picture frame and to create photographic communication that will be interpreted by the viewer just as the photographer intended.

Other physiological and psychological factors are involved in photographic composition. Balance, tonality, mass, and line are some of the many influences on how the final photographic composition is perceived.

Balance plays an important role in producing action or dynamics in the composition. Symmetrically balanced compositions are the easiest, but they have little dynamic quality in comparison to the dynamics and interest produced by asymmetrical compositions.

Lines within the composition are used to guide the eye and to support the mood of the subject. Vertical, horizontal, diagonal, curved, and zig-zag lines are the most common forms. Each produces a different mood ranging from rest to violent action, from stability to motion. Tone is also used to create mood. A photograph can be somber or happy, heavy or light, depending upon the tones within the composition.

# 8

# Film Development

The modern photographic process produces both latent and permanent visible images, but the procedures have few similarities to those which recorded the first permanent images. The optical formation of the image is similar to the process Niepce used to produce the first camera image only in that it is projected by the lens onto light-sensitive materials. The difference today is in the materials used. Also, Niepce produced a finished product during the image formation state. The modern process depends on a separate stage.

## HISTORY OF FILM DEVELOPMENT

Early experimenters created photographic images through a direct reaction between sunlight and the light-sensitive silver halides. Schultze, Wedgewood, and Davy each produced photographic images by allowing light to darken and discolor silver nitrate crystals. This produced an image directly on the sensitized material. While Schultze explored only the sensitivity of silver nitrate to light, Wedgewood and Davy made photographic images on paper and leather. Their images, however, continued to react to light and eventually disappeared, as did those of Niepce in his early experimentation with silver halides as the recording medium.

The process of direct image formation similar to that used by Wedgewood and Davy is easily duplicated with modern photographic materials. By exposing a piece of enlarging paper to bright sunlight, the darkening and

discoloration of the silver halides can be observed. If a portion of the paper is covered with a piece of opaque material, that area protected from the light will remain unchanged while the exposed part will discolor. After removing the opaque material, the difference in tonality of the two areas will eventually disappear if the paper is allowed to remain in the light. The silver halides will continue to react to light until the whole sheet of paper is equally dark.

The problem facing early experimenters was to find a way to make the image permanent. Niepce solved it by using a process which did not depend on the sensitivity of silver halides. He used an asphalt substance which hardened during exposure to light and allowed him to wash away the nonhardened areas before they reacted to light.

The problem could have been solved as early as 1819 when Sir John Herschel discovered a chemical that would dissolve silver chloride crystals. He thought it was sodium hyposulfate, but in reality he used sodium thiosulfate. Hypo is still used today as the name for the chemical that makes the photographic image permanent. Use of sodium thiosulfate as an image "fixing" agent did not occur until 1837. It is still the primary chemical used for this function. A second chemical, ammonium thiosulfate, fixes the image more rapidly.

The discovery by Daguerre of the existence of a latent image resulted in a new technique of image formation. It allowed shorter exposure times and chemical development of the image during a separate process. Daguerre used the fumes of mercury to produce the images on the Daguerreotype, but in the earlier stages, like other experimenters, he could not permanently fix the image. Daguerre originally used a solution of sodium chloride (table salt) and water to preserve the image. He later switched to sodium thiosulfate. Daguerre's process has little in common with the production of the negative image and positive print used today except for the chemical used to make the image permanent.

Talbot's invention of the Calotype made use of the negative-positive approach to photography. This process produced a negative image on sensitized paper which was then developed in gallic acid and fixed in sodium chloride. Talbot switched from sodium chloride to sodium thiosulfate and is credited as being the first photographer to use this chemical as a fixing agent. The Rev. J.B. Reade, however, had been using the chemical for the same purpose for several years before this time.

In the early and mid-1800s, several formulas were used. All depended on the physical development of the image rather than the chemical procedure used today. The difference between the two types of developers is in the deposit of the silver salts of the physical developer on the exposed silver halides in the emulsion. The chemical development converts the halides into metallic silver.

Physical developers contain soluble silver salts in an acid solution. They release silver ions which collect around the exposed silver halides in the emul-

sion to form the image. Although this process was used for many years, it produces an emulsion which has a lower effective sensitivity to light than that produced with chemical development.

In 1862, developers were formulated which reduced the exposed silver halides directly into visible metallic silver. They were alkaline in nature rather than acid. In reference to chemical development, it is stated that image development consists of reducing the exposed silver halide crystals into metallic silver. The term "reduction" is used in a chemical context. Chemical reduction takes place when an atom gains one or more electrons. The chemical compound of silver bromide is reduced to metallic silver when the positive charged silver atom gains an electron from the atoms in the developer. When the developer loses the electron, it is said to have been oxidized. All developing agents have the same primary function to reduce the exposed silver halide crystals into metallic silver.

## PHYSICAL ASPECTS OF FILM DEVELOPMENT

The size of the individual grains of silver that make up the film image is established during the manufacture of the film. The graininess of the image, however, can be altered by camera exposure and by the formulation of the developer. The development of the film can influence image sharpness and film speed, as well as control the amount of contrast recorded on the film.

Each film developer contains chemicals that interact with each other to produce a wanted effect. Although there are many types of photographic emulsions, and normally there is a special developer for each emulsion, the chemicals used in the developer have the same general purpose. Basically, each formula contains a reducer which develops the latent image, an alkaline solution accelerator that increases the activity of the reducer, and a preservative which prolongs the life of the chemical. In addition, there is a restrainer used to reduce film "fog," and a solvent. The purpose of the developer is to transform the silver halide crystals which have been exposed to light into metallic silver, while leaving unaffected the silver salts that were not struck by light. Most reducers are not totally effective since they react with the unexposed silver halides, converting some of them into metallic silver. This unwanted silver density is referred to as "fog."

The reducer or developing agent is the portion of the formula which produces the visible image. Approximately nine reducers are used in developers, but the most common are metol (discovered in 1891) and hydroquinone (discovered in 1880). The graininess of the image is controlled by the type of reducer or the proportion of the reducers in the formula. The graininess of the emulsion is increased as the activity of the reducer is heightened.

Increased activity can come from a more active reducer, or by the addition of greater amounts of accelerator to the formula. Some reducing agents eventually would develop an image without the presence of an alkaline accel-

erator, but with it the process takes place in a more reasonable length of time. The accelerator also neutralizes the acid formed during the development process. The formulation of the developer to speed the process can cause an increase in graininess of the film due to the activity of the reducing agent produced by the accelerator.

The preservative, usually sodium sulfite, plays a role in the graininess of the film image. Its main purpose is to retard the oxidation of the chemicals when they come in contact with air, but a high sulfite concentration in the developing formula tends to reduce the graininess of the image by dissolving portions of the silver halides before development.

Not only is the graininess of the image influenced by the composition of the developer, the resolution or accutance of the image is also affected. The ability to see small details clearly is influenced by the solvent action of the developer on the silver crystals, but the contrast in tonality between two adjacent areas becomes important in the resolution of the image. Most of the *high-accutance developers* have a short life but develop the film vigorously to increase the contrast between edges of adjacent areas. The increased activity of the developers adds to the graininess of the image, so most of the time this developer formulation is limited to films which have inherently fine or medium grain structures.

Fine-grain developers, on the other hand, use a high solvent action which, in effect, "feathers" the edges off the grains of silver and produces images of less grain and with less sharpness. Fine-grain developers tend to produce lower contrast than other types.

The amount of development is determined by the difference in densities of the silver formed in the shadow and highlight areas of the film. The ratio is normally referred to as the contrast of the negative. The density of the silver formed in the shadow area is largely dependent on the amount of light the area receives during the original exposure of the negative. The density of the silver formed in the highlight areas, however, is determined by the amount of development the negative receives.

To illustrate how film development can alter the contrast of the image, the following example interrupts the developing procedure at different stages. This example is not completely technically accurate as some exaggerations are used to emphasize the results the photographer can experience.

When the exposed negative is placed in the developer, both the highlight and shadow areas of the film will remain in the chemicals for the same length of time. If the two areas had equal amounts of silver halides exposed in them, they would develop to the same density. But since the shadow portions received less initial exposure to light than the highlight areas, fewer silver halides were exposed to form the latent image in the shadows portion of the negative. As the image is developed, the exposed silver halides in both the shadows and highlights are reduced to metallic silver at approximately the same rate. If the development of the film is interrupted at the time when all

exposed silver halides in the shadow areas have been reduced to metallic silver, an equal amount of silver will be formed in the highlight areas. Further development from this point will not form more silver in the shadows, because no other exposed halides remain to be reduced to silver.

If development is continued past the point that shadow areas are developed, only the highlights would continue to produce metallic silver. Continuing the process would only increase the differences in the densities of the shadow and highlight areas of the negative. That is, the contrast of the negative becomes greater.

Through the development process the photographer can adjust the contrast of the negative so that it will give the optimum print. For example, a scene photographed in bright sunlight contains greater contrast than the same scene on a cloudy day. But the photographer can adjust the developing time to produce the same negative contrast for each scene. If the photographer shortened the developing time of the scene shot under bright sunlight, the contrast would be reduced on the negative. Overdevelopment of the negative would produce greater contrast in the scene photographed under the relatively flat light of a cloudy day. (See Fig. 8.1)

Subject contrast is not the only factor that controls correct development of the negative. Other influences are the type of camera lens and its condition, the type of enlarger on which the print will be made, and the type of photographic enlarging paper which will be used to reproduce the image on the negative. Each of these things along with more subtle influences will determine the amount of over- or underdevelopment which the negative needs to produce on the optimum print.

Exceeding developing limitations, however, can create problems. If the

FIGURE 8.1 *A scene made early in the morning in the fog (b) has less contrast than the same scene during the day (a).*

(a)

(b)

film is developed too briefly, the image can take on a mottled, uneven appearance. Too much development can increase unwanted graininess and can deteriorate the sharpness of the image.

## TYPES OF FILM DEVELOPERS

Many different film developers are on the market and each produces a negative with different characteristics. Their formulas can be roughly divided into three general classifications: (1) fine-grain developers, (2) high-energy developers, and (3) compensating developers. The formulas can have common ingredients, but because of their different proportions, they will produce different results.

Fine-grain film developers produce a negative image which has a minimum apparent graininess. This is accomplished by either reducing the activity of the developing agent (reducer) or by increasing the solvent nature of the formula.

Many factors exert an influence on the final grain structure of the emulsion, but developing agents which vigorously reduce the exposed silver halides into metallic silver also cause the individual grains to dance around in the emulsion and to form aggregates. Less active reducing agents cause less clumping of the silver grains, and thus, less apparent image graininess. They also produce a negative image which has both lower contrast and less effective film speed than a negative developed in a nonfine-grain developer.

Some developers considered to be *fine grain* make use of the fact that both the reducing agent and the preservative, sodium sulfite, will dissolve some of the silver halide structures, and with other chemicals, dissolve portions of the silver granules. Formulas which increase the overall solvent nature of the developer have the effect of reducing the graininess of the image by eroding the sharper edges of the grain clumps so that they become feathered and blend into each other. Although this type of fine-grain developer produces less apparent graininess, it reduces the sharpness of the image and the effective speed of the emulsion.

Most modern fine grain formulas now use a mixture of high- and low-activity developing agents in a moderate alkaline solution to regulate the activity of the reducing agents. The formulas are designed to prevent a noticeable loss in effective film speed, and at the same time, to produce a rate of development which does not encourage clumping of the silver grains. Some formulas, such as Kodak's Microdol X, also produce a slight stain on the negative which improves its contrast characteristics.

In addition to Microdol X, other film developers considered to be fine grained are Ilford's Microphen, Edwald's Super 20, H & W Control 4.5, and Agfa-Gevaert's Atomal. Films processed in most of these developers require extra exposure to compensate for the slight loss in effective film speed during the development process. The photographer should consult the technical data sheets which describe the results with different film combinations.

*High-energy developers* are for general-purpose use and will produce a slightly grainier image than fine-grain developers. The developers in this category produce a compromise between graininess and accutance at a higher effective film speed. They are the working developers used by the majority in the photographic industry. They are the standard used in setting sensitivity ratings. Even within this general group, variations are found in the grain structures, contrast, and effective film speeds.

A general listing of high-energy film developers includes Kodak's D-76 and HC 110, Ilford's ID-11 (which has an identical formula as D-76) and Perceptol, Ethol's UFG, Edwal FG7, and Besseler's Ultrafin FD5.

*Compensating developers* work on the film image in a different manner than the fine-grain or high-energy developers. A compensating developer produces metallic silver in the highlight portions of the negative at a slower rate than it does in the shadow areas. The result of this action is an increase in shadow details without the highlight areas becoming overly dense. Compensating developers produce negatives which have a high accutance and a great tonal range; but if the negative is made with an inferior quality lens, or has motion in the subject, the compensating developer tends to exaggerate the faults.

Most compensating developers increase the effective sensitivity of the film. Typical developers which produce a compensating action are Acufine, Diafine, FR 22, Ethol's TEC, Edwal's Minicol 11, and Agfa-Gevaert's Refinal and Rodinol. These developers will generally produce the greatest sharpness and longest range of tones of the three general classifications.

Other specialized developers do not conveniently fall into the three general categories. Some are claimed to be universal developers, which can be used for developing film or photographic paper. Their activity is controlled by diluting the developing formula to fit a specific need.

Monobath developing formulas incorporate the developing and fixing of the image into a single step. Although many of the earlier monobath developers produced a loss of film speed, image fog, and uneven development, some of the formulas now on the market can yield acceptable results.

The main advantage of the monobath developer is that the image is fixed as it is developed. Time or developing temperature is not a critical factor since the image will only develop to a certain point and then the action ceases. Overdevelopment of the image is not possible. The main disadvantage is that it does not produce the fine grain or sharpness that can be obtained with conventional processes.

## FACTORS AFFECTING FILM DEVELOPMENT

Many factors affect the amount of development required for a negative. The basic condition is that it produces a negative of a required contrast to reproduce the scene in a normal manner during the enlarging procedure. Since the original film exposure controls the density of the negative's shadow area, the

development is used to control the density of the highlight area. *The expo-sure controls density; the development controls the contrast of the negative.* Standard development times published by film and chemical manufacturers assume that the negative will be made and reproduced under "normal" conditions. The recommended times are accurate only for conditions that match the norm set by the manufacturer.

Many factors, however, will alter the conditions from this norm. Some of these are: the contrast of the light under which the subject is photographed, the contrast of the subject; the condition and type of camera lens; the type of film, film developer, enlarger, and enlarging paper; the time, temperature and rate of agitation of the film developer; the condition of the enlarging lens; the developer used to process the print; and the photographer's visual-ization of the reproduced scene.

Influencing contrast factors interact and control the amount of develop-ment needed to produce a negative of optimum quality. Although the pho-tographer is faced with all of the contrast variables, film and papers are designed to make an acceptable print with the standard times under most conditions. The accumulated effect of the different factors, however, can produce a negative which cannot be corrected during the printing process to make an optimum image. An example would be a subject photographed under low contrast lighting with a dirty camera lens. The negative would be processed in a low-contrast film developer and the print made with a diffu-sion enlarger, producing less than normal contrast on the print. In such an extreme case, the negative and print would lack sufficient contrast to pro-duce an optimum image.

Although standard developing times will produce acceptable results under a variety of conditions, they do not compensate for the variables which affect negative contrast. These variables can be corrected, however, in two ways.

One method is to develop the film by inspection. As the image is devel-oping, a visual inspection will determine the amount of further development needed to produce the correct contrast in the negative. A disadvantage, how-ever, is that the film can be seen for only a brief time under a very dim green light. Without experience, judging the needed development time from a brief glance is almost impossible.

The drawback of this method can be overcome with dyes that reduce the sensitivity of the film during the developing process. They allow the photog-rapher to inspect the film for longer periods of time under a brighter light source, but they reduce the overall effective film speed. Thus, the photog-rapher has to compensate for the loss in sensitivity during the exposure of the film.

The second method of correcting contrast variables is to vary the time, temperature, and agitation rate of the developer and film. Standard film development is based on a standard time, temperature, and agitation rate while the film is in the developer. Any one of these can be changed, and a corresponding change in contrast will occur. The most common procedure is

to vary either the time or temperature. Reference charts and computer type dials, such as those distributed by Kodak (Fig. 8.2), allow the photographer to compensate for the variables which affect the contrast of the film. A computer-type dial allows the photographer to adjust the time and temperature combinations so that standard development can be maintained if one or the other varies from the norm. For example, if the temperature of the chemicals is increased, the dial can be used to compute an approximate decrease in developing time to maintain normal development contrast.

Changes in the temperature of the solution or rate of agitation can have other effects on the physical properties of the film and developer. Manufacturers publish figures which allow the photographer to develop film in temperatures ranging from 65 to 75°F (18 to 24°C) if a corresponding change is made in developing time. A variation as little as 1°F from the standard 68°F (20°C) can alter the characteristics of the negative unless a compensating change is made in the time.

Processing the film in temperatures beyond the recommended range can alter the physical properties of the film and developer. If the temperature of the chemicals is too warm they can soften and dissolve the gelatin emulsion of the film. Although the activity of the developer will increase as the temperature of the solution is increased, variations in temperatures can cause a change in the image which cannot be corrected by changes in time.

Most common film developers use two chemicals: metol and hydroquinone. These produce different reactions in the image while converting the silver halides into metallic silver. Metol is a low-contrast developing agent; hydroquinone produces higher contrast images. The developers are formulated so that the proportions of metol and hydroquinone used will produce standard contrast at the published times and temperatures. A change in temperature of the developer can alter its relative activity and result in a change in contrast. For example, if the developing solution is lowered to 50°F (10°C), metol is almost twice as active as the hydroquinone. The result of this change in activity is an image which has lower contrast even if the

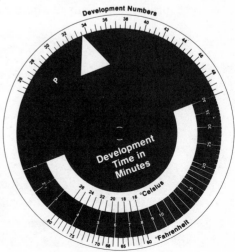

*FIGURE 8.2 This development chart is set for Plus-X film to be developed in Kodak's D–76. Acceptable development times and temperatures are 4 minutes at 76° F, 5 minutes at 71° F, 5½ minutes at 68° F, and 7 minutes at 63° F. (Courtesy of Eastman Kodak Company.)*

developing time is adjusted for the lower temperature. When the temperature is raised to 86°F (30°C), an opposite reaction takes place with the hydroquinone becoming almost twice as active as the metol. This produces a higher contrast in the negative.

When films are processed at temperatures higher than 75°F (24°C), uneven development can take place. Reducing the time of development to compensate for the higher temperatures can prevent even development in the highlight areas of the film.

Temperature changes can affect the physical structure of the film. The recommendation is that each chemical in which the film is placed during processing be of the same temperature. If a great variation of temperatures exists between the developer, rinse, fix, and wash, the film emulsion will expand and contract. This will produce minute cracks, called *reticulation*, in the emulsion. Many times these cracks will go unnoticed until they show up in the enlargement. (See Fig. 8.3) Reticulation was more common with older films which had a softer emulsion, but it still can occur if the temperature varies more than 3° between the chemicals.

Movement of film and developer speeds up the developing action. Development begins as soon as the solution is absorbed into the emulsion. As it reacts with the exposed silver halides, the developer becomes exhausted. Film and developer agitation replaces the exhausted solution so that development can continue. The more vigorous the rate of agitation, the more fresh developer will be in contact with the film and the faster the process will proceed.

Varying the rate of agitation will cause changes in the negative's contrast, but this is not a satisfactory method. Insufficient agitation increases developing time and can produce uneven development where the exhausted solution is not removed. (See Fig. 8.4) On the other hand, if the agitation is too vigorous when spiral developing reels are used, the developer is forced through the film spirals too rapidly causing the edges of the negative to be more developed than the center sections. The direction of movement is important, especially if the film is being developed in spiral reels. A constant

FIGURE 8.3 *The result of reticulation of the negative caused by the film's emulsion being subjected to more than 5° variation in the chemicals.*

(a)

(b)

FIGURE 8.4(a,b) Uneven development of this negative occurred because the film did not receive sufficient agitation to keep a fresh supply of developer in contact with the emulsion.

motion in a single direction results in streaks of uneven development. For this reason, movement of the developer should be varied.

Developing time is the easiest factor to change to compensate for differing contrasts. Many photographers make it a standard practice to automatically increase the developing time by about 25 percent when they photograph subjects under low-contrast situations. Conversely, when the subject is in bright sunlight, developing time is reduced by 25 percent to decrease the contrast of the negative and to give it better printing characteristics. The recommended developing durations are based on the assumption that the photographer is making the picture under normal conditions. They serve only as a guide for calculating the correct time. (See Fig. 8.5)

Timing errors are less apparent in the negative than incorrect agitation and temperature. It is common to have as much as a 5 percent difference in the time two rolls of film are developed without noticing it in the results. Timing is more critical with low-sensitivity films which have a shorter developing period. For example, the recommended duration for Kodak's Panatomic X with a rating of ISO 32/16° is 4¾ minutes. Kodak's Tri-X with a much higher sensitivity of ISO 400/27° is developed for 8 minutes. A 5 percent error would have greater consequences with the shorter period.

For consistent results with the time, temperature, and agitation method of development, the strength of the developer must be stable. This can be accomplished by using the developer once and then discarding it or replenishing the weakened solution with additional chemicals.

Developer replenishers contain a high percentage of the agents of the original developer and a high concentration of alkali to accelerate the process. They do not normally contain all of the original chemicals of the developer.

The combination of exposure and development determines the contrast and density of the negative image. This insert illustrates the results of several combinations.

FIGURE 8.5 *(a) Underexposure—underdevelopment. (b) Normal exposure—underdevelopment. (c) Overexposure—underdevelopment. (d) Underexposure—normal development. (e) Normal exposure—normal development. (f) Overexposure—normal development. (g) Underexposure—overdevelopment. (h) Normal exposure—overdevelopment. (i) Overexposure—overdevelopment.*

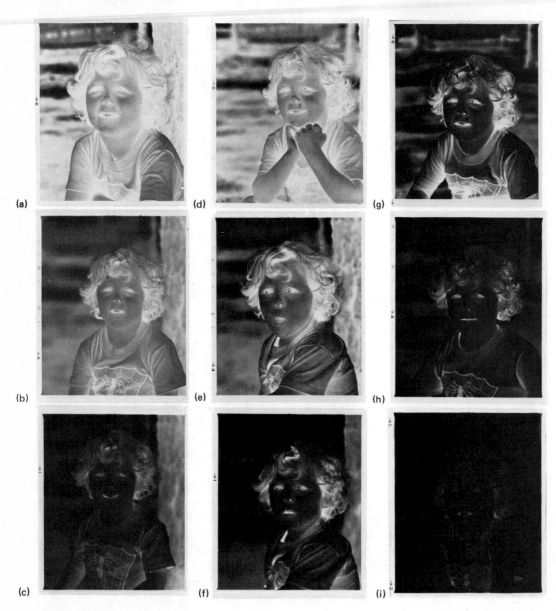

(a)    (d)    (g)

(b)    (e)    (h)

(c)    (f)    (i)

The amount of replenisher to add is calculated by the amount of film which has been developed. For example, Kodak's film developers are replenished at a rate of 3/4 ounces for each 80 square inches of developed film, an amount equal to a roll of 120-size film or a 36-exposure roll of 35mm film. This rate is based on the assumption that the film will contain an equal amount of high and low density areas. The developer is exhausted more rapidly if the negative contains mostly dense areas.

The main advantage of the replenishment system is that it reduced waste by allowing the photographer to use the same chemicals several times and still maintain relatively consistent results. Unless the photographer has access to specialized equipment, however, the developing rate is never quite the same from roll to roll.

Some film developers are designed to be used only once and then discarded, assuring a constant strength. Many standard developers can be used in this manner, but formulas designed for one-shot use have a short life span after they are mixed with water. They will oxidize rapidly and lose strength. The use of a standard formula as a one-shot developer can result in a waste of chemicals unless the photographer uses it in diluted form.

## DEVELOPMENT VARIATIONS

Many developers are designed to be diluted from a concentrated solution to the strength needed to develop the film. Other standard formulas can be diluted. Dilution gives greater shadow detail and resolution of the image than standard strength. The exposure, not the developer, however, is one of the reasons for this. Most films developed in diluted solutions have to be overexposed to compensate for the loss in development. The increased exposure produces greater shadow details. The shorter developing times, in turn, will produce less contrast or density in the highlight areas of the negative. The same basic results could be accomplished by overexposing the film and then underdeveloping the image with the standard developing formula. But often, the time needed to develop the film would be too brief to produce even development of the negative. The less active diluted solution increases the time needed to develop the film so that it compensates for the overexposure. Standard formulas, such as Kodak's D-76, when treated in this manner, are used once and then discarded.

Developing film with a water bath treatment is similar to using a diluted developer. But this technique is more suited for sheet films. The contrast of a scene can be radically reduced with this method. The procedure is to soak the film in the developer and then transfer it to a bath of still water. The developing formula which was absorbed by the emulsion will be rapidly exhausted in the areas of greatest density and will become inactive. It will continue to work in the shadow areas of the film where there are fewer exposed silver halides. Periodically, the film is transferred back to the developer to renew the developing activity of the highlight areas and to replace the ex-

hausted developer with fresh. Then it is returned to the water bath. With this method the contrast of the scene is reduced so that both shadow and highlight details can be reproduced on the photographic print.

Opposite results can be obtained by *pushing the film*. This involves underexposing the film and then compensating for the loss in light during the developing process. *Push processing* results in exaggerated contrast, increased graininess, and loss of image sharpness. Shadow details and exposures are sacrificed so that a faster shutter speed or wider aperture opening can be used to shoot in low light situations. Film pushing usually is better avoided in favor of a developing formula which will yield normal contrast.

By overdeveloping, the sensitivity rating of the film is increased past the manufacturer's recommendation. Several developing formulas will produce a higher rating, but their use is not considered to be pushing the film. For example, Kodak's Tri-X is rated by the manufacturer at ISO 400/27°. When the film is developed in a recommended developer, such as Kodak's D-76, this rating produces the correct shadow details, and the developer produces the correct highlight density for a normal contrast negative. But when the film is developed in Acufine film developer, the recommended rating of the film is ISO 1200/32°. Using ēthol Blue, the developer manufacturer recommends that the film be rated at ISO 2000/34°. When the film is processed with Acufine or ēthol Blue at their respective recommended ratings, they will produce a negative of normal contrast.

Another form of black-and-white film development is *reversal processing*, a method which produces a positive image. This is accomplished by overexposing the negative and processing it to convert the silver halides into metallic silver in the exposed areas. The next step is to convert the metallic silver, which forms the negative image, into another chemical compound which can be dissolved without affecting the unexposed and undeveloped silver halides. The negative image is then bleached out of the emulsion, and the remaining silver halides are re-exposed to light or to chemicals. Then, the remaining silver halides are developed, forming the positive black-and-white image.

Although most black-and-white films and paper emulsions can be used to produce the direct positive black-and-white image, the thinner, single layered emulsion will work best. Reversal processing kits containing all of the needed chemicals are available. One such kit is Kodak's Direct Positive Film Developing Kit which is designed to be used with a medium light-sensitive film to produce black-and-white positive transparencies.

## OTHER PROCESSING CHEMICALS

Several chemicals, other than the developer, are used for processing film. Only the fixing agent, however, is essential to the production of a permanent image.

Since the early 1800s, sodium thiosulfate has been used to make the photographic image permanent. It does this by dissolving the light-sensitive silver halides from the emulsion which were not originally exposed to light and converted to metallic silver by the developer. When all silver halides are removed from the emulsion, only the nonlight-sensitive grains of metallic silver remain. This forms a nonlight-sensitive image.

In recent years, ammonium thiosulfate has become a second fixing agent in general usage. It has the advantage of being a liquid concentrate which will fix the image quicker than the older sodium thiosulfate. Both chemicals, however, will produce the same general reaction with the silver halides.

Several factors affect the correct amount of time required to fix the image. Concentration of the fixing agent, its temperature, and the rate of agitation will influence the rate in which the silver halides are removed from the emulsion as will the concentration of silver left in the fixer by previous rolls of film. The type of emulsion being fixed will have a determining effect. Fine-grained, low-sensitivity films will be fixed quicker than the coarse-grained, high-sensitivity emulsions.

Allowing the film to remain in the fixer longer than necessary will produce several unwanted side effects. One of them is that the fixing agent, which works primarily on the silver halides, also will dissolve metallic silver at a slower rate, reducing image density. More importantly, however, the emulsion will absorb the thiosulfate, making it more difficult to remove this bleaching agent by washing.

For the photographic image to remain permanent, the fixing agent has to be totally removed from the emulsion. Otherwise, even the smallest amount will continue to dissolve the silver image over the years. Removal of the fixer can be accomplished by thoroughly washing the emulsion for about 30 minutes with running water if the emulsion has received the correct fixation.

To shorten this time, the photographer can treat the film in a solution that reacts with the fixing agent to neutralize its action and increase its solubility in water. Washing aids, usually sodium sulfite, are readily available under different brand names. The two most common are Kodak's Hypo Clearing Agent and TKO Chemical Company's Orbit Bath. After fixing and an initial rinsing, the film is placed in the neutralizing chemical for 2 to 3 minutes, depending on the brand, and then washed for 5 minutes.

Another useful chemical in film processing is a wetting agent, such as Kodak's Photo-Flo. This chemical decreases the surface tension of water so that it will flow evenly off the film without collecting on the surface in drops. If the wash water is allowed to collect in droplets, they will dry as spots on the surface of the emulsion. These spots are the chemicals contained in most tap water and will show up on the photographic enlargement. (See Figs. 8.6 and 8.7)

(a)

(b)

(c)

(d)

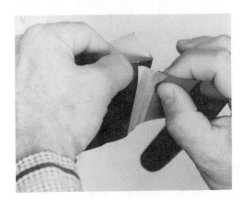

FIGURE 8.6(a)   The materials needed to develop film include: a timer, a developing tank and reel, a thermometer, a graduate, film developer, and fixer.

FIGURE 8.6(b)   The film developing tank provides a light-proof container which allows processing in regular light. Film is wound onto the developing reel which keeps each layer of film from contacting other layers.

FIGURE 8.6(c)   The procedures for unloading 35mm film and other sizes differ. In the case of 35mm film, the end of the cassette container must be removed so the film can be unloaded. An easy way to open the container is with a can opener. **The procedure must be done in total darkness.**

FIGURE 8.6(d)   Roll film, such as the 120 size shown here, is attached to a paper backing that is spooled on a center core. When you unreel the film from this core, it must be separated from the paper backing, which is attached by a piece of tape. Many people find that loading the film on the developing reel is easier if the tape is removed from the paper backing and folded over the end of the film to stiffen it.

(e)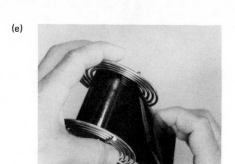

(f)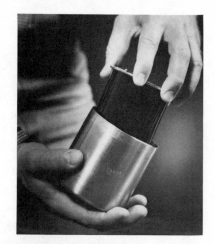

(g)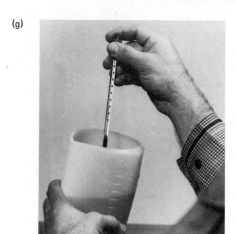

(h)

FIGURE 8.6(e)  Both roll film and 35mm film are placed on developing reels in the same way. You insert the film underneath the retaining clip of the reel and "cup" it just slightly so that the film is bowed downwards along the edge. This allows the film to fit between the spiral wire of the developing reel. Handle the film only by the edges since fingerprints on the film's surface can prevent these areas from developing.

FIGURE 8.6(f)  After the film is loaded on the spiral developing reel, put it into the developing tank and place the light-proof lid on it. This allows the film to be processed in normal light.

FIGURE 8.6(g)  The temperature of the chemicals used in processing the film should be at 68°F (21°C). It is important that all of the chemicals being used be within 3° of each other. A variation in the temperature of the developer will necessitate increasing or decreasing developing time.

FIGURE 8.6(h)  After the chemicals are at the correct temperature, set the timer. In this example, using Kodak's Plus X film and D-76 developer, and with the chemicals at 68°F, the correct development time is 5½ minutes.

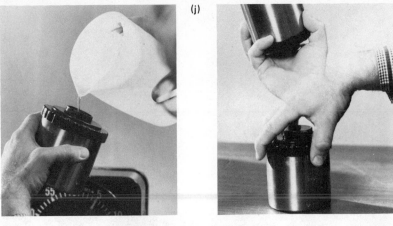

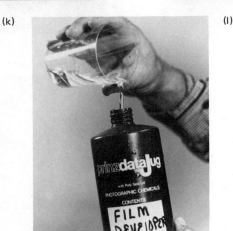

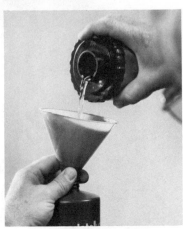

FIGURE 8.6(i)  After the timer has been set, pour the developer into the developing tank as rapidly as possible. Some tanks should be slightly tilted for easier filling. Start the timer.

FIGURE 8.6(j)  The type and rate of agitation of the film and developer are important to achieve even and correct development. You should initially rap the bottom of the developing container on the sink to dislodge any air bubbles which may have formed on the surface of the film when the developer was poured into the tank. Agitate the film at the rate suggested by the chemical manufacturer. It is important that the rate of agitation be consistent from roll to roll and that an interruption in the direction of agitation be included in the cycle. For this reason, it is suggested that you rotate the container and then invert it before completing the agitation cycle.

FIGURE 8.6(k)  While the film is developing, you should replenish the developer. This is done by adding a replenishment formula to the unused developer. This keeps the developer at the same strength from film roll to film roll.

FIGURE 8.6(l)  When the developing time is completed, pour the used developer back into the container which has the unused and replenished developer. The replenisher will replace any exhausted portions of the developer and keep the mixture at the same strength.

(m)

(n)

(o)

(p)

FIGURE 8.6(m) *After the developer has been removed from the film, rinse the film to retard the development. You can do that by filling the tank twice with water and dumping it. If the developer was at a high temperature, you should use an acid stop bath, similar to the one used in developing prints, to stop the development of the film. The film now contains an image, but it is still light sensitive so the top of the developing container should be left in place.*

FIGURE 8.6(n) *The next step in the process is to make the photographic image permanent and nonsensitive to light, using a fixing agent. The fixer, normally referred to as hypo, dissolves any of the undeveloped light-sensitive silver halides from the emulsion. Pour the chemical into the container and leave it for the amount of time recommended by the manufacturer. The normal time is between 5 and 10 minutes.*

FIGURE 8.6(o) *The fixing agent, like the developer, is reusable, so it should be returned to its container afterwards. Be careful not to confuse it with hypo clear, a chemical which neutralizes the fixer.*

FIGURE 8.6(p) *Rinsing the film after the hypo is removed helps to reduce the amount of fixer left on the film. It also allows the hypo clearing solution in the next step to act more effectively. Rinse the film about four times.*

(q)

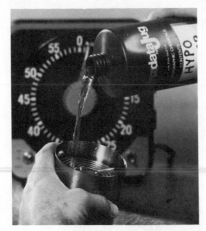

(r)

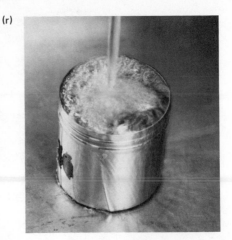

(s)

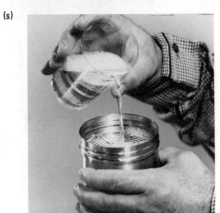

(t)

FIGURE 8.6(q)  *A hypo clear or fixer neutralizer is an optional chemical which can be used to reduce the required washing time of the film. For example, a film that normally needs washing for 30 minutes can be washed in only 5 minutes if it has been processed through the clearing agent. As with the other chemicals, pour it into the container and leave it for about 2 minutes, depending on the brand.*

FIGURE 8.6(r)  *Washing the film removes all chemical residues left by the developer, hypo, and hypo clearing agent. Otherwise, the film image will gradually deteriorate.*

FIGURE 8.6(s)  *After the film is washed, treat it in a wetting solution to prevent water spots of chemical residue present in the wash water. The solution causes the moisture to run off the film rather than dry in spots. It also produces negatives with a cleaner surface for printing.*

FIGURE 8.6(t)  *The final step is to hang the film to dry at room temperature. Drying can be speeded up by wiping off excess moisture from the surface of the film with a squeegee or other material designated for this use. In this illustration, a lint-free paper material was used to wipe the film.*

(b)

(a)

FIGURE 8.7 (a and b)
DESCRIPTION OF FAULT: Low contrast in the negative, good shadow detail.
PROBABLE CAUSE: Film was properly exposed but underdeveloped.
REMEDY: Print on a higher than normal contrast paper (such as grade 3 or grade 4). Check developing times recommended for the film being used. Also, check temperature and rate of agitation.

(c)

(d)

FIGURE 8.7 (c and d)
DESCRIPTION OF FAULT: Entire image blurred.
PROBABLE CAUSE: Camera moved during the exposure.
REMEDY: Hold camera steady during the exposure or use a tripod.

(e)

(f)

FIGURE 8.7 (e and f)
DESCRIPTION OF FAULT: Excessive density in the highlight areas, normal density in shadow areas.
PROBABLE CAUSE: Overdevelopment of a normally exposed negative, or contrast lighting within the scene.
REMEDY: Print on a lower than normal contrast grade of paper (such as grade 1). Check developing times recommended for the film being used.

(h)

(g)

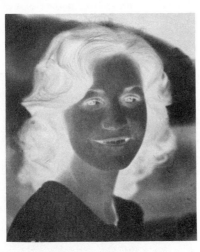

FIGURE 8.7 (g and h)
DESCRIPTION OF FAULT: Portions of the subject in focus and other portions unsharp.
PROBABLE CAUSE: Lack of sufficient depth of field to produce a sharp image over all planes of the subject.
REMEDY: Use an aperture setting which is smaller in diameter to increase the depth of field of the lens, move farther from the subject, or use a wide-angle lens to increase the depth of field.

FIGURE 8.7 (i and j)
DESCRIPTION OF FAULT: Subject out of focus, but other portions of the negative in focus.
PROBABLE CAUSE: Missed focus when making the picture. Another possibility is nonalignment of the lens.
REMEDY: Reshoot with the subject in critical focus and check lens alignment.

FIGURE 8.7 (k and l)
DESCRIPTION OF FAULT: Edges of negative overlap onto the next picture frame.
PROBABLE CAUSE: Failure to advance film a suitable distance, or mechanical failure in the film advance system.
REMEDY: Be sure to advance film correctly, or repair the camera.

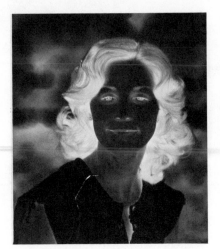

FIGURE 8.7 (m and n)
DESCRIPTION OF FAULT: Torn negative.
PROBABLE CAUSE: Mishandling film when loading it onto reel. In the case of 35mm film with torn sprocket holes, the damage can be caused by failure to set the camera on rewind before winding the film back into the cassette, or it could be from camera malfunction.
REMEDY: Handle film more carefully when loading, or operate the camera more carefully.

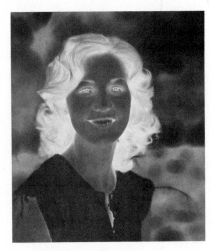

FIGURE 8.7 (o and p)
DESCRIPTION OF FAULT: Dark semicircular marks on film that appear like crescents.
PROBABLE CAUSE: Film emulsion bruises were caused by bending the film while trying to load it onto the film processing reels.
REMEDY: Handle the film more carefully.

186

(q)

(r)

FIGURE 8.7 (q and r)
DESCRIPTION OF FAULT: End frame on the film is dark and without an image.
PROBABLE CAUSE: Opening the camera before the film is wound through the camera and onto the take-up spool; or in the case of 35mm film, the film is not wound back into the cassette.
REMEDY: Do not open back of camera until the film is protected.

(t)

(s)

FIGURE 8.7 (s and t)
DESCRIPTION OF FAULT: Dark opaque areas along the edge of the film that possibly extend over into the picture areas.
PROBABLE CAUSE: Film was not tightly wound onto the take-up spool, or if marks are consistent throughout the roll, the camera may have had a light leak.
REMEDY: Have camera checked.

(u)

(v)

FIGURE 8.7 (u and v)
DESCRIPTION OF FAULT: No image on portion of the negative; this area may be clear or opaque.
PROBABLE CAUSE: Film stuck together when processing
REMEDY: Load film developing reels properly.

## SUMMARY

The discovery by Daguerre of the existence of a latent or hidden image that could be converted into a visible image with chemicals greatly shortened the length of the photographic process and the time it required. For many years, the image was made visible with physical developing formulas until the discovery of chemical reducing agents.

The modern film developer uses one or more reducing agents to convert the latent image into metallic silver. The selection of the agents and other chemicals used in the formula will produce different photographic results in the image. Some developing formulas will create minimum graininess in the image. Other formulas are a compromise between graininess and film sensitivity, and still others will develop the shadow areas at a greater rate than the denser, highlight areas. Through the selection of the developing formula the photographer is able to change the recorded contrast of the scene and the sensitivity of the film.

There are factors other than the developing formula which will influence the development of the image. The amount of time the film is in the developer, the temperature of the developing solution, and the rate of agitation of the developer over the surface of the film affect the amount of development the film receives, the graininess of the image, and the contrast recorded on the film.

To make the image permanent, however, a second chemical is needed to remove the light-sensitive silver halides from the emulsion that are not converted to metallic silver by the developer. This is accomplished with a fixing agent, two of which are commonly used today. Both serve the same function.

Sodium thiosulfate, the older of the two, was used by Reade, Fox Talbot, and Daguerre to make the earlier photographic images permanent. It is still used by a majority of photographers.

Ammonium thiosulfate is a newer photographic chemical which performs the same function faster and comes in a more convenient concentrated liquid form. Both will produce permanent images, but the chemical must be removed from the emulsion or it will deteriorate the permanent image.

The fixer can be removed by washing the film for a long period of time or by using a washing aid. This chemical, usually sodium sulfite, reduces the need for long washing periods. Another chemical used in film processing is a wetting solution, which causes water to run off the film in a sheet. This prevents spots of chemical residue from being left on the surface of the emulsion.

Although several chemicals are used during film processing, only the developer and fixer are essential. Other chemicals are used because they perform convenience functions.

# The Darkroom

The modern photographic darkroom is where film is processed and the print is made. In the early days of photography, the darkroom was used to manufacture emulsions and to develop the negative image. The print was made in sunlight where the paper was exposed and the image was produced directly.

## HISTORY OF THE DARKROOM

The early photographic negative was formed on a glass plate support coated with a light-sensitive emulsion. The emulsion was prepared and coated on the glass immediately before the camera exposure was to take place. For the emulsion to retain the highest sensitivity to light, the exposure had to be made before it had a chance to dry. The need for immediacy resulted in the early darkroom being a place where the emulsion was mixed and spread on the glass plate. Film processing was also conducted in the early darkroom, since the plate had to be processed immediately after the exposure. (See Fig. 9.1)

After the negative image had been processed, the photographer mixed a personal print emulsion and let it dry in the darkroom until it was ready to be used. Unlike the modern print which is produced in the darkroom, the earlier ones were made in sunlight (Fig. 9.2). The negative was placed in contact with the sensitized paper emulsion and then put in sunlight until an image formed. Even after the positive image was chemically developed, sunlight was still used to make the exposure. (See Fig. 9.3)

FIGURE 9.1 *The darkroom traveled with the photographer, as shown in this illustration. The photographic plates had to be prepared just before the exposure was made and processed almost immediately afterwards. O'Sullivan, like other photographers of the time, used wagons like this to transport the chemicals needed to prepare the photographic emulsion. (Timothy O'Sullivan: Carson Desert Nevada, Sand Dunes. Reproduction courtesy Library of Congress.)*

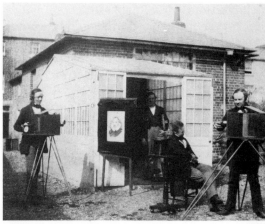

FIGURE 9.2 *Fox Talbot (right) is shown making a portrait while one of his assistants makes a duplicate of a drawing. (William Henry Fox Talbot, Fox Talbot's Calotype Establishment at Reading, England, 1854. Courtesy The Science Museum.)*

FIGURE 9.3 *An interior view of the Kodak photofinishing operation in 1894. Negatives were placed into frames, exposed to sunlight and then transferred to a fixing solution. (Courtesy of Eastman Kodak Company.)*

Mass production of photographic film and paper changed the function of the darkroom from a chemical-mixing laboratory to a place where the photographic image is produced. In today's terms, the darkroom is not a room without light. It is a place where the color of light can be controlled. For the enlarging process, the darkroom is well lighted; and since most photographers use daylight processing tanks to develop the film image, only the loading of film into the light-proof tank is done in the dark. (Daylight processing tanks are light-proof containers into which the film is loaded in the dark and processed under normal room-light conditions.)

# THE MODERN DARKROOM

The modern darkroom is a far cry from those of the past, both in comfort and equipment. Modern darkroom designs take many forms dictated by the needs of photographers. For example, many hobbyists use the bathroom of their home as a darkroom for occasionally developing film and making photographic enlargements. If the room does not contain windows, it can be made light-proof with relative ease. In addition, the bathroom has running water which makes it convenient for processing film and paper.

The bathroom, however, has its limitations. Usually its use is confined to portions of the day and night when other members of the family do not need it. Also, the size of its sinks are inadequate for processing and for working comfort. Perhaps its greatest drawback is that it must be converted from a bathroom to a darkroom each time it is used, which means moving in the enlarger, tanks, trays, and other materials needed in the process. Often this prevents the hobbyists from using the darkroom except on special occasions and thus missing much of the enjoyment of photography.

An alternative solution is to permanently convert or construct a room for photographic processing. Such a room can be as elaborate as the individual budget will allow. Some rooms are designed with air conditioning systems that filter the air and remove suspended dust and lint. Besides having normal hot and cold water, they may contain equipment that automatically regulate the temperature of the water to keep it at a constant level. Some darkrooms contain a filtering system on the water supply to remove many of the small chemical particles normally suspended in public water supplies.

Whether the photographer uses a bathroom or has a specially designed room, each type of darkroom will contain some common pieces of equipment.

# SAFELIGHTS

An essential part of the modern darkroom is a safelight. This is an illumination source which restricts the color of light in the room. Depending on the type of photographic materials being processed, the color of the light will vary from dark red for orthochromatic emulsions or amber or yellow-green for most enlarging papers to dark green for some panchromatic emulsions.

Most darkrooms will have an amber (OC safelight filter) or yellow-green (OA safelight filter) source. Printing emulsions are either nonsensitive or have little sensitivity to these colors. Each paper is designed for one of these colors, allowing the photographer to observe the image developing process without exposing the paper emulsion.

The type of safelight used determines how intense the light can be. All safelights produce a small amount of unsafe wavelengths of light. The more restricted the light is in the safe area, the brighter the light can be. The safelight which produces the brightest safelight uses a sodium vapor bulb. This

bulb produces a color of light which is restricted to a narrow band of yellow-orange light. This band of color is filtered further to produce a color which does not expose photographic paper. The brightness of the light source is controlled with adjustable louvers. (See Fig. 9.4)

Other types of safelights normally use regular household bulbs. The bulb's light is filtered to produce the correct color. This type of safelight is relatively dim since the size of the bulb is usually 10 to 25 watts and it generally has to be at least five feet from the photographic materials to keep its unsafe light from affecting the paper's emulsion. Even if the level of illumination is correct, the filter color can change, creating a greater amount of unsafe light. Therefore, the photographer must check the condition of the safelight at least once a month. (See Fig. 9.5)

*FIGURE 9.4 This type of safelight uses a sodium vapor bulb which projects light within a narrow band of wavelengths. Because of this restricted color, this safelight can be much brighter in the darkroom than the more common filtered safelights. (Courtesy of Thomas Duplex Company.)*

*FIGURE 9.5 To test the safety of a safelight, place a sheet of photographic paper on the enlarger and expose it to light so that a light gray tone is produced upon development. This slight exposure sensitizes the paper so that any unsafe light will be more pronounced in tonality. After the exposure is made, place an opaque object such as a coin on the paper (a) and let the paper sit underneath the safelight for twice the time normally necessary to process the image. Now process the paper as usual and inspect the fixed print. If the spot where the coin was placed is lighter (b) it indicates that the safelight is producing light which is fogging the photographic paper. This fog may be caused by the light being too close to the enlarger and process trays, or unsafe wavelengths of light may be emitting from the light source.*

(a)

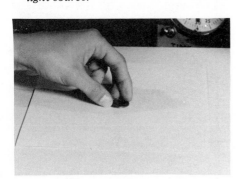

(b)

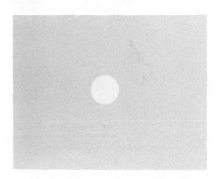

Both the color and brightness of the safelight are important for photographic quality. A safelight which produces the wrong color of light or which is too bright can create an overall fog exposure of the silver halides in the emulsion. The fog is produced during development and is not readily apparent, but it causes a decrease in highlight brilliance and can give the print an overall gray effect. Using safelights which depend on a filter to produce the correct color of light can cause this fog. The light and heat generated by the bulb gradually cause the filter material to fade. This fading results in the safelight producing unsafe wavelengths and brilliance of light.

## ENLARGERS

Usually the final product of the black-and-white process is a positive print designed for viewing. During the early years of photography this was accomplished by placing a large negative on a sheet of sensitized paper to produce a *contact print*. This method is still used in some cases to make proof sheets for a visual record of the images on a whole roll of film.

As the popularity of the smaller negatives increased, a need for enlarged images was created. This need was met by placing the negative into a projector that enlarged the image onto a sheet of photographic paper. This projector is called an enlarger.

Although they come in many sizes and shapes, each enlarger is made up of the same parts and performs the same basic functions (Fig. 9.6). The lamp

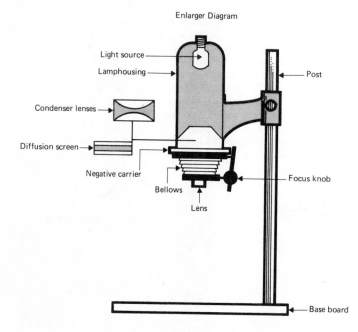

*FIGURE 9.6  Enlarger diagram of its parts.*

housing contains the light source. Its shape helps control both the sharpness and contrast of the image produced by the enlarger. Lamphouses designed to scatter the illumination of the light source produce less contrast and sharpness from the negative.

Located beneath the lamphouse are either lenses to gather and concentrate the light or a diffusion screen which spreads out the light. Both the condenser lenses and the diffusion screen regulate the spread of light striking the negative.

Below the condenser lenses or diffusion screen is the negative carrier, a metal or glass support for the film image being enlarged. The negative carrier is usually referred to as being either glassless or glass. The glassless type is extremely popular, but movement of the negative caused by expansion and contraction due to heat from the light source, and changes in air pressure produced during focusing can cause unsharpness of the projected image. This unsharpness is more prevalent with large format negatives than with the smaller 35mm and 120 sizes.

A glass negative carrier is made of two pieces of glass that sandwich the negative and hold it flat during the exposure. It is difficult, however, to keep clean and lint free; and dirt, fingerprints, and lint on the glass are projected in enlarged sizes on the print. Glass carriers can also project Newton rings on the enlargement. These are concentric bands of light and dark caused by moisture or lack of contact between the transparent materials. This is most likely to occur during conditions of high or low humidity.

Between the negative carrier and the lens is an adjustable bellows, which controls the distance between the lens and the negative. A sharp image is obtained at various degrees of enlargement by adjusting it. The lamphousing, condenser or diffusion screen, negative carrier, and bellows make up the enlarging head.

The enlarging head is connected to a vertical support and can be raised and lowered to vary the degree of enlargement. The higher the head is elevated, the larger the image becomes. In addition, image enlargement can eliminate portions of the scene of the original negative image from the print to enhance composition.

Although most enlargers are basically alike, individually, they have special features, uses, and limitations. Some enlargers produce extremely sharp photographic prints while others give a softer, diffused image. The quality of the reproduction depends on the type of light source, the design of the lamp housing, whether the enlarger uses a condenser lens or diffusion screen to regulate the spread of the light, and the quality of the enlarging lens.

One of the primary concerns of enlarger designs is to provide equal light to all parts of the negative. Without an even distribution of light, portions of the image will print darker or lighter than normal. In some inexpensive models, this is evident as *fall-off* of light along the outer edges of the negative, causing them to be darkened on the print. Designers even out the light

by either diffusing it or by collecting the light rays traveling in different directions and redirecting them through a lens system called condensers.

Many types of enlargers are on the market, but all of them fit roughly into two categories. They are (1) diffusion enlargers (Fig. 9.7) and (2) condenser enlargers (Fig. 9.8). Both types come in different price ranges and with several attachments to extend their versatility. Each type accommodates specific negative sizes or a combination of sizes. The main difference between them is the quality of light they project through the negative. The concentrated light of the condenser enlarger can be compared to the quality of light on a bright sunlit day; the diffusion enlarger's light is more like the quality of light on a cloudy day.

Bright sunlight creates greater contrast between areas in light and shadow than a cloudy day. By comparison, the condenser enlarger creates greater contrast in the image than the diffusion enlarger, which gives a softer light. The intensity of the light in bright sunlight is greater than on a cloudy day. Similarly, the light produced by the condenser enlarger is brighter than that of the diffusion enlarger if the wattage of the bulbs is equal. The exposure time, therefore, is usually shorter for the condenser enlarger.

As a result of the short exposure time and the image contrast and sharpness produced by the more direct light, the condenser enlarger has become the most popular design for black-and-white photography. It is popular because the quality of the image it produces is suitable for most subject matter.

Unfortunately, sharpness and contrast have their disadvantages. The sharp reproduction of the image, for example, can compound negative and subject flaws. Dust, scratches, or fingerprints on the negative will be enlarged on the print. Cleanliness and gentle handling of the negative are necessary when this type of enlarger is used.

Sharpness and contrast of the condenser enlarger can be enhanced by putting a concentrated light source on the enlarging head or by placing an aperture between the light source and the condenser. (See Fig. 9.9) Normally, the condensers collect the nonparallel light rays and focus them in such a way that most will travel parallel to each other. Some light rays, however, strike the condenser at such an angle that they cannot be made parallel to the other rays. But an aperture placed between the condenser and the light source will block out many of the rays, allowing passage to only those originally traveling nearly parallel to each other. With the aperture, a *point light source* design, these rays can be focused better by the condenser; and sharpness and contrast of the image is enhanced.

To reduce the contrast produced by the condenser, some manufacturers use only a single rather than a double condenser design. The concentration of the light rays results in less of a loss of contrast and sharpness. To further reduce contrast in the projected image, some manufacturers use a compromise design that combines features of both the condenser and diffusion enlargers. While the condenser concentrates the light, the diffusion screen softens it. The main advantage of this design is that it will produce greater contrast and

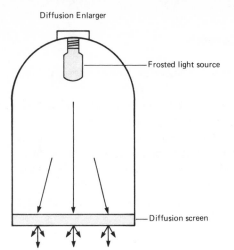

Diffusion Enlarger

Frosted light source

Diffusion screen

FIGURE 9.7 Diffusion enlarger.

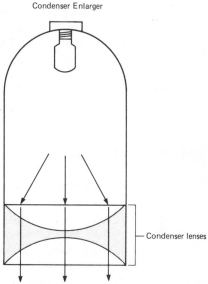

Condenser Enlarger

Condenser lenses

FIGURE 9.8 Condenser enlarger.

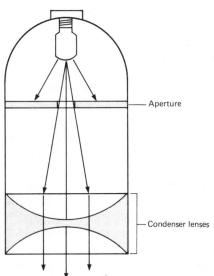

Point Light Source

Aperture

Condenser lenses

FIGURE 9.9 Point light source enlarger.

sharpness than a diffusion enlarger and still retain some diffusion of the image. This diffusion causes fewer negative flaws to be reproduced on the print.

The diffusion enlarger intentionally causes the light rays to diverge, which reduces the sharpness and contrast of the image. This design was at one time extremely popular for reproducing portraits in black and white. With its softer image reproduction less retouching has to be done on the negative to remove or tone down wrinkles and facial flaws. And the retouching is not as apparent on the enlargement.

Although it is not as popular for black-and-white photography now, the

diffusion enlarger has experienced renewed popularity as the design most used for printing color negatives.

The quality of the final print will depend on the condition of the enlarger and its optics. An enlarger which is not rigidly constructed can vibrate during the exposure, causing the image to appear unsharp. The negative carrier, lens board, and base of the enlarger should be parallel to each other. If any is out of alignment, the projected image will not be at its sharpest from corner to corner. The alignment can be checked easily by placing a carpenter's level along the three points and then adjusting the enlarger until each is level with the others.

## ENLARGING LENSES

Just as the sharpness and quality of the negative image depend on the quality of the camera lens, the sharpness, contrast, and overall quality of the print is greatly influenced by the quality of the enlarging lens. Not only does the lens need to be spotlessly clean, it should have the highest optical quality to reproduce the maximum details and contrast of the negative image.

Manufacturers produce lenses of different designs and quality so they will fit into different price ranges. Although price is not an absolute determiner of lens excellence, it does normally indicate the general quality of the lens. Most enlarging lenses on the market are suitable for general amateur photography; but if the photographer is serious about the degree of sharpness and contrast, or if negative enlargement is great, then one of the higher priced lenses is a necessity.

For example, Schneider manufactures several lenses for different markets. The *Componar-C* is modestly priced and designed for amateur use. It will produce its optimum quality when the degree of enlargement does not exceed a 4X magnification of the image. The recommended maximum magnification for the more expensive and better quality *Comparon* lens is a 6X-image size. The top of the line *Componon* and *Componon-S* lenses will produce excellent enlargements up to 20X and are designed for professional photographers and others who want optimum quality in the reproduction.

The focal length of the lens is also important and must be selected according to the size of the negative being enlarged. Normally, the enlarging lens' focal length is equal to or larger than the normal lens which makes the negative. Generally, a lens with a 50mm focal length is used for printing 35mm negatives; a 75mm lens is used for 2 1/4 X 2 1/4 negatives, and 90mm is used when the negative is 2 1/4 X 2 3/4 in. A longer focal length can be used, but the enlarger head has to be raised significantly to produce the enlargement.

A focal length which is shorter than that recommended for the negative size will project only a portion of the image on the paper. It can be used

effectively, however, when the photographer desires to enlarge only a small portion of the image. The shorter focal length lens gives a greater blow-up of the image with the enlarging head set at a lower than normal position.

Specialty lenses can be used on the enlarger occasionally. One is a wide-angle lens which makes mural-sized enlargements without having to change the position of the enlarger. Normally, the enlarger would have to be adjusted on the stand so that the image could be projected on the floor.

Zoom lenses are available for the enlarger. This variable focal length lens changes the size of the projected image without having to reposition the height of the enlarger. In addition, it allows the photographer to produce special effects during the printing process of the negative. (See Fig. 9.10)

(a)

(b)

(c)

*FIGURE 9.10 The Betavaron zoom lens manufactured by Schneider allows the photographer to make enlargements of different sizes without adjusting the height of the enlarger head. In these illustrations, enlargements of (a) 3X, (b) 5X, and (c) 10X, were made from the same enlarger height. (Courtesy of Schneider Corp.)*

# EASELS

The photographic term *easel* is a misnomer which dates from the time enlargers projected the image horizontally rather than vertically. Then, the enlarging paper was positioned and held into place by an artist's easel.

Although the structure has changed, the name and function of the easel remain the same. It positions and holds the enlarging paper during exposure. This may seem like a simple matter, but the selection of the easel can affect the qualify of the enlargement. Some things to consider are the size of the paper which will be used to make the enlargement, and the construction and weight of the easel. (See Fig. 9.11)

Occasions arise during the enlarging process when the position of the easel can be accidentally changed. This is especially true of a lightweight easel. Position shifts can occur, for example, when focusing aids and paper are moved on and off the easel while focusing the enlarger or making the exposure. A heavier easel will lessen the danger of accidental movement.

Convenience and print sharpness are other features affected by the physical construction of the easel. Easels come in many different forms, and some will accept photographic paper of only one size while others accommodate a variety of sizes for the enlargement. The size of the print can be controlled by the easel by placing white borders around the image or causing the image to be printed without a border. They can be used to make prints of different dimensions or of only one size. For example, one easel will make only 8 × 10-in. prints, while others will provide openings for 8 × 10-, 5 × 7-, 4 × 5-, and 2 × 3-in. prints, depending on the placement of the paper in the easel. This design has openings of different sizes, but other styles have adjustable blades to vary the dimensions.

Regardless of the type of easel used, the bed on which the paper rests

FIGURE 9.11 *Photographic easels come in different construction styles. Here are two examples: (a) An adjustable easel that allows the photographer to control the size of the picture, and (b) a borderless easel which holds the paper in position without printing a white border along the edges of the print. (Courtesy of Saunders Photographic.)*

(a)

(b)

should be absolutely flat and parallel with the negative. Lighter easels have a tendency to sag in the middle or have uneven sides and ends. As a result, the surface of the enlarging paper will not be parallel to the negative, and portions of the print will not be as sharp as they could be, regardless of how well the lens is focused.

## TIMERS

The enlarging timer serves the same purpose in making the print as the camera's shutter does in producing the negative image. It regulates the amount of time light is allowed to strike the emulsion of the paper. Since more time is required to properly expose the paper emulsion than the film emulsion, photographic prints can be made without using a mechanical timer. The timer, however, increases the ease of making the print and predicting the end results.

The timers designed for photographic enlarging are electric or electronic. The enlarger's light source is connected to the timer so that when it is activated the light turns on. Most enlarging timers have a manual focusing mode. When the timer is set on *focus*, the light in the enlarger stays on until it is manually turned off. This allows the photographer to focus and compose the image on the easel.

Enlarging timers come in different forms. Some automatically reset themselves to a predetermined interval after each exposure. Other models have to be manually reset each time. Some types use a manual dial to indicate the time; others make use of lighted digital readouts. Regardless of the type used, they provide more consistent exposure than counting seconds or using a watch to calculate exposure times in the darkroom.

## OTHER DARKROOM EQUIPMENT

Types of other equipment used in the darkroom vary substantially. Some are fairly standard, while other equipment is only used in specialized laboratories. For example, there are several pieces of processing equipment which allows the photographer to develop film and prints without trays and tanks.

Automatic film processors are usually reserved for large commercial darkrooms, but automatic print processors have become common even in the smallest darkrooms. The automatic print processor has several advantages to offer the photographer. Most models will develop and produce a semidry stabilized print within a few seconds. They do not need running water, trays, or much room to operate. For these reasons, they are an ideal piece of equipment for the person who wants to process prints but has minimum space. An automatic or stabilization processor is available in prices ranging slightly less than $1000 to slightly more than $100. All seem to work equally well.

The stabilization processor is used with special photographic paper which has a portion of the developing chemistry already suspended in the emulsion. After the exposed print is placed into the processor, an activator solution is placed on the print. The activator causes the chemicals suspended in the print's emulsion to develop the image quickly. The print is then passed through a stabilizing chemical that stops the developing action. One of the main drawbacks to this type of processing is that the print is not permanently fixed; the image is only stabilized. This image will remain useful for many weeks and even months with proper storage, but it will gradually deteriorate unless the photographer goes through the regular process of fixing the print. A less serious shortcoming is that only a few paper surfaces and textures are available with the chemicals incorporated into the emulsion. For a permanent print the photographer still must have facilities to fix, wash, and dry the print.

The print washer's function is to remove the hypo from the base and emulsion of the print so that the image will not fade. Permanency of the image is determined largely by how well the print is washed. Like other pieces of photographic equipment, the print washer comes in many forms and prices. But a more important consideration than price in their selection is the type of material which will be washed in them.

Print washers can be a tumble design which rotates the print through water in a drum. This type of washer is suitable for fiber-based papers but is unsuitable for resin-coated or RC printing papers. The reason for its unsuitability is that the sharp edges of the RC papers will dig into other prints during the rotation.

The other type of washer is a flat tray design which sends a flow of water over and under the prints without a tumbling motion. This type of washer is suitable for both types of paper bases. The least expensive models which use water motion are trays with water hoses attached to them. The more expensive systems automatically agitate the prints and time the length of the wash cycle. (See Fig. 9.12) Regardless of price, however, the most important consideration is its washing efficiency.

The water being used to wash the print should be changed by the washer

*FIGURE 9.12  This      rocker-type print washer gently agitates the water over the surface of the print in a wave action. It is designed for washing a print with a minimum amount of water.*

every 5 minutes. The flow of the water should not create excessive turbulence that could damage the print. A simple test of efficiency is to add a small amount of dye to the wash water, without a print in it, and then time the span needed to remove the dye.

A print dryer is another piece of equipment used in the final stage of printing. The dryer is a convenience rather than a necessity, since the print can be air dried by simply laying it on a clean absorbent material. An electrical or gas-heated print dryer, however, is quicker and more convenient. The design to use depends on the type of photographic paper and the kind of finish the photographer wants on the print.

Enlarging papers are manufactured with two types of base support, and each kind requires a different approach to drying. One is resin-coated (RC), a paper base covered with a plastic-like substance. The other type uses a pure paper stock as the emulsion support. The RC base requires that the print be air dried, either by blowing hot air over the surface of the print with a dryer designed for this type of paper, or by placing the paper on a rack until it is air dried.

Moisture on a paper base type can be removed by blotting the water from the surface and then air drying it or placing it on a heated plate to evaporate the remaining moisture.

If the paper-base emulsion is designed to produce a glossy surface, it must be placed on a polished, heated surface. This produces the high shine designed into the paper. (See Fig. 9.13) RC glossy papers do not need this special aftertreatment and, in fact, would be damaged by it. Glossy RC papers dry to a high shine.

(a)

(b)

FIGURE 9.13 *The dryer in (a) is for paper base supports; the dryer in (b) is used for the enlargements made on RC paper. (Courtesy of Pako Corp.)*

## SUMMARY

The function of the photographic darkroom has changed over the years. It has evolved into a place used primarily for the production of prints. Earlier, it was used for mixing emulsions and developing film.

The primary equipment in the darkroom is the safelight and enlarger. The safelight produces a color of light to which the photographic emulsion is insensitive. The specific color to use depends on the type of photographic material being processed. For black-and-white enlarging paper, the color of the safelight is usually amber or yellow-green.

Unless the photographer follows instructions on the color of the light and its brightness level, the safelight can produce a fogged effect on the enlarging paper. This fog will reduce the contrast and brilliance of the print image.

Print sharpness and contrast are affected by the type of enlarger selected for the darkroom. Enlargers come in two designs. One diffuses light, and the other collects it through a condenser lens system to project light evenly to the negative. The condenser enlarger produces greater contrast and sharpness with shorter exposure times than the diffusion enlarger does.

Another factor which will affect image sharpness and contrast is the cleanliness and quality of the enlarging lens. Manufacturers produce lenses for different photographic customers, and the price usually indicates the quality of the optics. Some are designed for amateur photographers who produce enlargements of minimum size. Others are made for greater degrees of enlargement where the optimum in definition and color correction are required.

Although the enlarger and safelight are major requirements in the darkroom for printing black-and-white negatives, other equipment, such as print washers and dryers, and timers to regulate enlarging exposures, can be helpful.

# Photograms

A photogram is a photographic image, but it is produced without the use of a camera. The image is the shadow or silhouette of objects recorded by placing them between a light source and light-sensitive paper or film. An example of the process occurs during the summer among sunbathers. The sunlight's darkening effect on the skin is similar to what happens when light strikes a photographic emulsion.

## HISTORY

The photogram is one of the oldest forms of photographic reproduction and illustrates many of the principles of the process. One of the first images was produced by Johann Schultze during his experiments to prove the sensitivity of silver nitrate to light. In effect, Schultze produced a photogram when he wrapped a bottle containing silver nitrate and chalk with paper in the shapes of cut out letters and exposed them to light until the silver nitrate darkened. When the bottle was unwrapped, a photographic image of dark cutout letters was recorded against a white background. The photogram had been produced, but Schultze, like other early experimenters, failed to make the image permanent. It continued to react with light and eventually became equally dark overall.

Wedgewood and Davy produced "silhouettes" by placing objects on sensitized paper and leather and exposing the material to direct sunlight. The physical conversion of the silver halides to metallic silver produced an image

with reversed tones similar to those made with today's photographic papers. The main difference, however, is that the early photograms were made by a direct reaction with light rather than through chemical development of the image. Like Schulze, they could not make the image permanent. That would come later when Niepce used the asphaltic process. Although Niepce is credited with being the father of photography because of his camera images, he also produced photogram images.

Niepce, Wedgewood, and Davy found that the photogram was the easiest image to produce because of the shorter exposure time required when a lens is not used. The camera lens allows only a small portion of the total light to strike the film as compared to the amount striking an object in bright sunlight. The direct reduction of the silver halides to silver used by Wedgewood, Davy, and Frederick Scott Archer can easily be duplicated with regular photographic enlarging paper.

By placing objects on the paper in bright sunlight, the physical reaction of the silver salts to the light can be observed. A silhouette image with reversed tones will be present when the objects are removed from the darkened paper. (See Fig. 10.1)

Over the years the photogram has had alternating periods of popularity. Laszlo Moholy-Nagy, Man Ray, and other artists have used it as a medium for artistic expression. (See Fig. 10.2) Since it is created without a camera, it

*FIGURE 10.1 The simplest photographic image can be reproduced without a camera, as was this 1839 Fox Talbot photogram. (William Henry Fox Talbot, Shadow picture of field of flowers, 1839. Courtesy of The Metropolitan Museum of Art, Harris Brisbane Dick Fund, 1936.)*

*FIGURE 10.2 Laszlo Moholy-Nagy. Photogram, 1926. (Courtesy of George Eastman House.)*

more closely approaches a classical art form than many of the photographs made with the technically oriented camera procedures. In recent years, the photogram procedure has grown in popularity as an instructional tool.

The photogram can be made with many different materials. It can take the form of construction art when the image is produced with cutouts as in Fig. 10.3. It can be created from found objects. (See Fig. 10.4) Materials which reflect and refract light, such as glass and plastic, can be used as in Fig. 10.5. Standard art media, such as pen, pencil and paints, are other possibilities as materials to be used in making photograms. (See Fig. 10.6) Often the image is a combination of two or more types of materials, including a photographic negative or transparency. (See Fig. 10.7)

*FIGURE 10.3 Different degrees of translucency produced this photogram with black, white, and gray tones. The white tones were created by cardboard cutouts which protected the photographic paper from all light; the gray tones were produced by the more translucent typing paper which allowed a portion of the light to expose the photographic paper. The black areas of the photogram were unprotected from light and received the full exposure. (Courtesy of Elizabeth Sneed.)*

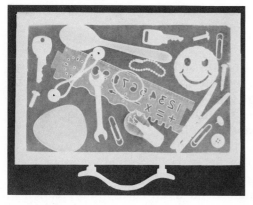

*FIGURE 10.4 Common objects found around the house in drawers was the inspiration for this photogram. The clothes pins, old keys, and other items were placed in a cardboard frame with a drawer pull on it. (Courtesy of Dee Bunnell.)*

*FIGURE 10.5 Glass objects can be combined to produce a wide variety of tones. This photogram was made from an ashtray and a piece of broken stemware.*

FIGURE 10.6 *Ink drawing on glass produced this photogram image. Like the photogram in Fig. 10.3, opaque materials created white areas; translucent materials gave a gray tone, and transparent areas reproduced as black. (Courtesy of Steve Coleman.)*

FIGURE 10.7 *Different materials can be combined to produce a photogram image. Here the combination of weeds and paper cutouts are the main ingredients. (Courtesy of Cheri Campbell.)*

## DEMONSTRATION OF PHOTOGRAPHIC PRINCIPLES

Many principles of camera image formation and photographic enlarging can be demonstrated easily by the process of creating the photogram image. One advantage over film is that the image can be seen as it is formed. The photogram is exposed and processed under safelight conditions allowing the photographer to observe the process from start to finish.

Essentially, the same procedure is followed for making a photogram as that for making a contact print of a negative. The same equipment and chemicals are also used for making a photographic enlargement. The photogram can help the photographer understand more clearly the reaction of silver salts to different intensities of light and the chemical process of developing and fixing the image. In addition, the process requires familiarity with the operation of the enlarger, timers, print drying, mounting, and with print presentation.

Another comparative similarity is the effect of light on film emulsion and the paper emulsion used for the photogram. The same reaction takes place in the suspended silver halides of both materials. The difference is that

film must be processed in total darkness during the early stages of emulsion image development. That period of the process cannot be easily observed.

When making a photogram, the photographer is allowed to observe differences in tonality (shades of gray) produced when areas of the emulsion are exposed to different amounts of light. Because of this, the relationship of tonality to aperture and time settings is readily apparent. The enlarger has the same basic function as the camera in the formation of the film image. The camera lens has an aperture which controls the intensity of light striking the film emulsion. The enlarger lens also has an aperture which performs the same function in regard to paper emulsion. Both apertures are measured in *f*/stops.

The camera shutter regulates the duration of light striking the film in fractions of seconds. The timer connected to the enlarger serves the same purpose, except time is measured in whole seconds. The differences in time measurement are due to the differences in the sensitivity of paper emulsions and film emulsions to light. The ratio of change between camera shutter speeds and enlarging times remains the same, and like the aperture, it is measured in stops.

Many photogram images are produced with materials which have different translucent qualities. Opaque material blocks all light from the emulsion, preventing exposure of the silver halides. Without exposure to light no metallic silver is formed during the chemical development stage of the process in areas covered. Areas covered with translucent items that permit light to pass through and react with the silver halides darken into shades of gray. Exposure to the total amount of light will cause a greater degree of darkening within the emulsion and will produce black tones.

Depending on the aperture and time settings, tonal relationships can be altered. The areas that would be gray in tone with normal exposure can be made to reproduce as a darker shade of gray or black by increasing light intensity or time of exposure. (See Fig. 10.8) The same areas can be made lighter in tone by reducing the intensity or time (Fig. 10.9). The equivalence

*FIGURE 10.8   The tonality of the objects used to make a photogram can be altered by changing exposure times of light intensity. (a) This photogram was produced with an exposure time of 5 sec. (b) This photogram, which is darker in tonality, received 10 sec of exposure.*

(a)

(b)

*FIGURE 10.9 The material used to make this photogram was reproduced at a lighter tone by exposing it for only 2 sec.*

of exposure can be demonstrated by making images which alter both the aperture and the time setting. If the diameter of the aperture is increased by one stop, and time is reduced by half, the resulting exposure will be identical to a photogram made with the previous exposure. With test exposures, the photographer can manipulate the tonality of the grays in the photogram to their desired values.

Besides illustrating various exposure relationships, making a photogram allows the photographer to become familiar with the chemical procedure of converting the latent image into a visible permanent image. The chemical process for developing a photogram is identical to that used for a photographic enlargement. It is similar, in many respects, to the process used for film. Each requires developing the image, fixing it so that it is permanent, and washing and drying. (See Fig. 10.10)

The procedure for making the photogram is similar to making a photographic proof sheet, which is a contact print of the negatives from a roll of film. These negatives are all exposed on a single sheet of photographic paper at the same time and at the same exposure.

The proof sheet is a record of the pictures made and gives a general

## How To Make a Photogram

The procedure for making a photogram is similar to that for exposing and developing film and for making photographic enlargements. It is helpful in familiarizing the beginning photographer with the darkroom and the process of making enlargements.

*FIGURE 10.10(a)  After selecting materials to form the image, the first step in making a photogram is to raise the enlarger's lamp housing almost as high as it will go. Then rotate the aperture ring on the lens until the least amount of light is being projected through the lens. Focus the enlarger, and turn off the light.*

*FIGURE 10.10(b)  Cut your enlarging paper into small pieces of about 2 by 8 in. to conserve paper. Larger sheets are unnecessary at this stage. Select an item from the materials to be used in making the photogram and place it on one of the pieces of paper.*

(a)

(b)

(c)

(d)

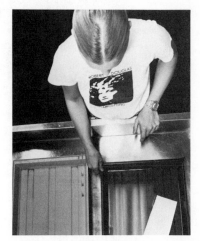

FIGURE 10.10(c)   With the enlarger timer set on about 2 sec, cover three-fourths of the photographic paper with an opaque piece of board and make an exposure. Cover half of the paper and make a second exposure and then cover a fourth for the third exposure. Finally, uncover all of the paper for a fourth exposure. This will give you exposures on different areas of the paper of 2 sec, 4 sec, 6 sec, and 8 sec.

FIGURE 10.10(d)   Place the exposed photographic paper into the print developer for the amount of time recommended. Keep the print in constant motion during the development stage. Drain the print over the developer for a few seconds and then transfer the print to the stop bath for 10 to 30 sec to stop the developing action. This will produce a developed but unfixed image. Do not expose the image to light at this point.

211

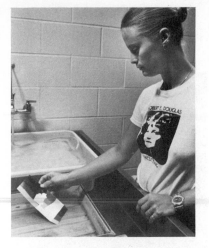

(e)

FIGURE 10.10(e) Remove the print from the stop bath, drain and transfer it to the fixer. The fixing bath will dissolve the light-sensitive silver halides from the emulsion which have not been converted to metallic silver, and make the photographic image permanent. After the print has fixed you can inspect the image in regular light to select the exposure time which produced the desired tones in the materials. If your test strip does not produce a desired tonality, remake the test at different exposure settings.

(g)

(f)

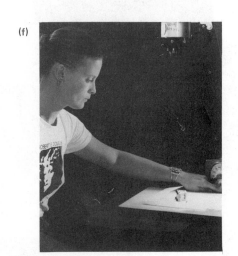

FIGURE 10.10(f) Once you have selected an exposure time, compose your photogram and set the timer.

FIGURE 10.10(g) After making the exposure, process the photogram through the chemicals at the same times and at the same rate of agitation as your test. The tonalities you get on the photogram should match those of the test strip.

indication of how the pictures will look. It does not show how sharply the image is focused or how much contrast and time will be needed to make the enlarged print.

The densities of the negative images in the proof sheet record similarly to those of the materials in the photogram. The opaque highlight areas of the negative will produce lighter tonalities just as the more opaque materials used in the photogram produce lighter tonalities. The more transparent the areas of the negative are, the darker the tonality reproduces. (See Fig. 10.11)

*FIGURE 10.11(a)  The materials needed to make a proof sheet are: a light source (the enlarger), a timer, enlarging paper, negatives, and a piece of glass. In this illustration, the photographer is using a commercial proofing frame, but a piece of window glass can work just as well. The glass keeps the negatives and the photographic paper in good contact with each other during the exposure to light.*

*FIGURE 10.11(b)  To make the proof sheet, position the photographic paper so that it can be exposed by the light from the enlarger. Place the negatives on the paper with the emulsion (the dull side) facing downward.*

*FIGURE 10.11(c)  This illustrates the proper position of the different proofing materials.*

*FIGURE 10.11(d)  After the materials are in place, expose the paper through the glass and negatives. Make a test strip using a single row of negatives as a guide to save time and materials before exposing a full 8 × 10 in. sheet of paper.*

(b)

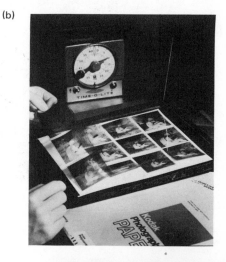

(a)

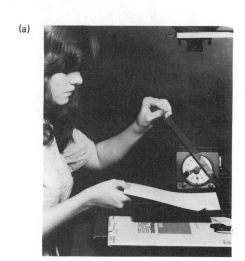

(d)

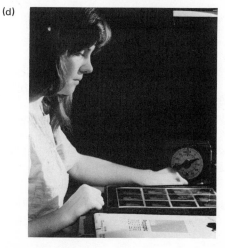

(c)

(e)

*FIGURE 10.11(e) The exposed proof sheet now is ready for processing. Place it in the developer for 90 sec. This time can vary depending on the developer used. Transfer the developed sheet to a short stop for 10 to 30 sec, then fix the image in a fixing agent for the recommended time. Finally, wash and dry the proof sheet in the normal manner.*

(g)

(f)

*FIGURE 10.11(f)  A proof sheet of 35mm negatives.*

*FIGURE 10.11(g)  A proof sheet of 120 negatives.*

## MATERIALS FOR MAKING PHOTOGRAMS

Materials that can be used to make the photogram are limited only by the photographer's imagination. All items which either transmit or block light are useful. The purpose of the photogram, however, can dictate what should be selected. For experiments into the characteristics of light and materials, for example, glass and plastic objects which reflect and refract light in patterns are used. Many of these take on an abstract quality.

Photograms designed to produce a more conventional image can be created with cutout objects and items found in nature and around the house. Materials can be selected to achieve a wide or limited range of tones, depending on their translucent characteristics. Opaque objects under normal expo-

sure produce white images, but translucent items make images of varying shades of gray. Also, areas of the photographic paper exposed to light will produce black tones on the print.

In addition to the objects for making the image, the darkroom materials needed for the exposure and processing of the photogram are: a light source, photographic enlarging paper, a piece of glass (slightly larger than the enlarging paper), trays for processing the print, and chemicals for developing and fixing the photographic paper.

## VARIATIONS OF PHOTOGRAMS

The procedure for making a photogram can parallel that for making a photographic enlargement, or it can diverge into experimentation and expression.

The image of the photogram shown in Fig. 10.10 is illuminated from a light source which is directly overhead. The angle is the same for making a photographic enlargement or contact prints from negatives. The object can be recorded in a different way by simply moving the light source to an angle. Although this change in light direction would not be readily apparent in two-dimensional objects, those with depth take on a different recorded form caused by the different way the shadow is thrown from the object. (See Fig. 10.12)

Photogram materials located at different heights above the light-sensitive paper produce changes in the recorded image. Normally, they are placed directly on the enlarging paper. This produces sharp edges that delineate the shape of the object. As the material is raised above the level of the paper and suspended, however, the edges of the shadows become more diffused, and

(a)

(b)

*FIGURE 10.12 (a) If an enlarger is used to make a photogram, the light strikes the subject directly from above. (b) It is also possible to light the subject from the side.*

the image takes on a ghostly appearance. Combining the sharply defined figures with the unsharp areas for contrast also give a sense of depth to the image. (See Fig. 10.13)

Another technique to add life to the stationary photogram and increase the amount of tones at the same time is to place opaque and translucent objects on the paper during a portion of the exposure and then reposition or remove the items during the remaining time of exposure. (See Fig. 10.14)

The photogram image does not have to be limited to found or constructed objects. It can be a combination of media, such as drawn or painted areas, or it can consist of drawn and painted scenes alone (Fig. 10.15). Another variation is to make the image on cloth, glass, or metal. The avail-

(a)
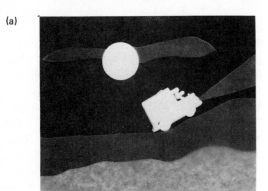

(b)

FIGURE 10.13 *Materials used to make the photogram can be recorded in many ways. (a) The materials were in direct contact with the enlarging paper during exposure. (b) The other photogram, which used the same materials, takes on a different appearance because the paper used to create the cloud formation was raised above the surface of the paper and moved during the exposure. This caused the clouds to take on a more transparent, softer shape.*

(a)

(b)

FIGURE 10.14 *Tonality can be changed in the photogram image by adding and removing objects during the exposure. In (b), the cutouts of the golf ball were added gradually during the exposure to give them slight tone gradations.*

*FIGURE 10.15   A combination of magic marker on plastic, glitter, and a cardboard cutout for the crescent of the moon were used to make this photogram. (Courtesy of Betty Baker.)*

ability of photographic emulsions, which can be made at home or purchased from specialty companies, make this technique possible.

Colored images can be produced when the photogram is projected on paper which is normally used for printing color negatives and slides. The complimentary or opposite color of the object will be recorded on paper designed for printing color negatives. Color papers designed for rendering positive images from slides will produce the same color as the object. The two types of color materials must be handled and processed differently than normal black-and-white papers, so the information which comes with the package should be consulted.

Procedural variations such as these certainly are not all inclusive. Imagination and creative experimentation will produce many more interesting formations and effects. Possibilities are unlimited.

## SUMMARY

The photogram is one of the oldest forms of photographic reproduction. Its history can be traced to the discovery of the light sensitivity of silver salts by Johann Schulze. Many experimenters, including Wedgewood, Davy, Niepce, and Archer, as well as artists such as Moholy-Nagy and Man Ray, produced photograms.

Primarily a means of artistic expression, the photogram can also serve as an instructional tool. The procedure for making it lays the basic foundation for making contact prints of negatives (proof sheets) and photographic enlargements. Therefore, it demonstrates many of the basic principles of image formation and allows the student photographer to become familiar with darkroom equipment and chemical procedures.

The photogram can be produced with many different types of materials such as glass, plastic, cutout paper, dried flowers, and other items found in nature and around the house. It can be made from conventional art materials such as pen and ink or paint or a combination of media. Imaginative experimentation can lead to many interesting formations and effects.

# ENLARGING

For many years after the invention of photography, enlarging photographic images was impractical. The early optical and camera systems were partially the reason. Long exposures were necessary for large photographs making portraiture impractical because of the recorded movement. To overcome the problem, small portraits were made, but early photographic processes had only a limited capability to enlarge them afterwards.

The two most popular types of early photographs were the Daguerreotype and the Calotype. The Daguerreotype was a positive image made on an opaque metal plate. The opaque nature of the plate prevented enlargements as we think of them today. The Calotype produced a negative image on an emulsion attached to a paper base. While it was possible to wax the paper to make it translucent enough for making contact prints, the texture of the base degraded and distorted the image when it was enlarged. The inventor of the Calotype, Fox Talbot, patented an enlarger and produced enlargements from small Calotypes, but the process differs from the one used today. His enlargements were made by placing the small original into a camera device which copied the original on a larger plate. (See Fig. 11.1) It was not until the invention of the transparent film base and the use of small negative sizes that enlarging became popular.

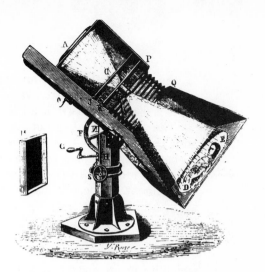

*FIGURE 11.1 One of the first photographic enlargers was the Liebert's Solar enlarger which was used in 1864. (Gernsheim Collection, Humanities Research Center, University of Texas, Austin.)*

## REASONS FOR ENLARGEMENTS

The reasons for enlarging the image are the same today as they were in the 1800s. The larger image enhances viewing as well as making it much easier to see the details. This is especially true for the smaller format 2¼ × 2¼ and 35mm negatives. The enlarging process also allows the photographer to manipulate different tonalities within the picture area and to make compositional changes by eliminating portions of the image on the negative from the areas of the scene printed on the paper.

The size to which an image can be enlarged and still retain acceptable sharpness and other quality considerations is controlled by many factors within each stage of the photographic process. But the maximum acceptable image size is mostly influenced by the sharpness of the negative and its quality. These factors are affected by the camera format size, the camera lens' quality, the negative's exposure, the type of film and its processing, along with the type of enlarger on which the print is made and the quality of its lens.

Sharpness of the negative is one of the critical conditions for making the enlargement. Prints of the same size as the negative usually have acceptable sharpness. The reason is that the circles of confusion (points of light which are not focused to their sharpest points) are small, and the eye cannot distinguish between the unsharp and the sharply focused areas because of their small size. However, as the size of the image is increased, the out-of-focus areas of the picture become more apparent, causing an out-of-focus appearance.

Areas that appear out-of-focus are difficult for the eye to view over a period of time. This out-of-focus appearance of the enlarged image is influenced also by the distance from which it is viewed. The closer the viewer is

to the picture, the more apparent the unsharpness is. An unsharp photograph seen from two feet away may appear in acceptable focus when the distance is increased to 10 or 20 feet.

The sharpness of the image, however, is inherent in the negative and can only be controlled to a small extent through the enlarging process. Placing the camera on a tripod, for example, increases image sharpness by eliminating the slight motions of the camera, which in turn creates sharpness in the final enlargement. Critical focus on the subject with a lens that produces a crisp, distinct image also helps in increasing the size of acceptable enlargement. Each of these precautions will help control the original circles of confusion that are recorded on the film.

Film size, type, and processing also play a part in determining the size to which an image can be enlarged. The film size determines the degree of enlargement needed for the subject to conform to a particular print size. For example, an image recorded on 35mm film would have to be enlarged to a greater degree for an 8 × 10 print than the same subject recorded on 4 × 5 film, if all factors were equal.

Besides film size, the type of film used to record the image has a role in the enlargement of the negative. For example, an image made on a slow-speed, fine-grained film allows a greater degree of enlargement without loss of detail than a similar image made on a high-speed, coarse-grained emulsion.

The development of the film, the enlarger, and enlarging lens have similar effects on the degree of enlargement. The negative progressively becomes more granular as the density increases. This density and granularity can be caused by overdevelopment.

The enlarger selected to make the print will affect the sharpness of the image, but it may create other problems. A condenser enlarger, for example, will produce a sharper print than that of a diffusion enlarger, but the granularity of the image also will be emphasized. On the other hand, the diffusion enlarger will diffuse the grain of the enlargement and possibly produce more pleasing results but less sharpness. For these and other reasons, the enlargement of photographic image is dependent on many factors.

Cameras produce images within set dimensions, and ideally, the photographer composes the subject up to the edges of the negative frame. Many times, however, a scene would be more pleasingly reproduced with different proportions. For example, a landscape photographed with a camera that produces a 2¼ × 2¼ negative may look better with a vertical or horizontal composition. (See Fig. 11.2) Through the enlarging process, the negative image can be *cropped* to emphasize the natural linear qualities of the scene.

Cropping allows the photographer to vary the size of the subject to conform it to the format of the print. (See Fig. 11.3) Obviously, it would be convenient if the subject was at its optimum position and size on the negative, but many times space between the subject and camera or other reasons make the preferred composition impractical to photograph.

(a) (b)

*FIGURE 11.2 Changing the format of a photograph by enlarging it can shift the emphasis to another part of the image. In (b), greater emphasis is placed on the youth and less on the background by changing the format from square to horizontal. (Courtesy of Mary Petterman.)*

(a) (b)

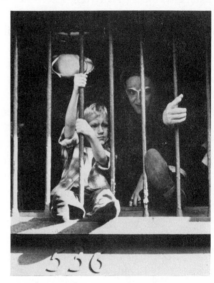

*FIGURE 11.3(a,b) Cropping and enlarging this photograph gives more emphasis to the subject, eliminates distractions and changes the picture's format from horizontal to vertical. (Courtesy of Damian Morgan.)*

Numerous compositional problems can be corrected to a certain extent during the enlarging process. The size of the subject can be altered in relationship to the surrounding background, or its placement within the picture frame can be changed. Distractions along the edges of the image can be removed, such as an area of sky in a landscape photograph. (See Fig. 11.4)

Relative to regulating the tonality of the photograph by enlarging it, areas of the image can be made lighter or darker than normal; mood and feeling can be created overall; and emphasis can be given to the subject. This tonal control is called *dodging and burning-in* and will be discussed more fully, later in this chapter.

FIGURE 11.4   *Cropping the image in the enlarger allows the photographer to remove distracting elements next to the subject. The building on the left in (a) was removed, and the size of the subject was increased to produce greater dominance in the composition of (b). (Courtesy of JoAnn Frair.)*

## ENLARGING PAPERS

One of the essential ingredients for producing the photographic print is the paper on which the print is made. There are several types, each with its own physical characteristics that can provide added emphasis to the mood and feeling of the picture.

Some papers are designed to make contact prints only, while others are capable of producing either contact prints or enlargements. In addition, papers are manufactured specifically for portraits, for use with commercial subjects, or for subjects to be reproduced in magazines, books, or newspapers. Specialized papers for rapid processing are also available.

The light-sensitive emulsion of photographic papers is similar to film emulsion. The main difference is in their levels of sensitivity. The albumen emulsion which used egg white as the suspension medium for the silver halides was originally designed to be coated on a glass plate for the production of negatives. But its greatest popularity occurred when it was coated on a paper base and used for making prints. (See Fig. 11.5)

Because of its low sensitivity to light, the albumen printing paper was a contact paper. The negative was placed on the emulsion of the paper, and the exposure was made by direct sunlight. Many of the contact printing papers on the market today have a similar low sensitivity and must be used with a special light source.

The invention of the bromide emulsions (those which use silver bromide as the light-sensitive halide) resulted in photographic papers being used for contact printing with a dimmer light source or for photographic enlargements.

Papers designed for portrait negatives are similar to other types except the emulsion is placed on a tinted base which gives the photograph a brownish appearance. The color supposedly adds life to the image.

Stabilization papers contain a portion of the developing chemistry already suspended in the emulsion. The paper is placed in an activating solution

FIGURE 11.5    (Courtesy of George Eastman House.)

which causes development at a faster than normal rate. Afterwards, the print is transferred to a chemical which stabilizes the silver halide's reaction to light. This produces a usable image that will last for months. While the resulting image is not permanent, it can be processed through regular fixing chemicals, then washed and dried to make it permanent. The stabilization paper can be processed in a tray but is usually done by a machine that produces a damp dry image in less than a minute. This processing speed is what makes stabilization a valuable tool, especially in areas like news photography where time is critical. When stabilization paper is processed in regular photographic chemistry, the speed of the emulsion is increased to compensate for the developing agents in both the emulsion and developer.

Papers also differ in emulsion supports, surface characteristics, and contrasts and tones reproduced.

Photographic papers are manufactured with two forms of emulsion supports. One is a standard fiber support; the other is a resin-coated (RC) support. The RC papers prevent absorption of the processing chemistry into the supporting base. As a result, their processing times are shorter. (See Table 11.1) The standard fiber emulsion support must be fixed and washed for a longer period of time, but the resulting image is more permanent. The resin-coated paper does have the advantage, however, of dimensional stability and quick drying without need of a heated dryer.

One of the major advantages of the fiber support is the availability of different image tones and surface characteristics. The image tone is controlled by several factors, such as the type of developer in which the image is processed, the color or tint of the support, and the type of silver halides used to sensitize the emulsion.

**TABLE 11.1**
**PROCESSING TIMES FOR PHOTOGRAPHIC PAPERS**

|  | Fiber-Based Enlarging Paper | Resin-Coated Enlarging Paper | Comments |
|---|---|---|---|
| Developer | 90 sec | 90 sec | Continuous agitation |
| Short stop | 10–30 sec | 10–30 sec | Continuous agitation |
| Fix | 10 min | 2 min | Two-bath fixing is recommended to extend the life of the fixer. |
| Hypo clear | 2–3 min | Not required | Occasional agitation |
| Wash | 10–20 min | 4 min | Single weight fiber-based paper requires 10 minutes washing after hypo clear (60 minutes without hypo clear). Double weight paper requires 20 minutes washing after hypo clear (2 hours without hypo clear). |

Both silver chloride and silver bromide are used in the manufacture of the emulsion for enlarging papers. Silver chloride combined with the bromide halides produces a warmer or browner tone than the silver bromide emulsion. Depending on the types of halides in the emulsion, the photographer can have dark tones, such as brown black, neutral black, or a colder blue black. The tones produced by the emulsion combined with the tint of the paper support provide a large range of tones to choose from. Each manufacturer has samples which demonstrate the tonality of each type of paper produced.

The surface characteristics of the paper add another dimension to the photographic print. Papers can have a surface with a high gloss, a matte finish, or many other textures ranging from surfaces similar to canvas to those resembling silk. By combining the characteristics of subject and paper, the photographer can place added emphasis on the subject's characteristics.

Each photographic emulsion, whether film or paper, has an inherent range of tones it will reproduce. This range can be varied somewhat by manipulating developing time and temperature, but this is not a satisfactory method of regulating contrast of photographic papers.

To give greater control, manufacturers produce papers which are graded according to the amount of inherent contrast they possess. This grading can be a numerical designation, such as contrast grade 1, 2, 3, 4, 5, and occasionally 6. The contrast grade with the lowest number (contrast grade 1) has the least amount of inherent contrast. Contrast grade 2 has a slightly greater amount, and each successive grade contains more contrast than the one before.

Other manufacturers give a description of the contrast produced by the paper. The designations may be "Soft," "Medium," and "Hard." The Soft contrast paper would indicate that the paper emulsion has little inherent contrast. If the Soft and contrast grade 1 papers were used to reproduce an image from the same negative, the contrast of the reproduced scene would be about the same.

Enlarging papers also come with emulsions which produce variable contrasts. The emulsions are manufactured in two layers. One is a low-contrast emulsion, sensitive to yellow light. The other produces high contrast and is sensitive to a red-blue (magenta) light. The amount of reproduced contrast is regulated by filtering the light striking the emulsion. When a yellow filter is used, the image is formed in the low-contrast emulsion. A red-blue filter affects the emulsion with high contrast. By varying the color of light with different filters, variable contrasts can be achieved, similar to that produced by graded papers.

In addition, variable contrast papers reproduce intermediate degrees of contrasts, and the amount can be controlled on each sheet. This is an advantage over the graded papers which must be purchased by the package, each with an individual contrast grade of paper. Most of the time, the intermediate grades are used more frequently than the lower and higher contrast papers, resulting in deterioration of the lower and higher contrast emulsions before the entire package can be used. Such waste does not occur with the variable contrast paper.

Another advantage of the variable contrast paper is that various portions of the image can have different contrasts by printing some parts of the scene with a high contrast filter and other sections with one of low contrast.

Ideally, the photographer always has a negative with proper contrast and exposure. In practice, this is seldom the case because of the variety of lighting conditions under which pictures are made. For example, a photograph taken on a bright sunlight day will contain more inherent contrast than a similar picture made in the shade. The difference in contrast comes from the quality of the light striking the subject. Bright sunlight is very directional and produces extreme differences in levels of illumination between areas being directly struck by the sunlight and those areas in the shadows. When transferred to the shade, the subject is illuminated by diffused light. In that case, the light strikes the subject from many directions at the same time and, therefore, creates few shadows. Those produced are similar in intensity to the brighter areas of the subject. The contrast of the subject then would be greater in the sunlight picture than that of the one made in the shade, and this difference would be transferred to the film. If both negatives were printed on an intermediate contrast grade of paper, the negative made of the subject in the shade would print possibly with too little contrast. The negative made in bright sunlight could print with too much contrast.

For this reason, enlarging paper comes with different inherent contrast to compensate for the contrast of the photographed scene.

A photographic paper with an inherent contrast grade of 1 (whether in individual packages or variable contrast paper using a #1 filter) is designed to be used with negatives that have a greater than normal contrast. Grade 2 is for negatives of normal contrast; grade 3, for negatives with lower than normal contrast; and grade 4, for negatives with low contrast.

## CONTRAST AND TONE CONTROL

The photographer must decide on which contrast grade of paper to use for a black-and-white print. Before selection is made, many variables need to be considered. In some instances, the following guidelines can be helpful.

The first rule of thumb is that the print should normally contain pure black-and-white tones, and at the same time, details should be reproduced in both the shadow and highlight areas. If the print exhibits these characteristics, then more than likely the contrast will be correct. (See Fig. 11.6)

Test strips made on different contrast grades will indicate the best paper for the illustration. If a print has pure black-and-white tones but lacks detail in either shadow or highlight areas, a lower contrast grade of paper will improve the contrast. Conversely, if the print has shadow and highlight details

*FIGURE 11.6(a)  This negative made on a rainy day exhibits close to normal density, but because of the lack of contrast in the lighting it has slightly less than normal contrast.*

*FIGURE 11.6(b)  A print made with grade 1 or softer than normal contrast paper does not produce a pure black or pure white. It does retain details, however, in both the shadow and highlight areas.*

FIGURE 11.6(c) When the negative is printed on a grade 2 or normal contrast paper, the contrast of the print is increased, but the print still lacks the pure black and white tonalities.

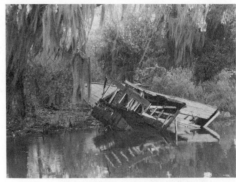

FIGURE 11.6(d) Increasing the contrast of the printing paper to a grade 3 for this print increased the depth of the black tones and retained the whites. At the same time, detail is still exhibited in both the shadow and highlight areas of the subject.

FIGURE 11.6(e) The use of a high-contrast grade 4 paper for this print also produced a pure white and black within the image. The loss of detail in the shadow areas, however, indicates that this print is too contrasty.

but lacks either a pure black-and-white, the contrast can be corrected by increasing the grade. (See Fig. 11.7)

As with any guideline, exceptions are sometimes in order. Deviating from the norm to create moods and feelings calls for violation of the rules. For example, to produce a dramatic photograph with exaggerated contrasts between the dark and light areas, greater than normal contrast is necessary. A photograph previsualized as being light and airy may be enhanced with less than normal contrast.

A highly subjective guideline is that the print should have the same contrast between the light and dark tones as the original subject. Beginning photographers tend to make prints without enough contrast. One of the possible

A test strip is a series of enlarger exposures made on a single sheet of paper to guide the photographer in selecting the best setting for a good photographic enlargement. We have used test strips in previous inserts. In addition, a test strip is a guide for selecting proper contrast and for making printing corrections, such as dodging and burning-in. A test strip saves time and money because a range of exposures can be compared without having to make several prints.

*FIGURE 11.7(a)  The first step in making the test strip is to make sure that the negative is clean. You can use a soft brush to loosen dust and lint on the negative. Then blow the loose particles off with a can of pressurized air. Any foreign material left on the negative will project onto the photographic paper as enlarged white specks. If the dirt is embedded in the negative and cannot be removed by brushing, use a chemical film cleaner or rewash and dry the negative.*

*FIGURE 11.7(b)  After the negative has been thoroughly cleaned, place it into the enlarger.*

*FIGURE 11.7(c)  To focus the enlarger, open the lens aperture to its widest diameter. This produces the brightest image for precise focusing and composing. Repeat the procedure each time you focus the enlarger.*

(a)

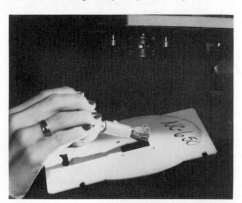

(b)

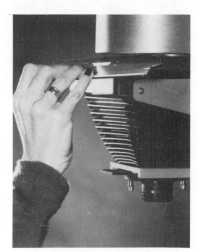

(c)

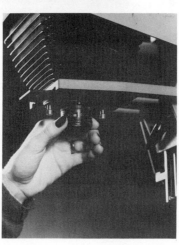

(e)

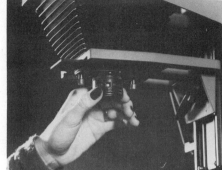

(d)

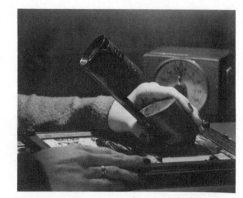

(g)

(f)

*FIGURE 11.7(d)  The size of the image in the test strips must be the same as in the final enlargement. Any difference will affect exposure and focus of the image. The photographer pictured here is checking the focus through a grain magnifier.*

*FIGURE 11.7(e)  Once you have determined the composition of the image and focused it, stop the lens down to its printing aperture setting. This normally is about two f/stops less than wide open. If the negative lacks density, you may need to stop the lens down even further.*

*FIGURE 11.7(f)  Set the enlarger timer, beginning with 2- to 3-sec intervals. If you use a projection print scale, set the time for 60 sec.*

*FIGURE 11.7(g)  Place a 2 by 8 in. piece of paper on the easel and cover up about three-quarters of it with a piece of cardboard. Then make your first exposure. If the paper was developed at this point, you would have a strip that had received a 2-sec exposure, and the rest of the paper would be unexposed.*

FIGURE 11.7(h)  *Without disturbing the paper on the easel, move the cardboard so that it now covers only half of the paper. Make another 2-sec exposure. The test strips now have two different exposures. That portion uncovered during both tests has been exposed for 4 sec. The other has received only the single 2-sec exposure.*

FIGURE 11.7(i)  *By repeating the procedure, more and more of the paper strip is exposed, and the time of exposure accumulates on each exposed section.*

FIGURE 11.7(j)  *An alternate procedure is to use a projection print scale. This scale is made on a piece of plastic and has wedge-shaped segments that have different degrees of translucency. The density of each wedge is measured to block out a set amount of light.*

*By setting the enlarger timer on 60 sec, portions of the image underneath the print scale receive the equivalent of 2, 3, 4, 6, 8, 12, 16, 24, 32, and 48 sec of exposure, depending on the density of the segment through which the light passes. After the test has been developed, the correct exposure time can be read directly from the best appearing section of the scale.*

FIGURE 11.7(k)  *After the exposures have been completed, put the test strip into the paper developer for the recommended time. It is important later that you use the same exact time to develop the print. Most paper developers recommend constant agitation of the print in the chemicals for about 90 sec.*

FIGURE 11.7(l) *Continue to process the test strip through the short stop and hypo. When the image is permanently fixed, it can be inspected under normal room light. If all sections of the test strip are too light, remake it with a wider aperture setting or longer exposure intervals. If they are too dark, use a smaller aperture.*

*Ideally, the test strip will have the correct exposure somewhere in the center. Select the properly exposed section and count the number of strips to arrive at the correct exposure time.*

reasons is that the eye does not see contrast the way it exists in a scene. As mentioned earlier, it scans a scene, continually adjusting for brightness as it goes from light areas to dark, causing the tonal relationships to appear closer to each other than they actually are. The beginning photographer is faced with the problem of translating the world of color into the print's reproduced shades of gray.

A third guideline for selecting proper contrast is even more subjective than the others. The rule is that the print should be pleasing to the eye. For the beginning photographer, this is the hardest judgment to make. Prints that exhibit contrast extremes, of course, are easy to evaluate. But as the contrast comes closer to being correct, the more difficult it is to recognize and to previsualize what subtle changes will accomplish.

Photographers never totally agree on what is proper contrast, and what constitutes the correct amount changes over the years. Prints considered too contrasty or not contrasty enough today may be acceptable tomorrow.

Opinions about how dark or light a print should be are as subjective as those about contrast. Tonality, like contrast, can be a matter of personal taste. There are guidelines, however, which will aid the beginning photographer in selecting proper tones.

If the tones of the print match those of the original subject, then they should be correct. Here again the photographer may encounter problems in translating colors into tones of gray.

One of the essential factors in tonal selection is what the photographer wants to say with the picture. With each photograph, the photographer tries to capture and share with the viewer a particular mood or feeling. The tonality of the print can be used to emphasize and enhance this communication. For example, each tone has its own psychological projection. Dark tones convey somber, moody, unhappy feelings and create a sense of heaviness (Fig. 11.8). Light tones generate feeling of happiness, gaiety, lightness, and airiness (Fig. 11.9).

Printing to the mood being conveyed enhances it. But photographs with predominately light tones will not give somber feelings by simply printing them darker. They will appear only as dark prints. The *key* of the picture

FIGURE 11.8  Dark tonalities of the picture produce a feeling of somberness and give a heavy appearance to the picture.

FIGURE 11.9  A high-key photograph is made of predominantly light tones and creates a visual impression of lightness and gaiety. (Courtesy of Kenny Stevens.)

needs to match the previsualized mood of the photograph. *Key* is the relationship of light and dark tones within the picture frame. A picture which contains predominately light tones is referred to as a *high-key* photograph. One consisting of predominately dark tones is called *low key*. Most photographs, however, contain about equal amounts of light and dark areas and fall into the *mid-key* range. A naturally mid-key picture cannot normally be made into a high- or low-key photograph through printing. The tone of the prints is used only to emphasize the natural key.

Sometimes the lightness or darkness of the print depends on the subject matter, its texture, and its original color. Textured objects of light colors often must be printed slightly darker than normal to emphasize their natural textural qualities. Dark subjects with texture can sometimes be printed slightly lighter than normal. This will produce better detail in the dark tones without destroying the overall quality of the photograph.

Correct tonality depends on the purpose of the print. If the print is to be exhibited in a brightly lit place, then the tonality of the print can be darker than it would be if it were to be viewed in a darkened corner. The level of illumination, in this instance, affects the visibility of the dark areas.

A problem with some of the textured papers is that darker tones are produced when the emulsion is dry, and appear lighter when the paper is wet. This is a minor factor when the photographer prints on glossy surfaced papers, but it can be a major obstacle with some of the textured papers. They can dry down or *plum* to a tonality which appears as if the photographer made the print much darker than normal. (See Fig. 11.10)

Enlarging the image from the negative is a stage of the photographic process when all the elements of composition, exposure, and development come together to create the finished print. To save money and time, each photographic enlargement should begin with a test strip to get correct tonality and contrast without having to make a whole series of individual large prints.

*FIGURE 11.10(a)   Using a test strip as a guide, first adjust the enlarger's timer to that which gave the correct tonality. Occasionally, results on the print do not correspond to those of the test strip. The discrepancy occurs because a series of short exposures may not record exactly as a longer, single exposure. For example, three 2-sec exposures may not be the same as a single 6-sec exposure. If the final results are to be exact, use the same series of exposures you used in making the test strip.*

*FIGURE 11.10(b)   After adjusting the enlarger timer, open the aperture to its widest diameter, refocus the image, and then stop the lens back down to the setting which was used for the test strip. The photographer in this illustration is checking the focus of the grain through a focusing instrument. Occasionally, you may want to use a different aperture and time than that indicated by the test strip. This can occur when the time is extremely short or long. Ideally, you should have an exposure of 10 to 15 sec. Using the test strip as a guide, equivalent exposures can help you arrive at this longer or shorter time.*

*FIGURE 11.10(c)   Turn the enlarger off and place a piece of photographic paper into the easel, emulsion side up.*

(a)

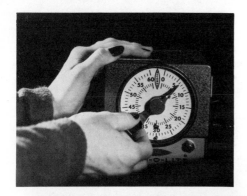

(b)

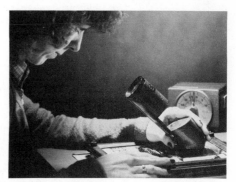

(c)

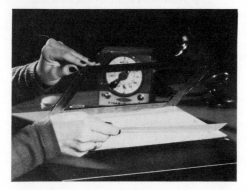

(d)

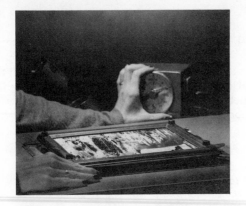

(e)

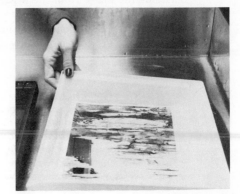

(f)

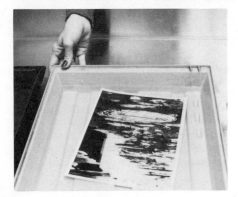

(g)

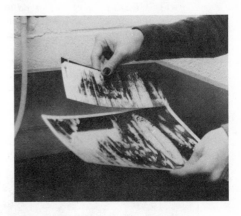

FIGURE 11.10(d) *Activate the timer on the enlarger to expose the paper. This will produce a straight enlargement, which means that no special tonal manipulations have been made during the enlarging process. Most prints need some sort of manipulation, but the straight enlargement can serve as a guide to help you later in determining which areas you should manipulate.*

FIGURE 11.10(e) *The exposed print is processed in trays of developer, short stop, and hypo. Put it first in the tray containing the paper developer. Even if the image develops too quickly or too slowly, allow the print to develop for the recommended time and then make tonal adjustments by reprinting it with different exposures.*

FIGURE 11.10(f) *Transfer the developed image to the short stop and then to the hypo to fix it permanently.*

FIGURE 11.10(g) *After about 2 to 5 minutes in the hypo, depending on the freshness and make of the fixing agent, you can inspect the print under normal lighting conditions. At this point, you should decide on which areas to lighten and/or darken. If you decide on keeping this print, you should return it to the hypo for the normally recommended time to fix it permanently.*

# PRINT MANIPULATION

Very seldom does the camera record a scene on film exactly the way the photographer previsualized it. The reason for this less than perfect image is that the photographer does not always have complete control over the different light intensities striking the scene or control over the original tones of the scene. During the printing process in the darkroom, however, the photographer can alter the different tones to improve the overall effect of the print and to make it more closely approach the way it was originally previsualized.

While there are many ways of manipulating the tones, the beginning photographer should start with the two basic controls: lighten and darken selected areas of the print. Both procedures usually are needed to improve the image produced by a "straight" enlargement.

The procedure for making certain areas of the print lighter than normal is called *dodging*. It is used to retain greater detail in normally dark areas, such as shadows. Dodging makes lighter tones even lighter. Since the normal reaction of the viewer is attraction to light areas of the print, the technique will draw attention to this point.

The process of dodging the print is conducted during the first phase of the enlargement exposure. If more than one area needs to be dodged, the exposure time can be divided into separate segments.

If the photographer dodges with tools in both hands, which requires a little practice, up to four separate areas can be lightened during the normal exposure. Dodging should not be attempted, however, until the photographer has arrived at the correct exposure times and contrast for the overall print. Otherwise, attempting to correct both normal and dodging exposures can lead to confusion. (See Fig. 11.11)

While the process of print dodging is done during the time of normal enlargement exposure, selective darkening of the print comes after the exposure is completed. This technique is called *burning-in*, and it is used to add details to light areas, remove distractions, and to darken light areas.

Film records several more shades of tone than photographic paper is able to reproduce. Often this causes light areas to record as pure white on the print even though details are present in the corresponding parts of the negative. The photographer can darken these light areas by burning-in so that details become visible. Since the eye is naturally attracted to light areas of the print, those apart from the subject become distractions by competing for attention. Darkening them solves the problem. Sometimes the details of dark areas can be distracting. Burning-in, in those instances, can make them darker without detail and, therefore, less distracting in the composition.

A straight enlargement receives a normal exposure before the darkening exposure is given. Therefore, the photographer is able to judge which areas should be burned-in. Once that decision is made, test exposures can be made to determine the amount needed to produce the wanted tones. (See Fig. 11.12)

*FIGURE 11.11(a)  Dodging can be done with the hands or with com-mercial dodging tools, such as those illustrated here. The small wire handle is used for dodging interior areas of the picture.*

*FIGURE 11.11(b)  One of the first steps in dodging is to decide which areas would be improved with a lighter tonality. By checking the test strip made during an earlier procedure you can estimate the exposure times required to produce the lighter tonality. Normal lightening will be at least half of the original exposure.*

*FIGURE 11.11(c)  Place the dodging tool between the light source and the photographic paper so that a shadow is thrown over the area to be lightened. After the required time is completed, remove the tool and allow the dodged area of the print to receive the remaining enlargement exposure. To keep from getting a sharply defined area where the print was dodged, keep the tool in constant motion.*

*FIGURE 11.11(d)  The hand also can be used as a dodging tool, but be careful that the wrist and arm do not dodge other areas of the print where tonality change is not desired.*

(b)

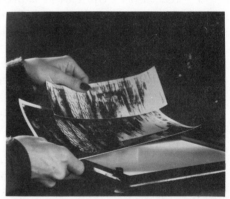

(a)

(d)

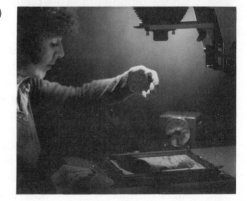

(c)

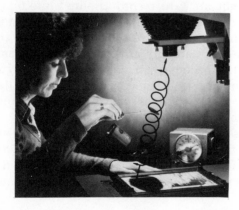

*FIGURE 11.12(a)  Burning-in the print, like dodging, begins with an examination of a straight print and comparing the areas to be darkened with a test strip to arrive at an estimated exposure time. Increasing the exposure by one stop over the original exposure is usually the minimum time needed to achieve a noticeable tonality change, but it can be longer, depending on the original tonality of the area to be darkened.*

*FIGURE 11.12(b)  An opaque board with a cut out hole is a suitable tool for burning-in. A board with a light tonality on the side facing the light source makes it easy for you to see the areas which need to receive the extra exposure.*

*FIGURE 11.12(c)  The hands can be shaped to form a funnel that allows light to pass through to the appropriate area of the print. Remember to keep the hands, or the board, in continuous motion to prevent definite lines being formed around the darkened area.*

(b)

(a)

(c)

Prints can be lightened and darkened by two other manipulations, called vignetting and flashing. *Flashing*, like burning-in, is used to darken portions of the print, but the procedure generally produces overall black tones or dark gray tones without increasing details. Flashing is done with a raw light from either a separate light source, such as a pen light, or from the enlarger

while the negative is removed. By changing the exposure time, a light area can be made to record in different tones of gray or pure black. The process is used to remove distractions and to create visual barriers in the print. (See Fig. 11.13)

*Vignetting* is the technique of holding back light so that the outer edges of the image are not recorded on the print. It is usually associated with portrait photography, but occasions arise when the photographer can use the technique with other subjects. (See Fig. 11.14)

(a)

*FIGURE 11.13  Flashing eliminates distractions in the picture by changing their tonality to black or dark gray. Here the background has been exposed to raw light (light that does not contain an image) causing it to become black without detail. The technique brings the viewers' attention to the face of the subject in (b).*

(b)

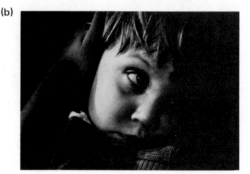

(a)

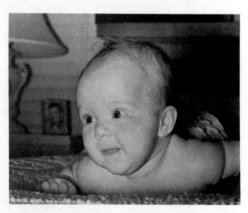

(b)

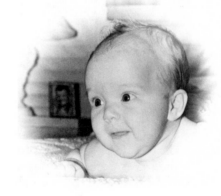

*FIGURE 11.14  Vignetting the image can be done when the picture is made or during the enlarging procedure. Here, in (a), the original picture contains distracting background elements which were removed when the enlargement was made by projecting the picture through a circular hole during the paper's exposure. This caused the distracting elements to be dodged from the final print (b).*

# SUMMARY

Enlarging is one of the creative phases of the photographic process, but for many years after the invention of photography, it was impractical. The popularity of small negatives, however, created the need for enlarged images.

During the enlarging process the photographer can alter the composition of the original image to a limited extent. More importantly, the tonality of the final image can be changed to match what the photographer previsualized.

By altering contrast and tones and by selecting different paper surfaces and color stocks, the mood of the photograph can be enhanced. The image can be made more abstract by manipulating contrast to place emphasis on texture and patterns. Tonality control can emphasize or delete detail in the subject.

The techniques of dodging and burning-in are used, respectively, to lighten areas of the print so that greater detail is produced, or to darken areas to remove distractions or reproduce light areas with greater clarity. By combining the procedures, the photographer is able to change the tonal composition of the print so that it is more pleasing to view. Flashing and vignetting are two other methods used to darken and lighten portions of the print.

# 12

PRINT FINISHING

The final use of the photograph determines what procedures are still needed after the print is washed and dried. If the print is to be reproduced in a newspaper or other type of publication, only spotting is necessary. For displays or exhibitions, the print will need *spotting*, *mounting*, and possibly *matting*.

## PRINT MOUNTING

Print mounting is the procedure of attaching the photographic print onto a heavy support board, masonite, or other type of material to keep the print flat and to protect it from being bent or creased during handling.

Mounting can serve an aesthetic purpose by directing attention to the print with the visual frame it creates around the image or by creating a mood for the photograph.

Mounting can serve many useful purposes, but proper care must be exercised in selecting the mounting materials. Otherwise, all positive aesthetic qualities can be negated, and actual physical harm can be done to the photographic image. One of the reasons for mounting the print, for example, is to direct the viewer's attention to the image. If a brightly colored board surrounds a black-and-white image, the eye will be attracted more to the colors than to the gray tones of the print. This, in effect, causes the mount to become the subject.

Although the process of selecting a surrounding mount is highly subjec-

tive, normally black-or-white boards or those of differing shades of gray are best suited to display black and white photographs. If the image is toned (Toning is changing the hue of an image with dyes or by chemically changing the silver image.) it can be enhanced further with a similar but darker hued mounting board. (See Fig. 12.1)

Both mounting boards and adhesives contain chemicals which can be harmful to photographs. The varying amounts of acids and sulfur compounds they contain can react with the silver image to create discoloration and even deteriorate the image itself.

In terms of print durability and permanance, proper selection of mounting boards and adhesives can be a critical factor. If the photographer wants archival quality so prints will last hundreds of years, a board of 100-percent rag content should be used. But this is extremely expensive, so most photographers select high quality boards with low acid and sulfur content. Prints with this type of mount will last for many years without signs of deteriorating. The wrong adhesive can cause rapid deterioration of the print image. Some compounds, such as office rubber cement, contain an extremely high sulfur content that produces deterioration and staining within a couple of years.

(a)

(b)

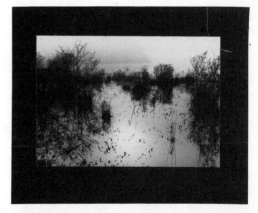

(c)

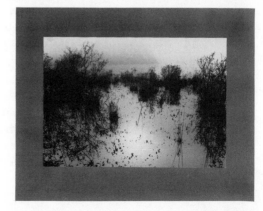

*FIGURE 12.1(a,b,c) The appearance and contrast of a print can take on different visual impressions with different tones of mount boards.*

**SPRAY ADHESIVES.**  Mounting adhesives can come in the form of a spray which is dispersed on the back of a trimmed print by a special applicator or aerosol can. Afterwards, the print is positioned on the mounting board.

Spray adhesives create little mess and generally do not need special equipment to complete the mounting. Depending on the type and brand, some will bond the paper on the board immediately upon contact. Other adhesives are *positionable*. This means that the coated print can be moved around the mount board until a suitable place is found. Then pressure must be applied to bond it. Most of these adhesives do not create a permanent bond between the photograph and board. The print can be peeled off, or it will separate naturally after a period of time.

Some positionable adhesives can be permanently bonded with special mounting presses. The press creates a vacuum which sucks the print and board together with great pressure. The bond should last as long as other permanent types of mounting if the manufacturer's recommendations are followed closely. This form of cold mounting was developed to be used with color photographs printed on RC (resin-coated) paper. Color prints are expected to last only for several years before the dyes which make up the image fade and the print has to be replaced. Used in this context, the permanency of the mounting is longer than the useful life of the print. Photographs printed on black-and-white RC paper also can be mounted successfully with this method since they are not permanent images. As is with color prints, the mounting adhesion will outlive the life of the print.

This type of mounting, however, does not work well with fiber-based pictures which have a natural tendency to curl. Eventually, the print will separate from the bonded board.

Another type of cold mounting that works well with RC based papers but is unsuitable for fiber-based papers is adhesive sheets, which are placed between the print and the board and then bonded with pressure. Here again, this type of mounting will outlast the image on the resin-coated paper, but it will not bond well with fiber-based materials.

If the photographer chooses to mount a print made on RC materials, the positionable quality of the adhesive sheets allows them to be moved about until the correct mounting position is acquired. Once this position is found, the photographer only has to apply pressure to the face of the print for it to be tacked to the mounting board. A burnishing tool or a special mounting press is applied to the print and mount board to complete the mounting procedure.

**WET MOUNTING.**  Some photographers prefer to mount their photographs on masonite or wood panels, using a *wet mounting* technique. This type of mounting works well with large photographs. The adhesive is either ordinary wall paper paste or a white plastic resin glue, such as Elmer's Glue, but neither type of adhesive produces a permanent bond. When a print is wet

mounted, either adheisve will cause slow deterioration but the print and mounting will last for many years.

To wet mount a photograph, first soak the base and emulsion in clean water, then blot the print dry. Spread the adhesive on the board with a serrated edge tool, similar to that used to install tile. If the print and mounting surface are small, a comb can be used.

After the adhesive has been distributed, roll the print onto the board from one end. This prevents air bubbles from being trapped underneath the print. Small bubbles can be squeezed out by working them from the center of the print outwards to the edges. After the print is attached, wrap the edges around the ends of the boards so that the dried print will not lift.

This method of mounting is usually reserved for large prints. The trouble and mess associated with the process make it impractical for small pictures.

DRY MOUNTING. One of the easier, neater, and quicker ways of attaching the print permanently to a mount is with dry mounting tissue and a heated press. Not only does the method create a permanent bond, but unlike pastes and glues, it does not react with the photographic image to cause deterioration and discoloration.

Modern dry mounting tissue uses either a thermoplastic adhesive or a shellac-impregnated paper to create the bond in the heated press. The heat melts the adhesive and bonds the print and board together. The bond is permanent unless the mounted print is subjected to temperatures which will remelt the adhesive.

Several types of dry mounting materials are available. Some adhesives form the bond as they are heated; others bond as they cool. Melting points come at different temperatures, ranging from 180 to 225°F (82 to 107° C).

Other materials are designed for mounting color or black-and-white prints, with either smooth or roughly textured surfaces. One of the more convenient tissues is the *self-trimming* type, which automatically conforms itself to the dimensions and curvatures of the print. Those using material without this feature leave tissue at the edge of the print that must be manually trimmed. (See Fig. 12.2)

Most dry mounting adhesives must cool under pressure to form a permanent bond. After the print mount cools the state of the tissue can be checked by lifting an edge of the print.

If the tissue adheres to the back of the print but not to the mount board, the temperature of the press was probably too low or the time was too short for the temperature used. Normally, the unattached surface of the tissue will retain its shiny finish.

If the tissue is attached to the mounting board but not to the print, too much heat or time was used. This usually happens if a cold press is not used. This condition can be corrected by reheating the print and placing it in a cold press until both the print and the mount board have cooled.

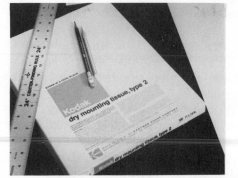
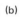

FIGURE 12.2(a)   *The first step in print finishing is to place the print on a stable support. The materials needed are: mounting board, dry mounting tissue, metal-edged ruler or straight edge, and X-acto or other type of razor knife, a cover sheet, and a heated mounting press. An iron can be substituted for the mounting press with limited success.*

FIGURE 12.2(b)   *To get a complete bond between the photograph and mounting board, all moisture must be removed from the materials. To do this, wrap the photograph with a smooth porous paper, such as unprinted newsprint, and place it into the heated press. With the temperature between 180 and 225°F (82 and 107°C), leave the print in it for about 45 sec. Open the press to release the collected moisture and repeat the cycle for an additional 30 sec. Repeat the procedure for the mounting board.*

FIGURE 12.2(c)   *After all the mounting materials have been predried, place a sheet of mounting tissue on the back of the print. To attach it make a small X in the center of the tissue with the tip of a tacking iron (pictured) or heated iron. The iron should not directly contact the tissue. Use a piece of silicon release paper to protect it. It is important that the working surface underneath the print be smooth and clean. Otherwise, impressions of the surface may be transferred to the print. To check how well the tissue is attached to the print, lift it by the edge of the mounting tissue. The reason for tacking is to ensure that the position of the print and tissue does not change when the print is trimmed and mounted.*

(e)

(d)

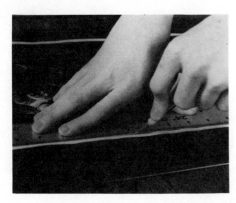

FIGURE 12.2(d)  Unless the print is to be flush mounted on the board, the print and the mounting tissue must be trimmed to the same exact size. If this is not done, tissue will protrude from underneath the print. If you try to trim the tissue to the print size before tacking it, portions of the print may not have tissue on the edges. This will cause the print to curl. To trim the print and tissue, place the print face up on a piece of scrap mounting board or cardboard. Trim the borders off the print with a metal straight edge and razor knife. If you want to retain a normal white border, place the trimmed print on a piece of white paper and then mount the print and submount on a piece of mounting board.

FIGURE 12.2(e)  A standard procedure for positioning a print on a mount board is to place it first in the upper left corner. Measure the distance from the upper right corner of the print to the upper right corner of the mounting board (a to a1). Divide this distance in half to arrive at position a2. A simple way to measure is with a scrap piece of paper. Then simply fold it in half to get the a2 position. Repeat the procedure from the bottom right corners to get the a2a position. With a straight edge, mark a light vertical line between a2 and a2a. You need not mark the entire distance, but only enough to represent a portion of the print's vertical dimension. At this point if the print were to be moved to the measured spots, it would have equal space on the left and right sides. With the print still located in the upper left corner of the mounting board, make a light pencil mark at the lower left corner of the print on the mount board (point b). Measure the distance from point b to the lower left corner of the mounting board (b1) and divide this distance in half. Transfer this half distance to the bottom right side of the mount board to arrive at point b2. With a straight edge, connect the points b–b2. This will produce a diagonal line that causes the bottom of the photograph to be moved to a higher than center position. Make a light mark at the intersection of lines a2–a2a and b–b2.

(f)

(g)

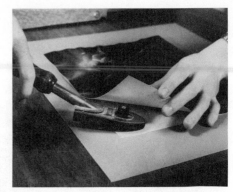

(h)

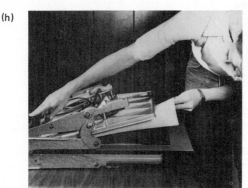

*FIGURE 12.2(f)  Drop the bottom left corner of the print to the inter-
secting vertical and diagonal lines. Align the vertical right edge of the
print with a vertical line created between a2 and a2a. This produces a
position equally spaced on the left and right sides of the print and with
slightly more space at the bottom than at the top of the photograph. This
position is the optical center of the mount board.*

*FIGURE 12.2(g)  After the print has been properly positioned on the
mount board, lift up the corner of the print and carefully apply the tip
of the tacking iron to the mounting tissue on the board. Repeat this pro-
cedure with a second corner. This will keep the print and tissue from
shifting during the transfer to the mounting press.*

*FIGURE 12.2(h)  With the print, tissue, and mounting board in position,
place them into the heated mounting press. Cover the face of the print
with a cover sheet to protect it from any material which may have been
previously left on the press platen. Check the temperature of the press
to make sure that it is at the recommended temperature for the mount-
ing tissue being used. Then close the press for the manufacturer's recom-
mended time. The duration given by the manufacturer can only serve
as a guide, since the thickness of the photograph and mounting board will
affect the time needed as will the humidity. Normally, 30 to 40 sec is
sufficient at temperatures from 180 to 255°F (82 to 107°C).*

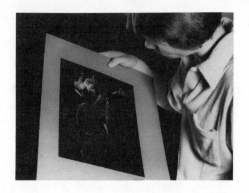

FIGURE 12.2(i)  The finished, mounted photograph can take many other forms than the simple mounting and submount illustrated here. It should be pointed out, however, that the photograph is still the most important ,part of the mount and should be given the greatest attention. The mount should not draw attention to itself.

**POSITIONING THE PRINT FOR MOUNTING.**  Unless the photographer is mounting a print on a board of the same size (flush mounting) positioning the print is a subjective matter. There are no hard and fast rules to guide the photographer. Each print will look best in relationship to its surroundings.

For the beginning photographer, however, some guidelines may be helpful. The one given here is based on the idea that image placement along a third quadrant will increase the visual interest of the photograph. This rule of thirds was discussed briefly in the Chap. 7 when we covered composition. A composition based on this rule has its main point of interest placed along one of the imaginary lines which divide the photograph into three equal parts, both horizontally and vertically. Because of psychological influences, the intersecting points create both compositional weight and visual interest.

The same basic premise works in mounting a print. Visual interest can be highlighted, for example, by placing the print in the upper third section and away from dead center, which is the area with lowest interest. This position will not always produce the greatest image enhancement, but it will seldom create visual distractions.

**PRINT MATTING.**  A print is matted by framing it behind a board with a cutout opening. Mats can be made from the same type of board used for mounting, but they are often more textured.

The mat protects the print just as mounting does, and also gives a feeling of depth to the presentation. To increase this impression, the inside edges of most mats are beveled.

Mats are almost always used when the photograph is to be framed behind glass. The mat keeps the emulsion of the print from sticking to the glass, which could ruin the print. Matted prints usually are mounted to provide a suitable support.

**SPOTTING.**  The removal of white spots from the print is called *spotting*. The specks are caused by lint, dust, or other foreign materials on the negative that block the light striking the enlarging paper.

Spot removal can take several forms depending on the intended use of the photograph and the surface of the paper. The three most common materials are (1) water or spotting colors, (2) dyes, (3) and pencils. Each has its own advantages and procedures.

**SPOTTING COLORS.**  Spotting colors are similar to water colors or tempera paints. They are water soluble and nonabsorbent. When applied to a print, they lay on the surface of the emulsion to cover the light spots. Because they are not absorbed into the emulsion, their best use is for photographs with rough surfaces or those for publication.

Most spotting colors have a matte finish when they are dry. Therefore, the spotted area remains visible even though it matches the tonality of the surrounding areas. This is especially true for emulsions with a glossy or sheen finish. Rough textured, matte finished emulsions will not show the spotted areas as readily as other surfaces.

The spotting colors can be used with shiny surfaces if the print is sprayed with a lacquer after all retouching is finished. The lacquer covers the emulsion and colors to make the spotted areas less noticeable, but their raised surface makes them slightly visible when the print is viewed at certain angles.

A major advantage over other materials is that spotting colors can be easily removed since they lay on top of the emulsion and are water soluble. Then the color can be reapplied. Removal of other spotting materials is more complicated.

**SPOTTING DYES.**  Since they can be used on all print surfaces without need of special preparations or aftertreatments, spotting dyes are the most common material used in print spotting. They differ from spotting colors in that they are transparent and are absorbed into the emulsion. Because of this, they do not disturb the surface characteristics of the print.

Another advantage is that they can be mixed to match exactly the different hues of black-and-white emulsions. The idea that black-and-white have colored hues may seem contradictory, but each type of emulsion will produce different hues of tones depending on the silver halides used in its preparation. Some emulsions produce greenish-brown tones rather than black; others are blue-black, brown-black, or even a neutral black. Most spotting materials give the photographer only a single hue to choose from for matching the emulsion color, but spotting dyes come in different hues that can be mixed to produce the same color as the emulsion.

The main reasons for the popularity of spotting dyes are that they do not disturb the surface characteristics of the emulsion, and they cannot be seen after they are applied to the print. When other materials are used, the print has to be treated to make the emulsion suitable for the spotting material or to cover up the areas afterward.

Their main disadvantages are the difficulties of removing the dye from the emulsion when mistakes are made and matching them to the darker tones because of their transparent nature. The dyes can be reduced in tonality or removed, however, with the application of ammonia or with a concentrated wetting solution, such as Kodak's Photo Flo. (See Fig. 12.3)

(b)

(a)

(c)

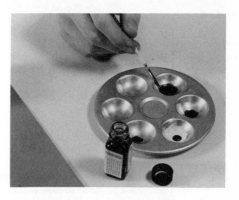

FIGURE 12.3(a)  *The print can be spotted with colors, pencils, or dyes. The spotting dyes shown here are the most popular. If you use dyes, a water color palette or a piece of glass, and a spotting brush are needed. Many photographers prefer to spot their prints before they are mounted, but the flat surface of the mounted print is easier to work on.*

FIGURE 12.3(b)  *The selection of a spotting brush is an important consideration. Any good quality brush that can make a sharp point is acceptable, but small spotting brushes ranging in sizes from #0 to #0000 are usually better because of their finer points.*

FIGURE 12.3(c)  *The first step in spotting with dyes is to mix the colors of the different dyes in the proportion recommended for the type of paper to be spotted. Place the brush into the concentrated mixture and transfer it to the artist's palette. This will give the darkest color. Without rinsing the brush, place it into a container of water and transfer it to a second area of the palette. This will produce a much lighter tone than the first and is suitable for midtone areas. Repeat the procedure a second and third time. Each time the brush is transferred from the water to the palette, the colors become lighter. Instead of water, sometimes a special mixture designed to break down the surface tension of the emulsion and spotting dyes is necessary to dilute the colors. This mixture is 3 drops of 2 percent acetic acid, 1 drop of diluted Photo-Flo, and 8 ounces of water. It is used in place of plain water for spotting with dyes or colors.*

(d)

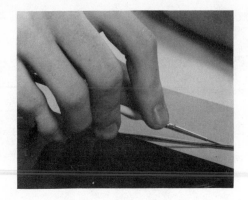

(e)

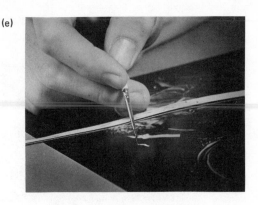

FIGURE 12.3(d)   Fill the brush with the tone of dye that closely matches the area surrounding the places to be spotted. Put a scrap piece of paper next to the area to be spotted. The scrap can be the border of the print which was trimmed off during mounting. Hold the brush horizontally and gradually rotate it as you pull it across the surface of the absorbent paper. This will dry the outer portion of the brush and at the same time form a point on it. Continue this procedure and watch the color of the dye being placed on the white paper. The dye will be absorbed into the emulsion, so the longer the brush is left in contact with the paper, the darker the color becomes. If the brush is too wet, droplets will form on the print and leave an undesirable mark.

FIGURE 12.3(e)   Once the proper color has been determined, touch the tip of the brush to the print where the white spot appears. This should be a very light touch. Do not try to paint out the spot. Simply place a very small dot of dye within the area. To fill in the spot make a series of small dots and match the surrounding area. For an enlarged area caused by lint, you first divide it in half by placing a single dot of dye in the center. Then continue to divide the area in half until the lint spot disappears. Spotting is an art. You should practice on old prints before trying to spot one you want to keep. You may achieve less than desirable results on your first attempt, but a little practice will produce invisible spotting.

**PENCILS AND OTHER METHODS.**   Some emulsion surfaces can be spotted with regular lead or carbon pencils. Those with matte or rough, nonglossy surfaces can be marked similar to regular writing paper. The lead can leave a visible shine on the matte surfaces when the print is viewed from certain angles. To make the marks invisible, the finished prints can be sprayed with a lacquer similar to the one used with spotting colors.

Glossy surfaces or emulsions with a sheen will not accept the lead because of the smooth finish. Spotting these surfaces with a pencil requires a

pretreatment that roughens the print's surface. This is usually done with a roughening lacquer spray, such as matte lacquer. Although most brands will work to a limited extent, a special kind, such as Macdonald's Retouch Lacquer, is normally used.

The retouch lacquer produces a *tooth* (roughness) to the surface of the print, which allows spotting with a pencil. Afterward, the spotting is sealed to the print with a finishing lacquer.

Occasionally, the photographer will need to remove the retouching or finishing lacquer. This can be done by wiping the emulsion with a lacquer thinner.

Other materials can occasionally be used for print spotting. Some of these are oil-based pencils which come in various shades of gray, pastels, oil, and acrylic paints. Like pencils, the oils and pastels require glossy and shiny surface emulsions to be pretreated with a retouching lacquer. And all of the alternate materials must be sealed with a finishing spray.

## FINAL FINISHING

Mounting and spotting can be the final steps in finishing a print unless spotting materials other than dyes are used. If so, then a spray lacquer finish must be applied to hide the spotting marks.

**SPRAY LACQUER.** A finishing lacquer serves several purposes. Not only does it hide the spotting marks, it can be used to protect the print. When the emulsion is sprayed with several coats of lacquer, it is laminated and sealed off from any outside contaminants. These contaminants can be as obvious as the acid from fingerprints, or insidious as the chemicals in the air, or harmful as ultraviolet light which fades and deteriorates the photographic image.

Spray lacquers can be used to change the textural qualities of a print. A matte surface, for example, can be made glossier, or vice versa. Because of this, many different types of sprays are manufactured. Some will produce a glossy finish; others give a luster or a matte finish to the emulsion. The photographer can select the spray which best portrays the feeling of the photograph.

A word of caution, however. The contrast of the print will be affected by the final finish. A glossy finish produces the greatest contrast of the image, and a matte surface gives the least contrast. If identical prints were made on a luster paper, and one print was covered with a glossy spray and the other with a matte finishing lacquer, the difference in contrast of the two prints would be quite noticeable. The reason is that the matte finish breaks up the light and reduces the contrast of the image. It will have less visual sharpness than the glossy photograph.

Other types of lacquers produce a textured finish. They are designed to spray unevenly over the surface of the print to create a texture of unlevel surfaces. The photographer can choose from among several different spray textures.

## SUMMARY

Print finishing is the final phase of the photographic process. In its basic form, it consists of mounting and spotting.

Mounting the print consists of attaching it with adhesives to a heavier support to keep it flat, to allow easier viewing, and to protect it.

Many of the adhesives on the market, can cause physical damage to the photographic image because of the sulfur compounds and acids they contain. These compounds can react with the silver image to produce discoloration and image distortion over a period of time.

Many different adhesives on the market are designed for photographic use. The most popular and permanent ones are spray and thermo adhesives. The spray type comes in pressurized cans that disperse the substance on the back of the print. Thermo adhesives, commonly referred to as dry mounting tissue, are either incorporated into a sheet of thin paper or in an adhesive sheet which melts at temperatures between 180 and 225°F (82 and 107°C).

The dry mounting tissue goes between the photographic print and the mounting board. The materials are placed in a heated press until the adhesive melts and permanently bonds the photograph and board together.

After the print is mounted, the next step in print finishing is spotting. This is the removal of white specks on the print, which are usually caused by lint, dust, or other materials on the negative. The print spots are enlarged areas of these materials.

Spotting usually is accomplished with water soluble colors, dyes, or pencils. The type of material selected depends on the use of the photograph and the kind of finish desired. Spotting colors are opaque and water soluble. They are applied on top of the emulsion to cover the lighter area and are easily removed. Dyes are absorbed and become part of the emulsion. The difference between the two mainly is in the finish. Spotting colors leave a noticeable difference in the surface finish of the print even though they cover the spot and blend with the surrounding area. This visibility is not important if the print is to be reproduced for publication. But if the print is to be exhibited, spotting dyes are the best choice since they do not disturb the surface characteristics. They are harder to remove, however, when mistakes are made in their application.

Pencils normally require pretreatment of the paper with a retouching tooth. Like spotting colors, pencil markings lay on top of the emulsion and can produce different textural characteristics. They are visible to the eye

when the print is viewed at certain angles. To make them invisible, the print needs an aftertreatment with a finishing spray.

Spray lacquers cover spotting and seal the print. They protect it from airborne chemicals and handling. Sprays, normally in the form of quick drying lacquers, come in many varieties. Some produce a glossy or matte finish to the print. Others are designed to produce a texture. The selection of the finishing spray is made according to the mood previsualized by the photographer.

# 13

# Available Light Photography

Available light photography is one of the earliest methods of taking pictures. In the 1800s, photographers had to make pictures by sunlight, inside as well as outdoors. Electronic and incandescent light sources were not yet available. For inside shooting, studios were designed with large windows and skylights to allow in as much sunlight as possible. Although the capabilities of available light photography have changed over the years, the term still refers to taking pictures under low, natural illumination.

## DEVELOPMENT OF AVAILABLE LIGHT PHOTOGRAPHY

Many of the photographs in the 1800s and early 1900s made inside with available sunlight lacked the candid quality now associated with the technique. It was not until the late 1920s and early 1930s that a German photographer, Dr. Erich Salomon, made a break from tradition to create what is now referred to as candid available light pictures. (See Fig. 13.1)

With a small, inconspicuous camera equipped with what was considered a fast lens at the time, Dr. Salomon began making candid available light pictures of political and other international leaders during their meetings and while they were relaxing. The development of the small format camera, somewhat larger than today's 35mm cameras, along with improved film sensitivity to light, allowed Salomon to make his pictures with only the existing light

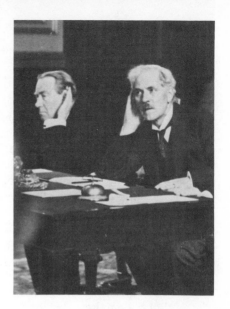

FIGURE 13.1 Stanley Baldwin and Prime Minister Ramsay MacDonald during a Press Conference. London, September, 1931. One of the first informal photographs taken at the British Foreign Office. (Dr. Erich Salomon. Courtesy Magnum Photos.)

sources where the leaders gathered. The portraits he published in German magazines were radically different.

The pictures made by Salomon and other photographers in the following years suffered from inherent technical problems. The film's low sensitivity to light coupled with the low light level under which the pictures were made required use of a wide open aperture setting and long shutter speeds to record the subject. Both of these problems contributed to the less than perfect technical quality of the photographs.

Undiscouraged by the technical imperfections, other photographers followed Salomon's lead, especially in making pictures of news and news-related events. The search for better technical quality led to a special mystique among those who made photographs with available light. Each photographer believed in a special developing formula or film and developer combination to improve the quality of available light pictures.

The amateur photographers of that era were restricted to fairly bright inside areas if they wanted good pictures under available light conditions. But by 1954 a series of technical developments brought candid available light photography to a point where it could be used successfully by even the beginner. In that year Eastman Kodak introduced a revolutionary new highspeed film marketed under the name of *Tri-X.* Not only was the film more sensitive to light than other films of the time, but it produced sharper images with less grainularity than earlier high-speed films. This allowed the photographer to use the film with relative ease under low levels of illumination. Other developments were lenses that admitted more light to the film, and improved film developing formulas. The new formulas made it possible for existing films to be rated at a higher sensitivity, and at the same time, they produced better image quality. With today's cameras, lenses, films, and film developers, even the beginning photographer can get excellent results under almost any lighting condition.

## EQUIPMENT REQUIREMENTS

Technical advances in photographic equipment and films since the 1920s now allow the photographer to produce available light pictures with relative ease. Lenses permit more light to enter the camera, and at the same time, produce a sharper image at the wide-open aperture settings. Films with high sensitivity to light are constantly improving the chances of taking successful pictures under almost any lighting condition. Ratings today are as high as ISO/ASA 1250/32°.

Since most available light pictures are made under low light levels, the type of camera, lenses, and films should be carefully selected. Most cameras that can be manually adjusted to accommodate different light levels are best suited. The inexpensive, nonadjustable cameras can be used occasionally if the light level is relatively bright and if the film selected is highly sensitive to light. But they are not suitable for most types of available light photography because they are designed to be used in sunlight or with a flash.

The adjustable camera allows the photographer to manipulate the shutter and aperture settings to compensate for the varying levels of illumination. Some types are more convenient than others. One measure of convenience is the camera's viewing system. This determines the ease and clarity of seeing and focusing the subject under low light levels. The system which produces the clearest viewing is the viewfinder. (See Chap. 2) Since this system does not use complicated lenses to form the image, more light passes through the viewfinder to the eye. The bright viewing screen lets the photographer see the scene with the same level of illumination through the camera as it is naturally.

Both the twin-lens and the single-lens reflex camera viewing systems project the image through a lens and onto a mirror. Part of the light being reflected from the scene is absorbed by the lens and mirror. This keeps the image from being as bright as it is with the viewfinder system. Under most circumstances, the light levels are bright enough to keep the darker images produced by the two reflex systems from being more than a nuisance. Under extremely low levels of illumination, however, the darker image can be difficult to frame and focus.

The selection of lenses for available light photography is another critical consideration. A lens that admits the greatest amount of light to the film takes better advantage of the lower levels of illumination, but those considered to be fast lenses may not produce the optimum image results when they are used under both low and normal lighting conditions.

The reason for this discrepancy is that most camera lenses produce their sharpest images at an aperture setting of about two $f$/stops less than their widest diameter. While the photographer may use the lens at its widest setting, $f$/1 or $f$/1.4, for making pictures under available light conditions, it will normally be stopped down to $f$/11 or $f$/16 for outside shooting. The result

is that the lens may be suitable for inside shooting; but for outside use, it may not produce as sharp an image as one with a smaller maximum aperture opening, such as $f/4$. This variation in image quality has been reduced by modern technology. Lenses can be used with a wide range of settings under different light conditions. But the older models still degrade the image considerably. Often it is best to select a compromise lens which is not as fast and which gives acceptable quality in both available light and daylight levels of illumination.

The photographer can select from many types of film with different sensitivity levels. A basic guideline is to select the film with the lowest sensitivity that can be used under existing light levels. The reason for this rule is twofold. The sensitivity of the film determines, to a large extent, the size of the individual grains of silver. The more sensitive the film is to light, the larger the individual grains of silver are, and the grainier the image appears to the eye. For this reason, highly sensitive films produce less detail and resolution of the subject than slower, finer grained films.

The second reason for the guideline is that attempts to increase the film's sensitivity by overdeveloping it enlarges the grain and increases the contrast between highlights and shadows. Most available light sources produce high contrast, and overdevelopment of the film further reduces the details in the shadows and increases the density of the highlight areas. The greater grainularity results in more loss of detail and resolution.

Available light levels are normally lower than sunlight, but on many occasions the photographer can use a medium-speed film with a rating of ISO 125/22° to produce a better overall image. Of course, some situations require more sensitive film emulsions, such as when the subject is moving or if a great depth of field is required. The extra sensitivity allows the use of a faster shutter speed to stop the motion or a smaller aperture opening to increase the depth of field.

One of the most obvious times to use the higher speed film is when levels of illumination are extremely low. The film permits exposure settings which are within a convenient range of the camera lens and shutter. (See Fig. 13.2)

An accessory, such as a tripod, which keeps the camera in a stationary

*FIGURE 13.2 The photographer should use the slowest possible film, but sometimes the low level of the available light, such as in this illustration, dictates that a highly sensitive film be used.*

position for the duration of the exposure, can be a helpful aid for available light photography. When the camera is steadied with a tripod, both the sharpness and graininess of the image can be improved. Often the granularity of the image, apparent in available light pictures, is the result of slight camera movement during the exposure. The motion slightly blurs the image, and film graininess is most noticeable and objectionable in the unsharp areas of the negative.

A tripod is essential for many types of available light pictures. Night exposures, for example, may need to be several minutes long. Unless the camera is steadily braced, some movement will be evident (Fig. 13.3). Although many photographers believe they can hold the camera steady for long exposures, a good rule to follow is to hand hold a camera no longer in fractions of a second than the focal length of the lens. That is, if you are using a lens with a focal length of 125 mm, the slowest shutter speed you should try to hand hold is 1/125 sec. Acceptable results can be achieved without following this guideline rigidly, but for the sharpest image, a tripod or some other type of camera support is needed.

Although camera steadiness is a major concern, a tripod is not always convenient or practical. In these cases, the photographer can use proper camera holding techniques to decrease the chances of camera movement. (See Fig. 13.4)

*FIGURE 13.3(a)  Night exposures made without a tripod can take on an abstract appearance because of camera movement during the exposure.*

*FIGURE 13.3(b)  Most night situations require use of a tripod or other type of camera support to prevent camera movement during the exposure. Sharp images are almost impossible to record without one when exposure times run into seconds. (Courtesy of Wanda K. Watson.)*

(a)

(b)

(c)

FIGURE 13.4 To reduce camera movement during the longer exposures required for available light photography, several techniques can be helpful. (a) A common method to brace the camera is to lean against a steady support such as a wall. (b) Another way is to wedge yourself into a corner so that walls on both sides keep your body from moving during the exposure. You can rest the camera or elbows on a table or other support during the time of the exposure.

## AVAILABLE LIGHT CONDITIONS

Sources of available light are usually associated with such things as table lamps, ceiling fixtures, or fluorescent lamps, all of which are part of the normal environment of homes, classrooms, offices, and other interior places. Other types of illumination which can be used in available light photography are candle light, fireplaces, and even spotlights and floodlights, when they are a natural part of an environment. An example would be the spotlights used at concerts, ice shows, circuses, or for lighting the exterior of buildings at night.

Light sources used to illuminate the scene produce their own moods and feelings. A highly directional light creates strong highlights and deep shadows in a photograph, while diffused lighting produces fairly uniform illumination

on the subject. A spotlight piercing through a smoke-filled room to encircle a performer on stage can create a very dramatic mood in the picture in comparison to the rather bland light produced by the fluorescent ceiling lamp in a typical classroom. In addition, fluorescent lighting does little for the subject in terms of producing modeling and contrast. The light from a candle or fireplace, on the other hand, gives an impression of intimacy and romance.

Under some circumstances, sunlight can be considered an available light source. To light a subject in an indoor setting or to supplement natural inside illumination are examples.

Sunlight in the early morning hours or late afternoon can be an effective available light source. Scenes which appear commonplace during regular daylight hours take on a special quality at twilight and dawn. The resulting pictures at those times can be refreshing and eyecatching. (See Fig. 13.5)

FIGURE 13.5  *Available light pictures are those made early in the morning or at twilight. (Courtesy of Ken Gaines.)*

Buildings and skylines with no particular interesting characteristics during the daylight hours can become the subjects of many provocative photographs during the time the sun starts to set and finally disappears from view. Depending on the moment selected, a building can appear as a silhouette against a still, light sky or one with lit windows shining against a darkened sky.

## ADVANTAGES AND DISADVANTAGES OF AVAILABLE LIGHT

The advantages of making pictures with natural light are numerous. One of the most obvious is convenience. Since the scene is already illuminated, the photographer can start taking pictures immediately without having to set up lights or use flash. This makes it less expensive, since the photographer

doesn't have to purchase artificial light sources. Occasionally, however, the existing light will not produce acceptable results. Therefore, most photographers own at least a flash unit and possibly other artificial light sources.

Perhaps the greatest advantage of available light photography is the sense of realism created in the minds of the viewers. It captures the essence of time and place, evoking a feeling that they are participating in the event as it actually happens. (See Fig. 13.6) This sense of realism is almost impossible to duplicate with artificial light sources. The mood of a room, for example, is partially produced by the pattern of light which illuminates it. It can be created accidentally or by design, but in either case, the use of other light sources can destroy or dilute the feeling which normally exists.

As mentioned earlier, the quality of available light depends on its source. Each type of light produces its own unique feeling which can best be captured through available light photography. While it is possible for a lighting specialist with proper equipment to duplicate many qualities of available light, the average photographer would find it difficult to accomplish.

Realism is enhanced by the relaxed state of the subject in available light situations. Unless they are professional models, people generally tense up when they are confronted with cameras and lights. Although they may never completely forget that their pictures are being taken, they are better able to relax if they are not reminded by the blinking flashes or continuous lights shining in their faces. (See Fig. 13.7) For some subjects, such as children, attention span is very short. Once the photographer starts to photograph

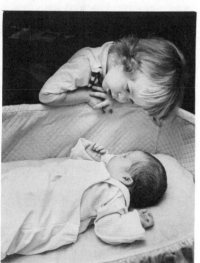

*FIGURE 13.6 Available light produces a sense of realism and of being there when the event occurs. This illustration would not have the same impact and softness if it were made with artificial light sources or with flash.*

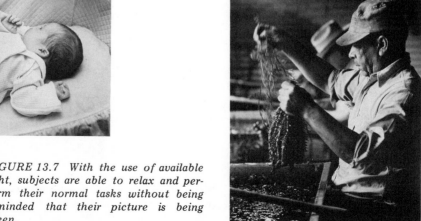

*FIGURE 13.7 With the use of available light, subjects are able to relax and perform their normal tasks without being reminded that their picture is being taken.*

them in their natural environment, they will forget about the camera and become totally involved in their activity. Thus, the photographer can capture more natural expressions, a refreshing change from the sometime stiff portraits made in studios. (See Fig. 13.8)

Available light photography allows an immediate response to the actions and expressions of the subject. Artificial light sources, depending on the type, limit the movement of the photographer and how quickly pictures can be made. A critical moment may occur between flash bulb changes or during the time the electronic flash unit is recharging. Although some units give almost instantaneous recharging, they are normally connected to a 110-volt power supply, as would be spotlights or flood lights. The 110-volt flash units have a connecting wire to the camera which limits the photographer's movement to the length of the cord. (See Fig. 13.9)

Other types of artificial lights produce a definite lighting pattern which has to be modified as the subject moves or as the photographer changes position. During this time of modification, the photographer is not able to shoot pictures at any given moment. With available light, however, pictures can be made as quickly as the film can be advanced and the shutter tripped, allowing an immediate response to the actions and expressions of the subject.

The benefits of available light are many, but some disadvantages keep it from being ideal for all subjects and situations. The main weakness is the low level of illumination generated by the light sources, resulting in the need for slower shutter speeds, wider open aperture setting, and/or films with greater

*FIGURE 13.8 Informal portraits made with available light allow the subject greater relaxation. This technique is especially effective for child portraits. The child should be occupied in a quiet pose to reduce the possibility of motion.*

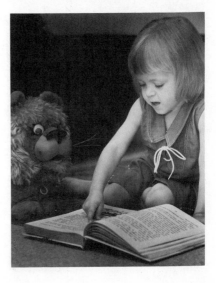

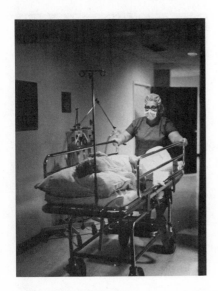

*FIGURE 13.9 Available light makes it possible to retain the mood of the situation and at the same time to immediately respond to the actions of the subject.*

sensitivity to light. Each of these variables affects the picture in some way. The longer exposures, for example, provide a greater probability that subject or camera movement will be recorded on film as a blur (Fig. 13.10).

Occasionally, the photographer will want to blur the subject to create a feeling of speed and motion. But if the blur is a distraction, motion must be restricted to a pace that can be halted by the camera's shutter. Slowing down the subject or panning the camera with the motion might be helpful, but often a faster shutter speed is the only solution. This, however, necessitates increasing the size of the aperture to compensate for the loss of light. But then, another problem arises. As we saw in Chap. 4, the size of the aperture not only controls exposure but also the distances of acceptable sharpness. As the diameter of the lens opening is increased, the area of acceptable focus in front of the camera is decreased. This situation forces the photographer to select a single distance to be in sharp focus and to allow all others to be recorded unsharply. (See Fig. 13.11)

Although depth of field can be used as a creative tool, the problems associated with it and available light are just the opposite of those encountered in making pictures outside. Daylight can produce light levels which cause too much of the surrounding and background areas to be in distractingly sharp focus. The photographer usually tries to limit the areas in acceptable focus outside to a shallow depth, but when pictures are made inside by available light, the depth of field can be so shallow that even a slight miscalculation of the point of critical focus will cause the entire photograph to appear out

*FIGURE 13.10   A problem presented by available light photography is the possibility of motion by either the subject or camera during the exposure.*

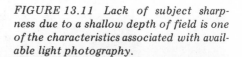

*FIGURE 13.11   Lack of subject sharpness due to a shallow depth of field is one of the characteristics associated with available light photography.*

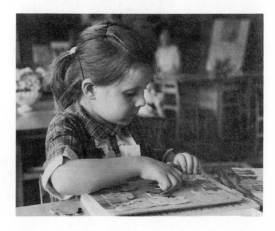

of focus. Many times, the areas of acceptable focus of pictures made under available light conditions can be measured in inches rather than in feet, as it is in outside photography.

An alternative to decreasing depth of field and to increasing subject motion is to increase the sensitivity of the film. Since less light is required to properly expose the film, a faster shutter speed and a smaller aperture opening can be used. The film, itself, however, creates problems for the photographer. As the sensitivity of the emulsion is increased, the size of the individual grains of silver is enlarged, resulting in a grainier image with less detail and accutance.

Another way to overcome the problems associated with the low light levels of available light photography is to use sunlight, either as the main light source or as a supplement. Sunlight allows the use of exposure settings similar to those for outdoor photography.

When direct sunlight is used as an available light source, the subject must be placed in front of a window or door, but this creates other problems for the photographer. The subject is brightly illuminated on the exposed side, but a deep shadow is recorded on the side facing away from the sun. (See Fig. 13.12)

Extremely nice dramatic portraits can be made with high contrast lighting, but generally the photographer will find it more pleasing to use sunlight as a supplement to other light sources or to use reflectors to reduce the darkness of the shadows. Careful placement of the subject in relationship to the sunlight and the surrounding areas and the use of reflectors can raise the level of illumination in the normally dark portions of the picture. The photographer should remember, however, that the eyes make automatic adjustments to different levels of light which the film cannot make. Therefore, many

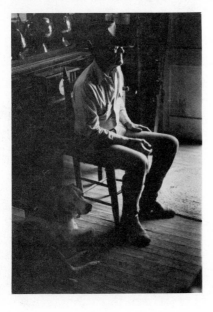

FIGURE 13.12 Subjects photographed indoors with direct sunlight as the main source of illumination have a large range of contrasts between the lighted and the shadow sides.

times the lighting ratio between the level of light striking the sunlighted side and that in the shadow are not readily apparent. (See Fig. 13.13)

Diffused or indirect sunlight, on the other hand, will produce pleasing pictures of people without requiring supplementary light sources or reflectors. The quality of the light is very soft and not as contrasty as direct sunlight even though it is brighter than inside illumination. By placing the subject close to an open window, the photographer can use the same quality of light as would be present in the outside shade.

Perhaps the best use of sunlight for available light photography is to combine it with other light sources. The use of sunlight as a supplement rather than the main source helps reduce the contrast of the scene inside and gives the photographer a greater choice of aperture and shutter speed settings from which to choose.

The contrast produced in most available light situations can be regarded as a disadvantage at times. The light sources which normally exist in a room generate pools of light in surrounding black areas when the scene is recorded on film. This contrast is caused by several factors, one of which is that the placement of light fixtures in a home produces uneven levels of illumination.

Since the subject is usually placed near to an available light source to take the greatest advantage of the level of illumination, the *law of inverse squares becomes a factor.* In effect, this law states that the intensity of the light produced by a source will decrease proportionally to the square of the distance it travels. While it is a determining factor in flash exposures, a point to be

*FIGURE 13.13  (a) The bright sunlight causes the shadow areas of the subject to record too dark. (b) By adding a reflector of white cardboard just outside the picture frame extra light is thrown into the shadows to reduce the contrast between the highlight and shadow areas of the picture.*

(a)                                           (b)

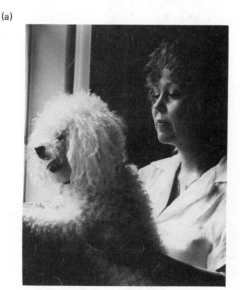

discussed in Chap. 14, the law affects the exposure and contrast of available light pictures.

Simply stated, the closer a subject is to the light source the more intense is the level of illumination on the subject. As the subject moves away from the source of illumination, the intensity rapidly decreases. The closer the subject is to the light source, however, less movement away from it is required for a noticeable change in the level of illumination to take place. For example, the exposure for a subject standing two feet from the light may be *f*/8 at 1/60 sec. If the subject is relocated three feet from the light source, the required exposure should be increased to *f*/5.6 at 1/60 sec. In other words, the shift in position from two to three feet caused the level of illumination on the subject to decrease by one *f*-stop. (See Fig. 13.14)

The photographer can compensate for this loss of light and higher contrast by turning on all the lights in a room and by allowing in as much outside light as possible. Ceiling fixtures which produce a diffused light will increase the level of light in the darker areas of the room.

Placing the subject of the photograph as close as possible to the light source is a way to give it more light, but another problem is created when the source is brought into the picture frame.

As we saw in Chap. 6, most camera light meters and other light measuring devices give an average reading of the total amount of light reflected from a subject. These instruments produce accurate exposure settings only if the scene has an equal amount of lightness and darkness.

When a light source is included in the picture frame, its brightness creates a light imbalance, resulting in inaccurate exposure readings. The photographer can overcome the problem by making a light reading close to the subject so that the meter is not affected by the light source. Once the exposure calculations have been made, the photographer can return to the position from which the picture will be made and use the settings of the close-up readings. (See Fig. 13.15)

*FIGURE 13.14 Light intensity varies when subjects are at different distances from the light source. The subject on the right, located next to the light source, has received correct exposure. The subject on the left received less light and is underexposed.*

(b)

(a)

FIGURE 13.15 The inclusion of a light source into the picture frame can cause a false light reading from a meter built into the camera. This can be corrected by moving closer to the subject (a), or changing the camera angle so the light is no longer in the frame (b), and making the light reading. After the reading is taken, you can move back to the original position to make the photograph.

If the light source is extremely bright in comparison to the light on the subject, its inclusion in the picture can cause a *flare* on the film. This occurrence is similar to what can happen when the sun is included in outside exposures. The result is a loss of image sharpness and contrast. The only solution is to change the position of the subject or the camera angle to remove the bright light source from the picture area. (See Fig. 13.16)

FIGURE 13.16 (a) Bright light sources close to the subject can create a flare over the subject and degrade the image, as the window light did. (b) The flare was removed by changing the camera position slightly to remove the light source from the picture frame.

(a)

(b)

267

# SUMMARY

Taking candid pictures under naturally available light sources, with or without sunlight, is a technique called available light photography. Its use for capturing candid pictures began in the 1920s and grew in popularity among photojournalists throughout the years. Before it became a practical tool for the beginning photographer, however, technical developments in lenses, developing formulas, and film emulsions were necessary. By 1954 a series of technical advances and the introduction of Kodak's highly sensitive Tri-X film improved the quality of candid available light photography and made it practical and convenient for everyone.

The use of available light sources such as table lamps, ceiling fixtures, candles, fireplaces, etc., to illuminate the subject has several advantages over artificial light sources. Perhaps one of its major strengths is the realism it creates in a photograph. Available light gives the viewer a vivid impression of how the scene actually exists. Freedom of movement is another advantage. Since the photographer is not bound to artificial light sources by either a physical connection, as is the case with electronic flash, or with a set lighting pattern, the camera position can be changed at any time. This freedom also allows better reaction to the movements and expressions of the subject.

Under available light, the subject usually is more relaxed and has a more natural expression. In the case of children, it is possible many times to take their pictures without their even being aware that the camera is in the same room.

In spite of all its inherent advantages, available light photography has its own special problems that keep it from being ideal for all subjects and situations. One of these characteristics is the low level of illumination that lights the scene. Because of it the photographer must use slower shutter speeds that increase the possibility that camera or subject movement will record as a blur on the film. The low level of light requires a larger aperture opening than that needed for outside shooting. This reduces the area of acceptable focus within the scene and can produce pictures which appear out of focus.

To compensate for the reduced lighting, the photographer can use a film which is highly sensitive to light. But this type of emulsion gives greater granularity to the image and reduced details.

Sunlight streaming through a window or other opening on the subject can be used advantageously to improve illumination. But care must be taken to counter the high contrast created by the deep shadow on the side of the subject facing away from the sun. Generally, the photographer will use sunlight as a supplement to other light sources or reflectors to reduce the darkness of the shadows.

# 14

# Flash Photography

In the early 1800s, the sun was the only reliable light source for making pictures. The limitation it placed on photography led to a search for suitable light alternatives that would make photography possible and convenient at all times, day or night, and in all places, inside or outside.

## HISTORY OF FLASH PHOTOGRAPHY

The search for artificial light sources took several directions, after some false starts, before the modern flash bulb and electronic flash were invented. One of the first forms was the "lime light," a light source consisting of a sheet of lime heated to an incandescent glow with the flame of a hydrogen-oxygen torch. It was suitable for some forms of photography, but the light was too harsh for portraiture. It was used in some studios during the late 1830s and early 1840s but replaced soon after by more convenient forms of light.

In 1857, John Moule began burning a pyrotechnic compound in a large lantern to light his studio for night portraiture. The light, which he named "Photogen," had a burning time of about 15 seconds. The fumes and smoke produced in the lamp were carried out of the studio in a stovepipe. This light was also very harsh. To soften it, Moule placed panels of blue glass between the light source and the sitter.

Lime light and the Photogen were forerunners of studio lighting, but they did not have the portability needed for all types of photography conducted outside the studio.

269

The flash bulb and electronic flash had a different beginning. The discovery in 1859 by Robert Wilhelm Bunsen and Sir Henry Roscoe that burning magnesium wire would produce a bright light suitable for photographic purposes set the stage for the development of the flash bulb. In 1864, Alfred Brothers is credited with making the first portrait and subterranean photograph with a portable magnesium light source. It should be noted that Nadar (Gaspard Félix Tournachon) had photographed the catacombs of Paris with an electrical light source in 1861, but the light was constant rather than intermittent.

After Brothers demonstrated the possibility of using the "magnesium ribbon light," photographers started making pictures in previously inaccessible places. C. Piazzi Smyth photographed the interior of the Great Pyramid in 1865, for example. He could only make a single photograph a day, however, because of the toxic smoke produced by the burning ribbon of magnesium.

Although the smoke created a problem, the magnesium ribbon was an improvement because it could be measured for specific light output or woven into a mat of a specific size. This allowed the photographer to control the light for the exposure. The same year that Smyth was photographing the interior of the Great Pyramid, suggestions were made that the same control could be maintained with magnesium powder in place of the solid wire or ribbon. The powder could be dusted into a receptacle similarly to sand passing through an hour clock. Nearly 20 years passed before G.A. Kenyon revived the idea in 1883 and added a second chemical, potassium chloride, to the powdered magnesium. This formula created the popular flash powder that was used through the 1920s. The intensity of its light and the increased sensitivity of the gelatin emulsion that came into common use produced exposure times that ranged from 1/25 sec to 1/2 sec.

Flash powder suffered from some of the same problems produced by the earlier burning magnesium ribbon. The fumes and smoke emitted after each exposure were the main disadvantages. Another drawback was the explosive nature of the powder.

The first flash bulb was designed by Louis Boutan in 1893 to make pictures underwater. To allow the magnesium to burn, it was encased in a watertight bulb filled with oxygen. The bulb was ignited by heating a fine platinum wire with an electrical current. Occasionally, the heat and expansion of the oxygen caused the bulb to explode. In 1925, Dr. Paul Vierkoetter reduced the danger with a patented design that burned magnesium wire in a near vacuum.

Another improvement in 1929 by Dr. Johannes Ostermeier substituted aluminum wire or foil for the magnesium and again used an oxygen atmosphere to support the combustion of the flash. This design is still used, although the flash bulbs have become smaller and more efficient. Today's flash bulb has been reduced from the size of a household lightbulb to one that weighs less than one ounce. The combustible in today's bulb is made of finely spun zirconium.

The roots of the more recently developed electronic flash dated before the invention of photography. For many years, it had been noticed that fast motion was momentarily frozen during flashes of lighting. As a result, early flash units used an open spark of electricity to produce the light needed to stop the action.

The first spark photograph was made in 1851 by Fox Talbot. Noticing that falling water seemed to be stopped by lightning, he set up an experiment during which a newspaper was rapidly rotated in front of the camera. An electrical charge was generated in a Leyden jar and then discharged, stopping the paper as it was recorded on film. Most early spark light pictures were made so that motion could be analyzed. While other photographers were using the burning magnesium wire to record the interiors of pyramids, experimenters such as Prof. Ernst Mach and Dr. P. Salcher were making photographs with spark light that stopped the fastest motions. In 1887, for example, the two experimenters successfully stopped a missile traveling at 765 miles an hour and recorded the sound wave it produced. Later in 1892, C.V. Boys photographed missiles traveling twice the speed of sound. He photographed a series of exposures of a bullet penetrating through a pane of glass. By the end of the 1800s high speed spark light photography was fairly common.

In 1931, Dr. Harold E. Edgerton led a research team at the Massachusetts Institute of Technology in the development of the stroboscopic flash. This device produced bright flashes of light in rapid succession by electrical discharge in a gas-filled bulb. The stroboscopic flash was a modification of the earlier spark light, and like its predecessor, was used for motion analysis. The design was soon adopted by the still photographer. The main difference between the stroboscopic flash and the modern electronic flash is that the latter, sometimes referred to as a strobe light, produced only a single burst of light during each exposure. (See Fig. 14.1)

*FIGURE 14.1 One of the developers of the stroboscopic flash was Dr. Harold Edgerton of MIT. The short duration and rapid flashing of the light allowed pictures, such as this, of falling milk drops and other fast moving objects to be stopped and their movement analyzed. (Courtesy of Harold Edgerton, MIT.)*

The electronic flash unit uses electronic circuits to build up and store an electrical charge of high voltage. When the camera shutter is tripped, the energy is released in a bulb to produce the light. Before it can be reused, the unit has to build up a sufficient supply of power. This creates delays between exposures. Modern flash designs rechannel the unused electrical charge back into the holding capacitors, reducing the time needed to recharge the flash unit. The electronic flash, like the earlier spark light, allows the photographer to stop even the most rapid movement. The duration of the light source is extremely short and will range from 1/500 sec to about 1/70,000 sec, depending on the model and make.

## FLASH EXPOSURE CALCULATIONS

The usual exposure controls for nonflash photography are the lens, aperture, shutter speed, and sensitivity of the film, but shutter adjustments do not affect the exposure for electronic flash. That factor, as well as several others, can influence exposure settings for flash pictures. This is especially troublesome for the beginning photographer.

The reason the shutter cannot be used to regulate exposure is that the duration of the flash is usually shorter than the shutter speed, and the light, for all practical purposes, reaches its peak output instantaneously. Therefore, the length of time of the flash rather than the shutter affects exposure. The following example illustrates how this works. When a shutter, set on 1/60 sec, is tripped, it opens and the electronic flash goes off. The light disappears after 1/1,000 of a second, but the shutter remains open until the full completion of its set time. Even if the shutter speed is advanced to 1/500 sec, the flash duration would be completed before the shutter closes. In both cases, the light would be recorded with the same brightness and for an equal length of time on the film. There would be no difference in the amount of flash exposure recorded on the film's emulsion.

Apart from the flash exposure, the shutter does have a function in controlling the amount of available light within the scene. Exactly how this light is recorded depends on the shutter speed. For example, if the slow speed is used, the available light will be recorded with greater intensity than it would be with a faster shutter. This can affect the appearance of the overall scene. (See Fig. 14.2) Sometimes, the amount of available light recorded is an aesthetic consideration. At other times, it is technical. Occasions arise, for example, when action is photographically stopped with the light of the electronic flash, but a blurred ghost image is recorded on the film by the available light (Fig. 14.3). A faster shutter speed will record less light, and the blurred ghost image will be dimmer, less extended, and less distracting. The photographer, of course, can use this to create many different effects and feelings of motion that cannot be achieved in any other way. (See Fig. 14.4)

(a)

(b)

(c)

FIGURE 14.2 *Flash exposures: (a) f/11 at 1/30 sec, (b) f/11 at 1/125 sec, and (c) f/11 at 1/500 sec. The tonality of the subject remains the same in all three illustrations, but the background gradually becomes darker because the faster shutter speeds record less available light.*

FIGURE 14.3 *A secondary image is sometimes created when the photographer uses electronic flash with a slow shutter speed.*

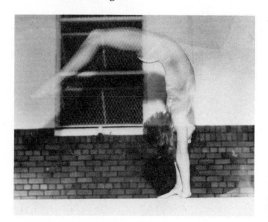

FIGURE 14.4 *Pen lights were attached to the subject and their movements were recorded on film during a time exposure, and then the subject and surrounding area were given a flash exposure to create context for the light tracings.*

Some cameras are manufactured with a focal plane shutter (see Chap. 4), which limits them to the slower speeds when they are used with electronic flash. The exact setting depends on the type of shutter.

The focal plane shutter, unlike the bladed, between-the-lens type, does not expose the complete film frame at one time except at certain shutter speeds. It travels across the front of the film in the form of a slit, exposing only a portion of the film at a time. The size of the slit is adjustable, and only speeds of 1/60 sec or slower produce a slit of sufficient size to uncover the entire film frame at one time. For this reason the shutter speed needs to be 1/60 sec or slower to give equal exposure to the entire frame. Faster speeds will allow proper exposure of only a portion of the film. The other part will be covered by the shutter curtain and will remain unexposed when the electronic flash produces its light. With the camera set at 1/125 sec, only half of the frame will be exposed; at 1/250 sec, a fourth; at 1/500 sec, an eighth; and at 1/1000 sec, a sixteenth. The portion of the exposed frame at these different shutter speeds, however, will receive the same amount of flash exposure. (See Fig. 14.5)

*FIGURE 14.5   (a) When the speed of a focal plane shutter is set at 1/60 sec or slower the complete film frame is exposed at one time because of the size of the shutter opening. (b) When the speed of a focal plane shutter is set at 1/125 sec and used with electronic flash, only half of the film frame is exposed at one time. (c) At the higher shutter speed of 1/250 sec the exposed area is reduced to only about a fourth of the total film frame. (d) At a shutter speed setting of 1/500 sec only about an eighth of the original film area is exposed by the light of the electronic flash unit. The density of the exposed area is still unaffected by the shortness of the shutter speed. (e) At 1/1000 sec exposure only about a sixteenth of the film frame receives the correct exposure.*

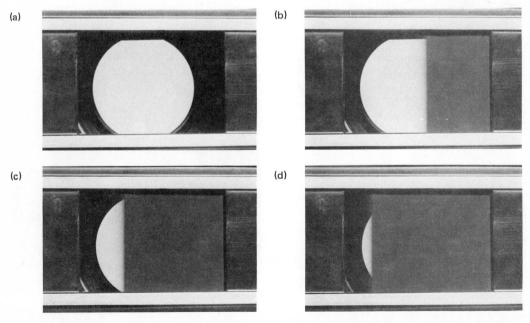

(a)   (b)
(c)   (d)

(e)

The newer, metal focal plane shutters open outward from the center and can be used with electronic flash at higher shutter speeds of up to 1/125 sec.

Unlike the electronic flash, the flash bulb exposure is affected by the shutter speed selection. Its light is not instantaneous but instead slowly builds to a peak intensity. A camera shutter speed of 1/60 sec will record about 85 percent of the light output of the flash bulb, but when a shorter time is used, less bulb light is recorded. At 1/125 sec, only about 55 percent of the light is recorded on film, and at 1/250 sec, about 25 percent is recorded.

Because of the difference in the amount of light that can strike the film at different speeds, exposure can be regulated to a certain extent by the shutter. It is not recommended, since the burning rate of flash bulbs may vary.

The effect of film sensitivity on exposure is similar for flash as it is for other types of photography. The more sensitive the film is, the less light intensity is needed to properly expose the image. Highly sensitive films, however, are normally unnecessary for flash because of the high light intensity produced. But flash exposure is considered to be a speed process, since it is used to stop action many times. Therefore, photographers have a tendency to use the fastest film available, usually resulting in greater grain and less image sharpness.

Another influence on the speed of film is the color of the light source. Electronic flash produces a color similar to daylight. Some brands of high-speed film arrive at their sensitivity by being overly responsive to a red color usually present in available light situations. These films can have less sensitivity on occasion to the blue light of the electronic flash than a slower, fine-grain film. The photographer will discover, however, that a medium-speed film will produce better sharpness and granularity than the high speed films most of the time.

Two other factors play a major role in the calculation of exposure settings. They are: (1) the intensity of the light source, and (2) the distance of the light source from the subject.

Unlike light intensity, the distance of the light to the subject is seldom constant. It changes from picture to picture, and the greater the distance the light has to travel, the dimmer it becomes. The rate it loses its intensity is proportional to the square of the distance it travels. As we have seen, this is called the law of the inverse square. (See Fig. 14.6) It means that light will increase or decrease more rapidly over a small change in distance when the

FIGURE 14.6 Light diminishing over distance.

subject is close to the light source than it will for the same change at a greater distance. If the subject is located a foot from the light source, for example, a shift of six inches toward it increases the intensity of light striking the subject by two f/stops. But if the subject is four feet from the light source, and the position is shifted six inches closer, the resulting change in intensity is only half an f/stop. A fall off in light can create unpleasant results where the subject is overexposed in the foreground, correctly exposed in the middle ground, and underexposed in the background (Fig. 14.7).

Reduction in light intensity is constant, however, and it can be predicted over set distances. The photographer can measure the distance the light will travel and compensate for its reduction in intensity. For this reason, distance is one of the controlling factors in calculating exposure settings. It plays such an important role that most electronic flash units are designed with distance versus f/stop dials to help the photographer set proper exposures. (See Fig. 14.8)

FIGURE 14.7 A decrease in light intensity as it travels from the light source can produce results similar to this illustration. The subject was exposed correctly by the camera settings, but the objects in the foreground received too much light.

FIGURE 14.8 To use the flash calculating dial that comes on most electronic flash units, the photographer must first align the speed of the film with the arrow on the dial and then read the aperture setting which is opposite the distance the subject is located from the flash.

Both electronic flash units and flash bulbs are manufactured in a variety of models to produce different levels of light output. The light intensity of electronic units is measured in several ways, while illumination of flash bulbs is figured in *lumen seconds*. This is a measure of light energy. Electronic flash is usually rated by the *effective candle power per second* (ECPS) of the flash. This is a measurement of the light over the different angles it is projected. A second calculation is the *beam candle power per second* (BCPS). This differs from the ECPS rating in that the measurement of light output is made only along the central or main axis of the light. A third measure, *watt seconds*, is made of the stored energy within the flash and is used as a rough indication of the amount of light that will be produced with each flash.

Although the light output can vary according to the model design of the flash bulb or electronic unit, it remains relatively consistent if a single size unit is used.

The size and color of the surrounding area and the color and texture of the subject are other variables that affect exposure settings of flash pictures. Standard flash exposure guides are calculated for making pictures under normal conditions. Variations from the norm set by the manufacturer may necessitate corrective adjustments.

The recommended exposure calculations assume that walls or other objects will reflect the light back to the subject. When pictures are made outside, however, there are no walls to reflect the light. If the recommended settings are used, the result would be an underexposed negative or slide. Even inside, the exposure would be incorrect if the room is as large as an auditorium or gymnasium. A small room can upset the calculations because of the greater reflection of light on the subject.

The color of walls, floors, and ceilings play an additional role. White walls reflect more light than dark paneling. The color and texture of the subject has an affect, but to a smaller degree. The photographer must usually make exposure compensation for these variables. However, many times the difference in light output will not greatly affect the exposure.

A basic rule of thumb for figuring exposure settings is to reduce the aperture's diameter (stop down) by a half to one stop when the picture is made in a small room or in one with white walls and ceilings. Increase the recommended exposure by a half to one stop for large rooms, dark walls or ceilings, or for outside settings.

Because of the many variables affecting flash exposure, no specific aperture setting will produce the proper exposure for all situations. The calculator on the back of small electronic flash units is designed to produce acceptable results over a wide range of conditions. It is convenient to use, but it will not give correct exposure unless conditions are exactly like those the manufacturer considers normal.

Some electronic flash units automatically read the amount of light bouncing back from the subject and regulate the intensity of the flash to

match the aperture setting and film speed. These units give the correct exposure for a wide range of conditions, but they can be wrong at times.

**DETERMINING GUIDE NUMBERS.** The only way the photographer can be assured of correct exposure without the aid of a light meter is to establish exposure guide numbers for each condition under which photographs are normally taken. If many pictures are taken in a particular room of a house, or in a church, or gymnasium, then an exposure guide number should be established for each condition.

An easy way to determine a guide number is to place a subject in a situation that can be controlled, such as 10 feet from the flash unit. Then make a series of exposures with different aperture settings. This will produce a roll of film exposed at $f/22$ on the first frame, $f/16$ on the second frame, $f/11$ on the third, etc. Continue this procedure until each aperture setting has been used and then develop the film normally. Afterward, inspect the negatives to see which exposure was best. Repeat the procedure for each condition under which you normally make flash pictures.

Each time pictures are made under the same conditions, the exposure should be the same. But if the distance from the flash unit changes, a mathematical equation can give the correct exposure settings.

The first step in determining a numerical guide number based on test exposures is to multiply the $f/$stop which gave the best exposure by the distance of the subject from the flash. For example, if the correct $f/$stop was $f/8$ and the distance was 10 feet, the guide number for that situation would be 80.

$$f/\text{stop } (f/8) \times \text{Distance (10)} = \text{Guide number (80)}$$

Once a guide number is established, exposure settings for any distance can be figured by dividing the distance of the subject from the flash into the guide number. Therefore, if the guide number is 80, and the distance is five feet, the correct $f/$stop would be $f/16$.

$$\frac{\text{Guide number (80)}}{\text{Distance (5)}} = f/\text{stop } (f/16)$$

**USING A FLASH METER.** Another way to determine correct exposure is with a mechanical light meter. This meter is different from other types discussed in Chap. 6 in that it is sensitive to a surge of light such as that from a flash. To get the correct exposure settings, place the meter where the subject is and set off the flash. This is done without tripping the camera's shutter. The light intensity is converted into the correct $f/$stop directly by the flash meter's dial. (See Fig. 14.9)

FIGURE 14.9 A flash meter is similar to a regular light meter except it reads abrupt changes in light intensities. It can be used as either a reflective or incident meter (as in this figure).

## FLASH SYNCHRONIZATION

Flash pictures cannot be made unless the shutter opens at the same time that the light flashes. This important action is called *flash synchronization.*

Normally the flash unit is connected to the camera by an electrical cord. When the shutter opens, contact is made which causes the flash to fire instantáneously. This type of synchronization is often built into the camera and may be indicated by the letter "X" or by a color on one shutter speed to indicate the setting for flash. (See Fig. 14.10) Cameras equipped with this synchronization can use both flash bulbs and electronic flash units.

When a flash bulb is used, a slight delay between the time the bulb begins to burn and the shutter opens is often better. A bulb is equipped with a primer material that ignites first, and then the heat from the primer ignites the other material in the bulb to produce its light. This can be compared to the burning of a bonfire. Kindling is used to start the fire. As it is ignited, it sets fire to larger pieces of wood until, soon, the entire bonfire is burning.

FIGURE 14.10 The X synchronization for electronic flash can be located on the camera (a) or simply shown on the shutter speed dial, a common location for many single-lens reflex cameras. (b) The metal focal plane shutter synchronizes with electronic flash at 1/125 sec rather than at the slower 1/60 sec.

(a)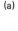

(b)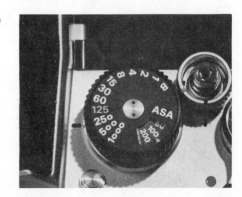

Later, the wood that started burning first is consumed first and goes out. This will continue until all of the original pieces of wood have burned, and the heat and light are extinguished. The flash bulb operates similarly in that the largest amount of light is not produced until most of the material has been ignited.

When the camera shutter opens at the same time the flash bulb is ignited, the film is exposed for a portion of the time to the initial ignition of the bulb's filaments. Many cameras are equipped with a flash synchronization which delays the opening of the shutter until the bulb has time to reach its peak light output. The most common delay is referred to as "M" synchronization. It is measured in milliseconds, and allows for more light efficiency from the flash bulb. (See Fig. 14.11)

While flash bulbs can be used at either "X" or "M," electronic flash must be set on "X" synchronization. The reason is the instantaneous discharge of electronic flash. With "M" synchronization, the electronic flash discharges before the shutter has a chance to open. (See Fig. 14.12)

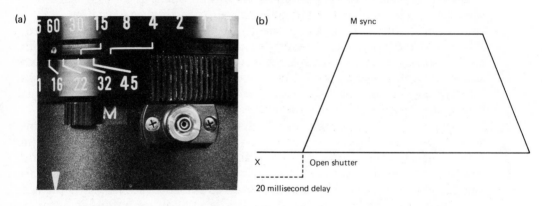

FIGURE 14.11   (a) The M or medium delay setting can be indicated on the camera just like the X flash synchronization. (b) Many of today's cameras are not equipped with this synchronization which delays the opening of the shutter.

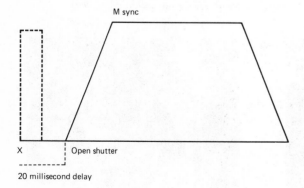

FIGURE 14.12  M synchronization is for use with flash bulbs. The shutter delays before opening, and by the time it does open, the light from the electronic flash unit has already dissipated, as the figure indicates.

Several other synchronizations were incorporated in older camera models, but for the most part, these are no longer used. The designation of "FP," for example, was used on earlier models to synchronize bulbs designed for focal plane shutters.

## FLASH TECHNIQUES

Several basic techniques can be used in making flash pictures. Each has special uses and disadvantages. The techniques can be classified according to the type of light used to illuminate the subject. These are: (1) direct lighting techniques and (2) indirect lighting techniques.

Direct lighting can be subdivided into two more divisions according to whether the flash is located on or off the camera. In each of these categories the flash is aimed directly at the subject. The difference is in the flash unit's placement in relationship to the camera.

**DIRECT ON-CAMERA.** Most inexpensive cameras are designed with the flash attached to them. The flash unit is usually a flash cube or flashbar which automatically fires as each exposure is made. Since the flash unit plugs directly into the camera's body, it cannot work if it is separated from the camera. (See Fig. 14.13)

Having a built-in flash is convenient because it points in the same direction as the camera regardless of which way the camera is aimed. It makes calculating exposures simpler, too. Since the distance of the subject to the camera and flash is the same, the photographer using a camera with adjustable aperture settings can focus on the subject and then simply read the

*FIGURE 14.13 Direct on-camera flash unit. (Courtesy of JoAnn Frair.)*

distance directly from the camera's focus settings to calculate the flash exposure. The inexpensive cameras with preset lens apertures produce exposures with flash over a set range of distances.

A major disadvantage of direct on-camera flash is that it can produce the least pleasing pictures of any flash technique. The pictures are characterized by a distracting shadow which is projected to the side and background of the subject. (See Fig. 14.14) The shadow is caused because the flash and the camera lens are located in different places. The off-center relationship results in the subject being illuminated from a slightly different angle than that seen through the lens. Adapters or flash brackets can help eliminate the shadows by repositioning the flash more closely to the lens, but the resulting photograph will not have the modeling that other flash techniques give. With the flash positioned so close to the lens, the light it produces is flat, which removes the roundness and modeling of the subject's different planes.

Another problem with direct on-camera flash is in achieving proper exposure for subjects located at different distances from the camera. With this flash technique, each will receive different amounts of illumination, producing pictures with only the one distance plane correctly exposed. For example, the subject closest to the camera will be too bright, and the one in the background, too dark. This variation in exposure is caused by the fall-off of light as it travels from its source.

(b)

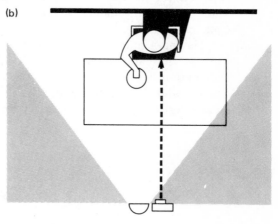

(a)

*FIGURE 14.14  (a) A direct on-camera flash produces distracting shadows along the side of the subject opposite the flash unit. (b) This is caused by the different perspectives of the light source and the camera lens.*

**DIRECT OFF-CAMERA.** A means of correcting uneven exposure and eliminating distracting shadows is to use direct off-camera techniques. The simplest approach is to remove the flash from the camera and hold it above the camera lens, a position which eliminates shadows. To be able to use the off-camera flash, the flash must be designed with a connecting cord between it and the camera. Some inexpensive units are synchronized through the base of the flash and a *hot shoe* on the camera body. The hot shoe is a bracket built into the camera with electrical connectors attached to the camera shutter and flash unit. Other units are equipped with a *sync* cord that plugs into the camera. (See Fig. 14.15) The cord may come with the flash unit or may be bought separately in different types and lengths.

Even with a flash attached to the camera, synchronization cord can be extended by connecting other units with a special extension cord. The extension cord can be plugged into the camera so that a single unit can be used at a greater distance from the camera. By removing the flash, the photographer is able to vary the lighting pattern on the subject to simulate other types of lighting. For example, placing the flash to the side of the subject results in the same type of picture that could be taken with daylight coming through a window. (See Fig. 14.16)

Another form of direct off-camera flash is *tipped* or *feathered flash*. This technique is used to compensate for subjects located at different distances from the camera and flash unit. The light emitted from the flash is more concentrated along its center plane than at the outer edges. Therefore, by aiming the center of the light source at the farthest subject, the closer subjects are

(a)

(b)

*FIGURE 14.15 (a) Some flash units connect directly to the camera through a hot shoe which fires the flash automatically when the shutter release is depressed. (b) Other units are connected to the camera with a synchronization cord which allows the flash to be detached from the camera.*

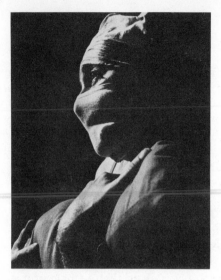

FIGURE 14.16 Direct off-camera flash can give the impression that the main light is located away from the camera. Here it produced the appearance of sunlight striking the subject from the side of the camera, rather than the subject being in a room without windows.

lighted only by the feathered outer edges of the flash. The exposure is based on the greatest distance the flash has to travel, and areas of the subject at different distances receive less concentrated light. (See Fig. 14.17) This type of flash technique is suitable for receiving lines, banquet tables, and other situations where lines of subjects are involved.

The main problem with the technique is in aiming the flash. Unless care is taken the light may not strike all of the subjects. This is especially critical if a wide-angle lens is used. (See Fig. 14.18)

As we saw, the photographer can connect two or more flashes to light the subject simultaneously. This practice is common in photography studios

(b)

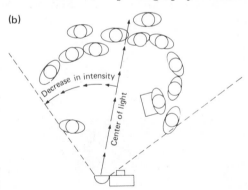

(a)

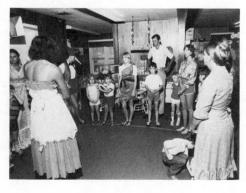

FIGURE 14.17 Feathered or tipped flash: (a) the center of the flash was aimed at the people farthest from the camera. The exposure calculations were made and set for this distance. (b) Since the center of the flash's light is the most intense, the closer subjects only received the less intense, feathered edge of the flash. Therefore, the exposure is about even from background to foreground.

FIGURE 14.18 *The intensity of the flash light decreases as it approaches the edge of its circle of illumination. Here the decrease in intensity is apparent on the edge of the picture. The center portion of the flash lighted the left side of the picture. While the packages received the full intensity, the face and the feet only received the feathered edge of the light.*

which have units designed for this purpose. But studio lighting can be achieved even by the beginner. The flash units can be connected physically with an extension cord, or they can be fired by a photoelectric cell. By sensing the light of the flash unit connected to the camera, the photoelectric cell fires the flash units off the camera. (See Fig. 14.19) This allows the photographer to light large areas evenly or use more than one light to make the picture of the subjects.

FIGURE 14.19 *A light-sensitive photoelectric cell.*

**INDIRECT FLASH TECHNIQUES.** Indirect flash techniques produce lighting that is similar to available light by bouncing the light from the flash off a wall, ceiling, or other materials to soften its quality and to change its direction. *Bounce* flash used creatively can be most pleasing because of the soft quality of the light. It is good for making interior pictures because of its even illumination level. (See Fig. 14.20)

To make bounce flash pictures the photographer aims the flash at a reflecting surface which directs the light back to the subject. (See Fig. 14.21) Exposure calculations are made on the total distance the light travels rather than the distance between the subject and the flash unit. This amount of light loss resulting from the reflecting surface is another consideration. Usually,

FIGURE 14.20 *Bounce flash can be used to give the foreground and background objects in a large area about the same intensity of light. It will produce the appearance of available light, but allows a faster shutter speed and an aperture setting which produces greater depth of field.*

(b)

(a)

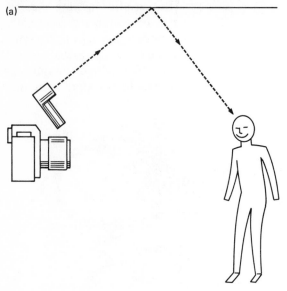

FIGURE 14.21 *The quality of light of bounce flash is similar to available overhead lighting, except that the intensity of the former is usually greater. (a) Technique, (b) result.*

the photographer can increase the normal exposure by one stop to compensate for the loss of light.

Flash bounced off a ceiling produces almost shadowless lighting. Off a wall, it gives the impression of outside light from an open window. Because the flash travels farther, it can be used to make pictures of subjects located at various distances from the camera and flash. The light decreases more rapidly at close distances; therefore, its length of travel from the flash to the ceiling and then to the subject results in more even illumination.

Although bounce flash produces an even distribution of soft light, the photographer is forced many times to shoot at a larger aperture opening, which reduces the area of acceptable focus of the scene. This smaller depth of field can create problems if large areas of the scene need to be in focus. In such cases, tipped or feathered flash may be a more desirable technique.

**SYNCHRO-SUNLIGHT FLASH.** A technique which combines the light from a flash with sunlight is called synchro-sunlight flash. This technique can be used to balance the intensity of light on a subject inside with a sunlit background outside, or on a subject in shadows with a brightly lit background, or to reduce the contrast of a subject being photographed in bright sunlight.

Occasionally, when the photographer needs to photograph a subject inside, in front of a window or door that is open to the outside, the correct exposure on both the subject and the outside must be calculated. Through a combination of flash and sunlight the exposure can be adjusted to record both areas on the film correctly. Since the flash from an electronic unit is affected only by changes in the aperture, the aperture setting is used to control the flash exposure, and the shutter speed controls the outside background exposure. Thus, the photographer is able to adjust two light intensities so that both will record equally on the film.

To illustrate how this works, assume that the background is lit by bright sunlight and that the film being used is Kodak's Plus-X with an ASA/ISO rating of 125/22°. The normal aperture and shutter speed for the background condition would be $f$/16 at 1/125 sec (ASA/ISO rating of the film) according to the basic reference exposure guide. Assume that the flash unit being used has a guide number of 110 with Plus-X film and is located five feet from the subject. The equation for figuring the flash exposure would look like this

$$\frac{\text{Guide number (110)}}{\text{distance (5)}} = f/\text{stop } (f/22)$$

Since the correct $f$/stop in this example would be $f$/22 for the flash and $f$/16 at 1/125 sec for the bright sunlight, balancing the two light sources would be a simple equivalent exposure problem

$$f/16 \text{ at } 1/125 = f/22 \text{ at } \underline{\quad ? \quad}$$

The size of the aperture opening is decreased from $f$/16 to $f$/22 to produce the correct flash exposure. If the shutter speed was left at its 1/125 sec setting, the outside exposure would be one stop underexposed. By allowing more light to enter the camera at 1/60 sec, both the outside and the flash exposure would be correct. The shutter speed change only affects the daylight exposure. The photographer would have created a 1 : 1 lighting ratio between the subject illumination and background illumination. (See Fig. 14.22)

At times, however, the photographer makes pictures outside and wants to retain the lighting pattern produced by the sunlight. But often, the contrast between the highlight and shadow side of the face is too great for the film to record detail under normal conditions at the same time. When this happens the photographer can use the flash as a supplementary rather than a

main light source. The flash increases the amount of light in the shadow areas of the subject without affecting the sunlight pattern. (See Fig. 14.23)

This situation complicates the exposure calculations because the photographer no longer wants to correct exposure for both the flash and main light source. When synchro-sun flash is used in this manner, the photographer usually needs to calculate the flash so that it is from one to two stops underexposed while the daylight is correctly exposed. This will produce more light in the shadow areas by retaining the light in the highlight portions of the pictures. The same type of calculations are used here as in the previous example except the flash is deliberately underexposed.

FIGURE 14.23 *The use of flash outdoors allows the photographer to lighten the dark shadow areas without destroying the natural light pattern produced by sunlight. (a) The shadows on the face caused by the bonnet produce too great a contrast to record with adequate detail. (b) When flash fill is used the shadow area becomes much lighter in tone.*

(a)

(b)

# SUMMARY

Flash photography developed along two paths that produced the different types of equipment in use today. The most common light source is the flash bulb. The root of this lighting mechanism is a pyrotechnic compound called flash powder. The early flash consisted of powdered magnesium that was burned to produce light for the photographic exposure. During that time, experimenters were also using an electrical discharge to produce a spark light of extremely short duration. This type of light was used to study motion. It was not developed for convenient photography until after World War II.

Both flash bulbs and electronic flash are used today for making pictures indoors, but each creates its own special problems. One difficulty is in calculating the exposure settings. Several variables will affect flash exposure. Among them are the aperture setting, the speed of the film, the intensity of the light source, the distance of the light source from the subject, and the size and color of the room.

Most flash units are equipped with a dial to calculate the exposure settings. But the dial is correct only if all variables are within a standard established by the manufacturer. To counter this problem, the photographer can set individual guides for each flash condition. The correct exposure, then, can be figured by dividing the distance of the subject from the flash into the guide number.

Flash can be used in several ways. The techniques are generally labeled as direct or indirect flash. Most pictures are made by the direct method where the flash is attached to the camera and aimed directly at the subject. Although it is convenient, it can produce distracting shadows and unflattering light conditions on the subject. Many faults of this technique can be corrected by removing the flash from the camera and using an electrical connector to fire it. This direct off-camera flash can be used to even out exposures on subjects located at different distances from the flash with a feathering technique, called tipped flash. The direct off-camera technique allows simultaneous lighting of several flash units connected together electrically or to a photo-electric cell.

Indirect flash bounces the light from a secondary surface, such as a ceiling or wall, to soften and equalize the light's intensity. This technique is good for large groups and for softening the light's quality.

Synchro-sunlight flash is a combination of flash and sunlight. This technique is useful for balancing the light which strikes a subject indoors or in shade with a bright sunlight condition. It can be used to reduce the contrast between the highlights and shadows of the subject when the picture is made in bright sunlight.

# Filters

Photographic filters come in several designs to serve different purposes. Some filters should only be used with black-and-white films, others only with color emulsions. Some filters are compatible with either type of film. Regardless of the type of filter, however, its primary function is to change the way a scene is recorded on film. The purpose may be to form a star pattern in a specular highlight area of the scene or to correct the colors and tonality of the scene so that they are recorded as the eye perceives them.

## FILTER CONSTRUCTION AND DESIGNATIONS

Filters designed to alter the color of light and to produce tonality and color changes are constructed similarly, whether they are used with black-and-white or color films. They are manufactured in one of three forms, either gelatin, laminated, or stained glass.

*Gelatin filters* are the least expensive of the three types and are manufactured in a variety of colors and sizes. They are produced by mixing a solution of pure gelatin and dyed distilled water, which is poured onto a flat piece of optical glass. When set and dried, the filter material is stripped from the glass and dipped into lacquer to give it added protection. It is then cut into its proper sizes. The filters can be purchased in precut squares, normally ranging from 2 to 5 in., but sizes up to 15 × 20 in. are available.

Because they are very thin, these filters have no effect on image definition. They are used as industry standards since they can be produced with great quality control.

Despite their advantages, the gelatin filter is still just a lacquer covered gelatin. Its surface is similar to a piece of film, and therefore, difficult to clean without scratching. Although the dye in the material is quite stable, it will fade when exposed to the ultraviolet wavelengths in sunlight.

Gelatin filters are used often in the movie industry, and many cameras have been modified to fit the filter into a slot behind the lens. This protects the filter from fingerprints and dust, while at the same time, the lens filters out much of the ultraviolet light which causes the filter to fade.

For increased protection, the gelatin filter was sometimes sandwiched between two layers of glass and bonded together with a metal ring. Moisture and high humidity, however, could still damage the filter; and as the gelatin aged, it had a tendency to wrinkle. As a result, gelatin sandwich filters are not being produced today for general photographic use.

A more permanent filter is made by cementing the gelatin filter material between layers of optical glass. This sandwich construction is affected by heat and humidity but not as readily as the simpler sandwich. It usually has to be made by the photographer or specially ordered from a filter manufacturer.

The more sophisticated *laminated filter* is manufactured by combining the filter dye with a bonding material. The dyed adhesive is spread on a piece of optical glass in a precise layer and bonded with a similar glass. Unlike the gelatin type, the laminated filter is resistant to heat and humidity and can be easily cleaned, giving it a longer photographic life. The glass layers protect the filter dye from fading by absorbing much of the ultraviolet light.

The major fault of this filter is the thickness of the glass, which, if not carefully controlled, can change the lens' point of focus and deteriorate the image.

The *dyed* or *stained glass filter* is made from the same quality glass used in the manufacture of camera lenses. The colorant which filters the light is added to the glass mixture during the manufacturing process so that the glass itself is colored. This filter material is more expensive, but it has several advantages over other types of filters. The glass of the filter is usually much thinner than the laminated kind, which produces somewhat better optical quality. The filter is protected from fading and can be cleaned.

Both the laminated and stained glass filters can be screwed directly on the camera lens giving them a secondary function. Once the lens is thoroughly cleaned, and the filter is placed over it, only the filter needs cleaning later on. This protects the lens from fingerprints, dust, and scratches.

Until recently, no identity standards were established among filter manufacturers. Each company used its own code. Now a standard designation called a *Wratten* number indicates the hue of the filter material. Here is an example:

| 0–2 | Colorless |
|------|-----------|
| 3–15 | Yellows |
| 16–22 | Oranges |
| 23–29 | Reds |
| 30–36 | Reddish blues to purple |

Although these designations are commonly used today, much of the literature still refers to the older, letter designations. The two identification systems for the more common filters are compared in the following chart.

| Wratten Designation | Letter Designation | Filter Color |
|:---:|:---:|:---|
| #6 | K1 | Light yellow |
| #8 | K2 | Medium yellow |
| #9 | K3 | Deep yellow |
| #11 | X1 | Yellowish green |
| #13 | X2 | Dark yellowish green |
| #15 | G | Orange |
| #25 | A | Medium red |
| #29 | F | Deep red |
| #47 | C5 | Blue |
| #49 | C4 | Dark blue |
| #58 | B | Green |
| #61 | N | Deep green |

## FILTER USAGE

Filters alter tonality by absorbing portions of the electromagnetic spectrum while transmitting selected wavelengths of light. The color and depth of color of the filter determine the extent of the change.

For example, a dark red filter designed for black-and-white photography will transmit all red colors in a scene but will absorb or block out portions of all the other colors in the visible spectrum. The closer the color is to the complimentary color of the filter, the more the filter will absorb that color. In the case of the red filter, the complimentary color is a combination of blue and green, called cyan. When a scene is recorded on film through this filter, the blue and green areas, or any combination of these two colors, will record with less than normal density. This will cause them to print darker than normal. Any red tones will record with more density on the negative and will reproduce lighter than normal on the print. In other words, *a filter will lighten colors in a scene which match its own color and will darken the opposite or complimentary colors.* (See Fig. 15.1)

To be able to predict the effect of a filter on a scene, the photographer

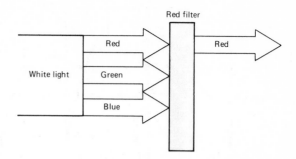

*FIGURE 15.1  A filter transmits light of the same color as the filter and absorbs other wavelengths. Here the red filter passes all of the red wavelengths. This would cause the red areas of the picture to record in their normal tonality. Other areas would be transmitted to the film with less than normal intensity, making them appear darker.*

should be familiar with the photographic color chart and the relationships of colors. The wavelengths of energy that produce the colors of sight and photography are considered to be the primary colors. These are red, green, and blue. White light consists of all three wavelengths. All other colors are combinations of the three colors. In photography, they are referred to as the *additive primaries*. A second set, called *subtractive primaries*, are the complimentary colors of the additive primaries. They are cyan, magenta, and yellow. (See Fig. 15.2) The combination of any two colors of one primary produce a color in the opposite primary. For example, the equal combination of red and green produces yellow. Yellow and cyan produce green. If the photographer is not familiar with the relationship of colors, a filter can produce unexpected results. For example, a red filter will darken the subtractive primary of cyan and lighten the red primary color, but it will also darken blues and greens and lighten yellows and magentas.

*FIGURE 15.2  Additive and subtractive primary colors.*

Filters designed only for black-and-white photography will produce one of two effects. They will either correct the film's tonality to fit eye perception or they will exaggerate the contrast of the scene's tonalities.

**CORRECTION FILTERS.**  As we saw in Chap. 1, panchromatic film and the eye respond differently to some colors of the visible spectrum. Both have some degree of sensitivity to all colors, but the eye is more responsive than film to the yellow-green portion of the spectrum. On the other hand, film is more sensitive to blue and red than the eye. (See Fig. 15.3) To correct this

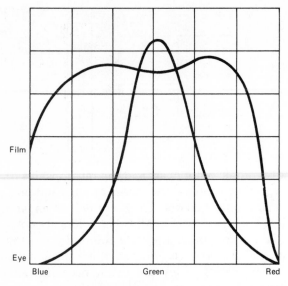

Film

Eye

Blue          Green          Red

*FIGURE 15.3  The eye and film respond to the wavelengths of light with different sensitivity. Film is more sensitive to the red and blue colors of light, and the eye is more sensitive to green.*

imbalance, filters are used to block out red and blue lights so that the film records as the eye perceives. These filters are referred to as *correction filters.*

Although several filters can be considered correction filters under special circumstances, the two most common are a medium yellow filter and a green filter. The medium yellow filter will produce the most accurate outdoor tones by increasing the separation in foliage and by darkening blue skies. It is generally used when clouds are present to give greater contrast between the white and blue of the sky. Otherwise, because of its sensitivity to blue light, panchromatic film records clouds and sky with an overall even tone. (See Fig. 15.4)

*FIGURE 15.4(a)  Panchromatic film records sky tones lighter than the eye normally sees them and produces less contrast between the sky and clouds than the eye perceives.*

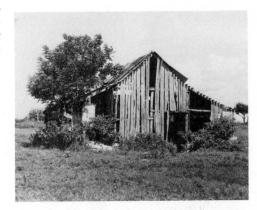

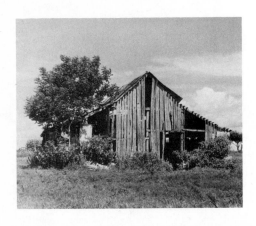

*FIGURE 15.4(b)   A yellow filter darkens the blue of the sky so that the tonal relations are closer to what the eye sees.*

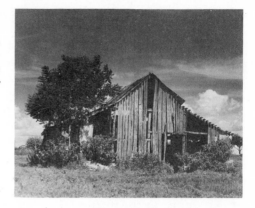

*FIGURE 15.4(c) A dark red filter produces a more dramatic effect in the sky tones. Darkening the blue makes the clouds more pronounced. The red filter also slightly darkens the green foliage.*

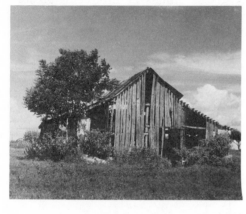

*FIGURE 15.4(d) A polarizing filter does not affect the colors of the scene, but it does remove the reflections which give the sky much of its blue color. It can also darken the sky.*

A yellow filter will lighten its own color and darken its compliment; therefore, blue, the compliment of yellow, is darkened. Since green is half yellow, foliage is lightened by this filter, allowing greater detail to be recorded in landscape pictures (Fig. 15.2).

The green correction filter is used for photographing people against a sky background. It increases contrast between skin tones and the darker blue of the sky. It is useful in landscape photography since it lightens foliage more than the yellow filter and gives added tonal separation and detail to shrubbery and trees. (See Fig. 15.5)

*FIGURE 15.5 A green filter used for landscape photography produces greater than normal detail in foliage. At the same time, it produces greater separation between sky and clouds by darkening the tonality of the sky. The tone is similar to that created with a light yellow filter.*

**CONTRAST FILTERS.** At times the photographer needs to exaggerate tones in a scene to give added emphasis. This can be done with a contrast filter. Unlike the correction filters, these filters produce darker and lighter tones than the eye sees. In Fig. 15.4, for example, the pictures were made both with medium yellow and dark red filters and without a filter. The red is considered to be a contrast filter since it darkens the blue in the sky until it is almost black. This gives emphasis to the clouds by producing greater contrast between the dark of the sky and the lightness of the clouds.

The red filter can create the appearance of a nighttime scene during midday when the photographer slightly underexposes the film and places a light source in the picture. (See Fig. 15.6) A dark red filter is used for making pictures with black-and-white infrared sensitive film. (See Fig. 15.7)

*FIGURE 15.6 The appearance of night can be photographed during daylight hours by using a red filter and a light source, such as a flashlight. The red filter darkens the sky, and the film is underexposed by about two f/stops to produce the night sensation.*

*FIGURE 15.7 Infrared film is sensitive also to ultraviolet energy. (a) A red filter was used to filter out noninfrared energy. (b) Without it the scene was recorded with only ultraviolet and infrared light.*

(a)

(b)

The orange filter increases contrast in a scene. It darkens blue and blue-green, which is useful for making pictures of marine subjects and for darkening skies for landscape pictures.

A blue filter emphasizes fog and haze to create flat pictures (lack of good contrast). It also intensifies the mood produced by the lighting condition. (See Table 15.1)

TABLE 15.1
FILTER RECOMMENDATIONS FOR BLACK AND WHITE FILMS IN DAYLIGHT

| Subject | Effect Desired | Suggested Filter |
|---|---|---|
| Blue sky | Natural | #8 Yellow |
| | Darkened | #15 Deep yellow |
| | Spectacular | #25 Red |
| | Almost black | #29 Deep red |
| | Night effect | #25 Red, plus polarizing screen |
| Marine scenes when sky is blue | Natural | #8 Yellow |
| | Water dark | #15 Deep yellow |
| Sunsets | Natural | #8 Yellow |
| | Increased brilliance | #15 Deep Yellow or #25 Red |
| Distant landscapes | Addition of haze for atmospheric effect | #47 Blue |
| | Very slight addition of haze | None |
| | Natural | #8 Yellow |
| | Haze reduction | #15 Deep yellow |
| | Greater haze reduction | #25 Red or #29 Deep red |
| Nearby foliage | Natural | #8 Yellow or #11 Yellow-green |
| | Light | #58 Green |
| Outdoor portraits against sky | Natural | #11 Yellow-green, #8 Yellow, or polarizing screen |
| Flowers–blossoms and foliage | Natural | #8 Yellow or #11 Yellow-green |
| Red, bronze, orange, and similar colors | Lighter to show detail | #25 Red |
| Dark blue, purple, and similar colors | Lighter to show detail | None or #47 Blue |
| Foliage plants | Lighter to show detail | #58 Green |
| Architectural stone, wood, fabrics, sand, snow, etc., when sunlit and under blue sky | Natural | #8 Yellow |
| | Enhanced texture rendering | #15 Deep yellow or #25 Red |

**FILTERS FOR COLOR FILMS.**  In addition to those used in black-and-white photography, some filters correct colors of pictures made with color negatives and transparency film.

Each color film is designed to be used under a specific color of light, measured according to its *Kelvin temperature.* The Kelvin scale is used to indicate the temperature required for a black body to radiate the same wavelengths of energy as the light source. Daylight has a temperature of 5500 K. Films balanced for daylight will produce the correct colors of a subject if it is lighted by a source at 5500 K. If the Kelvin temperature is lower, the subject's colors will shift overall toward red. The filter will correct this by compensating for differences in the color temperature of the light sources. Table 15.2 gives the filters available for color film corrections.

Filters designed for black-and-white film can be used with color film, but they transmit only a small range of wavelengths. Therefore, any picture made will take on an overall tint or color of the filter. They are generally used for special purposes with color film.

**TABLE 15.2**
**CONVERSION FILTERS FOR COLOR FILM**

| | | | Filter | | |
|---|---|---|---|---|---|
| Color Films | Balance for | Daylight or Electronic Flash | Photo Lamp (3400K) | Tungsten (3200K) | Clear Flash Bulb (3800K) |
| Daylight | Daylight, blue flash, or electronic flash | No filter | 80B | 80A | 80C |
| Type A | Photo lamps (3400K) | 85 | No filter | 82A | 81C |
| Type B | Tungsten (3200K) | 85B | 81A | No filter | 81C |

## FILTER FACTORS AND EXPOSURE CHANGES

All filters transmit only a portion of the light which strikes them; the remainder is reflected or absorbed. In order to correctly expose the scene, the photographer must compensate with the aperture and/or shutter speed for the loss of light. This compensation is called a *filter factor.* (See Fig. 15.8)

The loss of light from each filter is indicated in a factor form, such as 2X, 4X, 6X, etc. A factor of 2X means that only half of the light is transmitted. So the photographer would have to adjust the exposure to allow in twice as much light. This is accomplished by decreasing the shutter speed by one stop or by opening the aperture by one stop. A 4X filter factor shows

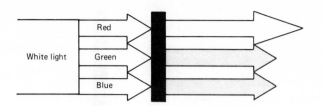

FIGURE 15.8 *A filter normally transmits only a portion of the total light which strikes it. The other light is either absorbed by the filter or reflected.*

that only a quarter of the light is being passed through, and a two-stop adjustment needs to be made.

Each filter has a chart which gives its specific filter factor and needed exposure adjustments, but the more common ones are in the following list

| Filter Factor | Exposure Adjustment |
|:---:|:---:|
| 1X | No adjustment |
| 1.2X | 1/4 f/stop |
| 1.4X | 1/2 f/stop |
| 1.7X | 3/4 f/stop |
| 2X | 1 f/stop |
| 2.8X | 1 1/2 f/stops |
| 4.4X | 2 f/stops |
| 5.7X | 2 1/2 f/stops |
| 8X | 3 f/stops |
| 11.4X | 3 1/2 f/stops |
| 16X | 4 f/stops |
| 32X | 5 f/stops |
| 64X | 6 f/stops |

## SPECIALTY FILTERS

Specialty filters are designed for both black-and-white and color films. Some produce tonality changes, while others create optical effects.

**SPECIAL-PURPOSE FILTERS.** These filters affect the transmission quality of light without substantially altering its color. There are three basic types.

The *neutral density filter* reduces the amount of light transmitted to the film without selectively filtering particular wavelengths. They are neutral because they absorb and transmit equal amounts of all three wavelengths of the primary colors (Fig. 15.9).

They are used mostly in bright light conditions when a wide-open aperture setting is needed to control the depth of acceptable focus. For example, if the photographer is using a medium-speed film in bright sunlight with a shutter speed of 1/500 sec, the lens aperture would be set approximately at f/8. This aperture opening would provide the minimum depth of field that

FIGURE 15.9 A neutral density filter, unlike other types of filters, transmits equal amounts of all three primary colors, but in reduced intensities.

could be produced under the circumstances. With a neutral density filter, however, the depth of field could be reduced further, depending on the density of the filter. Most commonly manufactured neutral density filters will reduce the light by one, two, or three *f*/stops. Some are manufactured to handle increments as small as a third of an *f*/stop and up to about 13 *f*/stops.

A filter which removes unwanted reflections from nonmetallic surfaces is a *polarizing filter*. To understand how this filter performs, it is necessary to understand how light travels.

Light normally moves from a source in a straight line with the waves vibrating perpendicular to the line of travel. This is *unpolarized* light. When it strikes a reflecting surface, all vibrations move in the same direction and are seen as reflections. This is *polarized* light. If the light strikes a metallic surface, however, it remains unpolarized.

The polarizing filter passes only light waves which vibrate in a single direction. It absorbs reflections, but the filter must be rotated so that its position of light acceptance is different from the angle in which the reflected light is vibrating. (See Fig. 15.10) For maximum reflection reduction, the camera should be angled about 35° to the reflecting surface.

Since the vibrations are filtered and not the light wavelengths, the color of a scene is not affected. This allows the filter to be used with all types of film. For making color pictures, this is one of the few ways to darken the sky without altering other tones in the scene. Much of the sky's color is the result of light being reflected from moisture suspended in the atmosphere.

FIGURE 15.10 A polarizing filter is used to remove or reduce reflections from nonmetallic surfaces.

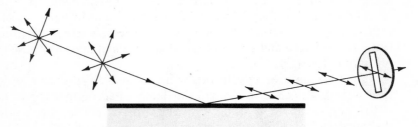

When light strikes these particles, it becomes polarized. The filter will re-
move the aerial reflections, and in the process, it will darken the sky.

The degree of darkness will depend on the direction of the camera's aim
in relationship to the sun. The greatest amount will occur if the camera is
pointed at a 90° angle to the sun. The filtering effect can be seen through
the viewfinder camera as the filter is rotated on the lens. (See Fig. 15.11)
One word of caution. What is seen through the viewfinder will not corre-
spond to what is recorded on film if polarized sunglasses are worn.

The polarizing filter is used for making pictures of landscapes because it
produces better color purity and color saturation within the scene. Much of
the natural colors is diluted by surface reflections on the leaves of grass and
shrubbery. Proper use of the polarizing filter will partially remove these
reflections, allowing the natural colors of the scene to be recorded.

The ability of the filter to transmit only a portion of light without af-
fecting colors gives it the capacity to reduce the overall intensity of light
striking the lens. Most polarizing filters will reduce the intensity by one to
two *f*/stops.

Special-purpose filters of a third category will change the way colors are
recorded on film, by correcting light as the eye perceives it. For example,
when an *ultraviolet* or *haze filter* is used with color films, it reduces the blue
in haze, marine, and mountain scenes without affecting the other colors.

Atmospheric haze is caused by very small particles of dust and moisture
interfering with light rays. As the distance of the subject from the camera
increases, the subject's overall tones become lighter, contrast is decreased,
and an overall shift occurs in the color of the scene towards the blue. The
haze scatters the light rays and changes their wavelengths into the invisible

*FIGURE 15.11   A polarizing filter allows the photographer to control the
amount of reflections recorded on film. (a) The sky is darkened to its maxi-
mum for the conditions but (b) is only slightly darkened. The two illus-
trations demonstrate the wide variety of tonal values that can be produced
with this filter.*

(a)

(b)

ultraviolet. Since photographic film is more sensitive to the blue and ultraviolet portions of the electromagnetic spectrum, the film will record more haze than the eye can see. The use of a filter to absorb the blue and ultraviolet portions of the light will reduce the haze and cause the scene to record color more normally.

Similar to an ultraviolet or haze filter is a *skylight filter*. It reduces the amount of ultraviolet light reaching the film but not to the same extent as a haze filter. It does filter blue out of the scene and is useful for making color pictures in the shade.

**SPECIAL-EFFECT FILTERS.** Filters produce optical effects in several ways. The combination of different special-purpose filters with ordinary glass, for example, produces a filter that is half neutral density and half normal. This type of filter can be used to reduce the exposure of a scene where intensity is greater in one area than an adjacent section, much as a horizon or skyline.

Most special-effect filters use different densities of glass to give their effects. Typical of the more common ones are those which produce a sharp image in the center of the frame and a softer, less focused image along the edges; a star pattern in bright points of light; an overall fog effect; or multiple images on the same frame of film. The number of these filters increases each year making them too numerous to list, but some of the more common ones and their effects are pictured in Fig. 15.12.

*FIGURE 15.12(a)  A star filter produces star shapes from light sources. The shape of the star is controlled by the way the filter is manufactured. The stars in this illustration have four points, but some filters will produce shapes with more points.*

*FIGURE 15.12(b)  A soft focus filter degrades the sharpness of the image recorded on film. Although this illustration is made with a commercially available filter, similar results are possible by photographing the subject through netting or by diffusing the image during the enlargement.*

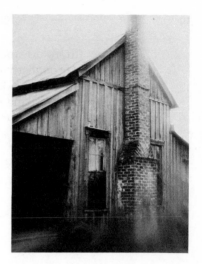

*FIGURE 15.12(c) Results similar to those obtained with a soft focus filter can be achieved with petroleum jelly smeared on a piece of glass or on an existing filter. This photograph was made through smeared glass. (Courtesy of Tim Hope.)*

*FIGURE 15.12(d) Filters that use prisms can be designed to produce several images of the same subject at one time on the film. The filter used here allowed the photographer to record five images. Other filters can produce three or more. Some of these specialty filters make images which appear parallel to each other rather than in a circular shape.*

## SUMMARY

Filters are manufactured in several forms. They are used to alter tonality, to correct color and contrast, or to produce optical effects. Some are designed exclusively for black-and-white film or for color. Others can be used with all films.

To alter the tonality of the scene, filters are usually manufactured in one of three ways. They are either a dyed gelatin material, a lamination of gelatin between layers of glass, or a dyed optical glass. The latter is the most expensive filter, but it does not have many of the disadvantages of the other two types.

Those filters to be used exclusively with black-and-white films are categorized as either correction or contrast filters. The correction filters produce an image with tonality similar to the way the eye sees it. Contrast filters alter the tonality of the scene, but the results are more pronounced. Instead of the sky being recorded in its natural tonal relationship to clouds, for example, these filters will darken the sky tones more, creating a dramatic contrast between sky and clouds.

Filters designed for color film alter the light's color so that the colors of the scene will be recorded correctly.

Some filters do not produce radical changes in the wavelengths of light which pass through them, so they can be used with any type of film. These are neutral density, polarizing, haze, and skylight filters. For making color pictures, the polarizing filter provides one of a few ways to darken the colors of the sky without altering other tones in the scene. Typical filters that produce optical effects in a scene are soft focus, multiple image, and star filters.

# Printing Variations

Throughout this book, the focus has been on standard photographic procedures used in black-and-white photography. This chapter presents a brief look at some of the many variations to the processes and techniques that alter the image in the darkroom or after processing is completed.

## USING TEXTURE SCREENS

One of the easiest methods to change the appearance of the finished print is to combine the negative with a texture screen, a device which gives the print a textured appearance. Commercially manufactured screens are available in two forms, one of which is combined or sandwiched with the negative in the enlarger and both the texture and the negative image are projected simultaneously on the photographic paper. The other is placed in contact with the enlarging paper, and the image of the negative is projected through the screen onto the paper. Although both types are readily available, most photographers prefer the smaller screen that goes with the negative. It is more convenient, has less area to clean, and it makes better contact with the negative than the larger screen does with the paper. The smaller screen's main disadvantage, however, is that the screen enlarges with the negative. Because of this, the texture size will vary with the print size.

Some of the more common commercial screens produce textures which resemble canvas, linen, painting brush strokes, etching, and other art finishes. Others create dot patterns, exaggerated grain, reticulated grain patterns, gravel, and different types of concentric circles. (See Fig. 16.1) Texture

(a)

(b)

(c)

FIGURE 16.1 *The texture of the image can be altered with a texture screen. (a) Linen texture, (b) canvas texture, (c) reticulated grain screen. The textures are separate and are printed in contact with the negative.*

screens can be made by the photographer with objects such as lace and other translucent cloth, tissue paper, and textured glass.

**SANDWICHING NEGATIVES.** Similar to combining a texture screen with a negative or paper is sandwiching two negatives and then making an exposure through them at the same time. (See Fig. 16.2) The photographer, however, should be aware of several problems. The negatives, for example, must be positioned so that the subject of each will print through areas of the other that have little or no density. Subjects containing large amounts of light tones do not print as readily in the sandwich as subjects which are predominantly dark. If both negatives contain large dark or dense areas, the density in the negative cancels out the image in each other.

Another problem is with exposure times. If the photographer sandwiches

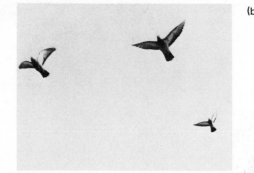

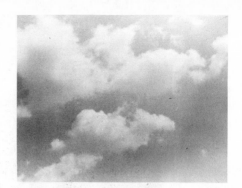

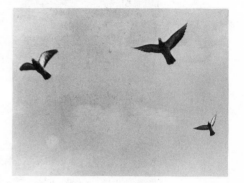

FIGURE 16.2 (a) The birds were pho-
tographed against a sky which did not con-
tain clouds. Sandwiching it with a picture
of clouds (b) produced the impression that
the birds were flying in a clouded sky
(c).

the two negatives in their correct orientation, a distance equal to the thick-
ness of the film base will separate the two emulsions. For both emulsions to
print sharply, the photographer has to stop the enlarger lens down by about
three f/stops more than normal. This increases the lens' depth of field simi-
larly to what would happen with a camera lens and causes both levels of
emulsion to be recorded with equal sharpness. The density of the projected
image is greater than normal, however, since the light is being projected
through two negatives. Combined with the small aperture opening, the in-
creased density of the image necessitates exposure times which range some-
times into minutes rather than the normal seconds.

Shorter exposure times are possible if the negatives are placed emulsion
to emulsion rather than emulsion to base. Using the emulsions together
does not require the lens to have as great a depth of field to record both
images sharply. Therefore, the exposure times can be shorter because of
the greater amount of light being projected on the paper. However one of
the images will be printed backwards.

**PHOTOGRAPHIC MONTAGES.** A technique which produces an image
similar to one with the sandwiched negative is the photographic *montage*.
The montage is created from more than one negative combined with other
images, but unlike the sandwich technique, the negatives are printed one
at a time rather than in combination with each other. (See Fig. 16.3)

The montage can take many forms. A simple illustration is a cartoon
character who suddenly gets an idea, and a bulb lights up in a little balloon

(a)

(b)

(c)

FIGURE 16.3 *A photographic montage is a combination of two or more negatives printed together. The images are shown separately [(a) and (b)] and combined (c). Each image is blended into the other during printing so that they appear as one composition.*

above his head. To develop this for a montage, you would make two negatives, one of the characters in a thinking or dreaming pose, and the second of what the character is thinking.

The second step in the procedure is to combine the two images. This can be done by making a print of the first negative or by tracing the outline and position of the subject on a piece of paper in the enlarger's easel. Afterwards, place the second negative in the enlarger and project it on the sketch or photograph of the first negative, then position the enlarger for correct image placement and size and trace the second image on the first image outline. Keep track of the enlarger's height during the entire procedure so that the degree of enlargement is repeatable.

The next step in producing the montage is to do exposure and contrast tests for each image, making sure that both images are developed exactly for the same length of time. Even though these tests are done on separate sheets of paper and developed at different times, the final print, which combines both images on a single sheet of paper, has to be developed for the same duration as the tests.

After the tests are completed, cut out an area just slightly smaller than the original from the dream portion of the montage on the sketched outline. Place it on an opaque board and use it to dodge the area which will contain the dream image during the exposure that produces the image of the character. Once the initial exposure is completed, remove the first negative and paper and position the second negative in the enlarger. Readjust the enlarger for the next exposure. Replace the photographic paper containing the undeveloped image of the first exposure in the enlarger easel. The outline with the cutout area used earlier as a dodging tool for the first exposure is now used to dodge the rest of the print, while you project the second image through the hole on the paper. After both exposures are completed, the paper is processed normally through the developer, hypo, and wash.

This example is a very simple utilization of the montage. The technique can be used in many other ways, such as to combine events occurring at different times or places into a single photograph, or to add clouds or other material to a landscape to help create a mood for the picture.

## PRINT TONING

The normal image hue of a black-and-white print is in the different shades of gray, but coloration can be controlled to some extent through the selection of paper and developer. For more radical changes, the print needs to be toned.

Print toning involves changing the normal gray image into another color with dyes or by making chemical changes in the silver image. The latter is produced by converting the individual grains of silver into another compound, such as silver sulfide, or by coating them with another metal. The chemical process gives the image a wide range of hues.

Several factors, however, influence the hue produced by the chemical toners. These include the type of paper emulsion, the contrast of the paper, its age and surface characteristics, the chemical composition of the paper developer that originally formed the black-and-white image, and the tint of the paper stock to which the emulsion is attached.

The photographer has to consider all of these variables, including the tonality and quality of the print itself when selecting a toner. The photographer should experiment with different toner and paper combinations so that the end results will be predictable.

Processing also plays an important role in print toning. The print should be completely fixed so that all remaining silver salts are removed from the emulsion and fully washed to remove all residual hypo from the paper or emulsion. If either silver salts or hypo remain, staining and uneven toning of the print can result. Hypo clearing the print and then thoroughly washing it afterwards is a good way to make sure that all the hypo is removed. If the print has been washed and dried previously, the photographer should wash the print again before it is toned so that the toner will color the emulsion at the same rate.

Several types of toners come prepackaged and need only to be mixed or diluted in water. Some of the more convenient, commercially available toners are manufactured by Kodak and are sold under the names of *Rapid Selenium Toner*, *Brown Toner*, *Poly-Toner*, and *Sepia Toner*. Other manufacturers have similar products which they market under the same descriptive name or under a similar designation. Each of the toners is recommended for specific paper emulsions. In the case of Kodak, Rapid Selenium Toner is recommended for their Ektalure papers; Brown Toner for Kodabrome RC, Medalist, Polycontrast, Polycontrast Rapid, and Polycontrast RC; Poly-Toner is recommended for Ektalure and Medalist; Sepia Toner can be used with Kodabrome II, Kodabrome RC, Kodabromide, Medalist, Polycontrast, Polycontrast Rapid, and Polycontrast Rapid RC enlarging papers.

Selenium toners coat the silver grains to produce the desired change in color. They come in a concentrated form that must be diluted. The degree of dilution helps control the reddish-brown tone of the print. Unlike some toners, this toner is a single solution. The amount of time the print is left in the toner ranges from two to eight minutes, depending on the paper, the dilution of the toner, and the temperature. Since this toner coats the silver grains, it intensifies the image tone. Therefore, it should be used with a print that is slightly lighter than normal.

Another single solution toner is Kodak's Poly-Toner. This toner produces a wide range of hues, from a reddish-brown, similar to that produced by Rapid Selenium Toner, to a brownish-black. The hue the print takes on depends on the dilution of the toner and the time the print is left in the toner.

Kodak's Sepia Toner, on the other hand, comes as two solutions. The first is a bleach that removes the black image of the silver. The image is redeveloped in a second solution. The complete process is carried out in regular room light and produces a warm brown tone with most cold tone papers. These papers are designed to produce a blue-black image. With Sepia Toner, prints need to be made originally a little darker than normal so that the bleached and redeveloped image will have the proper tone densities.

Besides chemical toners, a variety of materials can be used to dye the image. Dyes do not produce a chemical change, but they give a distinctive hue to the overall photograph, tinting all areas and tones of the picture. Unlike the chemical toners, they normally leave a residual hue in the white

areas of the picture. Print toning dyes range from commercially prepared solutions to materials, such as food colors, coffee, or tea.

**MULTIPLE TONING.** To enhance artistic expression, toners can be used in combinations to produce a wider range of colors and to affect selected portions of the print while leaving other parts in their original condition.

The simplest way to produce multiple toning is to overlay two toners on a print. Their combination will create a different color. If a print is first toned with a brown or sepia toner, for example, and then with a blue toner, the resulting hue will be in the red range of colors. Through experimentation, the photographer can find different combinations of colors to enhance the black-and-white image.

If the photographer desires to tone only a portion of the print, the other area must be covered with a waterproof material, such as rubber cement or a substance called *Photo-Maskoid*. The latter is a dyed rubber cement which shows more clearly where the substance has been applied. The toner reacts only with the silver where it soaks into the emulsion; therefore, the area covered with the rubber cement will not be affected. After the print has been toned, the rubber cement is simply peeled off, leaving an untoned area with natural tones.

The photographer can vary the process by covering the toned area with rubber cement and giving the previously untouched portion a different color of toner or dye. This procedure can be carried out in steps to give the print several colors.

**PHOTO SKETCHING.** A technique similar to multiple toning involving the use of rubber cement is the photo sketch. Essentially, this is a combination of a photograph and drawing in the same print. Instead of the toner, however, a chemical potassium ferricyanide is used. This is a bleaching agent which removes the silver from the paper.

Initially, the print is prepared as it is for multiple toning. Rubber cement is placed over the area which is to remain as a photograph. Then an outline of the uncovered image is traced with waterproof ink to form the drawing. Afterwards, the print is put into a tray of hypo and then transferred to the bleaching solution. The procedure is repeated until the image underneath the drawing is completely bleached out and the yellowish color of the bleach is removed from the print. The print is then stripped of the rubber cement and washed and dried. (See Fig. 16.4) The final product is a print which is a combination photograph and drawing. Even if the photographer is not an accomplished artist, the technique can produce good results.

Not only do multiple toning and photo sketching allow the photographer greater expression, the techniques have commercial applications. They isolate portions of the picture and provide greater visibility to details for closer study.

(a)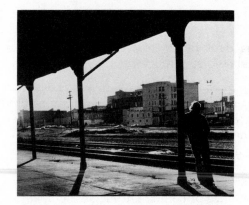

(b)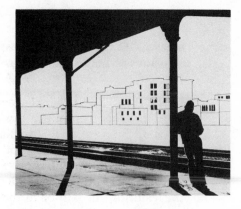

FIGURE 16.4(a,b) A photosketch. (Courtesy of Jeff McAdory.)

## USING HIGH-CONTRAST FILMS

Occasionally the photographer does not want normal contrast in a picture because of the subject matter or treatment. In those situations, the photograph may be best represented as a high-contrast image, that is, one containing only black-and-white tones rather than the various shades of gray. A high-contrast photograph is not simply a picture which has been printed to a higher than normal contrast. It contains no middle values of any shade. The image is pure black and white. The middle values are removed in the darkroom with high-contrast film. Typical subjects photographed in this manner are those with strong graphic shape or shown in normal high-contrast situations. (See Fig. 16.5)

The use of high contrast can initiate many photographic variations in the darkroom, in addition to the emphasis it gives to basic form and design.

High-contrast films normally used in the printing industry come in three basic categories. They are *lithographic*, *process*, and *commercial high contrast* films. While all three give greater contrast than normal photographic

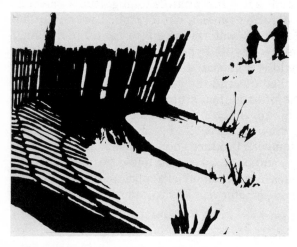

FIGURE 16.5 High-contrast film allows the photographer to remove all of the gray tones in the image. (Courtesy of Russ Cloy.)

films, the lithographic films produce the highest contrast and best serve the photographer for making high-contrast images.

Lithographic film is available with two types of emulsions. The panchromatic emulsion is sensitive to all wavelengths of visible light. Similar to regular photographic film, it needs to be exposed and processed in total darkness. The other type is an orthochromatic emulsion. It is not sensitive to red light, therefore it can be exposed and processed under a safelight. Manipulation of the image is easier with this film because the photographer can visually monitor the process from beginning to end.

On the surface, it appears that lithographic orthochromatic film should be easy to use. It can be handled under a safelight similarly to photographic paper (the safelight has to be red instead of yellow-green) and the photographer does not have to worry about retaining middle values in the image. Correct exposure and development of the image, however, are critical parts of the process. The higher the contrast of the emulsion the less latitude the film has for over- and underexposure.

The exposure of the film determines both the opaqueness of the image which produces the white, and the sharpness of the image. In each stage of producing the high-contrast image, the photographer usually wants an exposure that gives the minimum opaque density. Longer exposures will only serve to decrease the amount of fine detail in the image; less exposure will not produce sufficient density to give a clean white on the photographic print.

The developer controls the density and tonality of the image produced on the high-contrast film. The type designed for lithographic film is a two-solution, lithographic developer, commonly referred to as an *A-B* developer. When the lithographic film is processed in these solutions, it produces the greatest contrast, but many photographers prefer the convenience of processing it in the same developer as regular photographic paper. Although paper developer is generally used in undiluted form for the litho film, it will not always completely drop out the middle tones as the A-B developer does. This necessitates contacting the film on another piece of high-contrast film to complete the tonal drop out.

Many photographers find that making a sequence of images of the same subject required with straight paper developer processing is an advantage since it allows them to make compensations and alterations to the image at different stages of production. The first reproduction, referred to as the first-generation image, is made directly from the subject. Succeeding generations are made from the previous reproductions, or lower generations. For the examples in this book (Figs. 16.5, 16.6, 16.7, 16.8, 16.9, 16.12, 16.13), the film is processed in paper developer (Kodak's Dektol) in concentrated form for three minutes.

**BAS-RELIEF PRINTING.** A bas-relief picture is an image traced by either a light or dark line, but it can retain some tones of the original scene. The pho-

tographer can approach bas-relief photography in several ways. One method is to combine a regular negative with a high-contrast positive; a second procedure combines a high-contrast negative with a positive image. Bas-reliefs can also be made by combining a continuous toned positive and negative image together. (See Fig. 16.6)

The bas-relief with a regular negative is made first by contact printing the negative on a sheet of high-contrast lithographic film. The high-contrast and negative images are then sandwiched together. If they were placed in complete register with each other, that is, properly superimposed, the negative and positive tonal values would tend to cancel out each other. Instead, the two images should be placed slightly out of register, which will produce a distorted dark or light outline around the different elements in the picture. Portions of the original tonality of the negative also will print through the clear areas of the high-contrast negative, giving the picture a rough tonal design.

The other form of bas-relief is to contact print the negative or positive on a piece of high-contrast film, and after it is processed, repeat the procedure on another piece of high-contrast film. This produces a high-contrast positive and a high-contrast negative of the same size. These can be placed in register with each other. The bas-relief is created by placing them slightly out

(a)

(b)

(c)

FIGURE 16.6  (a) High-contrast negative. (b) High-contrast positive. (c) When a high-contrast negative and high-contrast positive of the same subject are combined, they cancel out one another's image.

of register and projecting the image from the enlarger onto photographic paper.

The difference between the two processes is that the one utilizing the regular negative retains some of the middle tonal values, while the other produces only the lined contour of the image. The amount of space in which the images are offset determine the width of the line along the edge of the objects in the photograph.

**TONE LINE.** Another way to produce lined images is with the technique of tone line. (See Fig. 16.7) This technique works on the principle that two images of equal densities but opposite tonalities will cancel each other's images if they are registered with each other. This happens if the images are placed on top of each other in direct contact. Because of the film's construction, however, its base support produces a small space between the two images.

When the registered images are viewed from an angle, the space between them allows light to pass through the layers of film. But from above, the densities of the two images block the light from view. (See Fig. 16.8)

To create the tone line image, positive and negative high-contrast images are made with equally dark densities. They are registered with the emulsion of each piece of film facing the same direction as the base. The result is a layer of emulsion and base placed in contact with another layer of emulsion and base. Finally, these layers are placed in contact with a piece of unexposed high-contrast film which will record the tone line image.

*FIGURE 16.7   Tone line image.*

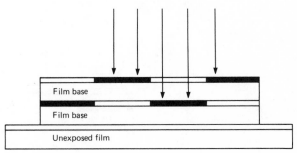

*FIGURE 16.8   The tone line reproduction is made with positive and negative images of equal densities.*

Film base

Film base

Unexposed film

The width of the line is determined by the angle of the light source to the film. A light directly overhead will not produce an image because the densities of the two images will block the light. As the angle of the light source is widened from vertical, the lines produced on the film become wider. Normally, the light source is positioned at about a 45° angle to the surface of the film.

Another consideration arises if the film is exposed with the light at an angle. The resulting image would be similar to that produced by the bas-relief technique with the line following one contour of the object in the picture. (See Fig. 16.9) For this reason, the materials are placed on a revolving turntable so that the light can be projected through the films at all orientations. This will produce an outline of the subject which follows its contours on all sides (Fig. 16.10).

*FIGURE 16.9  The negatives used to produce the tone line image appear like a bas relief when the sandwich is lit from the side without being spun.*

*FIGURE 16.10  To produce a tone line image the light source is moved at an angle to the film, and the film is rotated. This allows the light to penetrate the spaces between the different densities and expose the film underneath.*

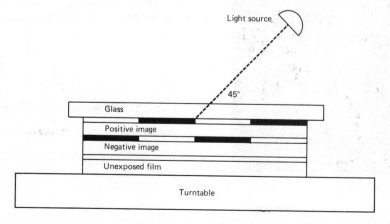

**SOLARIZATION.** The term solarization has come to mean a partial reversal of the photographic image caused by re-exposing it to light during its development stage. Most photographers discover this phenomenon when the print or film is accidently exposed by an unsafe light condition.

Solarization can occur because of the reaction of the emulsion to the developing image. As the image develops, the areas of the emulsion where it is forming becomes less sensitive to exposure. When the emulsion is re-exposed during development, the areas without an image are more strongly affected by the light, resulting in greater density there than in the imaged portions. Since the reversal of the image is actually reversal of tones, this second exposure produces a partial reversal of tonality. (See Fig. 16.11)

The technique was discovered in 1862 by Armand Sabattier, a French doctor and scientist. The Sabattier effect (solarization) can produce a wide range of photographic effects depending on the material used. Re-exposure of the paper emulsion gives the print a gray appearance, in addition to reversing tonality. The graying of the normally white areas is caused when the print is fogged during exposure. Regular film will also produce a similar effect, but the photographer can compensate for the graying by increasing the contrast when the image is printed. (See Fig. 16.12) Solarized high-

(a) 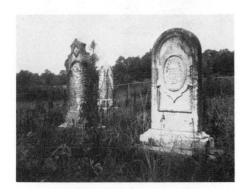  (b)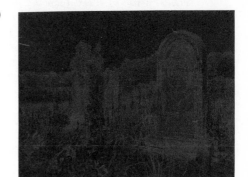

FIGURE 16.11(a, b)  *The solarization of a photographic image is a partial reversal of tonalities and is usually thought of as being an image which is partially positive and negative in nature.*

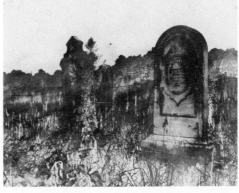

FIGURE 16.12   *(a) Solarization of a continuous tone negative produces a partial reversal of tones which gives the image an appearance of being half negative and half positive.*

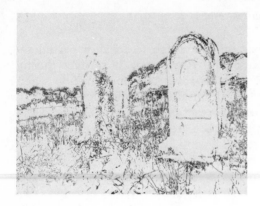

*FIGURE 16.12(b) When the photographer uses a high-contrast film which does not contain intermediate gray tones, the image takes on the appearance of a line drawing.*

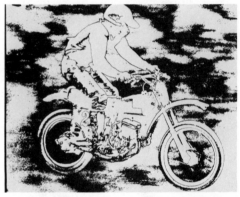

*FIGURE 16.12(c) The dark areas in this solarization were caused by the middle tones of gray retained in the solarized negative. These dark tones produce a greater sense of speed than the lines of a normal high-contrast solarization does. (Courtesy of Lynn Creel.)*

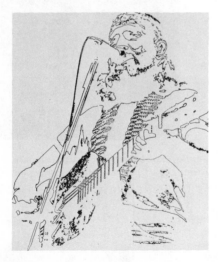

*FIGURE 16.12(d) When the photographer solarizes a negative which does not contain gray tones, the image is turned into a line drawing. (Courtesy of David Taylor.)*

contrast film, on the other hand, produces a tone line effect. Since there are no middle tones to produce partial reversal, the image is transformed into an outline. With this method, the lines retain greater detail of the image, however, than with the tone line technique. (See Fig. 16.13)

A solarized exposure will produce the lined effect after the image is transferred to high contrast film with only dark and light tones retained.

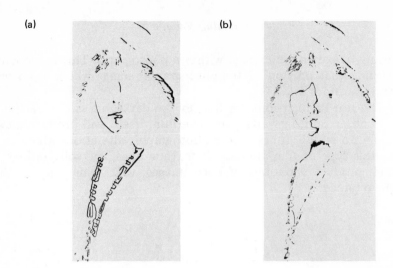

(a)  (b)

*FIGURE 16.13 Tone line and solarized images are similar in that the lines follow the contours of the subject. (a) Tone line images have thicker lines and do not retain the fine detail that is apparent in (b) a solarization.*

There are many processes which can change the photographic image. Some involve making different types of emulsions and putting the image on unusual surfaces. Whole books are devoted to these techniques. The techniques mentioned in this chapter are well within the reach of the beginning photographer and can be accomplished with equipment normally at hand.

## SUMMARY

Alteration of the photographic image can take place in the darkroom or after processing. One of the easiest ways to change it is with a texture screen, which when sandwiched with a negative or paper, produces a textured appearance to the print. In addition, this technique can cause the picture to look like it has been produced in another medium.

Multiple images occupying the same area of a print can be made by sandwiching two negatives together. The result is a double exposure effect. A similar variation is the photographic montage, but with the montage the images are printed separately rather than simultaneously. This technique allows the photographer to make room in the composition for a second image without an overlap.

Another simple alteration is toning, a technique that changes the normal gray image into another color after the photograph is processed. This is done with dyes or by chemically changing the silver image. Toning can be carried out in several stages with each producing a different hue to all or portions of the print. This allows the photographer to give the image many hues even when the original was in black and white.

Similar to multiple toning is photo sketching, a technique that creates a

drawing of part of the image within a photograph. This is accomplished by bleaching that portion of the photographic image which has been outlined with waterproof ink.

The use of high-contrast film in the darkroom is the starting place for many other printing variations. The film, itself, will produce images which contain no middle tones. Other photographic alterations which can be made with this type of film are bas-reliefs, tone lines, and solarizations. The techniques produce variations of lined images, with some tones of the original scene retained.

# Glossary

**ABERRATION, LENS** A deviation from the ideal in the performance of a lens and the image it forms. *Chromatic* aberration is the failure of the lens to focus different colors to a single point. *Spherical* aberration is the failure of the lens to focus light rays passing though different parts of the lens to a single point.

**ACETATE BASE** A clear film support produced by treating cellulose with acetic acid. The dimensions of the base material produced by this means remain the same during processing and it is referred to as a stable base material.

**ACCUTANCE** Measurable sharpness of an image.

**ADAPTER\*** A device which combines parts of different sizes or designs. It is generally used to combine filters and supplementary lenses to a regular camera lens or a camera lens of one design to a camera body of another design.

**ADDITIVE PRIMARIES** A spectrum of red, green, and blue colors, which when combined produce white light.

**AERIAL PERSPECTIVE\*** The impression of depth caused by haze. As the distance from the camera increases, contrast of the scene decreases, and tones become lighter.

*Terms marked with an asterisk have not been discussed in the body of this text but are familiar to those in the field of photography. These terms have been included to extend the usefulness of this glossary.

**AFTERTREATMENT** A general term used to describe alteration to either the negative or print image after the image is processed (toning, retouching, intensification).

**AIR BELL\*** Air bubbles that form on the surface of an emulsion during processing and prevent the processing chemicals from interacting with the image.

**ALL-GLASS (AG)\*** A type of small flashbulb which does not have the conventional metal base cap.

**AMMONIUM THIOSULFATE** A rapid-acting fixing agent, often used in place of the slower sodium thiosulfate.

**ANTIABRASION LAYER** A clear gelatin applied to the top of the photographic emulsion to protect the emulsion from physical damage.

**ANTIHALATION** A light-absorbing material in film which keeps light from passing through the film and bouncing back through it again to form a second image.

**APERTURE, LENS** The opening which light is admitted through to a lens. The diameter of the aperture in relation to the focal length and transmission of the lens determines its effective speed.

**APPARENT PERSPECTIVE** The illusion of depth in a two-dimensional object.

**ARCHIVAL** A term applied to images which have been processed to remain unchanged for a long period of time.

**ARITHMETIC SPEEDS** A numerical system of expressing the sensitivity of emulsions to light. The values increase inversely to the exposure needed to produce a specific density.

**ASA** American Standards Association. This is the former name of the American National Standards Institute (ANSI).

**ASA SPEED** A numerical rating which indicates the relative sensitivity of an emulsion to light.

**ATMOSPHERIC HAZE** The reduction of contrast in distant subjects caused by the scattering of light rays by small suspended particles in the air.

**AUXILIARY LENS** A lens added to an existing lens unit which changes the focal length or other characteristics of the original lens.

**AVAILABLE LIGHT** Light from sources which normally exist in a scene, as opposed to light sources provided by the photographer.

**B** Bulb, a shutter setting at which the shutter blades remain open as long as the shutter release is depressed.

**BACKGROUND NOISE\*** Random visual activity which prevents clear perception. An example is graininess of the image which prevents the perception of minute detail.

**BACKING** A layer applied to the back of film during its manufacture to absorb light (antihalation backing), or curling (anticurl backing), or a separate material which absorbs light, such as the paper backing on roll film.

**BACK LIGHTING** Subject lighting from a position opposite from the camera position.

**BASE, FILM** A material used to support the photographic emulsion.

**BEHIND-THE-LENS** A shutter located between the lens and the film.

**BETWEEN-THE-LENS** A shutter located within the camera lens and between the different lens elements.

**BLACK LIGHT\*** Ultraviolet radiation.

**BLADE SHUTTER** A between-the-lens shutter consisting of very thin pieces of opaque material that control the amount of time light is allowed to enter the camera.

**BLEACH** A chemical that converts metallic silver into compounds which can be removed from the emulsion.

**BLOCKED UP** Highlight areas that contain less than desirable details because of excessive density.

**BLOWUP** An enlarged photograph.

**BLOW UP** To make an enlarged photograph.

**BLUR** Unsharp image caused by movement of the subject or the camera during the exposure or because the image is out of focus.

**BORDER** A distinct line around the edge of the print.

**BOUNCE LIGHT** A diffused illumination created by directing the light source into a reflecting surface rather than directly at the subject.

**BOX CAMERA\*** An inexpensive camera with few or no adjustments for aperture and shutter.

**BRACKET** To expose a subject at the best estimated setting and to make additional exposures above and below that value to assure the correct exposure. (2) A device used to hold a flash unit on the camera.

**BROMIDE PAPER** Photographic enlarging paper which uses silver bromide as the primary light sensitive halide to form the image.

**BURN-IN** Selectively darkening the image on a print through increased exposure to specific portions of the image.

**BUSY** Photograph which is compositionally unorganized or has an excess of visual elements.

**CABLE RELEASE** A flexible wire attached to the shutter that activates the shutter when a plunger connected to the wire is depressed. It is used to minimize camera movement.

**CAMERA ANGLE** The position from which the picture is taken.

**CAMERA OBSCURA**  A light-tight room with a lens or a small aperture in one wall that projects the image to an opposite wall.

**CANDID PHOTOGRAPHY**  Making pictures of people without their knowledge or with little or no direction as to their actions.

**CARRIER**  A device which holds a negative for projection printing.

**CATADIOPTRIC**  A lens based on the same design as a reflecting telescope which combines both mirrors and lenses to project the image.

**CdS**  Cadium sulfite cell, used in light meters to measure the intensity of light.

**CELLULOSE ACETATE**  A chemical substance derived from wood pulp used as a film base.

**CELSIUS (°C)**  Temperature scale where the freezing point of water is 0° and the boiling point of water is 100°.

**CENTER-WEIGHTED METER**  An in-camera light meter which measures the intensity of the light near the center of the lens axis rather than at the edges of the projected image.

**CHANGING BAG***  An opaque device used to load and unload film in daylight or in other bright light conditions.

**CHLORIDE PAPER**  A photographic paper which utilizes silver chloride as the main sensitizing halide. The paper's sensitivity to light is less than that on bromide paper and is used primarily as a contact printing paper.

**CHROMATIC ABERRATION**  A lens defect that prevents light of different colors to be focused at more than one point.

**CIRCLES OF CONFUSION**  The out-of-focus image formed by a lens of an image point.

**CLICK STOPS***  A feature of some lenses which allows a sudden increase in friction as the aperture is changed at each aperture setting.

**CLOSE DOWN**  To decrease the diameter of the lens aperture so less light can pass through the lens.

**COATING, LENS**  A thin coating of a metallic vapor applied to the exposed surfaces of a lens to reduce light reflection.

**COCK**  Movement of the lever or knob on a shutter which puts tension on one or more springs and prepares the shutter for activation.

**COLLAGE***  A composite picture prepared by pasting several images on a common support.

**COLOR BALANCE**  The fidelity with which an object is recorded in relation to its actual appearance.

**COLOR BLIND**  Photographic emulsions which are sensitive to only ultraviolet and blue wavelengths of radiant energy.

**COMA\*** A lens fault which causes points of light to be projected as elongated cones.

**COMBINATION PRINTING** A composite print made from two or more negatives through a variety of techniques.

**COMPOSITION** The orderly arrangement of visual elements.

**CONDENSER** A lens or lens system used to change the direction of light for enlarging.

**CONTRAST GRADE** A numerical figure given to photographic enlarging paper to indicate the relationship of tones it will produce.

**CONTRE-JOUR\*** Against-the-light; more commonly referred to as backlight.

**COUPLED RANGEFINDER** An optical device designed to measure distance; connected to a camera's focusing mechanism.

**CRITICAL FOCUS** The position at which an image point is projected to its sharpest point.

**CROP** Alteration of the boundaries of an image.

**CURTAIN** A flexible strip containing a slit that travels across the surface of the film to control exposure.

**DARKROOM** A room where the illumination can be eliminated or controlled as to color for the processing of photographic materials.

**DEFINITION\*** The clarity of detail in the perceived recorded image.

**DELAY TIMER** A device which delays the opening of the shutter.

**DENSE** A term applied to opaque or nearly opaque areas of the negative caused by either overexposure or overdevelopment of the subject, or both.

**DENSITY** Darkness of the photographic print or opacity of the negative.

**DEPTH OF FIELD** The areas in front of the camera that are recorded in acceptable sharpness.

**DIAPHRAGM** A device which restricts the amount of light allowed to pass through a lens.

**DIFFUSE** Scattering of light rays so that the specular nature of the light is reduced. When used with photographic lighting, the light is passed through a translucent material or is reflected into the subject. When the term is used in shooting and printing, the image is passed through a translucent material to soften its details.

**DILUTION** The adding of water to a stock solution to weaken the solution.

**DIN** Deutsche Industrie Norm, a standard established by the German counterpart of the American National Standards Institute. DIN is also used as a means of rating the sensitivity of photographic emulsions to light that uses logrithmatic progressions.

**DIRECT-POSITIVE** A process of producing a positive image of a subject without the intermediate negative stage.

**DODGE** To reduce exposure in specific areas of the image by shading these areas from light during the printing process.

**DOUBLE EXPOSURE\*** The making of more than one exposure on the same frame of film.

**DOUBLE WEIGHT** A designation of the thickness of the base material used for photographic paper.

**DRUM DRYER** A photographic paper drying device which utilizes a heated drum.

**DRY MOUNTING** The attachment of photographic prints to support materials with adhesives that soften when heated.

**DRY-TO-DRY** The complete processing sequence of photographic material.

**DUST SPOTS** Defects on the photographic print caused by the light being blocked by small opaque dust particles on the negative.

**EASEL** A device used to hold and position photographic materials during printing.

**ECPS** Effective candlepower per seconds; a measurement of light energy output of electronic flash units.

**ELECTROMAGNETIC SPECTRUM** The range of radiant energy traveling in wave form.

**ELECTRONIC FLASH** A light source created by passing a high-intensity, short-duration electrical discharge through an atmosphere of special inert gas.

**ELECTRONIC FLASH METER** A device used to measure the intensity of the light produced by an electronic flash.

**ELEMENTS, LENS** A single piece of glass or transparent material which functions as a lens or part of a lens.

**EMULSION** The suspension of silver halide crystals or other light-sensitive materials in gelatin.

**EMULSION SIDE** The side of the photographic film or paper that contains the light-sensitive emulsion.

**ENLARGEMENT** A photographic print which produces an image that is larger than the negative image.

**EXPOSURE INDEX (EI)\*** A rating given to a film to produce desired results when photographing individual subjects or situations.

**EXPOSURE LATITUDE** The permissible changes in camera exposure settings which cause an increase or decrease in exposure without appreciably affecting the image quality.

**EXPOSURE METER**  A mechanical device used to measure light intensities and then translate the measurements into camera exposure settings.

**EXPOSURE SETTINGS**  The timer and $f$/numbers used to control the amount of light projected to a light sensitive material.

**EXPOSURE VALUES (Ev)\***  An exposure system used to produce the correct aperture and shutter speed setting combinations for a particular light level.

°**F**  Fahrenheit

**f**  Focal length

$f/$  Designation for f-stop or number

**FARMER'S REDUCER\***  A chemical compound used to reduce density by changing the metallic silver to a soluble silver compound.

**FAST**  (1) Lenses with small $f$/numbers (such as $f/1.4$); (2) a paper or film emulsion with high sensitivity to light; and (3) shutter speeds of short duration (such as 1/1000 sec).

**FERRICYANIDE**  A chemical which when combined with potassium produces a bleaching action on metallic silver.

**FILL LIGHT**  A light source used to illuminate the shadows caused by the main light source in the scene.

**FILM BASE**  The support medium for the photographic emulsion.

**FILM CLEANER**  A liquid material used to remove foreign particles from processed film.

**FILM HOLDER**  A device in which film is loaded and then attached to the camera in a position ready for exposure.

**FILM PLANE**  The position of the film's emulsion at the time of exposure to light.

**FILM SPEED**  A numerical value used to indicate the film emulsion's sensitivity to light.

**FILTER FACTOR**  The amount of exposure change required to compensate for the loss of light transmitted through a filter.

**FINE GRAIN**  A term applied to films and developers which produce images with relatively low granularity.

**FIX**  (1) To remove undeveloped silver halides from an emulsion, (2) a term applied to the chemical used to remove underdeveloped silver halides from the emulsion.

**FIXED FOCUS**  A camera preset to produce a sharp image at a particular distance and which cannot be altered by the user.

**FIXER**  See *fix*.

**FLARE**  Non-image-forming light recorded on the film. This can be caused by the reflection of light from the surfaces of the lens or by photographing subjects against an extremely bright background, such as backlighted subjects.

**FLASH**  A sudden surge of light of short duration; an abbreviated term for flashbulb or electronic flash.

**FLASHING**  A printing technique in which the light not passing through a negative is used to darken areas of the print.

**FLASH SYNCHRONIZATION**  The coordination of the opening of the shutter and the flash of light produced by electronic flash or flash bulbs.

**FLOODLIGHT**  A light source which produces a highly diffused light over a large angle. Also referred to as a flood.

*f*-**STOP OR NUMBER**  A number arrived at by dividing the focal length of the lens by the diameter of the aperture opening.

**FOCAL LENGTH**  The distance from the near nodal point of the lens to its focal point when it is focused on a subject at infinity.

**FOCAL PLANE**  The hypothetical surface behind the lens where a projected image is in sharpest focus.

**FOCUSING**  The procedure for altering the image to produce sharpest definition.

**FOG**  Density present in processed photographic materials that is not associated with formation of the image.

**FORESHORTENING**  A perspective illusion which makes the distances between objects appear less than they actually are.

**FORMAT**  The dimensions of a negative on which the image is recorded (such as 35mm format, square format, large format).

**FREEZE**  To record an unblurred image of a rapidly moving object.

**FULL STOP**  A change in aperture or shutter speed which causes the previous amount of light passed to the film to be doubled or halved. Consecutive $f$/numbers represent full stops ($f/4.$, $f/5.6$, $f/8$).

**GELATIN**  A material produced by processing selected parts of animals. In photography it is used to suspend the light-sensitive silver halides and forms the emulsions of films and papers.

**GESTALT**  The perception of images as a group rather than as a collection of individual units.

**GHOST IMAGE**  A less-defined image next to a well-defined image caused by the recording of two images when using flash. One image is created by the flash and the other is recorded from the available light of the room.

**GLARE**  A mirror-like reflection of intense light.

**GLASSINE\*** A smooth translucent paper commonly used for the storage of negatives.

**GLOSSY** A photographic paper surface which is smooth and shiny.

**GRADE, PAPER** A rating of the inherent contrast of photographic printing paper.

**GRAIN** (1) A silver halide crystal in a photographic emulsion, (2) the developed particle of silver which forms the image.

**GRAININESS** Nonuniformity in density in a uniformily exposed area as perceived by the viewer.

**GRAINY** A spotty appearance in a uniformly exposed area caused by the clumping of silver particles or other materials.

**GRANULARITY** An objective measurement of nonuniformity in density in a uniformly exposed area.

**GRAY CARD** A neutral colored board having 18 percent reflectance.

**GROUND GLASS** A sheet of glass which has a textured surface used for focusing the image.

**GUIDE NUMBER** A numerical value used to determine exposure when making pictures with flash or electronic flash units.

**HALATION** An unsharp image around the desired image of a bright object caused by the light penetrating through the film and then forming a secondary image when the light rays are reflected from the back of the camera.

**HALFTONE\*** A photomechanical reproduction in which the different gradations of tone are represented on the image by dots of different sizes but of the same density.

**HALIDES, SILVER** A compound which combines bromine, chlorine, flourine, or iodine with silver to produce a light-sensitive silver salt.

**HALOGEN** Any of a group of chemicals which can be combined with a metal to produce a light-sensitive salt.

**HAZE FILTER** A material which absorbs ultraviolet light rays and reduces the hazy appearance in landscape pictures.

**HIGH CONTRAST** A term applied to lighting, developer, printing paper, film, etc., to indicate the increased contrast between tones. The highest contrast image would be one which only contained the tones of white and black.

**HIGH KEY** A photograph with predominately white or light tones.

**HIGHLIGHT** The subject area illuminated by the main light or any area which produces a strong reflection.

**HOLD BACK** To reduce the exposure in a selected area of the print so that the density of the image is altered. See also *dodging*.

**HOT SPOT** An area which appears lighter than the surrounding area. This is usually caused by an uneven distribution of light from a flash or other light source.

**HUE** The perceived color of light rays.

**HYPO** A common name for sodium thiosulfate or other fixing agents.

**HYPO ELIMINATOR** Chemicals which help in the elimination of the fixing agent from the photographic materials and thus reduce the time needed for washing.

**INCANDESCENT** A light produced by heating a filament to a high temperature.

**INCIDENT** Light which falls on the surface of an object rather than reflected from the object.

**INDIRECT LIGHT** A form of light reflected from a surface rather than transmitted directly from the light source to the subject.

**INFINITY** A term used to indicate that the distance of the subject is so great that it is at the principal focal plane of the lens.

**INFRARED FILM** A photographic material sensitive to energy of wavelengths that are longer than the extremes of red.

**INSTANT RETURN** A term used to identify a viewing mirror in a camera which returns to a viewing position immediately after each exposure is terminated.

**INTENSIFICATION** A process to increase image density through a chemical means after the image has been developed.

**INTENSITY** A measurement of the brightness of a light source.

**IRIS DIAPHRAGM** A variable diaphragm of overlapping metal blades that controls the size of the lens aperture opening.

**K (formerly °K)** Kelvin, a temperature scale based on absolute zero and used to indicate the color of light sources.

**KELVIN** See *K*.

**LARGE FORMAT** A term applied to film sizes and cameras which use films that are 4 × 5 in. or larger.

**LATENT IMAGE** An image recorded invisibly within silver halides and awaiting development to make it visible.

**LATITUDE IN EXPOSURE** The permissible change in camera exposure without a significant change in image quality. This is usually referred to simply as film latitude.

**LATTICE** The structural arrangement of atoms or ions in a crystalline solid.

**LEADING LINES** In pictorial composition, these are elements which are thought to direct the eye motion in a specific direction.

**LENS CAP** A protective cover which fits over a camera lens.

**LENS COATING** See *Coating, Lens.*

**LENS FLARE** Light reflected and then rereflected by the different surfaces of a lens and then finally recorded on the film. This reduces the contrast of the image in the shadow areas of the negative.

**LENS HOOD** A device placed around and projecting in front of the lens to shield the lens from extraneous light rays.

**LENS SHADE** See *Lens Hood.*

**LENS SPEED** A measurement of the lens capacity to admit light and usually expressed in $f$/numbers.

**LENS TISSUE** A soft, nearly lintless paper used to clean optical surfaces.

**LIGHTING RATIO** The differences in brightness of a subject on the portion illuminated by the main light and the area in shadows.

**LIGHT METER** A mechanical device for measuring the intensity of light waves. The measurement can be of the light striking the subject or the amount of light being reflected by the subject.

**LIGHT STRUCK** Photographic materials accidentally exposed to non-image-forming light.

**LITHOGRAPHIC FILM** A photographic film which produces extremely high-contrast images (i.e., only black and white).

**LOADING ROOM** A room without light used to transfer film into a developing tank or another light-proof container.

**LOGARITHMIC SPEED** A form of sensitivity rating based on logarithmic progressions.

**LOUPE\*** A small magnifying glass used to inspect fine image details.

**LOW CONTRAST** Images which have small differences in tonality extremes.

**LOW KEY** A photographic image which consists predominately of dark tones.

**MACROPHOTOGRAPHY\*** Reproduction of an image in the camera of an object to a one-to-one scale.

**MAT** A board with a cutout portion that serves as a frame for a photograph.

**MATTE** A dull finish as contrasted with glossy when referring to the surface characteristics of printing paper.

**METER**   A light meter or a device used to measure the intensity of light.

**METOL POISONING**   A skin ailment involving irritation of the hands due to sensitivity to the developing agent metol.

**MICROPHOTOGRAPHY**   In-camera reproductions greater than one-to-one scale; usually made through a microscope.

**MICROPRISM**   A focusing screen in a single-lens reflex camera that consists of an area of very small prisms which form the screen.

**MILKY**   Cloudy; not clear. Films which have not been fixed properly have this translucent appearance.

**MILLIMETER (mm)**   One thousandth of a meter or 0.03937 in. This is a measurement used to designate lens focal lengths.

**MINIATURE**   A term used to describe both 35mm cameras and 35mm and smaller film sizes.

**MIRROR LENS**   A lens system which includes at least one mirror reflecting surface to form the image. This type of lens design also is referred to as a catadioptric lens.

**mm**   Millimeter.

**MONOBATH**   A solution which both develops and fixes the image during processing.

**MONTAGE**   The assembling of different images on a single picture area through the use of different negatives.

**MOTTLE***   A defective image which displays uneven densities in an area which should have uniform tones.

**MOUNT BOARD**   A stiff paper or cardboard on which prints are attached.

**MOUNTING TISSUE**   One of several forms of adhesives used to attach a print to a support. Mounting tissue usually takes the form of a heat-softenable adhesive and is referred to as dry mounting tissue.

**MUDDY***   A term used to describe a photographic print which is gray in appearance.

**MULTIPLE EXPOSURE**   The recording of two or more separate images on a single piece of photographic material.

**NEGATIVE**   A photographic image with reversed normal tonalities.

**NEOCOCCINE***   A red dye used in negative retouching to produce effects similar to those obtained by dodging.

**NICAD***   Nickel cadmium cell or battery which is rechargeable and is used in electronic flash units.

**NODAL POINT**   The optical center of a lens.

**NONCURL**   A layer of gelatin applied to the back of film to reduce curling.

**NONSILVER** Photographic process which produces images without the use of silver halides.

**OPACITY** The ratio of light striking the surface of film to the amount transmitted through the film.

**OPAQUE** (1) A material which does not allow the transmission of light through it, (2) a material which is put on negatives to block the transmission of light.

**OPEN SHADE** An outside lighting condition where the subject is in the shadows but not directly underneath an overhanging object.

**OPEN UP** (1) A term used in reference to applying more light into the shadows of a scene so that it will record more clearly. (2) An increase in size of the aperture's diameter.

**OPTICAL GLASS** A transparent material used in the production of lenses that is clear, colorless, and free of defects.

**OPTICAL SENSITIZERS** Dyes added to coat silver halides in an emulsion to extend sensitivity to colors to which they are not normally sensitive.

**ORTHOCHROMATIC** Photographic materials which are not sensitive to red wavelengths of light.

**OUT-OF-FOCUS** A term applied to images which are not sharp because the lens and films are not in the correct position.

**OVERDEVELOPMENT** Processing of the photographic material in the developer for too long a time or in too high a temperature to produce the optimum image.

**OVEREXPOSURE** Allowing more than an optimum amount of light to strike and expose photographic material.

**PAN** (1) Short for panchromatic, (2) the act of moving the camera in the same direction as a moving object while making the exposure.

**PANCHROMATIC** Description of photographic materials which are sensitive to all the wavelengths of visible light.

**PAN MOTION** A photograph taken with the camera panning a moving subject. This causes the subject to be recorded as stationary and the background as movement.

**PAPER GRADE** Numerical designation of photographic papers to indicate their inherent contrast.

**PARALLAX** The apparent shift in position of an object when viewed from different positions.

**PC CONNECTOR\*** An electrical terminal which has a pin in the center surrounded by a metal cylinder. It is used as part of the electrical connection between a flash unit and the camera.

**PEANUT BULB\*** A very small flash bulb roughly shaped like a peanut. These bulbs also are referred to as AG bulbs.

**PENTAPRISM** A viewing system used on cameras to provide correct upright and lateral image position.

**PERSPECTIVE** The impression of depth when a three-dimensional scene is represented in a two-dimensional photograph.

**PHOTOFLOOD LAMP** An incandescent bulb that produces light with a color temperature of 3400 K.

**PHOTOGRAM** An image produced without a camera or optics by placing materials of different translucencies between the light source and the photosensitive material.

**PHOTOJOURNALISM\*** Photographic reporting intended for reproduction in newspapers, magazines, etc.

**PICTORIAL\*** A photograph made to represent a subject or for its subject beauty.

**PICTURE ESSAY\*** A series of pictures which represents the photographer's viewpoint and feeling about the subject.

**PICTURE SEQUENCE\*** A series of pictures which present the same subject recorded in a series of related action.

**PICTURE STORY\*** A series of photographs relating to a single theme in a progression from start to finish. The picture story is usually accompanied with words.

**PINHOLE\*** A small circular clear spot on the negative caused by lack of development. Pinholes are normally caused by air bubbles adhering to the surface of the film during development.

**PLUMMING** The darkening of tonalities of a print during drying.

**POLARIZATION** The angular orientation of different vibrations of light waves. Polarized light rays have light wave vibrations that travel in a single direction or orientation.

**PRESSURE PLATE** A device that rests against the film to keep it in a flat plane in relationship to the lens.

**PREVISUALIZATION** The ability to accurately imagine what a finished photograph will look like before the image is recorded.

**PRIMER** In a flashbulb, an easily ignitable substance which starts to burn when the filament is heated.

**PRINTING IN** Selectively darkening specific areas of the photograph during the printing process.

**PROCESS FILM** A film used to make high-contrast images.

**PROOF** (1) A test print, (2) a contact print of one or more negatives for filing and viewing.

**PUSHING FILM** A process of increasing the effective film speed through the use of more active developers or by overdeveloping the film.

**QUARTZ-HALOGEN LAMP** A tungsten lamp which has a filament surrounded by an active gas so that its operating temperature can be higher, thus producing a greater amount of light in a small bulb size.

**RANGEFINDER** An optical device which uses mirrors and prisms to estimate distances. When the rangefinder is attached to a camera, it is used as a focusing aid.

**RAPID TRANSPORT\*** A term which describes a lever that advances the film one frame with a single movement.

**RARE EARTH\*** A form of optical glass which uses metals other than the normal sodium or lead in its production.

**RC** Resin-coated; an identification of photographic papers which have been treated so that they absorb little moisture during processing.

**READY LIGHT\*** A small light on an electronic flash unit that informs the user when the flash unit has built up a sufficient charge for the next flash.

**RECIPROCITY EFFECT\*** The failure of equivalent exposures to produce identical densities and contrasts because of extremely long or short exposure times. This is also called reciprocity failure.

**RECIPROCITY, LAW OF\*** Exposures which produce equal amounts of light striking the film and photographic paper will produce identical densities on the photosensitive materials. This law will hold true for a wide range of exposure times, but not for short or long exposure times. See *reciprocity effect.*

**RED EYE\*** The effect which is sometimes recorded when using flash to take pictures of people in dark areas. The pink appearance of the eye is caused by the light from the flash reflecting back into the camera from the retina of the eye.

**REDUCER** A chemical which decreases the density of developed photographic materials.

**REFLECTED LIGHT METER** A device which measures the intensity of light being reflected from a scene as opposed to an incident light meter which measures the amount of light striking the subject.

**REFLECTOR** Any of many different types of materials which can be used to reflect light from a separate light source.

**RESOLUTION** A term used to describe a lens' ability to project sharp images of small adjacent areas (i.e., lines per millimeter).

**RETICULATION** A defect in negatives caused by abrupt changes in temperature while processing. The result is a random wrinkling of the emulsion.

**SABATTIER EFFECT** The reversal or partial reversal of tonalities caused by re-exposure of the developing image. Also referred to as solarization.

**SAFELIGHT** A light source which produces wavelengths that do not react with a photographic emulsion.

**SELF-TIMER** A device connected to the camera's shutter that delays the opening of the shutter for set periods of time.

**SEPIA** A yellowish-brown color produced by some print toners.

**SHORT STOP** A solution of acetic acid and water used to neutralize photographic developers.

**SILVER HALIDE** See *Halides, Silver.*

**SINGLE-LENS REFLEX (SLR)** A camera with a lens that makes the picture and is used to frame and focus the image with the aid of a movable mirror.

**SINGLE WEIGHT (SW)** A designation of a relatively thin photographic paper.

**SMALL FORMAT** Refers to cameras which use 35mm film or smaller, or to films of those sizes.

**SODIUM THIOSULFATE** A chemical compound used to remove unexposed and underdeveloped silver halides from a photographic emulsion. It is normally referred to as fixer or hypo.

**SOLARIZATION** See *Sabattier effect.*

**SPECULAR** An undiffused reflection of light.

**SQUEEGEE\*** (1) A device to remove excess moisture from photographic materials. (2) The act of removing excess moisture from photographic materials.

**STATIC MARKS\*** A defect on film which resembles miniature lightning caused by the discharge of static electricity along the film.

**STOP DOWN** The reduction of the diameter of the aperture so less light can enter the camera.

**STRESS MARKS** A film defect which normally takes the shape of dark crescents in the emulsion. It is caused by excessive bending of the film.

**STROBE** A term used for electronic flash units.

**SUBSTITUTE READING** The use of a substitute material for making a reflected-light meter reading (such as the back of the hand in place of the subject).

**SUBTRACTIVE PRIMARIES** Three wavelengths of light used in color photography: cyan, magenta, and yellow.

**SUNSHADE** A device which fits around the end of a lens to protect it from stray light rays which could degrade the projected image.

**SUPPLEMENTARY LENS** A lens which is attached to the regular camera lens to alter its focal length or focus.

**SW** Single weight.

**SYMMETRY** Balance of composition elements on either side of a center dividing line.

**SYNC** Short for synchronization.

**SYNCHRONIZATION** The timing of the opening of the camera shutter to the peak output of an electronic flash unit or flash bulb.

**SYNCHRO-SUN** The use of flash outside in bright sunlight to fill shadow areas with supplementary light.

**T** Shutter setting representing a time exposure. The shutter remains open until the shutter release is depressed a second time.

**TELEPHOTO LENS** A term commonly applied to a lens which has a longer than normal focal length and produces an enlarged image size on film.

**TEST STRIPS** Printing exposure test in which several increments of different exposure times are made adjacent to each other.

**TEXTURE SCREEN** A device through which the negative is projected to add the appearance of texture to the print.

**THROUGH-THE-LENS** Used in describing light meters built into the camera which measure the light passing through the lens.

**TLR** Twin-lens reflex, a camera with one lens to view the subject and a separate lens to make the camera exposure. The viewing lens projects the image to a mirror and then to a viewing screen.

**TONALITY** The relationship between the photographic representation of tonal values to that of the subject.

**TONE LINE PRINT** A photograph which has the appearance of a drawing that is produced by placing a high-contrast positive and a high-contrast negative image in register with each other and then projecting light through them at an angle.

**TONER** A material which changes the hue of a black-and-white print.

**TRIPOD** A three-legged support on which the camera is attached to help steady it during an exposure.

**TUNGSTEN** A metallic element used as a filament in many light sources. Many artificial light sources are referred to as tungsten light.

**TWIN-LENS REFLEX** See *TLR*

**UNDERDEVELOPMENT**  The processing of photographic materials for less than the optimum amount of time. This results in lower density and contrast.

**UNDEREXPOSURE**  Less than the correct amount of exposure to light to photographic materials to produce the optimum image.

**UNIPOD***  A camera support with a single leg.

**VARIABLE CONTRAST**  A photographic paper with two superimposed or mixed emulsions that is used with filters of different colors between the light source and the paper's emulsion to change different print-contrast characteristics.

**VIEW CAMERA**  A camera with a lens that projects the image directly on a movable viewing screen that is replaced by the photographic film for the exposure.

**VIEWFINDER**  A framing device used on inexpensive cameras to give a rough indication of the area of the scene which will be recorded on film.

**VIGNETTE**  The merger of the photographic image into a featureless surrounding.

**VISIBLE LIGHT**  That portion of the electromagnetic spectrum of radiant energy to which the eye is sensitive and is perceived as light.

**VISUAL LITERACY***  The ability to convey and communicate information accurately with visual imagery.

**WAIST-LEVEL**  Applied to camera viewing systems, such as the twin-lens reflex camera, that is comfortably seen through when positioned at the photographer's midriff.

**WARM-TONED**  Photographic images which are slightly brownish in hue when compared to neutral gray tonality.

**WASHED OUT**  An image which is too light and lacks highlight details and dark tones.

**WATER SPOTS**  Chemical deposits left on film by uneven drying of the moisture used to wash the film.

**WAVELENGTH**  The distance between the crests of energy vibrations.

**WETTING AGENT**  A chemical used to help ensure uniform drying of photographic film.

**WIDE-ANGLE**  A lens with a focal length that is less than what is considered normal for a particular film format.

**X**  A synchronization setting on shutters intended to be used with electronic flash.

**ZONE FOCUSING**  The prefocusing of the camera on an area that action

will move through and using sufficient depth of field to cover all distances of that area.

**ZONE SYSTEM\*** A film exposure and development combination system which produce optimum shadow and highlight details.

**ZOOM** A variable focal length lens which allows the photographer to produce images of different sizes on the film without changing the physical distance between the photographer and the subject.

# Bibliography

Adams, Ansel, *Camera and Lens*. Hastings on Hudson, N.Y.: Morgan & Morgan, 1970.

——, *Natural Light Photography*. Hastings-on-Hudson, N.Y.: Morgan & Morgan, 1957.

——, *The Negative*. Hastings-on-Hudson, N.Y.: Morgan & Morgan, 1968.

——, *The Print*. Hastings-on-Hudson, N.Y.: Morgan & Morgan, 1968.

Blaker, Alfred A., *Photography Art and Technique*. San Francisco, Calif.: W.H. Freeman and Company, 1980.

Caffin, Charles, *Photography as a Fine Art*. Introduction by Thomas Barrow, Hastings-on-Hudson, N.Y.: Morgan & Morgan, 1971.

Craven, George M., *Object and Image*. Englewood Cliffs, N.J.: Prentice-Hall, Inc., 1975.

Crawford, William, *The Keepers of Light*. Dobbs Ferry, N.Y.: Morgan & Morgan, 1979.

Croy, O.R., translated by F. Bradley, *Graphic Effects by Photography*. New York, N.Y.: Focal Press, 1978.

Davis, Phil, *Photography* (3d ed.). Dubuque, Iowa: Wm. C. Brown Company, 1979.

Eastman Kodak Company, *Creative Darkroom Techniques*. Garden City N.Y.: Amphoto, 1975.

——, *The Joy of Photography*. Reading, Mass.: Addison-Wesley Publishing Company, 1980.

Feininger, Andreas, *The Creative Photographer*. Englewood Cliffs, N.J.: Prentice-Hall, Inc., 1978.

Gernsheim, Helmut, *The History of Photography*. London, Thames and Hudson, 1969.

Gregory, R.L., *Eye and Brain*. New York, N.Y.: McGraw-Hill Book Company, 1974.

Hattersley, Ralph, *Photographic Printing*. Englewood Cliffs, N.J.: Prentice-Hall, Inc., 1977.

Holter, Patra, *Photography Without a Camera*. New York, N.Y.: Van Nostrand Reinhold Company, 1972.

John, D.H.O., and G.T.J. Field, *Photographic Chemistry*. London: W. & J. McKay and Company, Ltd., 1963.

Lamore, Lewis, *Introduction to Photographic Principles*. New York, N.Y.: Dover Publications, 1965.

Langford, Michael, *The Step-By-Step Guide to Photography*. New York, N.Y.: Alfred A. Knopf, 1979.

Life Library of Photography, *Great Photographers*. New York, N.Y.: Time-Life Books, 1970.

——, *The Camera*. New York, N.Y.: Time-Life Books, 1970.

——, *The Print*. New York, N.Y.: Time-Life Books, 1970.

Lyons, Nathan, ed., *Photographers on Photography*. Englewood Cliffs, N.J.: Prentice-Hall, Inc., 1966.

Mees, C.E. Kenneth, *From Dry Plates to Ektachrome Film*. New York, N.Y.: Ziff-Davis Publishing Company, 1961.

Mees, C.E. Kenneth, and T.H. James, eds., *The Theory of the Photographic Process* (3d ed.). New York, N.Y.: Macmillan Publishing Company, Inc., 1966.

Pollack, Peter, *The Picture History of Photography*. New York, N.Y.: Harry N. Abrams, Inc., 1969.

Rhode, Robert B., and Floyd H. McCall, *Introduction to Photography* (3d ed.). New York, N.Y.: Macmillan Publishing Co., Inc., 1971.

Rosen, Marvin J., *Introduction to Photography*. Boston, Mass.: Houghton Mifflin Company, 1976.

Spencer, Otha C., *The Art and Technique of Journalistic Photography*. Wolf City, Texas: Hennington Publishing Company, 1966.

*The Compact Photo Lab Index*. Dobbs Ferry, N.Y.: Morgan & Morgan, 1979.

*The Focal Encyclopedia of Photography*. New York, N.Y.: McGraw-Hill Book Company, 1975.

Upton, Barbara and John, *Photography*. Boston, Mass.: Little Brown and Company, 1976.

Vestal, David, *The Craft of Photography*. New York, N.Y.: Harper & Row, 1975.

Wade, Kent E., *Alternative Photographic Processes*. Dobbs Ferry, N.Y.: Morgan & Morgan, 1978.

White, Minor, Richard Zakia, and Peter Lorenz, *The New Zone System Manual*. Hastings-on-Hudson, N.Y.: Morgan & Morgan, 1976.

Zakia, Richard D., *Perception and Photography*. Englewood Cliffs, N.J.: Prentice-Hall, Inc., 1975.

Zelikman, V.L., and S.M. Levi, *Making and Coating Photographic Emulsions*. New York, N.Y.: The Focal Press, 1964.

# Index

# Index

Absorption of light, 11–13
Accelerators, 165–66
Acceptable sharpness (*see* Depth of field)
Acufine film developer, 169, 176
Additive primaries, 293
Adhesives, mounting, 242–43
Agitation rate, 170–73, 180
Albumen printing paper, 222–23
Allyl isothicyanate (mustard oil), 103–4
Amber safelights, 192
Ambiguous state, 158–59
American National Standards Institute, 107
American Standards Association, 107
Ammonia, 105
Ammonium thiosulfate, 164, 177
Angle of action, motion control and, 75, 77
Angle of view, 55–56
Anthony of New York, 103
Antihalation backing, 107
Aperture, 86–94
    in automatic and semiautomatic
      cameras, 93–94
    circles of confusion and, 86–88
    depth of field and, 87–93
    flash exposure calculation and, 273,
      276–88
    function of, 86

    hyperfocal focusing and, 93
    lens speed and, 52–53
    measurement of (*see* $f$/stops)
    preset, 121
    subject-background relationship and,
      145
Archer, Frederick Scott, 101, 206
ASA (American Standards Association)
    speed rating, 107–9, 118–19
Asymmetry, 158
Atomal film developer, 168
Automatic cameras, 93–94, 139–40
Automatic film processors, 201–2
Available light photography, 254–68
    advantages of, 260–62
    contrast, 265–66
    development of, 254–55
    disadvantages of, 262–67
    equipment requirements, 256–59
    film speed and, 256–57, 264
    light sources, 259–60
    subject placement, 265–67
    sunlight, 260, 264–65
Averaging exposure system, 135–37, 138

Background-subject relationships, 143–47
Backlighting, 129–30

Balance, 157–60
"Balanced to the light source," 6
Bas-relief printing, 313–15
Beam candle power per second (BCPS), 277
Bellows, 36, 63
Bellows factor, 63
Betavaron zoom lens, 199
Between-the-lens shutters, 69–71
Bitumen of Judea, 97–98
Black-and-white film (*see* Film)
Blue filter, 297
Blur motion, 74–75, 77–81
Blur motion technique, 80–81
Boards, mounting, 240–41
Bottom-weighted meter, 138
Bounce flash, 285–86
Boutan, Louis, 270
Boys, C.V., 271
Bracketed exposures, 139–40
Brightness, 6, 8–10
Brightness range reading, 136
Bright sunlight, 125–26
Bromide emulsions, 222
Brothers, Alfred, 270
Brush, 64–65
B setting, 122
Bunsen, Robert Wilhelm, 270
Burning-in, 221, 235, 237
Burnishing tool, 242

Calotype, 99–100, 164, 218
Camera obscura, 21–22
Cameras, 20–43
    automatic, 93–94, 139–40
    for available light photography, 256
    camera obscura, 21–22
    direct viewing, 35–37, 42, 70
    functions of, 20
    holding of, 37–40
    pinhole, 23–27
    reflex viewing, 30–34, 41–42
    semiautomatic, 94, 139–40
    special designs, 40–41
    viewfinder viewing, 27–30, 41
Cardano, Girolamo, 21
Catadioptric lens, 60–61
Cell focusing, 84–85
Celluloid, 101–3
Celluloid acetate, 100, 103
Celluloid nitrate, 100
Cellulose triacetate, 107
Center-weighted meter, 138

Chevalier, Charles Louis, 98
Chromatic aberration, 47, 60
Circles of confusion, 86–88
Cloth-curtain focal plane shutter, 72
Cloudy bright sunlight, 126–28
Coated lenses, 53
Coating stage, 107
Cold mounting, 242
Color:
    flash exposure calculation and, 275, 277
    of light sources, 5–6
    mood and, 15–16
    primary, 293
Color films, 15, 298
Color prints, 242
Commercial high-contrast films, 312–13
Componar-C lens, 198
Componon lenses, 198
Composition, 141–62
    balance, 157–60
    common mistakes in, 142–43
    defined, 141
    enlarging and, 220–22
    line, 154–56
    perceptual grouping, 148–53
    subject-background relationships, 143–47
    tone, 160–61
Compound lenses, 45–46
Compressed perspective, 52
Condenser enlargers, 196–97, 210
Cones of eye, 3–4
Contact print, 194
Contrast, 9, 11, 160–61
    available light photography and, 265–66
    of condenser enlarger, 196–97
    development time and, 170–72, 174
    of enlarging paper, 224–27
    film speed and, 111–12
    final finish and, 251
    of high-contrast films, 312–19
    mood and, 14–15
    of negative, 166–67
Contrast filters, 296–97
Control 4.5 film developer, 168
Controls, 68–95
    in automatic and semiautomatic cameras, 93–94
    (*see also* Aperture; Focus; Shutters)
Converging lens shapes, 46
Convex lens, 45
Copper plates, silver-coated, 98

Correcting the lens, 46
Correction filters, 293-95
Covering power, 54
Critical focus, 82-83, 91-92, 220
Cropping, 147, 220-22
Curved lines, 156

Daguerre, Louis Jacques Mandé, 73, 98-99, 117-18, 164
Daguerreotype, 99, 164, 218
Darkroom, 190-204
  automatic film processors, 201-2
  easels, 200-201
  enlargers (*see* Enlargers)
  enlarging lens, 195, 198-99
  enlarging papers (*see* Enlarging papers)
  history of, 190-91
  modern, 192
  print dryers, 203
  print washers, 202-3
  safelights, 113, 192-94
  timers, 201, 233-34
Davy, Humphry, 97, 205-6
Daylight balanced film, 6
Daylight processing tanks, 191
Deep shade, 130-32
della Porta, Giovanni Battista, 21-22
Density, 170, 175
Depth of field, 32, 87-93
  aperture opening and, 87-88
  available light photography and, 263-64
  defined, 87
  focal length and, 88-90
  hyperfocal focusing and, 93
  subject distance and, 88-90
  zone focusing and, 91
Depth-of-field preview, 34, 90-91
Developers, 164-65, 168-69, 171, 173-76, 180, 313
Developing tank, 178-79
Developing time, 170-73
Development chart, 171
Diafine film developer, 169
Diagonal lines, 154-55
Diffraction, 24
Diffusion enlargers, 196-98, 220
Diffusion screen, 195
Digestion stage, 106
Dilution, 175
DIN (Deutsche Industrie Norm), 108-9
Diopters, 63

Direction of light, 10-11
Direct off-camera flash technique, 283-85
Direct on-camera flash technique, 281-82
Direct viewing system, 35-37, 42, 70
Distance, flash exposure calculation and, 275-76
Distortions, deliberate, 58
Diverging lens shapes, 46
Dodging, 221, 235-36
Drying, 182
Dry mounting, 243-47
Dry plate, 100-101
D-76 film developer, 169, 175-76
Dust, 64
Dyed filters, 291
Dyes, 106, 170, 248-50, 310-11

Easels, 200-201
Eastman, George, 22, 101-2
Eastman Kodak Company, 102-3, 255
  (*see also* Kodak)
Edgerton, Harold E., 271
Effective candle power per second (ECPS), 277
Electronic flash, 271-72 (*see also* Flash photography)
Emphasis:
  control of, 68
  subject, 142-43
Emulsions:
  enlarging paper, 222-25
  film (*see* Film emulsions)
Enlargers, 194-98, 220
  film development quality and, 167, 170
  photograms with (*see* Photograms)
Enlarging:
  contrast and tone control, 221, 224-27
  papers (*see* Enlarging papers)
  print manipulation, 235-38
  process of, 233-34
  reasons for, 219-21
  test strips, 226, 228-31
Enlarging head, 195
Enlarging lenses, 195, 198-99
Enlarging papers, 203, 222-26
  contrast grades of, 226-32
  film development quality and, 167, 170
Equivalent exposures, 123

Exposure:
  automation of, 93
  basic reference exposures, 124-32
  bracketed, 139-40
  combinations of development and, 174
  equivalent exposures, 123
  factors influencing (*see* Aperture; Film speed; Light intensity; Shutter speed)
  filters and, 298-99
  flash, 272-78
  light meters and (*see* Light meters)
  moment of, 146
Exposure tables, 124
Extension tubes, 63

Fall-off, 195
Feathered flash technique, 283-84
FG7 film developer, 169
Fiber emulsion support, 223
Field camera, 37
Film:
  black-and-white, 107-12
  color, 15, 298
  development of (*see* Film development)
  emulsions (*see* Film emulsions)
  emulsion supports, 98-103, 107
  high-contrast, 312-19
  history of, 96-101
  light-sensitive materials, 96-101, 104, 106
  sensitivity of (*see* Film sensitivity)
  unloading, 178
Film boxes, 119-20
Film development, 163-89
  combinations of exposure and, 174
  common negative faults, causes, and remedies, 183-88
  darkroom and (*see* Darkroom)
  developers, 164-66, 168-69, 171, 173-76, 180, 313
  factors affecting, 169-73, 175
  fixing agents, 164, 177, 181
  history of, 163-65
  physical aspects of, 165-68
  process of, 178-82
  subject-background relationship and, 146-47
  tonality and, 147, 166-67
  variations, 175-76
  wetting agent, 177-79, 182

Film emulsions, 96-116
  characteristics of, 107-12
  gelatin, 100-101, 103-5, 107
  history of, 96-101
  preparation of, 104-7
  special purpose, 112-15
  support for, 98-103, 107
Film "fog," 165
Film processors, automatic, 201-2
Film sensitivity, 4-6, 8-10, 12 (*see also* Film speed)
Film size, 220
Film speed (sensitivity), 107-12, 118-20
  available light photography and, 256-57, 264
  bracketed exposures and, 139-40
  contrast and, 111-12
  flash photography and, 275
  reference exposures and, 124-32
  subject enhancement and, 144
Filter factors, 298-99
Filters, 290-303
  color chart, 293
  for color films, 298
  contrast, 296-97
  correction, 293-95
  designation of, 291-92
  filter factors, 298-99
  function of, 292-93
  gelatin, 290-91
  laminated, 291
  polarizing, 14, 300-301
  special-effect, 302-3
  special-purpose, 299-302
  stained glass, 291
  ultraviolet, 66, 301-2
Fine-grain film developers, 166, 168
Fingerprints, 65
Fixer neutralizer, 182
Fixing agent, 164, 177, 181
Flare, 267
Flash bulbs, 270, 279-80
Flashing, 237-38
Flash meters, 278-79
Flash photography, 269-89
  direct off-camera technique, 283-85
  direct on-camera technique, 281-82
  exposure calculations, 272-78
  flash meters, 278-79
  flash synchronization, 279-81
  history of, 269-72
  indirect techniques, 285-86
  synchro-sunlight flash technique, 287-88

Flash power, 270
Flash synchronization, 279–81
Flat-field principle, 62
Focal length:
    camera lenses, 49–52, 57, 88, 90
    enlarging lenses, 198–99
Focal plane shutters, 69, 71–73, 274–75
Focus, 28–29, 82–85
    automatic, 93
    as creative control, 85
    critical, 82–83, 91–92, 220
    function of, 82
    types of focusing mechanisms, 83–85
Focus range, 61–62
"Fog," 165
Format cameras, 84
Fox Talbot, William Henry, 99, 164,
        191, 206, 218, 271
FR 22 film developer, 169
*f*/stops, 92
    bracketed exposures and, 139
    calculation of, 121
    defined, 121
    equivalent exposures, 123
    reference exposures and, 124–32
    steps between, 12
    (*see also* Aperture)

Gallic acid, 164
Gel, 105
Gelatin film emulsion, 100–101, 103–5,
        107
Gelatin filters, 290–91
Gestalt psychology, 151
Glass, 100–101, 107
Glass negative carrier, 195
Goodwin, Hannibal, 102
Goodwin Film and Camera Company,
        103
Graduate, 178
Graininess, 257
    film development and, 165–66,
        168–69
    film speed and, 144
Gray card reading, 136–37
Green filter, 295, 297
Grouping, perceptual, 148–53
Guide numbers, 278

Halides, 4–5
Halogens, 4
Haze filter, 66, 301–2

Hazy sunlight, 126–27
HC 110 film developer, 169
Helical focusing mount, 84
Herschel, Sir John, 164
High-accutance developers, 166
High-contrast films, 312–19
High-energy developers, 169
High-key photograph, 232
Highlights, 11, 16
High-speed films, 112
Horizontal lines, 154
Hot shoe, 283
Hyatt, John, 101
Hydroquinone, 165, 171
Hyperfocal focusing, 93
Hypo, 99, 164, 181, 234
Hypo clear, 182

ID-11 film developer, 169
Image distortion, 48–49
Image size, focal length and, 49–50
Incident light meters, 132, 137
Independent viewfinder, 28
Indirect flash techniques, 285–86
Infrared emulsions, 114–15, 296
Infrared spectrum, 2, 6–7
Inspection, film development by, 170
Internal focusing, 84–85
Intersecting lines, 156
Inverse squares, law of, 8, 265
Inverted telephoto lens, 58
ISO (International Standards Organiza-
        tion), 108–9, 118–19

Kelvin temperature, 298
Kennett, Richard, 100
Kenyon, G.A., 270
Kodak:
    cameras, 40, 101–2
    Direct Positive Film Developing Kit,
        176
    film, 119, 255
    film developers, 168–69, 175
    Photo-Flo, 177
    toners, 310

Lacquer, 251–52
Laminated filters, 291
Latent image, 98
Lens cleaning fluid, 64–66

Lenses (camera), 44–67
  angle of view, 55–56
  for available light photography,
    256–57
  bellows, 63
  care of, 63–67
  catadioptric (mirror), 60–61
  cleaning, 64–66
  covering power, 54
  depth of field of (*see* Depth of field)
  diopters, 63
  in direct viewing, 35–37
  extension tubes, 63
  film development quality and, 167,
    170
  focal length, 49–52, 57, 88, 90
  focusing and, 82–85
  history of design of, 44–46
  macro, 62
  macro-focusing, 62
  normal, 57
  optical faults and, 46–49
  in reflex viewing, 30–34
  resolution, 53–54
  speed, 52–53
  tele-extender, 61
  telephoto, 51, 59–61, 66
  wide-angle, 51, 57–58, 66
  zoom, 63
Lenses (enlarger), 195, 198–99
Lens flare, 53
Lens hoods, 66–67
Lens speed, 52–53
Lens tissue, 64–66
Leonardo da Vinci, 21
Light, 1–19
  absorption of, 11–13
  direction of, 10–11
  intensity (*see* Light intensity)
  mood and, 14–16
  polarization of, 13–14
  reflection of, 11–13
  subject isolation and, 17
  texture and, 10–11, 16–17
  visual element unification and, 18
  wavelength of, 2–7
Light intensity, 6, 8–10, 117
  control of (*see* Aperture)
  enlarging paper and, 225–26
  flash exposure calculation and, 275–
    77
  light meter and, 134
  reference exposures and, 124–32

subject-background relationship
  and, 144–45
Light meters, 93, 132–38
  built-in, 93, 133, 135, 138
  flash meters, 278–79
  taking readings with, 135–38
  types of, 132–34
Light-sensitive materials, 96–101, 104,
  106
Light sensitivity, measurement of, 118
Lime light, 269
Line, 154–56
Lithographic high-contrast films, 312–13
Long telephoto lens, 59–60
Low-key photograph, 232
Lumen seconds, 277

Mach, Ernst, 271
Macro-focusing lens, 62
Macro lens, 62
Maddox, Richard, 100
Magnesium, 270
Matte lacquer, 251
Matting, 247
Maxwell, James Clerk, 3–4
Medium-speed films, 112
Medium telephoto lens, 59
Meniscus lens, 45, 53
Metal-bladed focal plane shutter, 72–73
Metol, 165, 171
Microdol X film developer, 168
Microphen film developer, 168
Mid-key photograph, 232
Minicol 11 film developer, 169
Mirror lens, 60–61
Mirrors, in reflex viewing, 30–34
Modeling, 10–11
Moholy-Nagy, Laszlo, 206
Monobath developer, 169
Montages, photographic, 307–9
Mood:
  color and, 15–16
  contrast and, 14–15
  control of, 68
  enlarging and, 231–32
  light and, 14–16
  line and, 154–56
  tone and, 16, 160–61
Motion control, 73–81
Moule, John, 269
Mounting (*see* Print mounting)
Mounting presses, 242

M synchronization, 280
Multiple toning, 311

Negative carrier, **195**
Negatives:
    sandwiching, 306-7
    (*see also* Film development)
Neutral density filter, 299-300
Newton, Sir Isaac, 3
Niepce, Joseph Nicephore, 97-98, 163-
    64, 206
Nikonos camera, 41
Nitric acid, 96-97
Nitro-cellulose roll film, 102
Nodal point, 49
Normal development, 174
Normal exposure, 139-40, 174
Normal lens, 57
Normal telephoto lens, 59

Open shade, **128-29**
Optical faults, 46-49
Optical sensitizers, 5, 106
Optical viewfinder, 28
Orange filter, 297
Orbit Bath, 177
Orthochromatic emulsions, 113
Orthonon emulsion, 112-13
Ostermeier, Johannes, 270
Ostwald ripening, 100, 105-6
Overcast conditions, 126
Overdevelopment, 174, 176
Overexposure, 139-40

Panchromatic film, 5, 47, 113-14, 294
Pan motion, 77-80
Paper:
    emulsion support, 99, 101, 107
    enlarging (*see* Enlarging papers)
Paper exposure meter, 124
Parallax error, 29-30, 32
Pencils, spotting with, 250-51
Pentaprism, 34
Pentax Digital Spotmeter, 133
Perceptol film developer, 169
Perceptual grouping, 148-53
Perspective:
    compressed, 52
    distortion, 50-51
Petzval, J., 45

Photoelectric cell, 285
Photoelectric meter, 93
Photo-Flo, 177
Photogen, 269
Photograms, 205-17
    demonstration of photographic
        principles with, 208-14
    history of, 205-8
    materials for, 214-15
    variations of, 215-17
Photographic montages, 307-9
Photo-Maskoid, 311
Photo sketching, 311-12
Pinacyanol, 106
Pinhole camera, 23-27
Polarization, 13-14
Polarizing filters, 14, 300-301
Polaroid cameras, 40
Polymer plastic support, 100, 107
Positionable adhesives, 242
Potassium bromide, 104
Potassium chloride, 270
Precipitation stage, 104-5
Preservative, 166
Presetting shutter, 70-71
Press camera, 37
Pressurized air, 64-65
Primary colors, 293
Print dryers, 203
Print finishing, 240-53
    final, 251-52
    mounting (*see* Print mounting)
    spotting, 247-51
Printing variations, 305-20
    bas-relief, 313-15
    high-contrast films, 312-19
    photographic montages, 307-9
    photo sketching, 311-12
    print toning, 241, 309-12
    sandwiching negatives, 306-7
    solarization, 317-19
    texture screens, 305-6
    tone line, 315-16
Print mounting, 240-47
    dry, 243-47
    matting, 247
    mount selection, 240-41
    positioning, 247
    spray adhesives, 242
    wet, 242-43
Prints:
    early, 190, 191
    modern, 194-203

(*see also* Enlarging; Print finishing;
   Printing variations)
Print toning, 309-12
Print washers, 202-3
Prisms, 303
Process high-contrast films, 312-13
Proof sheet, 213-14
Proximity, perceptual grouping and,
   148-51
Psychological implications of color, 15-
   16
Push processing, 176

Reade, J.B., 164
Realism, sense of, 261-62
Red filter, 292, 296-97
Reducers, 165-66, 168
Reduction, chemical, 165
Reels, developing, 178-79
Reference exposures, 124-32
Refinal film developer, 169
Reflected light meters, 132-35
Reflection of light, 11-13
Reflex viewing, 30-34, 41-42
Replenisher, 175, 180
Replenishment time, 180
Resin-coated (RC) paper, 203, 223, 242
Resolution, 53-54
Restrainer, 165
Reticulation, 172
Reversal processing, 176
Ripening stage, 105
Rocker-type print washer, 202
Rodinol film developer, 169
Roscoe, Sir Henry, 270
Rule of thirds, 159-60

Sabattier, Armand, 317
Safelights, 113, 192-94
Safety film, 100
Salcher, P., 271
Salomon, Erich, 254-55
Sandwiching negatives, 306-7
Schultze, Johann Heinrich, 96-97, 163,
   205
Selenium toners, 310
Self-setting shutters, 70
Self-trimming tissues, 243
Semiautomatic camera, 94, 139-40

Sensitized plates, 97
Shade:
   deep, 130-32
   open, 128-29
Shadows, 11, 16
Sharpness (*see* Depth of field; Focus)
Sheppard, Samuel, 103
Short telephoto lens, 59
Shutters, 68-81
   in automatic and semiautomatic
      cameras, 93-94
   function of, 68-69
   motion control and, 73-81
   preset, 121
   types of, 69-73
Shutter speed, 75-76, 81, 118, 122-23
   equivalent exposures and, 123
   flash exposure and, 272-75
   measurements of, 118
   reference exposures and, 124-32
   subject-background relationship and,
      135-46
Silhouettes, 97, 205-6
Silver bromide, 100, 104-6, 224
Silver chloride, 97, 104, 224
Silver halides, 104, 106, 109-11, 117-
   18, 164-67, 177, 205-6
Silver iodide, 98-99, 104
Silver nitrate, 96-97, 104-5, 163
Similarity, perceptual grouping and,
   151-53
Single-lens reflex (SLR) camera, 30,
   32-34, 39-40, 42, 90-91
Size distortion, 58
Skylight filter, 66, 302
Slow-speed films, 112
Smyth, C. Piazzi, 270
Sodium chloride, 164
Sodium hyposulfite, 99, 164
Sodium sulfite, 166, 168, 177
Sodium thiosulfate, 164, 177
Sodium vapor safelight, 192-93
Soft focus filter, 302
Solarization, 317-19
Spark photographs, 271
Special-effect filters, 302-3
Special-purpose emulsions, 112-15
Special-purpose filters, 299-302
Specialty filters, 299-303
Spherical aberration, 47-48, 53
Split-image rangefinder, 28-29
Sports finder, 39
Spot meter, 133-34, 138

Spotting, 247-51
Spotting colors, 248
Spotting dyes, 248-50
Spray adhesives, 242
Spray lacquer, 251-52
Stabilization papers, 222-23
Stabilization processors, 201-2
Stained-glass filter, 291
Star filter, 302
Stop action, 74-75, 76
Stops (*see* f/stops)
Stress, visual, 159
Stripping film, 101
Stroboscopic flash, 271
Studio camera (*see* Direct viewing system)
Subject:
 -background relationships, 143-47
 balance and, 157-60
 emphasis, 142-43
 isolation, 17
 lines and, 154-56
 perceptual grouping and, 148-53
 tone and, 160-61
Subject distance:
 depth of field and, 88-90
 motion control and, 77-79
Subtractive primaries, 293
Sunlight:
 available light photography and, 260, 264-65
 bright, 125-26
 cloudy bright, 126-28
 hazy, 126-27
Super 20 film developer, 168
Supplementary lenses, 63
Symmetry, 157
Sync cord, 283
Synchronization, flash, 279-81
Synchro-sunlight flash technique, 287-88

Talbotype, 99-100
TEC film developer, 169
Tele-extender, 61
Telephoto lens, 51, 59-61, 66
Temperature, 170-72, 179
Temporal grouping, 150-51
Test strips, 226, 228-31
Texture, light and, 10-11, 16-17
Texture screens, 305-6
Thermometer, 178
Thermoplastic adhesive, 243

Thiocyanates, 105
Thirds, rule of, 159-60
Timers, 178-79, 201, 233-34
Timing, 170-73
Tipped flash technique, 283-84
Tissue, mounting, 243-46
Tonality:
 enlarging and, 221, 226-32, 235-38
 film development and, 147, 166-67
 mood and, 15, 160-61
 pan motion and, 79
 photograms and, 209-10
 reflection of light and, 11-12
 subject isolation and, 17
Tone line, 315-16
Toners, 309-10
Toning, 241, 309-12
Tournachon, Nadar Gaspard Félix, 270
Triacetate, 100
Tripod, 220, 257-58
True telephoto lens, 60
T setting (time exposure), 122
Twin-lens reflex (TLR) camera, 30-32, 37, 39, 41, 69-70, 84

UFG film developer, 169
Ultrafin FD5 film developer, 169
Ultraviolet filter, 66, 301-2
Ultraviolet wavelengths, 2, 4-5
Underdevelopment, 174
Underexposure, 139-40, 174
Underwater photography, 41

Vertical lines, 154
View camera (*see* Direct viewing system)
Viewfinder viewing, 27-30, 41
Viewing systems, 27-37, 40-42
 available light photography and, 256
 direct, 35-37, 42, 70
 reflex, 30-34, 41-42
 viewfinder, 27-30, 41
Vignetting, 237-38
Visual elements, unification of, 18

Waist level viewfinder, 31
Washing aids, 177
Washing stage, 105-6, 182
Water bath treatment, 175-76
Watt seconds, 277

Wavelength, 2–7
Wedgewood, Thomas, 97, 163, 205–6
Weight, compositional, 158–59
Wet mounting, 242–43
Wetting agent, 177–79, 182
Wide-angle lens, 51, 57–58, 66
Wire viewfinder, 28
Wollaston, William Hyde, 45
Wollaston meniscus lens, 45
Wratten number, 291–92

X synchronization, 279–80

**Yellow filter, 225, 294–95, 297**
Yellow-green safelights, 192
Young, Thomas, 3

**Zig-zag lines, 155**
Zirconium, 270
Zone focusing, 91
Zoom lens:
    camera, 63
    enlarger, 199